Rock Art in Africa

Mythology and Legend

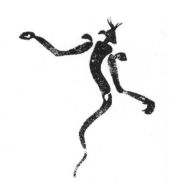

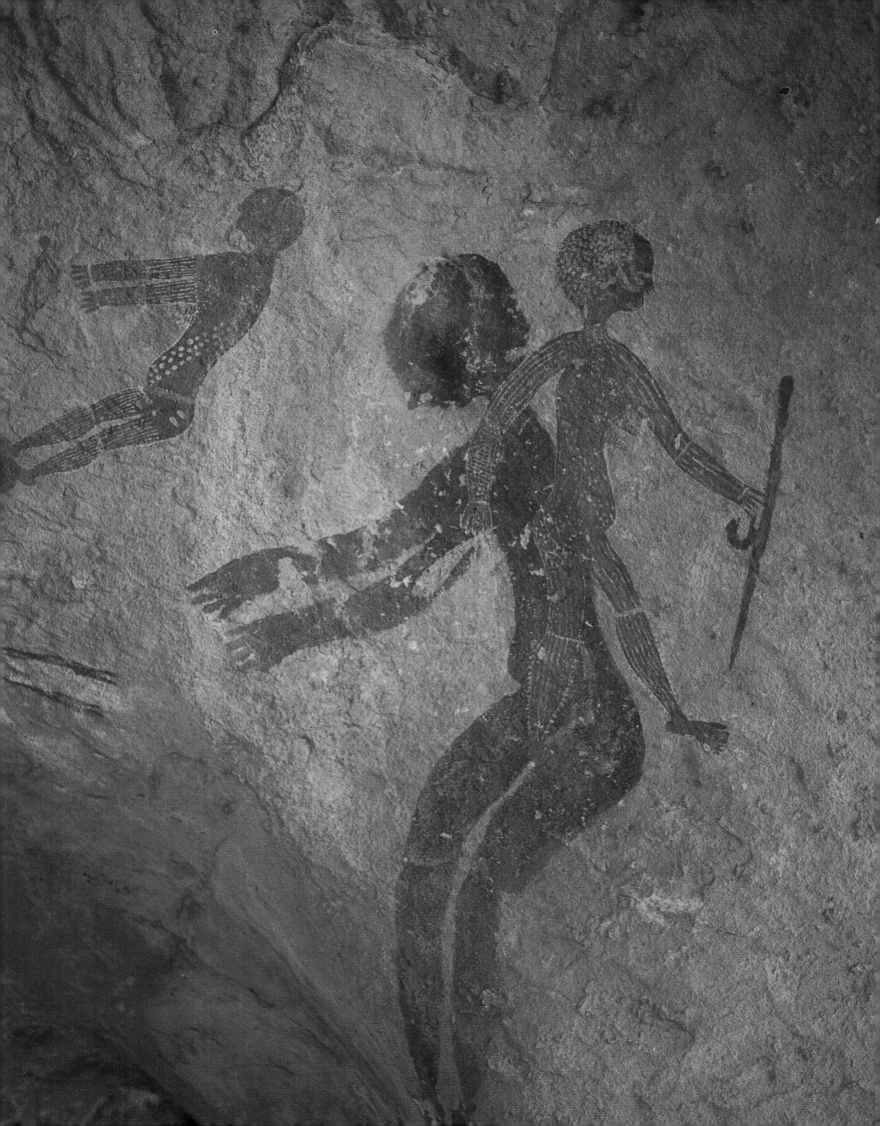

Jean-Loïc Le Quellec, translated by Paul Bahn

Rock Art in Africa
Mythology and Legend

Flammarion

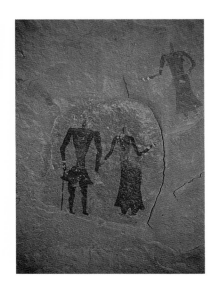

This work would have been impossible without the kindness of those people who enabled me to improve my documentation. I would like to offer my warmest thanks to Gezachew Abegaz, Didier Basset, Claude Boucher, Giulio Calegari, François-Xavier Fauvelle, Philippe and Pauline de Flers, Alain Gallay, Jean-Gabriel Gauthier, Philippe Guillaume, André-Paul Hesse, Bertrand Hirsch, Éric Huysecom, Sidina Kaza, Gerhard Kubik, Jean-Marc Large, Séverine Marchi, Giancarlo Negro, Martin Ott, Adriana and Sergio Scarpa Falce, and Andras Zboray. I am also grateful to those institutions which facilitated my research: the Institut Français d'Afrique du Sud (Johannesburg), Institut Français des études éthiopiennes (Addis Ababa), Centre de recherches africaines (Paris I), and the Department of Libyan Antiquities (Tripoli).

Copyediting: Slade Smith
Design: Marine Gille
Typesetting: Bianca Gumbrecht
Proofreading: Jennifer Ladonne
Color Separation: Quat' coul, Toulouse

Distributed in North America by Rizzoli International Publications, Inc.

Simultaneously published in French as *Art rupestre et mythologies en Afrique* © Éditions Flammarion, 2004
English-language edition © Éditions Flammarion, 2004

04 05 06 4 3 2 1

FC0444-04-X
ISBN: 2-0803-0444-5
Dépôt légal: 10/2004

Printed in Italy by Canale

Preceding pages
"Round Head" figures: Ta-n-Zumaitak, Tassili n' Ajjer.

Above
Horse-period figures: Awîs region, Acacus massif, Libya.

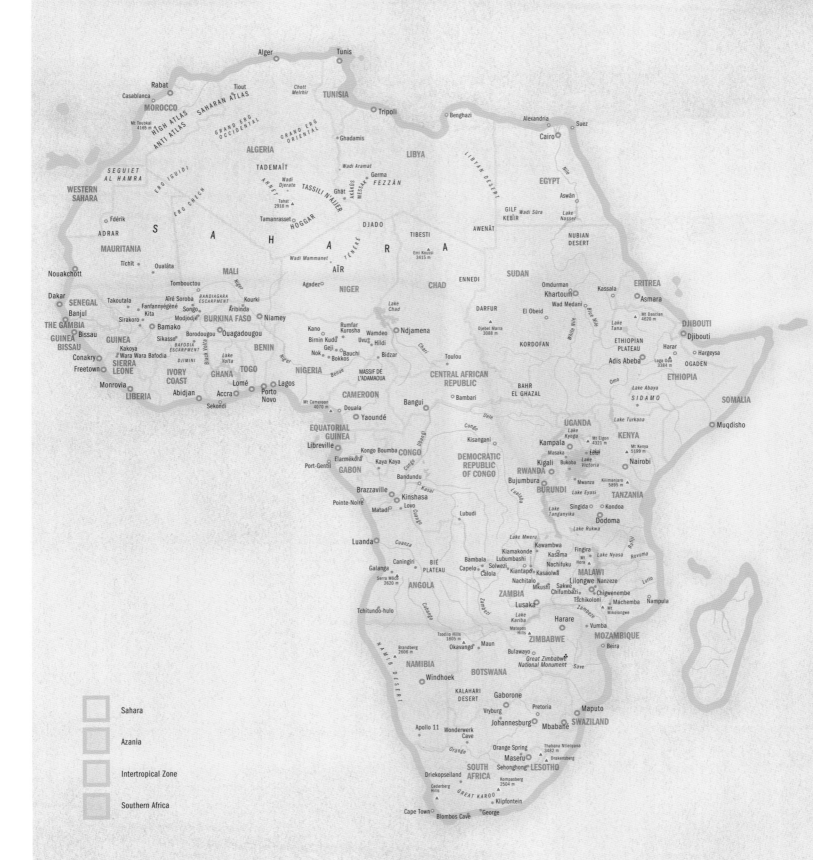

Alger Tunis

Rabat
Casablanca Tiout Chott
MOROCCO Melrhir TUNISIA Tripoli Benghazi Alexandria Suez
Mt Toubkal Cairo
4165 m HIGH ATLAS SAHARAN ATLAS Ghadamis LIBYA Aswân
ANTI ATLAS GRAND ERG GRAND ERG EGYPT
SEGUIET OCCIDENTAL ORIENTAL Wadi Aramat Nile
AL HAMRA TADEMAÏT Germa LIBYAN DESERT
WESTERN Wadi Ghât FEZZÂN Lake
SAHARA ERG IGUIDI Djerate TASSILI N'AJJER MESSAK Nasser
Fdérik Tahat HOGGAR GILF Wadi Sûra
ADRAR S 2918 m DJADO KEBÎR NUBIAN
Tamanrasset TIBESTI AWENÂT DESERT
MAURITANIA A Wadi Mammanet DJADO Emi Koussi
Tichît H TÉNÉRÉ R 3415 m
Nouakchott Oualâta MALI A ENNEDI SUDAN
Tombouctou Agadez NIGER CHAD Omdurman Kassala ERITREA
Dakar Takoutala Aïré Soroba BANDIAGARA Kourki Khartoum Asmara
SENEGAL Fanfannyégéné ESCARPMENT Rumfar Wamdeo DARFUR El Obeid Wad Medani Blue Nile Mt Dascian
Banjul Kita Songo Aribinda Kurosha Ndjamena Djebel Marra Lake 4620 m
THE GAMBIA Sirakoro BURKINA FASO Niamey Kano Uvu Hildi 3088 m White Nile Tana ETHIOPIAN Harar DJIBOUTI
GUINEA Bamako Borodougou Ouagadougou Birnin Kudu Geji Bidzar KORDOFAN PLATEAU Djibouti
BISSAU Bissau Sikasso BAFODIA Nok Bokkos BAHR Adis Abeba Laga Oda Hargeysa
Conakry Kakoya ESCARPMENT Lake Bauchi Toulou EL GHAZAL 3384 m OGADEN
SIERRA Wara Wara Bafodia DJIMINI Volta BENIN NIGERIA CENTRAL AFRICAN Omo ETHIOPIA
Freetown LEONE IVORY GHANA TOGO Benue MASSIF DE REPUBLIC SOMALIA
Monrovia COAST Lomé Lagos L'ADAMAOUA Bambari SIDAMO
LIBERIA Abidjan Accra Porto CAMEROON Bangui Lake Turkana Muqdisho
Sekondi Novo Mt Cameroon UGANDA
4070 m Douala Uele Lake Mt Elgon KENYA
EQUATORIAL Yaoundé Congo Kisangani Kyoga 4321 m Mt Kenya
GUINEA DEMOCRATIC Kampala Lolui 5199 m
Libreville REPUBLIC Masaka Bukoba Lake Nairobi
Elarmékora Kongo Boumba CONGO OF CONGO Kigali Victoria
Port-Gentil Kaya Kaya RWANDA Mwanza
GABON Bandundu Bujumbura BURUNDI Kilimanjaro TANZANIA
Brazzaville Kasai Lubudi Lake Eyasi 5895 m
Pointe-Noire Kinshasa Lualaba Singida Kondoa
Matadi Lovo Cuango Lake Dodoma
Luanda Cuanza Tanganyika Lake Rukwa
Lake Mweru Kawambwa
Caningiri BIÉ Bambala Kiamakonde Fingira Lake Nyasa Rovuma
Galanga PLATEAU Capelo Kasama Mt Lurio
Serra Môco Calola Lubumbashi Nachifuku Horn MALAWI
2620 m Solwezi Kiantapo Lilongwe Nanzeze
ANGOLA Kasaolwâ Mkushi Sakwe Chigwenembe Nampula
Nachitalo Chifumbazi Machemba
Tchitundo-hulo ZAMBIA Tschikoloni Mt
Lusaka Mikolongwe
Cubango Lake Harare MOZAMBIQUE
Kariba Vumba
Tsodilo Hills Matopos ZIMBABWE Beira
1805 m Brandberg Okavango Maun Hills
2606 m Bulawayo Great Zimbabwe Save
NAMIB Great Zimbabwe
Windhoek National Monument
NAMIBIA BOTSWANA
KALAHARI Gaborone
DESERT Vryburg Pretoria Maputo
Apollo 11 Wonderwerk Johannesburg Mbabane SWAZILAND
Cave Orange Thabana Ntlenyana
Orange Spring 3482 m
Driekopseiland Maseru Drakensberg
Cederberg SOUTH Sehonghong LESOTHO
Hills AFRICA Kompasberg
GREAT KAROO 2504 m
Cape Town Klipfontein
Blombos Cave George

Sahara

Azania

Intertropical Zone

Southern Africa

0 500 1000 km

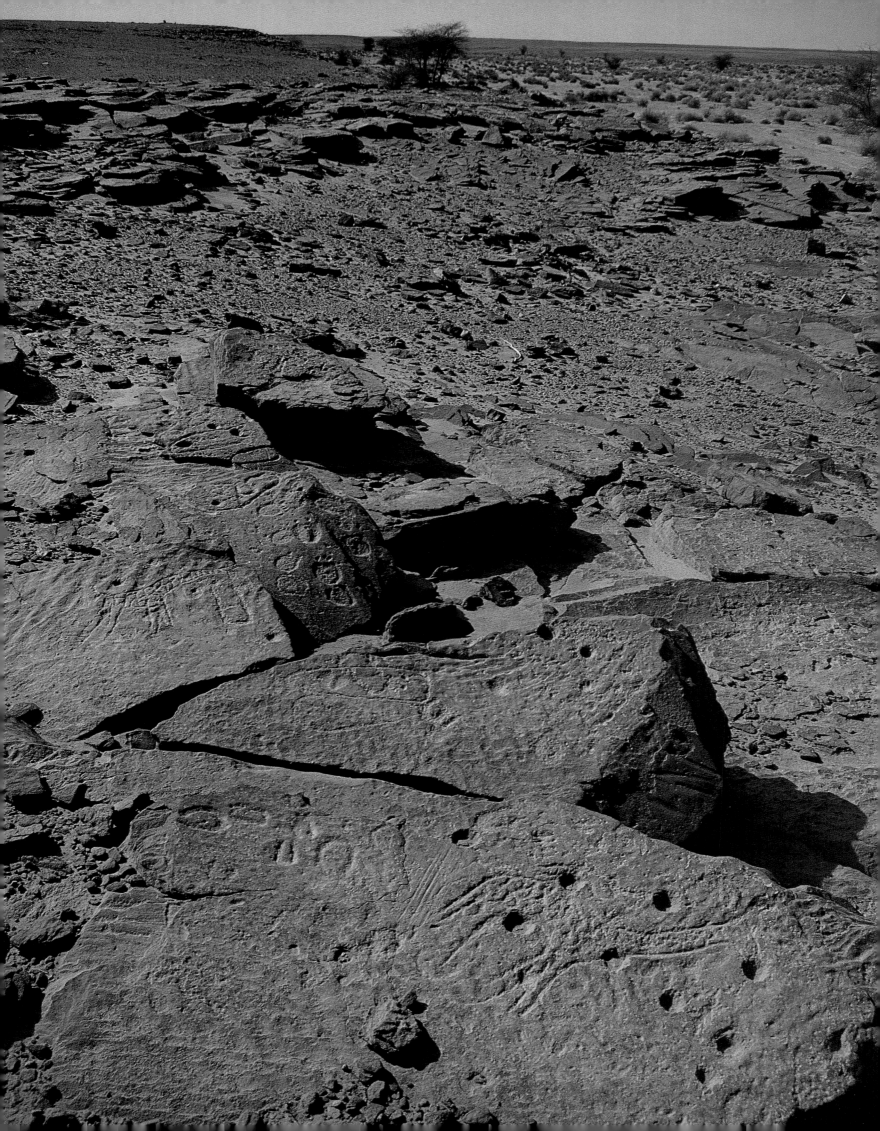

For a few years now, artists, enthusiasts, and museums have thought it possible to be interested in the idols of Africa and Oceania, from a purely artistic point of view by disregarding the supernatural character that was attributed to them by the artists who sculpted them and believing that they were paying them homage.

Guillaume Apollinaire, foreword to
the *Premier album de sculptures nègres,*
Paris, 1917.

to paint, cut,
inscribe in haste
in stone
or with words
that which
otherwise
would immediately be
as if it had
never been

Ch. Juliet

No academic book has been devoted to the *entirety* of Africa's rock art, and it seemed useful to dedicate a volume to the mythical aspects of these images. The present volume comprises a tour of Africa in four chapters, dealing first with the Sahara, followed by western and central Africa, the Horn and the East, and finally southern Africa. An iconography combining tracings, drawings, and photographs presents the rock paintings and engravings of each of these zones, characterized by their own artistic styles, ranging from accentuated realism to a sometimes very "modern" symbolism.

After having briefly placed these images in the context of their discovery (often made by the great explorers), this book deals primarily with the *meaning* of the rock art assemblages, at times citing present-day legends, which can partly elucidate those images that are from a more recent past, and at other times raising the possibility of reconstructing the mythology that they illustrated, not forgetting the analysis of the myths that the artworks themselves have occasionally created within our own culture.

Though the continent-wide scale of this study makes it impossible to be exhaustive, it does enable us to observe the wide occurrence in Africa of certain myths associated with rock art. These images quite often refer to origin myths, including a double anthropogony according to which the first creation produced men who were imperfect or at least very different from those of today (giants in the Sahara and in the Horn of Africa, or, on the contrary, dwarfs in sub-Saharan Africa)—and it was these primordial beings who, before they disappeared, engraved or painted the rocks. In many parts of sub-Saharan Africa, images and inscriptions are also attributed to people who were, if not primordial, then at least "ancient," and who are credited with power over the weather, especially the rain. A myth that is no less widespread (e.g., among the Chewa, Hurutshe, Kamba, San, Tswana, and Xhosa) sees the prints engraved on rocks as the traces of the first men and animals that, originally, emerged from the depths of the earth.

While a great number of images clearly depict mythical beings—like those half-man half-animal monsters called "therianthropes,"—there are also scenes illustrating rites connected with lost myths. Yet, an incalculable number of figures remain enigmatic and resist all attempts at serious interpretation. So what follows is only a kind of preliminary inventory, showing that the world of rock art is rich in precious documents that should be preserved to the best of our ability, scrutinized from every aspect, just as historians analyze documents, published with the help of digital images and aids, and finally studied by combining the data obtained in this way with those used by linguists, ethnologists and historians.

Saharan rock engravings are generally located on vertical walls, along valleys, but sometimes they were made on horizontal slabs, as in this site in the Libyan Messak.

The principle of C14 dating

The carbon 14 content of organic carbon compounds is in equilibrium with the carbon 14 content of the atmospheric carbonic gas of their period, but after the death of a living being its stock of carbon 14 is halved every 5,730 years. It was on the basis of this fact that Willard Frank Libby in 1946–47 invented the atomic clock which, with the help of a device for counting electrons (particles that result from the disintegration), makes it possible to date fossil organic remains. The method's effectiveness was rapidly demonstrated, but the hopes placed on it proved excessive, because it was soon noticed that it could be distorted by a great number of factors. The greatest source of error was the implicitly accepted hypothesis that the concentration of carbon 14 in the atmosphere had remained constant for a period of at least several spans of 5,730 years. Once this hypothesis was discredited, it became apparent that the time scale of radiocarbon dates was not linear and required correcting through the use of other methods, especially dendrochronology (tree-ring dating). Correction or "calibration" curves were drawn up, which enable one to obtain what are called calibrated dates. For example, if a sample gives a "raw date" of 3,950 years, that is to say, of 2000 B.C. in "C14 age," in reality this corresponds to an earlier age, and should be corrected to 2500 B.C. (calibrated date). It is customary to note the first date as 3950 B.P. and the second as 2500 B.C. Prehistorians specializing in the Neolithic also use the form 2000 b.c., meaning that the date is B.C., but not calibrated, that is, uncorrected.

The result of all this imbroglio is that it discourages the layman and can even lead certain prehistorians astray. The crucial point is to distinguish between dates in A.D., B.C., B.P., a.d., and b.c.:

A.D. is the code that poses the fewest problems: these letters are the initials of *anno Domini* ("in the year of the Lord") and not *after death* as is sometimes believed. Dates with this designation are quite simply those of our calendar, that is, the "after Christ" dates used by historians. On the other hand, while dates "a.d." (in lower case) are likewise situated "after Christ," they are uncalibrated, and thus cannot be directly transposed to the calendar. To avoid the Christian references, many authors now use C.E. and B.C.E., which mean *Common Era* and *before the Common Era*, rather than A.D. and B.C.

B.C.: the meaning of these initials is *before Christ*, in calibrated (and thus calendrical) dates. The abbreviation b.c. indicates dates that are also before the Christian era, but uncalibrated (and thus not calendrical).

B.P.: these letters stand for *before present*, but it must be understood that this is a conventional present, fixed at the year 1950 (the date after which the carbon 14 dating method began to be regularly used). So one has the following equivalence: 0 B.P. = A.D. 1950.

All of this leads readers into rather unpleasant gymnastics, necessitating them to remember, for example, that a date of 2000 B.C. cited for a Saharan site does not correspond to a date of 2000 B.C. for a piece of Egyptian data, because its calendar equivalent is actually 2500 B.C.. To simplify things, in this text we have avoided the forms A.D., a.d., B.C., and b.c. and have used only B.P., B.C.E., and C.E.

The problem is further complicated by the fact that, in numerous fairly old publications (and sometimes in recent texts), one is not too sure about which kind of dates are being cited by the authors. It is also necessary to take into account another characteristic of the dates obtained by the carbon 14 method—that is, that they are normally accompanied by an indication of the probability of error, which in statistics is called the "sigma" (s). For example, a sample may be dated to 5470 ± 130 B.P. (which is "calibrated" to about 4340 ± 130 B.C.), and one might be tempted to think that one need only add and subtract a "sigma" of 130 years to/from the theoretical date of 4340 B.C. to obtain the time span within which the sample's real date lies (in the chosen example, between 4470 and 4210 B.C.). But this would be a serious error, because the ± s value (or standard deviation) is statistical, and merely indicates that there is a 68 percent probability of the real date being situated between 4470 and 4210. In order to attain a probability of 95 percent, one would have to use a standard deviation of ± 2 s, and thus in our example a real date could be situated somewhere between 4600 and 4080. Naturally, the bigger the "bracket" the more reliable it is, so one needs to bear this uncertainty in mind or try to reduce it (for example, by obtaining multiple dates for the same *locus*).

In the Sahara, after the infrequent rains, water reserves are formed and, for a while, sites resemble what they may have looked like in the period when the rock images were made.

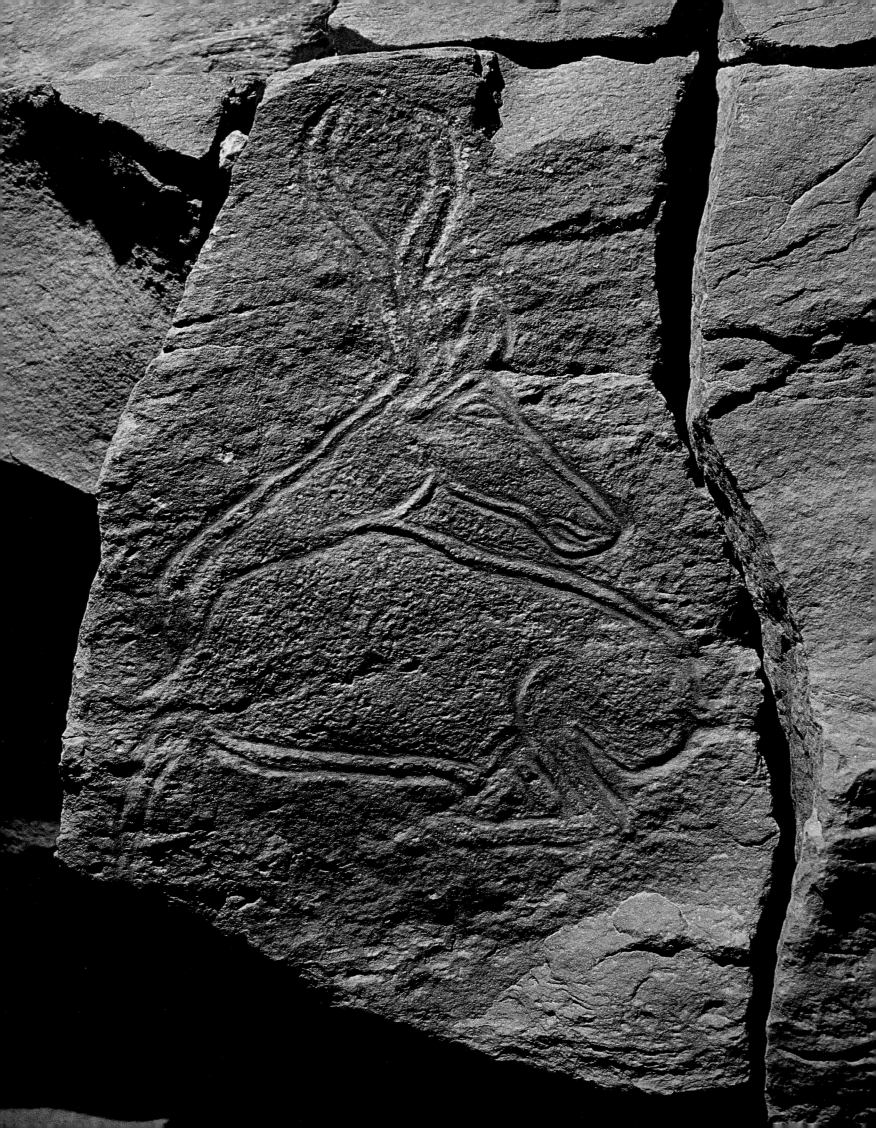

The Sahara

In ancient times, the mountain desert was in perpetual struggle with the sand desert. The divinities of heaven came down to earth with the rains; they separated the two companions and calmed the violence of their enmity. But scarcely had they moved away from the battlefield, scarcely had the rains ceased, when the war broke out again between the eternal enemies. One fine day, looking down from heaven, the divinities grew angry and sent down a punishment on the two adversaries. They froze the mountains of the Messak Settafet and stopped the stubborn progress of the sand on the edges of the Messak Mellet. Using a subterfuge, the sand then penetrated the spirit of the gazelles. Using cunning in their turn, the mountains took possession of the mouflon. Since that day, the mouflon has been inhabited by the spirit of the mountains.

—**Ibrahîm al-Kûnî,** *The Bleeding of the Stone*

Fig. 1 and Fig. 2

It was with the very first discovery of rock engravings in the central Sahara that the question of their mythical significance arose. On July 5, 1850, the explorer Heinrich Barth (*fig. 3*), on his way to Timbuktu with his caravan of Tin-Alkum Tuaregs, chose to bivouac in the Wadi Telizzâghen (located in the Libyan Messak). There he "became aware that the valley contained some remarkable sculptures deserving our particular attention . . . the sandstone blocks which studded it were covered with drawings representing various subjects, more or less in a state of preservation. With no pretensions to be regarded as finished sculptures, they are made with a firm and steady hand, well accustomed to such work." Barth then took the time to make some sketches of these images, and named one of them the "Garamante Apollo" (*fig. 4*). In the first of the five volumes telling the story of his travels, *Reisen und Entdeckungen in Nord- und Central-Afrika* (Travels and Discoveries in Northern and Central Africa), which constitute the first collection of scientific observations on all the regions he crossed, he makes the following comment:

> The figure on the left depicts the Garamante Apollo, and that on the right Hermes. Apollo is the mythical father of Garamas, the patriarch of the Garamantes, among whom cattle were highly venerated. . . . Hermes is frequently represented with an ibis head on Egyptian tombs as well as on Tyrian coins, and is considered to have been Apollo's rival for the mother of Garamas. One can perhaps also link the subject of the piece of sculpture in question to the cattle theft that was carried out by Hermes and often mentioned in song by the ancient poets, or this god's dispute with Apollo over the possession of the herds.[1]

This was written at a time when the very existence of prehistoric man was not yet fully accepted, more than twenty years before the discovery of the paintings on the ceiling of Altamira cave, and long before the recognition of the authenticity of prehistoric parietal art. So, at the time of his discovery, Heinrich Barth had no point of comparison available to elucidate the questions that arise even today with regard to these works, namely: Who made them, and what was their message? He had no choice but to refer them to his own culture, and assuming (correctly) that the images he had just discovered illustrated some myth, it was only natural, in view of his education, that he should turn to Greek mythology. Since he was in Libya, it was likewise natural that he evoked the mythical patriarch of the Garamantes people, and called on Egyptian mythology as the basis of his interpretation. This approach seems naïve today because, though we still know very little about the real motivations of the painters and engravers in the Sahara and the rest of Africa, it is at least understood that any immediate interpretation put forward at first sight of the works has a far greater chance of revealing the interpreter's biases than of identifying the ideas the artist had in mind when the work was created. After such a long time, we can clearly recognize the cultural filters that affected Barth's reading, but how many other readings proposed by present-day prehistorians undergo comparable distortions, even if they are less obvious, being so close to us? The images examined by Barth in the Messak were not much when compared with the tens of thousands of rock-art figures that have since been discovered in the Sahara, but their indomitable strangeness remains intact, and a number of commentators have unfortunately perpetuated the

[1] Barth 1857, vol. 1.

Fig. 3

Fig. 3 - Heinrich Barth was the first to make Central Saharan rock art known in Europe.

Page 12
Fig. 1 - At first sight, a great number of the Saharan rock images seem to have been only motivated by a desire to accurately depict nature. But the absence of landscapes or vegetation imagery, and the choice of animal species depicted——often with consummate artistry, as in the case of this antelope engraved in the Libyan Messak——make this whole ensemble a veritable mineral bestiary, illustrating above all the cultural choices that were dominant in the artists' society.

Page 13
Fig. 2 - The "swimmers" painted on the walls of the cave of Wadi Sûra, as reproduced in watercolors by Ladislaus de Almásy who in his renderings, artificially grouped figures which in reality are separate.

German explorer's errors by giving undue preference to superficial comparisons: sometimes with Egypt (showing contempt for chronology and environmental conditions), sometimes with the Fulani (see below), and sometimes even with Siberia, in the case of the hypothesis of a Saharan shamanism!

Elias, master of the rain and guardian of the desert

The vast majority of the rock engravings and paintings of the Sahara were produced by peoples who have long since vanished, often several thousand years ago; so there seems to be little chance today of collecting myths associated with these images. Nevertheless, there have been some dazzling exceptions, for example in the Aïr (Niger); but these engravings are relatively recent, as they include depictions of horses associated with alphabetic inscriptions made with the Tifinâgh characters that are still used by the Tuareg to write down their language, a fact that places these images, at the earliest, in the last centuries of the first millennium B.C.E.

For example, an image often found among the rock engravings of this region (especially at Gouré or in the Wadis Mammanet and Tamokrine) depicts a schematic man, seen from the front, with an inordinately long phallus, up to more than six feet (1.8 m) on some figures (*fig. 5*). The Tuareg see in this the image of Mandarazane, a legendary character who, as Lhote relates the story:

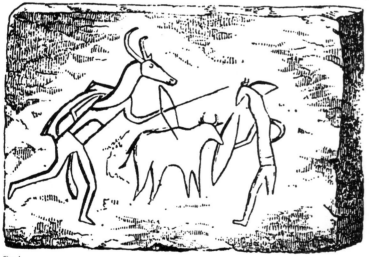

Fig. 4

> having decided to take a second wife, was forsaken by the first, who fled on a camel. Driven to despair by her departure, he began to call to the fugitive wife, begging her to return. But this had no effect and the camel moved away from him. So the unfortunate Mandarazane, mad with grief, saw his phallus stretch in a fabulous way until it rejoined his wife. This is the tale that is told in the evening around the campfires of the Aïr Tuaregs, and those who pass in front of the engraved images of Mandarazane never fail to give a slight smile and note the moral of the story, namely that one should avoid taking a second wife.[2]

Elsewhere, on a sandstone slab in the *kori* (dry valley) of Mammanet, close to Tesseroukane, the Tuareg recognize the engraved depiction of one of their most revered mythical characters, Elias. His image here is nine feet (2.8 m) high, and is accompanied by his servant Abou, who is holding his master's horse by its bridle (*fig. 6*). Travelers who reach this place never fail to trace these engravings with charcoal or a piece of sandstone picked up from the ground, in the hope of soon acquiring new clothes. As a result, the depth of the figures have attained some four inches (10 cm) in places. It is said that the inscriptions in Tifinâgh characters that are integrated with the engraved layout specify that the principal figure is indeed Elias—he is designated by name—and state that he came from Azrou.

Fig. 4 - Illustration of the first volume of the report of Barth's journey, and depicting the engraving that he had interpreted as an image of the "Garamante Apollo" (see fig. 50).

[2] Lhote, Colombel & Bouchart 1987, p. 139.

Now Azrou, which means "rock" in the Tamâsheq language, is also the name of a place located more than eighty miles (130 km) northeast of the engravings mentioned above, where every month of *aojem* (March) Tuareg from the whole of Aïr gather together to carry out a religious pilgrimage that combines Muslim devotions with pre-Islamic practices. According to the legends gathered in the 1970s and 1980s, Elias, pursued and attacked by enemies described (in different versions) as either "whites" or *kuffar* (pagans), and even identified as Tubu, supposedly took refuge with his horse on a rock that immediately began to grow until it became a veritable mountain, thus protecting Elias from his persecutors. At the foot of the miraculously enlarged rock, the pursuers lit fires, the black traces of which are still visible today, but seeing that Elias resisted the heat and flames, they finally abandoned the struggle. Some of the ashes indicated by the legend could well be those of a Neolithic site located about 900 yards (825 m) to the south-southeast of the marvelous rock. Charcoal from this site has yielded ages of 3880 ± 105 B.P. and 3930 ± 110 B.P. [3]

It is at the foot of this rock that the pilgrims gather every year, after several days' walk in the *kori* Azrou, to carry out their devotions in a small, dry-stone mosque built at an unknown date and that for some is the work of Elias himself. In the *mihrab* of this building are two stones engraved with Arabic inscriptions: One of them proclaims the uniqueness of Allah and is supposed to mark the exact spot where Elias stood; the other has been rendered illegible by a deep, broad groove that runs down it vertically, where the faithful rub it with a stone and then with the powder produced, rub their eyebrows, lower eyelids, and chest in order to preserve their sight and health and also so Elias will intercede with Allah on their behalf to gain his forgiveness. After carrying out this ritual, saying the traditional prayers, and communally saying the rosary in the little mosque, the pilgrims walk three times around the rock where it is said that Elias sometimes still appears, holding his mount by its bridle or accompanied by his servant Abou who, standing close to him, guides his horse.

This sugarloaf-shaped rock is nothing other than a neck of tachyte—that is, the result of relatively recent volcanic activity. For this reason some have suggested the legend has simply "mythologized" a real geological event. [4] But, quite apart from the fact that the date obtained from samples of the rock is about twenty million years, the mythological dossier cannot so easily be reduced to the interpretation of natural elements. Moreover, this type of positivist explanation, so common among the first mythologists, has henceforth been abandoned by all those who can see in myths something other than bad science or a prescientific stage of knowledge.

Elias is the subject of numerous other myths among the Tuareg, as far as Hoggar (or Ahaggar), where people tell how he triumphed over his uncle Amamellen ("he who has clarity"), who, though skilled in rock art, had become jealous of Elias who surpassed him in this art:

So at that time there lived a man called Amamellen, a noble by profession; he was rich, and he had numerous slaves to guard his flocks which were scattered throughout the Hoggar. It is not known how he learned his art, but he was singularly skilled at tracing on rocks the outlines of all the animals that he saw around him in the desert. He was also able to depict men. Most often he engraved on fine smooth stones, and sometimes he put different colors on his

Fig. 5

Fig. 5 - Rock engraving in the Aïr, locally considered a depiction of Mandarazane, a mythical hero whose phallus stretched enormously when his first wife left him.

3 Roset 1990. Guilbaud 1993. 4 Roset 1990.

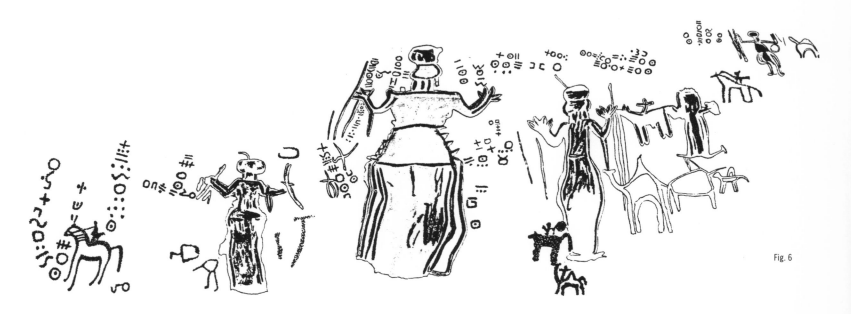

Fig. 6

drawings. Amamellen had a nephew, his sister's son, an intelligent, skillful and courageous boy, who often accompanied him in his travels. Through contact with his uncle, Elias very quickly learned to engrave and paint. As he grew up, the latter affirmed his gifts, and he became even more skilful than his uncle. Everybody talked about him, praised his expertise, and his skill in painting and engraving....[5]

Here, a long way from Azrou, we find another link between Elias and rock engravings, but with nothing to make one think of volcanic activity. Above all, Elias cannot be understood separately from his relationship to the prophet called Ilyas in the Koran or Elijah in the Bible. In the sacred texts this character known for having "withdrawn to the desert," is clearly associated with the mountain, fire, and the struggle against infidels. Tradition states that having obtained from God the power of influencing rain he took advantage of it to impose a three-year drought on the Israelites who worshipped Baal.[6] In the Koran, Ilyas attacks idols,[7] Allah carries him away when he is threatened by infidels, and legends make him a guardian of the deserts, who appears to lost travelers to point out the right road.[8] Like Elias on the mountain of Azrou, the biblical Elijah takes refuge on Mount Horeb to escape the enemies that Jezebel has sent against him, and there undergoes "fire" and "earthquake."[9] And it is on Mount Carmel that he brings down the fire of heaven onto the altar, at the same time confounding 450 prophets of Baal, whom he then executes.[10] The book of Sirach[11] calls him "like fire," and states that his ascension occurred in the midst of a "whirlwind of fire."[12] Finally, because Elijah did not die but ascended into heaven, numerous legends mention his reappearance.

Although none of these traditions can have the slightest connection with ancient volcanic phenomena that occurred at Azrou, the myth of Elias, on the other hand, recovered and illustrated in the rock art of Aïr and combining fire, mountain, the struggle against infidels, ascension, and reappearances, can be explained very well by a memory of the Elijah myth, transmitted by Islam and locally remotivating these pre-Islamic practices such as circumambulation, the scratching of rocks for therapeutic ends, and rock art itself.

Fig. 6 - Engraved panel of the kori Mammanet in the Aïr. According to the Tuareg, the central figure, nine feet (2.78 m) high, is Elias, near whom stands his servant Abou. Both of these characters are at the heart of Tuareg mythology.

[5] Blanguernon 1955, p. 134. [6] Aghali Zakara & Drouin 1979, p. 98–104. [7] Sourate XXXVII, 120–130. [8] Weber 1996, p. 113. [9] I Kings 19. [10] I Kings 18, 16-*sq*. [11] SIR 48, 1. [12] SIR 48, 9.

Lhote and the *Iotori*

It was in the central Sahara that the hypothesis of a link between prehistoric paintings and present-day mythology was set out most forcefully, leading its authors to propose a reading of certain works in the light of Fulani (also called Fulbe or Peul) mythology and ritual. From the beginning of his research into rock art, Henri Lhote assumed a proto-Fulani migration across the Sahara[13] and, on the occasion of a big exhibition organized at the pavillon de Marsan from November 1957 through March 1958, he presented the reproduction of a Jabbaren painting that he inaccurately called "The Young Fulani Girls."[14]

One of the visitors to this exhibition, who had come like all the Parisian smart set to see the famous Tassili frescoes, claimed that he could decipher several of the most enigmatic examples. This unexpected interpreter was none other than Amadou Hampâté Bâ, who had been invited and was accompanied by the ethnologist Germaine Dieterlen. The great Malian writer was very impressed, and immediately decided to publish a Fulani initiatory myth that he had collected in 1943, since it seemed to him that the prehistoric paintings of the Sahara presented "all the characteristics of depictions linked to the traditional initiatory concepts."[15]

One image in particular was thus given a brilliant explanation: that of Tin-Tazarift, which Lhote had captioned "schematic cattle" or "crouching cattle," because their legs are not depicted, nor are the legs of the masked people accompanying them (*fig. 7*). Amadou Hampâté Bâ explained that the reason the legs of these people and cattle are invisible is quite simply because the painting refers to the myth of Koumen (the first mythical shepherd of the Fulani) and represents the ceremony of *Iotori*, during which cattle were ritually lustered by being plunged into the water of a river or pond.

Fig. 7 - Rock painting of Tin-Tazarift (7 x 5 ft. [230 x 108 cm]) described later by Henri Lhote: "Cattle in water. Ritual ceremony called *Iotori*. Bovidian period. According to A. Hampâté Bâ, this painting represents the annual ceremony of lustering cattle, and the fingered motif depicts the social organization of the Fulani of the Diafarabé region. The initiates, decked out in masks and walking in water, pass through the different initiation huts and finish with a dance in an *S* shape, evoking the snake Tyanaba, protector of domestic animals. The colors are white with yellow and red ocher."

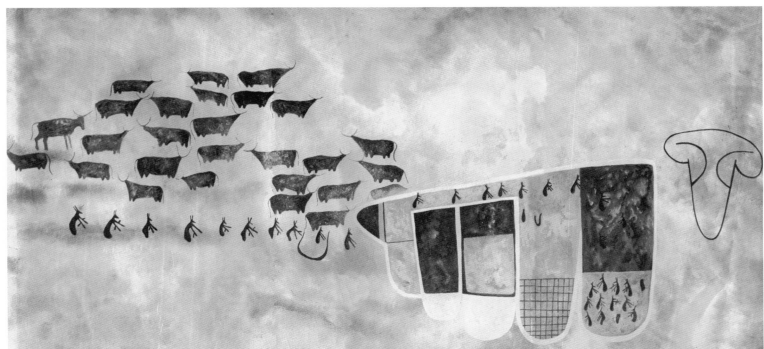

Fig. 7

13 Lhote 1953, p. 20. 14 Lhote 1957, p. 53. 15 Bâ & Dieterlen 1961, p. 94–95.

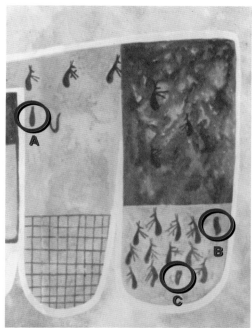

Fig. 8

Like many others who heard it, Henri Lhote was convinced by the reading proposed by the erudite visitor, and in the following edition of his best-seller *À la découverte des fresques du Tassili* he accorded it the greatest importance:

> One of the most prominent facts of these last few years concerning the rock art of the Tassili has been the decipherment of several painted pictures by a Fulani scholar, Amadou Hampâté Bâ, ex-ambassador of Mali in Ivory Coast. Initiated in his youth to the traditional rules of pastoralism, and having taken part in several ritual ceremonies among the Fulani of the Diafarabé region, he was able to shed light before an audience of Africanist scholars on the whole sociological content of the painting named "the schematic cattle," which summarizes the annual ceremony of the lustering of cattle, known as *lotori*, as well as the social organization of the Fulani shepherds.[16]

Since then, this proposed reading has been cited very frequently, and still today it is presented as being perfectly certain. However, it can scarcely withstand a thorough examination of the facts, some of which are worth setting out here. One of the major points of this reading is the interpretation of a particularly enigmatic motif in the Tin-Tazarift assemblage, designated as a "figure with fingers" (*fig.* 7, right). It has been proposed that this is the hand of Kikala, the ancestor of all the Fulani, whose four fingers are supposed to represent the clans of Dyal—Bâ, Sô, and Bari. But if this is the case, one is astonished at the schematism of this hand, which is so extreme that an uninformed observer might never guess it is a hand, whereas it is adjacent to a supposed depiction of the *lotori* ceremony that is so naturalistic that the painter took pains to indicate that the legs of the cattle and of the people were hidden by water. In fact, this "hand" of Kikala is so unrealistic that one could easily believe it to be the work of another painter or of a different period, and that is precisely what is confirmed by a careful examination of the tracing of this fresco, since the last bovine on the right is clearly obliterated by the so-called "hand."

Fig. 8 - Detail of the painting in figure 7, showing the people crossing to the right part of the fingered motif. In *a, b, c*, note the blobs of color that are sometimes interpreted as people (*b, c*) and sometimes not (*a*).

Fig. 9 - Painting described as follows by Henri Lhote: "Second fresco of 'possum people' at Tin-Tazarift. One should note the beginning of the cow that represents the earliest layer, the cattle and the Venus that constitute the second layer, the possum people and the fingered motifs that represent the third, and finally the beginning of the big bovid which constitutes the fourth."

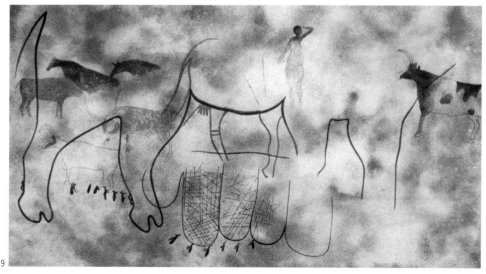

Fig. 9

[16] Lhote 1973, p. 236–237.

Moreover, Henri Lhote himself had noted that this fingered motif "certainly seems to cover one of the cattle on the right, and it thus appears that the whole scene of the procession of little people is later than that of the cattle herd."[17] This very important comment has been curiously ignored by all subsequent commentators on the fresco, and they have never taken into account the fact that the motif of the "cattle at the river," that of the "hand of Kikala" and that of the "possum people" (as Henri Lhote amusingly nicknamed them) do not constitute a single composition and are probably not the work of a single artist. If one wished to follow the interpretation of this fresco as the depiction of a *lotori* ceremony—or more exactly a very ancient antecedent of it—one would have to accept that only legless cattle had been depicted at the start. Later (but how much later we have no idea) the "fingered motif" was added, and then, in a third phase, the "possum people" were painted. So as a result one would have to suppose that the original image was spotted, among the thousands known in the Tassili n'Ajjer, by some initiated artist who then completed it in a coherent way, but in a different style, so as to transform it into a depiction of an initiatory ceremony. This is certainly not completely impossible, but we should recognize that it seriously complicates matters.

Fig. 10 - Engraved hands are far rarer than painted hands. The latter are found in the Fezzân (Libya), and their meaning remains an enigma.

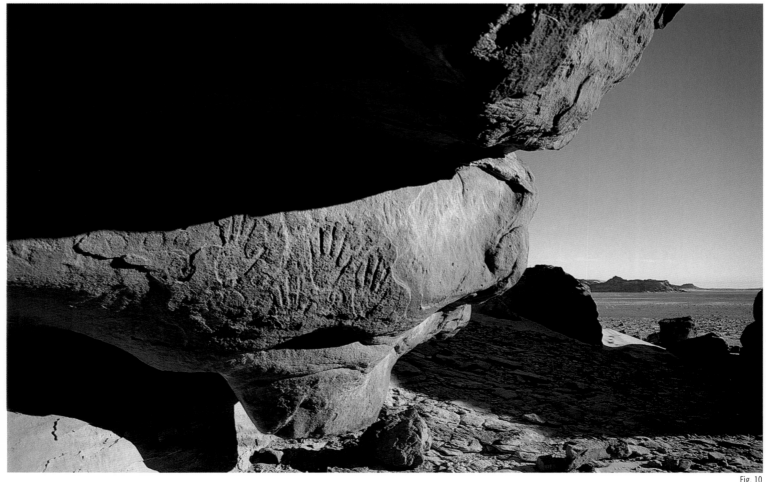

Fig. 10

[17] Lhote 1966, p. 8.

Fig.11 and Fig. 12

Amadou Hampâté Bâ reminds us that:

the Fulani also have a creation myth that is peculiar to them, based on the symbolism of milk, butter, and cattle. But at the time when they were conquered by Soundiata Keïta (founder of the empire of the Mande, or Mali) and deported from North to South, they became so well embedded in the Mande cultural system that they adopted part of its cosmogony, with a few variations—to the extent that it is no longer possible to differentiate the Fulani or Bambara cosmogonies. . . . In order better to integrate with society, the Fulani also adopted four names of clans (*diamu* in Bambara, *yettore* in Fula) so as to conform to the quadripartite system of the Mandé. So the four Fulani clans are borrowings.[18]

As the reign of Soundiata is datable to the thirteenth century C.E., since historians place it between 1230 and 1255,[19] the anachronism is flagrant. If the fingered motif of Tin-Tazarift was indeed related to the quaternary symbolism of the Fulani clans, borrowed from the Mandé, this painting could not be earlier than the thirteenth century C.E., and so would have absolutely nothing to do with the other bovidian paintings of the Tassili n'Ajjer, which are Neolithic.

So, no matter how appealing it may be, this mythological reading, which has so often been cited as a model of its kind, is highly questionable, and it runs up against some even more serious objections. During the lecture attended by Henri Lhote, Amadou Hampâté Bâ also explained that: the fingered motif represented the hand of the first shepherd, called Kikala. This hand, which has six digits (the last one, supernumerary, being of less importance) symbolizes the social organization of the Fulani: the first four digits, counting from the right, evoke the four great aristocratic Fulani families descended from the first four male children of Kikala, whose names are now well known. They are the Dyal, Bâ, Sô, and Bari. The fifth digit represents the combined tribes, descended from alliances with foreign clans, which placed themselves under the authority of the Fulani chiefs. Finally, the supernumerary digit depicts the slaves, who are not of Fulani origin, but nevertheless live in symbiosis with the nomads and participate in all their activities. The symbolic content of this motif does not stop there. Because the first four segments, or digits, carry the four fundamental colors of the cattle hides, red, yellow, white, and black, ascribed to the four great families mentioned above. A legend, known to the Bororo, tells that Kikala, seeing his death approaching, decided to divide the beasts of his herd among his first four sons, therefore making four shares, each according to the beasts' hides in order to avoid all disputes. By extension, the symbolism attached to these four colors should be applicable to the four elements, the basis of all creation: earth, water, air, and fire, and then to the four cardinal points which, in Fulani ritual, play a decisive role.[20]

Figs. 11 and 12 - Complete image and detail of a shelter ceiling at Ain Duwa (Awenât, Libya), unfortunately damaged by vandalism.

[18] Hampâté Bâ 1993, p. 348, n. 1. [19] Mauny 1959. Tamsir Niane 1959. Kesteloot & Dieng 1997, p. 96.

[20] Lhote 1976a, p. 147.

So if one assumes that the motif in question does indeed symbolize the hand of Kikala, and that four of his fingers do represent four fundamental clans, one understands that this figure blazons these clans by allotting each of them one of the fundamental colors of cattle hides (Dyal, yellow; Bâ, red; Bari, white; Sô, black). But if that is the case, how is it that these colors are not found in the fresco, which only has the first three? Henri Lhote specifies that on the original fresco "the colors are red and yellow ocher, and white."[21] So if each finger represents a clan—itself blazoned by a color—then why do three out of four of these fingers have not one color but two? This contradicts the proposed interpretation, especially as a similar remark can be made about the hide of the cattle in the herd, which is claimed to have been depicted during the *lotori* ceremony, and hence at a very important moment—and here the attention to the symbolic details should be extreme. And yet this group is absolutely monochrome and, as all the cattle in it are painted in ocher flatwash, one actually finds no echo at all of the symbolism that has for so long been mentioned by various authors. It should at least be specified that this part of the fresco is at present monochrome, because if the legs of the cattle had been painted in white, their current absence could easily be explained by the disappearance of this fragile color, as often happens in rock art figures throughout the world, where red lasts much longer than white. This is a banal process which has been reported very frequently, and which in no way obliges one to appeal to some kind of "lustering ceremony" to explain the absence of the legs.

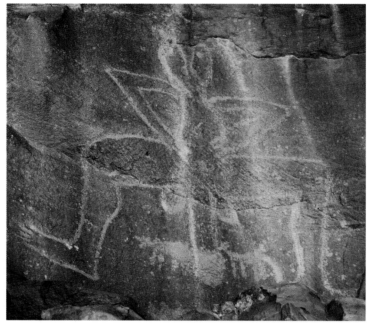

Fig. 13

One of the most problematic points concerning this interpretation of the Tin-Tazarift fresco is that although it is supposed to illustrate a tale as important as the founding myth of the Fulani—or at least the ceremony that brings it into being every year—no other rock art image in the Sahara (out of tens of thousands!) clearly represents this famous ceremony of lustering cattle. So commentators are incapable of finding—in one or several other figures—the slightest confirmation of their theory. If other rock images showed the same ceremony, it would be easy to check that the use of colors is the same, that the number of cattle and participants is identical, etc. Certainly, several other paintings were presented by Amadou Hampâté Bâ and Germaine Dieterlen in support of their interpretation, notably that of Wa-n-Derbawen, which these authors read as a "passage through the brush gate," but the scene of lustering cattle remains unique.

And yet, there is one example, and only one, of a painting that makes it possible to make a rough comparison. This too is a work at Tin-Tazarift, in which one can recognize another "fingered motif" accompanied by a dozen of the same little "possum people" that were already in procession in the previous work (*fig. 9*). This image was published and commented on at length by Henri Lhote, who saw four stages in it, and who showed that the assemblage of the fingered motif and the little "possum people" is not associated with any of the cattle in the panel, which fits with the fact that, in the previous fresco, their counterparts had been painted in a second episode. Here, this assemblage is mingled with older paintings, and with others that are more recent, in a palimpsest of a type that is

Fig. 13 - Megaphallic animal-headed person, engraved in the Wadi Alammâs (in the Libyan Messak), in full-frontal view with hands on hips (in the so-called "Bes" posture).

Fig. 14 - Megaphallic animal-headed person (*cf.* the pointed ears), engraved at el-Warer (in the Libyan Messak), in full-frontal view and with hands on hips ("Bes" posture); two long lines seem to spring from its eyes.

Fig. 15 - Dog-headed therianthrope engraved in the Wadi Djerat (Tassili n'Ajjer), with no ears, a long tail, and a very emphatic phallus.

21 Lhote 1973, p. 240.

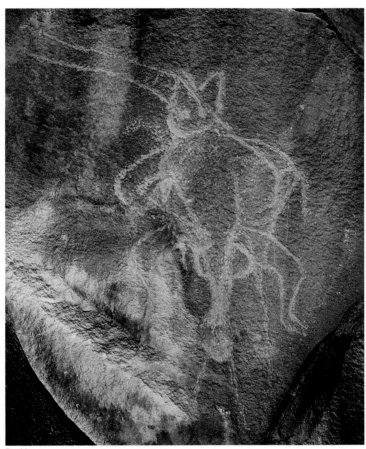

Fig. 14

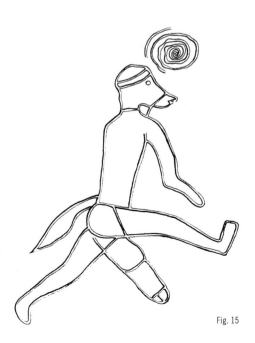

Fig. 15

common in the Sahara. It is not impossible that certain superimpositions may have been intentional, their authors having aimed to complete the meaning of an older work, but this remains to be proved. In the absence of such a demonstration, it is extremely probable that the fingered motif of the second fresco has very little connection with the other images in the panel. In which case, why should the same not apply to the first? Or if, on the contrary, one supposes that the superimposition is significant, and that the author's intention was to establish a coherent assemblage—and hence an illustration of the "hand of Kikala" and the processions of the *lotori* ceremony—why in the second fresco are the cattle not in water, and why is the number of participants not identical here if these frescoes are both based on the same symbolism of numbers that is peculiar to Fulani esotericism?

Finally it is curious that the interpretation proposed by Amadou Hampâté Bâ was able to convince Henri Lhote and many other authors, who all seem to have been impressed by the number of details accumulated by the famous Malian interpreter—Lhote even concluded his analysis by declaring: "Our painting is thus the evocation of the *lotori* ceremony, complete in every detail."[22] We have considerable doubts. Certainly, numerous details are cited in the course of the interpretation, but the great majority of them are derived from the great traditional knowledge of Hampâté Bâ, himself a *silatigi* (initiate), and their very great coherence is that of this tradition, and not that of the painting of Tin-Tazarift. Those who heard the famous lecture by Hampâté Bâ at the Société des Africanistes, and first and foremost Henri Lhote, were certainly "bluffed" by a brilliant and sincere orator, but, as can happen to anyone in a similar situation, they lost their critical senses to some extent in the face of someone who seemed capable of explaining everything with disconcerting ease. The proof of this is provided by a final detail: that of the number of people and cattle during the ceremony. With regard to the people, we are told that "these are the people officiating in the cult who have attained different stages of initiation," and that "the first thirteen, painted in the lower part of the first digit, are the great initiates who must watch over the strict observance of the rites."[23] Even better: "on examining the interior and exterior of the fingered motif, one counts thirty-three people walking in procession, one behind the other," and "the number thirty-three corresponds to the stages a novice has to pass through to attain full knowledge of the pastoral initiatory rites and the supreme title of *silatigi*."[24] This impressive concordance between the painting and the ethnographic data is very close to winning the support of even the most skeptical observer. But beware: in the lower part of the first finger (*fig. 8*), one can only really count eleven clearly recognizable people (whereas in the other "fingered motif" of the same site, there were unquestionably twelve). In order to reach the thirteen needed by the rite, one would need to add two blobs of the same color (*fig. 8b* and *8c*), which could (perhaps) represent people whose heads and arms have been obliterated. This is not impossible, but if we accept this reading, there is no reason not to count as a person another completely similar blob in the upper part of the second finger (*fig. 8a*), with the

[22] Lhote 1976a, p. 148. [23] *Ibid.* [24] *Ibid.*, p. 147–148.

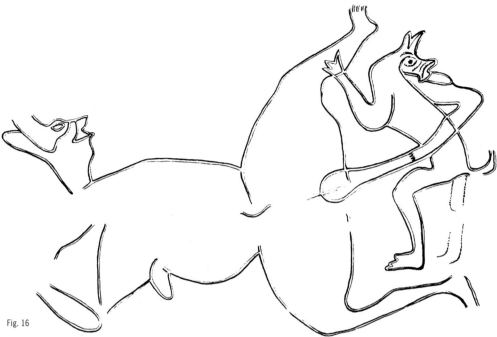

Fig. 16

Fig. 16 - Engraving in the Wadi Djerat showing a dog-headed therianthrope with a short upturned tail, little pointed ears, and an oversized phallus, having coitus with a tall woman.

Fig. 17 - In this engraving in the Wadi Djerat, a small therianthrope with short ears, a small upturned tail, and an enormous phallus seems to be sodomizing a person wearing an eared cap.

frieze of the other people of the same type. So it would no longer be a total of thirty-three participants, but thirty-four. Hence, either all these blobs are people, and there is a total of thirty-four participants, or none of them are, and there are only thirty participants. One has to face facts: the only way to make the image correspond to Fulani symbolism of numbers is to count certain blobs as people, but not all of them. Why? And which criteria lie behind this choice? We have not been told.

As for the number of cattle, "Amadou Hampâté Bâ also explains the meaning of the number twenty-eight. For the *lotori* ceremony to be beneficial, it was necessary for twenty-eight cattle to take part," Henri Lhote testifies once again. And this author, literally fascinated, summarizes as follows the lecturer's presentation of the symbolism of this number:

> The number twenty-eight also regulated the pastoral year of the Fulani, which was divided into twenty-eight sequences of thirteen days, each dependent on a constellation. The *lotori* ceremony took place at the end of the twenty-eighth sequence. Twenty-eight is also the number of knots or intertwinements in the string which the initiate has to untie every day in order progressively to attain knowledge of pastoralism, the number of zones of knowledge, the first and last knots belonging to God, the alpha and omega summarizing the mystery of the beginning and end of the world. It is also a multiple of four, the Fulani having established that there could be seven different crosses that gave twenty-eight different hides, the number seven being the symbol of completeness, thus bringing together the male principle (three) to the female principle (four), and represented thus: o | o, depicting the phallus and testicles, | | | |, depicting the minor and major labia of the female organ.[25]

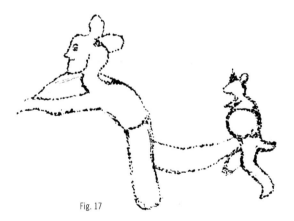

Fig. 17

This development easily convinces us of the importance of the number twenty-eight for the Fulani. . . . The problem is that no matter how one counts and recounts the cattle, in the fresco of Tin-Tazarift there are only twenty-seven! But the fantasy of the total explanation, "complete in every detail" (to use Lhote's expression), is so vivid that this apparently insurmountable difficulty is purely and simply swept aside. Indeed Henri Lhote, who had certainly seen the problem posed by the number of these cattle, wrote

Fig. 18 - In the Central Sahara, several hundred rock engravings show mysterious "oratories" that are sometimes traversed by an anima (here it is a bovine). Since these signs are also linked to images of "open women" they have been interpreted as symbols that associate female fecundity with animal fertility, within the framework of the mythology of a pastoralist society.

[25] *Ibid.*, p. 148.

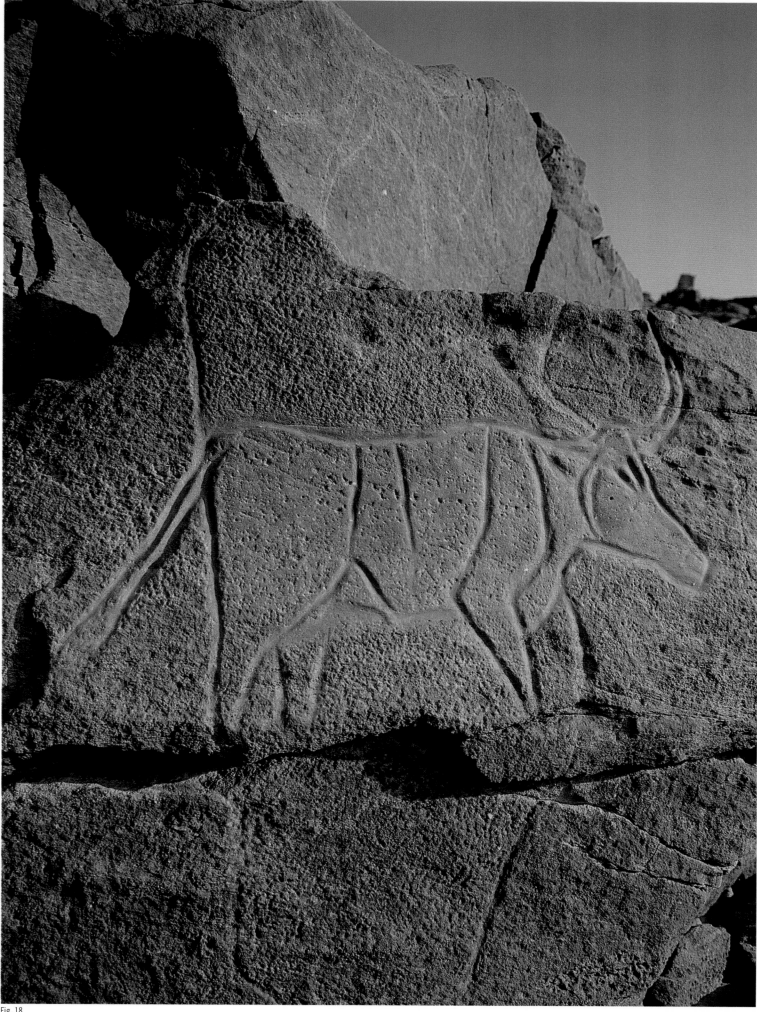

Fig. 18

Fig. 19 - Mythical therianthrope engraved in the Wadi Taleshut (Libyan Messak), and comparable to fig. 20: rounded ears, exposure of terrible teeth, collar, bracelets and loincloth. Moreover, this being wears a crossbelt, and at his belt there hang an aurochs trophy at one side and a rhinoceros head at the other. On the left, on the other face of the rock, an axe was added later in his hand, in accordance with the regional stereotype.

that "on the wall of Tin-Tazarift, we only count twenty-seven, but one specimen has perhaps been obliterated and thus escaped us."[26] One can compare this reaction with that of Ginette Aumassip, who notes: "At Tin-Tazarift, another painting of the Bovidian period evokes another *lotori* scene, twenty-seven (perhaps twenty-eight) cattle are depicted with stumps for legs."[27]

Well, no! There are not "perhaps" twenty-eight cattle, there are only twenty-seven. And using the Fulani symbolism of numbers as the basis of an argument aimed at substantiating "troubling"[28] relationships or concordances deserved far more rigor than simply resorting to imagination to match up established facts—the traditions reported by Hampâté Bâ—with what a neolithic fresco *should* have illustrated if, as luck would have it, its authors had represented the correct number of people and the correct number of animals.[29]

The interpretation of Amadou Hampâté Bâ and Germaine Dieterlen was not based on anything solid and, now that time has passed, it can no longer convince. So why did it enjoy such success? Doubtless because it came at the right moment: Lhote's works must be seen against the French political context of the time—specifically, attempts to establish a cultural justification for "French Algeria" and then, above all, the idea of a "French Sahara."[30] And the defenders of negritude, or of the precedence of a "black culture" that was to give rise to ancient Egypt, could only react favorably to the idea of a high Fulani civilization that was older than the pyramids, just like the authors who, with Hampâté Bâ, tried to construct an extremely ancient Fulani identity. Hence, rather than revealing some vanished "proto-Fulani" mythology, the interpretation of the fresco of Tin-Tazarift brought into play the major mythical themes that in the mid-twentieth century infused studies of African ethnology and prehistory.

Whether one regrets it or not, it has become impossible to dream of a direct, immediate reading of a Tassili rock art, which would thus, in a way, be "transparent" to initiates. Yet this does not mean that it will always be impossible to establish a link between more or less ancient rock art and recently collected oral traditions, especially in Africa. We shall see some examples later, but one must avoid excessive reliance on the documents and practice methodical comparison. Henceforth, if one needs to compare myths between themselves—some well established in verbal form, others assumed in a graphic form—how can one improve upon the Lévi-Straussian method, which has amply proved its efficacy?

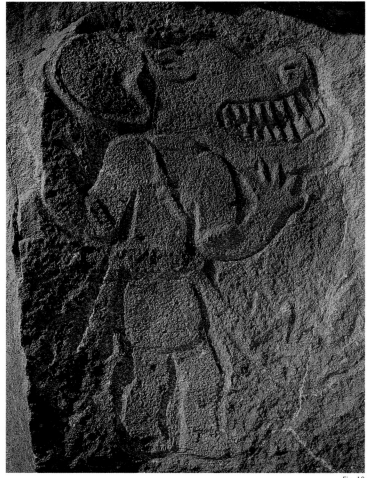

Fig. 19

[26] *Ibid.* [27] Aumassip 1993, p. 100. [28] This is the word used by Lhote 1966, p. 7, Lajoux 1977, p. 106, and Pellegrini 1987, p. 76. [29] Le Quellec 2002. [30] Keenan 2002, p. 137.

Facing page

Fig. 20 - Therianthrope with the head of a canid (lycaon) engraved in the Wadi Tin-Sharûma in the Libyan Messak, and displaying stereotyped characteristics: big rounded ears, lips curled back exposing formidable teeth, a striped collar, belt and loincloth, and bracelets; this mythical being, terrible in appearance, brandishes a dagger in one hand and a hafted axe of Guinean type in the other.

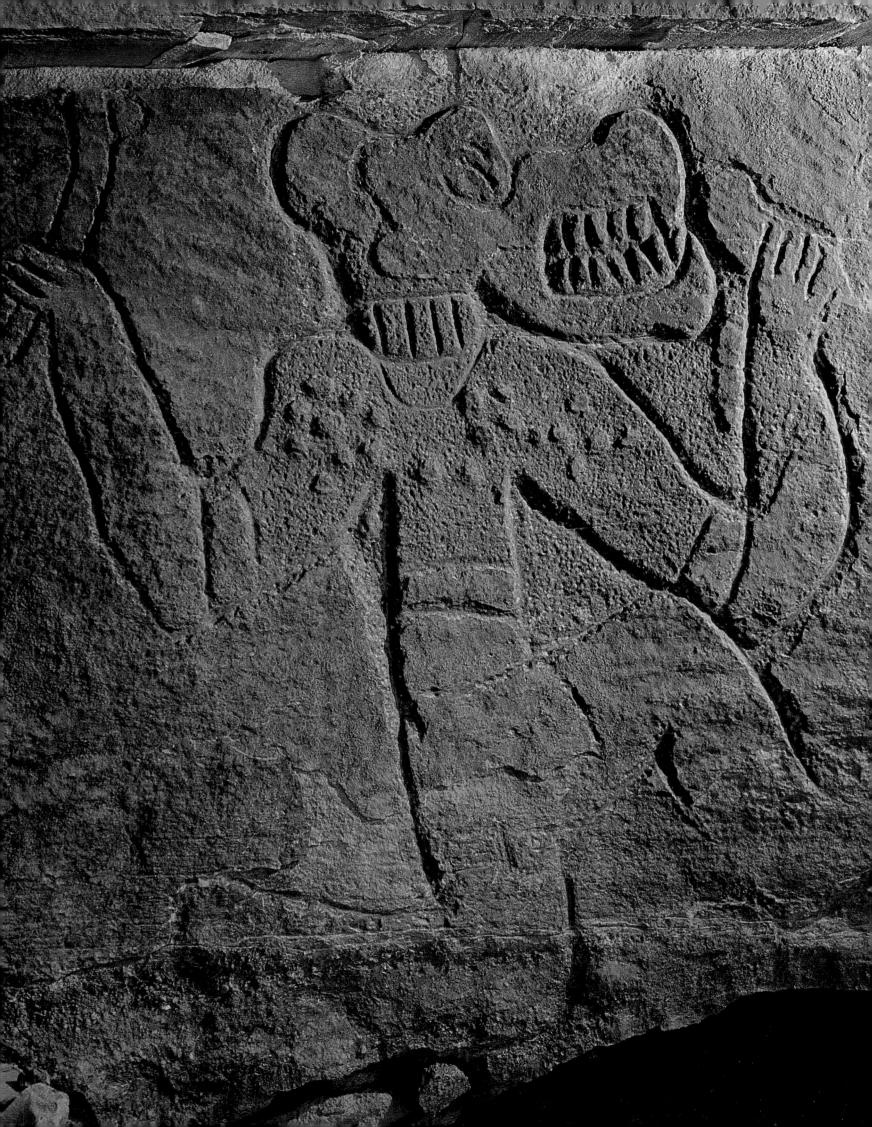

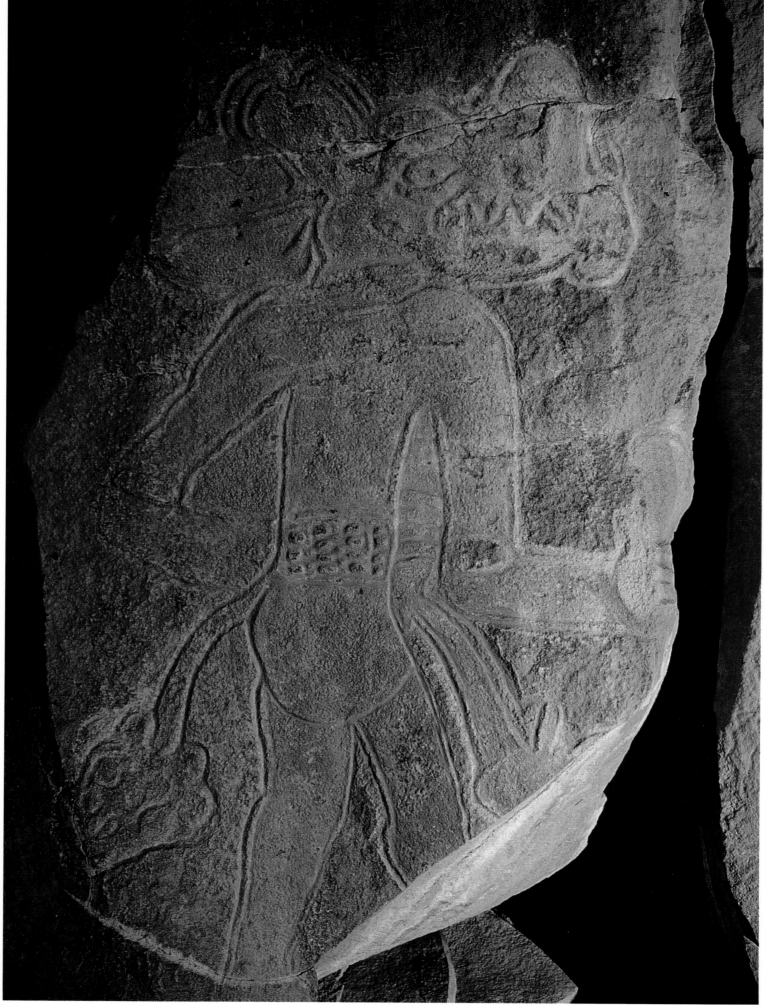

Fig. 21

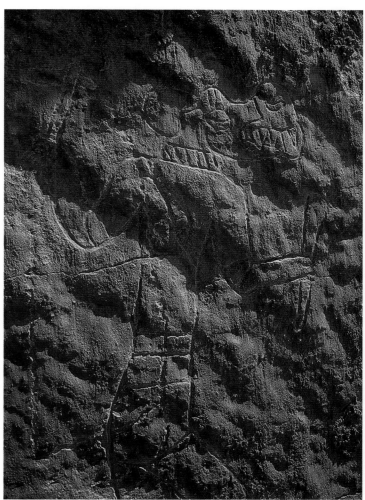

Fig. 22

Lévi-Strauss in the Sahara

Since the discovery of the famous "Garamante Apollo," the central Sahara has revealed tens of thousands of rock-art figures, including an important series of engravings that made it impossible to consider this art as a simple description of the engravers' natural environment, since they also depicted obviously imaginary beings, for example "megaphallic" anthropomorphs shown from the front, with a disproportionate hanging phallus, with a head often endowed with animal characteristics (*figs. 13*, *14*, and *26*). In the Tassili n'Ajjer one also finds male anthropomorphs with a canid head or muzzle (*figs. 15 to 17*), ithyphallic,[31] even megaphallic, and sometimes in the process of having coitus (or ejaculating); they are depicted naked and generally without weapons (sometimes they hold a bow), and do not seem particularly aggressive; their ears are small or absent and when they have a tail, it is quite long, bushy, and dangling or else very short and upturned. They are most often represented using the technique of engraving,[32] but a few are painted.[33]

One hypothesis often put forward is that the function of rock art was to mark a territory. This is difficult to prove on the basis of rock images alone, since they are the very means used to delimit the cultural areas which would then require some other identification. Nevertheless, it is fairly safe to postulate that in general, rock art graphically transmits values peculiar to the group and, for at least some of the figures, echoes its mythology. Moreover, it is highly improbable that the different communities of the central Sahara ever lived in absolute autarky, at least as long as climatic conditions did not make interregional contacts impossible, long before the arrival of the dromedary made exchanges easier once more. Hence there is every reason to think that the community—some of whose values were "condensed" by its artists in the form of therianthropes still visible on the Tassili rocks—was aware of the existence of neighboring communities, of which those of the Acacus and the Messak in Libya are among the closest. It is known that this type of proximity is apt to lead groups to enhance or intensify their cultural particularities, as was demonstrated by the influential French social anthropologist Claude Lévi-Strauss in his study of the masks of the northwest coast of North America. Here, one discovers that false faces with similar functions were treated—by the Salish and the Kwakiutl (who are neighbors)—in such a way as to invert the details, following a series of oppositions (detailed in *The Way of the Masks*): exophthalmic eyes in one case, hollow sockets in the other; tongue sticking out here, mouth open and hollow there, etc.; one can only refer the reader to this discussion, which also includes the mythical material.[34]

Fig. 21 - Another lycaon-headed therianthrope, engraved in the Wadi Taleshut (Libyan Messak); wearing animal trophies at his belt, he holds a dagger in one hand, drawn in a crack in the rock, as if he were responsible for this fissure.

Fig. 22 - Big lycaon-headed therianthrope engraved in the Wadi Tin-Sharûma (Libyan Messak), holding an axe in one hand and a dagger in the other.

31 In the central Sahara, the term "ithyphallic" is used to designate any male (man, animal, or mythical being) whose state of erection is either manifest or extremely probable, or whose phallus is oversized ("megaphallic"). 32 *Cf.* Lhote 1976b, for Wadi Djerat, n° 377, 572, 843, 1159, 1655, 1793. 33 Muzzolini 1991, fig. 11: at Baidikoré, armed with a bow; fig. 13: at Tazerouk. 34 Lévi-Strauss 1983.

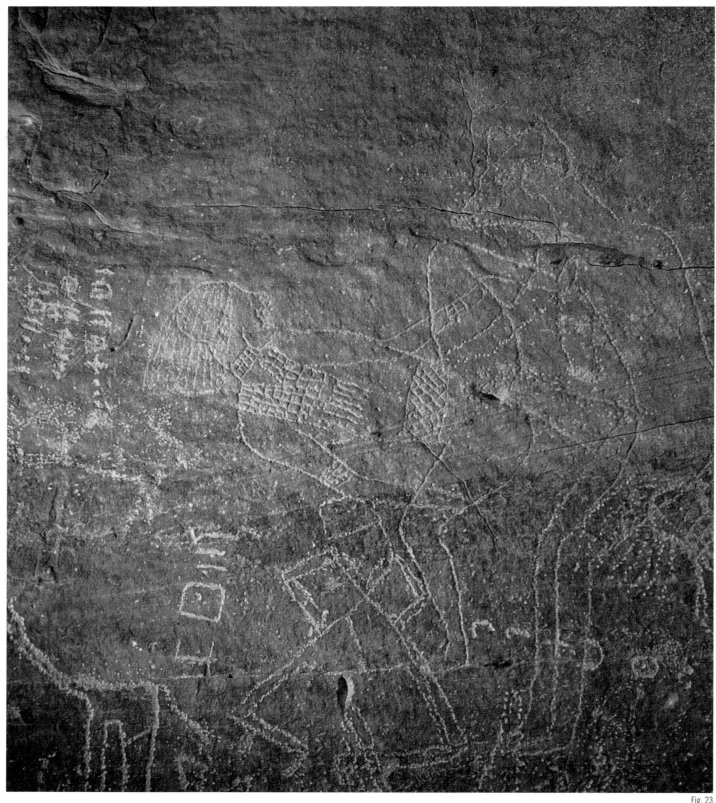

Fig. 23

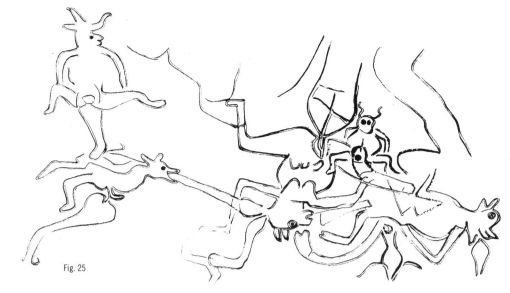

Fig. 25

Fig. 23 - Engraving at Tin-Lalan (Acâcus, Libya) showing a canid-headed being copulating with a richly adorned woman. Several characteristics (small pointed ears, slender muzzle, upturned tail, nudity, sexual activity, hypertrophied phallus) of this mythical being, geographically located between Messak and Tassili n' Ajjer distinguish him from the lycaon-headed therianthropes of the Messak (figs. 19 to 22), and link him with Tassili themes (figs. 16 and 25).

Fig. 24 - Engraved block in the Wadi Imrâwen (Libyan Messak) showing an "ovaloid" and two canids (lycaons?), one of which seems to leap at the throat of a person without a body, while the other animal is fellating a headless man.

Fig. 25 - Detail of the "orgiastic" scene of the Ahana rock in the Djerat (Tassili n'Ajjer), in which several canid-headed therianthropes are participating.

In the case of the prehistoric central Sahara, where oral traditions are lost, could a comparable process have influenced the symbolic productions of the inhabitants of neighboring but quite distinct massifs? In order to verify this hypothesis on the example of the Tassili therianthropes, we would need to find in at least one of the massifs images of masculine mythical beings that also have a canid head, but with features that are the reverse of those described above. Hence, they should not be naked and, especially, not ithyphallic, nor associated with women, far less having coitus with them; they should have weapons other than the bow at their disposal, while still appearing aggressive; their ears should be large, and they should have no tail, or if they do have one it should be neither bushy and dangling, nor short and upturned.

In this hypothetical "mirror image" description of the Tassili canid-headed therianthropes, one can recognize an exact portrait of those that really characterize the engraved art of the Messak (*figs. 19* to *22*): for these are usually dressed in a loincloth that makes their phallus invisible; they never approach women (being always isolated or associated with animals); they can be armed with an axe or dagger (the bow, in the Messak graphic tradition, being strictly reserved for men who, on the contrary, never carry the axe or dagger); their ears are very large in the very great majority of cases; they turn up their lips to show an extremely aggressive dentition; and they generally have no tail or when (very rarely) they do have one, it is thin and goes up between their legs. These beings are only found in the Messak—where about 150 have been counted[35]—with the single exception of one unpublished example, with a lycaon head, from the Algerian Tadrart, that is, a zone that from the viewpoint of rock engravings prolongs the Messak's cultural area to the southwest (through the presence of ovoids, double-outlined cattle, this therianthrope, and a man in a crocodile mask).

These oppositions between cynocephalous therianthropes of the Tassili n'Ajjer and the Messak can be summarized as follows:

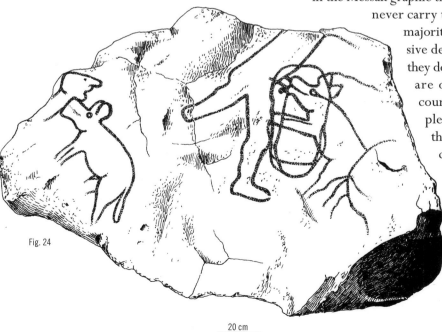

Fig. 24

20 cm

35 Le Quellec 1998, p. 336. Van Albada 2001, p. 87.

	Tassili n' Ajjer	Messak
Ears	Small or absent	Big, rounded
Dentition	Invisible	Exposed, impressive
Tail	Long, bushy and dangling, or very short and upturned	Almost always absent, or long and passes between the legs (in only two cases)
Sexuality	Ithyphallic and/or megaphallic, in coitus with a woman	Sex not represented, beings never depicted in coitus, nor even ever associated with a woman
Clothing	Naked, unadorned (one case with a belt)	Clothed and adorned (necklace, bracelets, crossbelt, pendants…)
Weapons	Unarmed, or sometimes carrying an bow	Regularly armed with an axe and dagger (the bow being reserved for humans)
Posture	Unaggressive	Generally bellicose

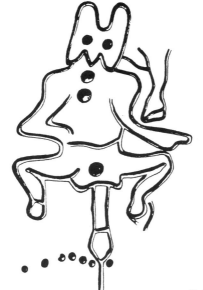

Fig. 26

Between these two cultural areas lies the massif of the Acâcus. This area is well known for its paintings (which have obvious affinities with the Tassili), but recently abundant engravings have been discovered there also, well over a thousand in the Awîs region alone, in the northern part of this massif.[36] In this intermediate zone between the others, which has now been well explored, two types of mythical characters have been identified: the so-called ithyphallics "in the posture of Bes" (that is, seen full-face with hands on hips), and a jackal-headed being with a little upturned tail, having coitus with an apparently normal human (*fig. 23*); all are clearly related to the Tassili types, just as are the engravings recently discovered in the intermediate zone between Tassili n' Ajjer and the Libyan massifs forming the environs of the Wadi Aramat (*fig. 27*).

These observations encourage us to consider the Acâcus as a zone with strong Tassili affinities through which contacts occurred between Tassili n' Ajjer and Messak; they make one think that in the course of the fifth millennium B.C.E.[37] the communities of the two great cultural zones between which this massif stretches each embellished opposite variations on the common theme of the mythical canid-headed therianthrope, thus constructing markers of their own identity.

A very old "story of the eye"

Several types of ithyphallic images have been identified and partly inventoried. A count was carried out in 1996 that made it possible to locate twenty-seven megaphallic characters engraved full-face, of the type which Lhote and Colombel (1979) nicknamed "Djenoun" (from the Arabic *junûn*, the plural of *jinn*, "spirit, demon"), and which are described as "ithyphallics in the posture of Bes" when they have their hands on their hips, although some of them have hands raised.[38] Their distribution includes the Tassili n' Ajjer and the Hoggar, the Tadrart (Acacus and Algerian) as well as the Libyan Messak,[39] and this

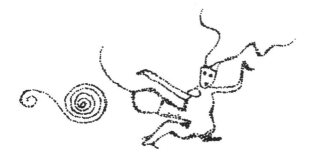

Fig. 27

Fig. 26 - Megaphallic "jinn" figure or "ithyphallic figure in the Bes posture" at Tiratimin in the Tassili n' Ajjer.

Fig. 27 - Small mythical being engraved at Abeïor, in the Wadi Djerat (Tassili n' Ajjer), endowed with long sinuous horns, a short upturned tail, and an enormous phallus, at the end of which a curved line depicts the seminal emission.

36 Choppy, Le Quellec & Scarpa Falce 2002. 37 On the dating of archaic or "Messak style" engravings, see Muzzolini 1995, p. 172–173, and Le Quellec 1998, p. 303.

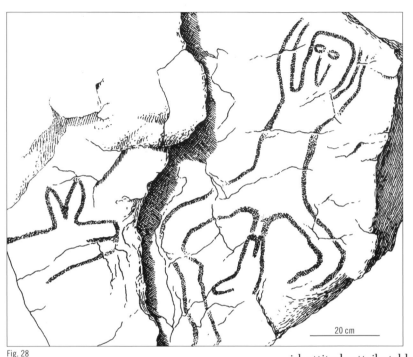

Fig. 28

20 cm

is one of the elements that helps to define a central-Saharan cultural area of rock art displaying numerous common characteristics. As a result of recent discoveries, notably in Libya, their number needs to be considerably increased, together with that of ithyphallic people shown in a non-frontal view and not in scenes of coitus, more than a hundred of which had already been counted for the whole of the Sahara ten years ago; the same applies to the ithyphallic people taking part in scenes of coitus, the inventory of which has also grown through new finds.[40] There are also numerous female depictions, including the so-called "open woman", which merit a separate study. The explanations that are most often given by authors in their commentaries on these images are those of a so-called "phallic" or "fertility" cult. But even more often these figures have been hushed up.

In 1847, Dr. Jacquot wrote of those he had just discovered at Tiout: "As for the lewd pictures, they will never emerge from our albums. One can see, in full view and with no secrecy, the unnatural intercourse that brought the storm of fire down on the cities whose names you know well; a hideous coupling which was far from unknown to the Latins . . ." One might think this a prudish attitude attributable to the spirit of the nineteenth century, but at the beginning of the twentieth, having seen the erotic engravings of the Wadi Djerat, E.-F. Gautier declared: "One cannot lay them before the French public because it would see them as pornographic." Without resorting to remarks of this kind, other authors simply took care not to publish their discoveries; for instance, Yolande Tschudi admits to having noticed that "the coupling theme is frequently depicted" among the paintings of the Tassili n'Ajjer, but she only publishes a single example.[41] Around the same time, the illustration of an article by Henri Lhote devoted to a coupling engraved in the Tassili n'Ajjer was censored in the publication[42]—fortunately, the same author was subsequently able to publish a photo of this work.[43] In 1974, in a synthesis devoted to "coupling in prehistoric art," René Nougier and Romain Robert preferred to minimize the importance of the depictions of coupling people, claiming, against all the evidence, that they were scarcely more than half a dozen in number, for the whole of the paintings and engravings of the Sahara! Moreover, it even happens that the publications of rock art assemblages with a sexual theme are subjected to reproving comments, such as those which came from the pen of Henri Lhote regarding the famous Ahana rock in the Wadi Djerat. Lhote characterized this assemblage, which he thought particularly "indescribable" (the word recurs three times in the thirty lines he devoted to the site), as portraying "particularly depraved scenes," with figures "expressing customs that go beyond wholesome nature," and concluded that it bore witness to a "place of collective depravity."[44]

Even today, as soon as sex rears its head, illustrated publications are—alas—very rare; publishers are reluctant and authors apply self-censorship. Hence we are deprived of a fundamental documentation for establishing the history of the depictions made by

Fig. 28 - Close to the engraved block in fig. 24, another engraved group also displays two canids, including one fellating.

38 Le Quellec 1993. p. 377–387, Choppy 1996. 39 Choppy 1996. 40 Le Quellec 1993, p. 361–375.

41 Tschudi & Gardi 1956, p. 29, pl. XX. 42 Lhote 1954. 43 Lhote 1976b, vol. 2, p. 812. 44 Lhote 1976b, vol. 1, p. 100–102.

humankind concerning what are among the most interesting parts of our anatomy. We risk ending up with the publication of falsehoods. Let us take for example a somewhat "taboo" subject, that of fellatio, the history of which was recently undertaken by Thierry Leguay (1999) and by Franck Évrard (2001). The first of these authors found no examples before the pharaonic period; and in her preface to the second study, Anna Alter, hoping to use rock art as documentation to go further back in time, asked Emmanuel Anati, who replied: "I have hundreds of penetrations, sexual acts with several people or with animals, and an Iron Age sodomy, but absolutely no fellatio."[45] And yet, in the "indescribable" assemblage of the Ahana rock, of which Henri Lhote published tracings and photos in 1976, one can see a canid-headed anthropomorph (fig. 25, bottom left), from whose mouth emerges a virile member that is heading, with several other phalluses, for an "open woman," also canid-headed; the whole thing suggests "a convergence of phalluses towards the head."[46] Since it only presents therianthropes and a horned "djinn," this enigmatic assemblage does not seem to agree with any descriptive motivation, and cannot be read as the simple graphic transcription of an orgiastic or even ritual scene, such as the famous "night of the error" (leylat el-arafat) or "night of the cavern" (leylat el-kâf) that was widespread from ancient times in the Berber domain, and which was cited by Henri Lhote. The role of the canid-headed therianthropes in the engraved assemblage of the Ahana rock even prompts one to cast doubt on any reading of the "erotic" depictions of the prehistoric Saharans that sees no other purpose in them than "to represent the male and female principles of reproduction."[47] Although one cannot take the analysis very far, it is certain that in the central Sahara canids must have played an important symbolic role, and in the Wadi Imrâwen, in the Messak Settafet (Libya), there are two engraved blocks (figs. 26 and 28)

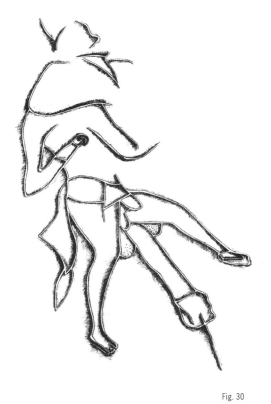

Fig. 30

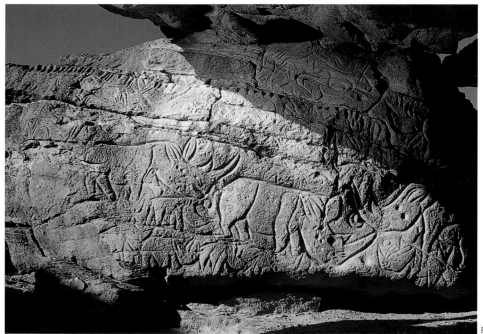

Fig. 29

Fig. 29 - The animal art of the Sahara was probably not intended simply to describe the animal world. Hence, in this cave in the Wadi-Telizzâghen (Libyan Messak) one can of course recognize some rhinoceroses, but their grouping is not meant to be realistic.

Fig. 30 - Engraved figure in the Wadi Djerat, the upper part of which is indistinct; from the end of his gigantic phallus a line meanders for almost twenty-three feet (7 m).

[45] In Évrard 2001, p. 10–11. [46] Hugot & Bruggmann 1999, p. 48. [47] Lhote 1984, p. 194.

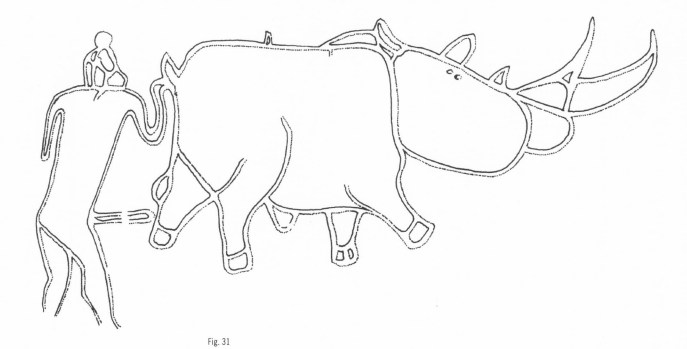

Fig. 31

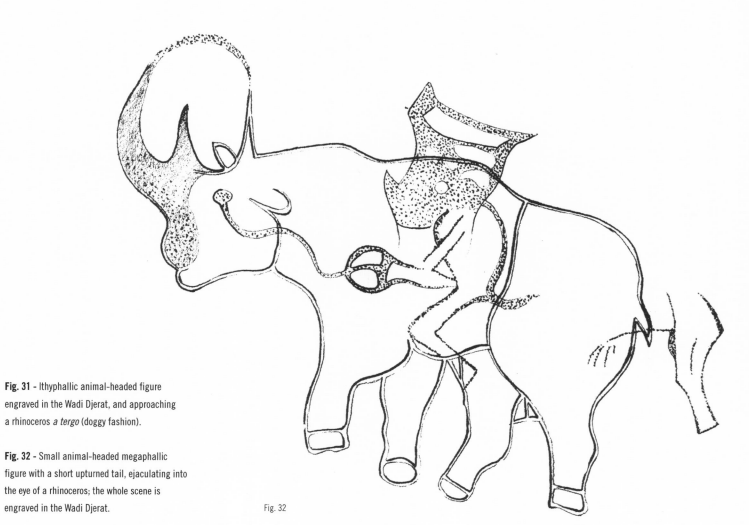

Fig. 31 - Ithyphallic animal-headed figure engraved in the Wadi Djerat, and approaching a rhinoceros *a tergo* (doggy fashion).

Fig. 32 - Small animal-headed megaphallic figure with a short upturned tail, ejaculating into the eye of a rhinoceros; the whole scene is engraved in the Wadi Djerat.

Fig. 32

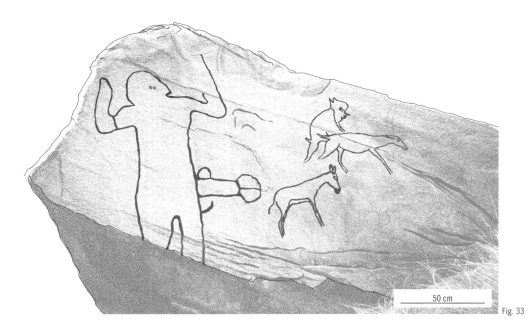

Fig. 33

that display a variation on the theme of "irrumation"[48] practiced on such animals, but include a series of oppositions and symmetries that allow one to guess at part of the logic that underlay the development of these two layouts. Because on both of them there are two canids, and in each case one of them has a mastiff-like muzzle and the other not, while their heads have ears that are rather pointed on one and somewhat rounded on the other. One of these canids seems to want to attack the right knee of the first man, while the second man appears to be "amputated" at the knee. Moreover, on one of the blocks, one of the canids swallows the phallus of a headless body, while its neighbor seizes a headless body by the throat.

The important role played by canids in the sexual symbolism of the Neolithic societies of the central Sahara is again illustrated by an engraved panel at Tin-Lalan, in the Acacus, the oldest part of which (*fig. 23*) shows a woman, wearing only bracelets, a necklace, a belt and a hairnet, having coitus with a therianthrope that has the head of a jackal and a small upturned tail. Gabriel Camps (1993) linked this image with the expression "marriage of the jackal" (*tamegra bbussen* in Berber, *éhen n-ebeggi* in Tamâsheq and *irs ed-dîb* in Arabic) that is widespread in the whole Maghreb and the Sahara to designate the rainbow or rain in sunny weather. It has been noted that in Berber the word *anzar*, meaning rain, is rather too old to allow one to assume the existence of an ancient divinity with this same name.[49] And, in the first third of the twentieth century, ethnographers described the carnival-like rites inspired by (or inherited from) the hierogamy of this "fiancée of Anzar" (*tislit n-anzar*), or "fiancée of water" (*tislit n-aman*), richly adorned as if for a wedding.[50] Hence, on the engraving of Tin-Lalan, the presence of the hairnets could be distantly linked with the ritual in which "the matron stripped the fiancée [of Anzar], who wrapped herself in one of the nets that were used for transporting sheaves and fodder."[51]

It is possible that the rock image of Tin-Lalan, created in a period when the worsening of the climate must have caused considerable anxiety to its authors, was meant to illustrate such fertilizing weddings that announced the arrival of rain and guaranteed fertility, in a symbolic constellation that derived the rain from the ejaculation of a supernatural being, through an association which extends far beyond the Berber world, as is indicated by this remark from Plutarch's *Isis and Osiris*: "In fact, the Greeks call emission

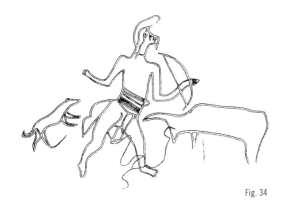

Fig. 34

Fig. 33 - Engraved block in the Wadi Aramat (Libya) showing a small person with animal ears and a short upturned tail penetrating a ewe *more ferarum* (doggy fashion), under the apparent domination of a big ithyphallic figure depicted in profile with arms in a gesture of entreaty, and whose phallus is aimed at a donkey.

Fig. 34 - Engraving in the Wadi Djerat showing a canid-headed archer with an emphasized phallus, followed by a canid from which a stream of semen or urine ends in the eye of a bovine with a single forward-pointing horn.

[48] "Placing the erect member into the mouth is called *irrumation*" (Forberg 1979). [49] Chaker 1989. [50] Probst-Biraben 1932. Joleaud 1933, p. 239–242 and 244–245. [51] Genevois 1976.

Fig. 35

apousia and coition *synousia*, and derive the son (*hyios*) from water (*hydor*) and rain (*hysai*); Dionysus also they call Hyes since he is lord of the nature of moisture; and he is no other than Osiris. Hellanicus seems to have heard Osiris pronounced Hysiris by the priests, for he regularly spells the name in this way, in all probability from *hysis* (rain) and *rhysis* (flow)."[52]

It is surprising to discover that the name "marriage of the jackal" or "marriage of the fox," which is popularly given to sunny rainfall, is found not only in North Africa but also in Eurasia and as far away as Japan: for the moment, there is no satisfying explanation for this phenomenon, but it tends to suggest a very great prehistoric time-depth.[53]

Having discussed the role played by sexuality in symbolic activity in general, let us now turn to two human functions that cannot be studied by traditional archaeological methods: urination and ejaculation. These are so rarely depicted that their inventory would not take long to produce. Close to Djanet, the phallus of a megaphallic man, engraved in a full-frontal pose (*fig. 26*) is characterized by an emission indicated by a line crossing a series of cupules.[54] At Abeïor, a small being endowed with long deformed horns, a short upturned tail and an animal foot, points its enormous phallus toward a double spiral—the phallus's emission is depicted by a simple curved line (*fig. 27*);[55] the same applies to a giant with an indistinct head, wearing a loincloth and endowed with a tail (false?) and enormous virile attributes (*fig. 29*), but here Henri Lhote indicates that "from the meatus there emerges a stream of urine which, on the slab, snakes for almost seven meters,"[56] with the result that this line—which could be thought to represent semen rather than urine—was not traced.

An even more astonishing image is engraved at Wadi Djerat. Its principal motif is a black-patinated rhinoceros, over four and a half feet (144 cm) long (*fig. 32*). At the level of its body there is a small figure with a short upturned tail, whose head is hard to read, but whose front resembles the muzzle of a one-horned rhinoceros. Is it a human being wearing a mask and a hide as adornment, or is it a supernatural being? Most likely the latter, because this ithyphallic being is holding its enormous phallus in one hand, from which there emerges a sinuous stream ending at the eye of the pachyderm. According to Henri Lhote, "this line must be the symbolic materialization of either a stream of urine or an emission of sperm,"[57] but the figure's pronounced ithyphallism leaves little room for doubt. Behind the rhinoceros there stands another person, lacking a head and upper trunk and whose phallus is not clearly depicted, from whom a line extends, tracing a curve that passes just below the animal's tail and ends in a small rain watering the pachyderm's hindquarters.

What can one make of such an image? The excellent photo published by Malika Hachid shows clearly that the ejaculating figure is pecked, while the rhinoceros is made with a polished line that, here and there, obliterates this pecking.[58] But even if the masked ejaculator is more recent than the pachyderm, their association is clearly intentional. From the Wadi Djerat, Henri Lhote also published an engraving that depicts another rhinoceros, this time with its tail being touched by an animal-headed ithyphallic figure (*fig. 31*); he hypothesizes that it was a dog-headed being, and provides this precise information: "The phallus is pointing towards the rhinoceros, and

Fig. 35: Decorated ceiling of the big shelter of Bû Hlêga at Awenât (Libya).

52 364C. 53 Blust 1999. 54 Lhote et Colombel 1979, p. 6, n° 1. 55 Lhote 1976b, n° 1544.
56 *Ibid.*, n° 1652. 57 *Ibid.*, n° 1566. 58 Hachid 2000, n° 419.

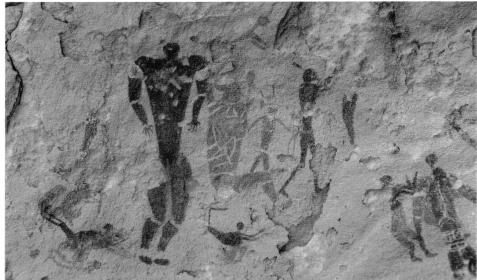

Fig. 36

the hand towards the anus, as if to enter it." This certainly seems to be the prelude to a scene of zoophilia, a certain number of which are known among the Saharan artworks (*fig. 33*).

The scene of the ithyphallic figure ejaculating into the eye of a wild animal is not unique, for at Djerat there is a similar scene, only this time it is into the eye of a bovine with a "single forward-pointing horn" (*fig. 34*). It is an archer with an animal head—probably a dog head, again—followed by a dog, and wearing a thick belt with hanging straps (or a false tail?); its hypertrophied phallus shows its glans and meatus, from which there emerges a long, sinuous, pecked line that divides into two after a few meanders: as in the preceding case, this stream of sperm ends in the animal's eye.

What mysterious "story of the eye" is represented in these images? Doubtless we shall never know, because the symbolic associations with sex can affect a wide variety of cultural or natural objects, and take on unforeseeable meanings. Nevertheless, since the figures mentioned above were created within a society in which big game hunting still held pride of place, one should at least recall that most hunting societies instill in their members a respect for sexual taboos, and that in East Africa sperm is used in the composition of a charm used to ensure success in elephant hunting.[59]

[59] Rachewiltz 1963, p. 114.

Fig. 36 - Partial view of the decorated wall in the cave of Wadi Sûra. On either side of the big dark figure on the left can be seen two of the "swimmers" drawn by Ladislaus de Almásy.

The "Swimmers" of *The English Patient*

In *The English Patient*, a film by Anthony Minghella from the novel by Michael Ondaatje, one can see close-up how the paintings in the so-called "Cave of the Swimmers" are recorded in watercolor. Both film and novel present a freely adapted version of the highly controversial life of Count Ladislaus "Lazló" de Almásy (1895–1951). In October 1933 this polyglot Hungarian adventurer, exploring the Gilf Kebir Plateau in search of the legendary oasis of Zarzûra, supposedly lost in the heart of the Libyan desert, discovered—in the Wadi Sûra ("image" in Arabic)—a cave whose walls were covered with rock paintings. Describing his discovery, the man whom the Bedouins had nicknamed Abû Ramla (Father of the Dunes) later wrote: "I was impressed by a fresco depicting swimmers; the drawing gives an excellent interpretation of the distortion of the body as seen

Fig. 37 - Detail of the decoration of the shelter discovered in May 2002 by M. Foggini and Zarzora Expeditions in the Gilf Kebir (Libyan desert). One can see tiny figures (including the so-called "swimmers") surrounding a kind of composite monster that is depicted several times in this shelter.

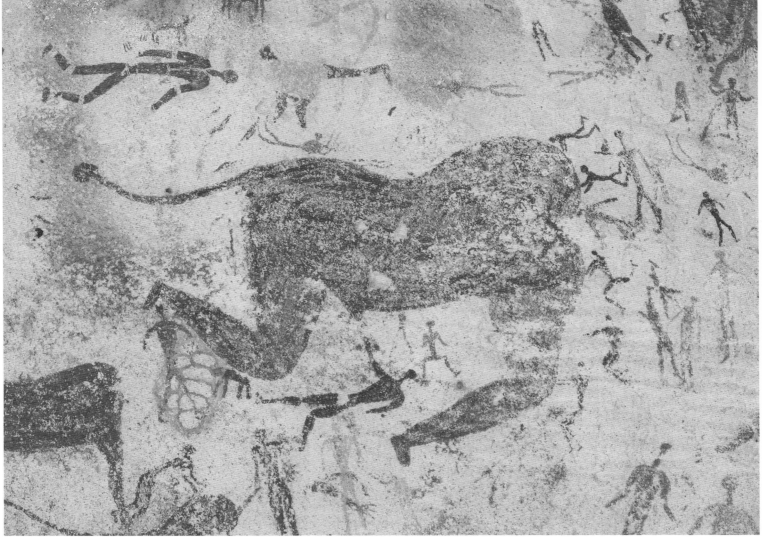

Fig. 37

below water. How curious to see images of swimmers in the heart of the Libyan desert, in a place where, today, for several hundred kilometers around, there is not even any water!"[60] He published a freely adapted manual tracing of his discovery (*fig. 2*) and, subsequently, he led the anthropologist Leo Frobenius to this site, which has rarely been visited since then, although the film has bestowed on it an unexpected fame. The mystery of the "swimmers of the Sahara" (*fig. 36*) has caused a lot of ink to flow, and has mostly been used to argue in favor of the weird theory of a Saharan shamanism that has absolutely no factual elements to support it.[61]

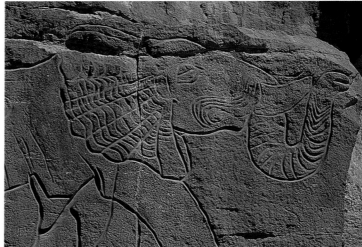

Fig. 38

In May 2002, an expedition led by Ahmed Mestekawi and Massimo and Jacopo Foggini discovered—in the Gilf Kebir Plateau—an enormous decorated shelter resembling that of the Wadi Sûra, and covered with hundreds of well-preserved paintings, forming what is without a doubt the richest assemblage of rock paintings in the whole of Egypt. These paintings, still unpublished for the most part, are currently being studied, but their affinity with those of the Wadi Sûra is very clear. Among its numerous novelties, such as an exceptional concentration of hand stencils, this site presents several depictions of a composite man-eating animal, with a feline tail and apparently human limbs,[62] surrounded by minuscule anthropomorphs that are extremely similar to the so-called "swimmers" that hitherto had only been known at the Wadi Sûra. It now appears that these little figures are not really swimming, but that their activity is linked to this gigantic mythical monster—either they are prostrating themselves before it and submitting to its power, or they are trying to avoid its all-devouring fury, or, on the contrary, they are seeking to master its power or take advantage of it. (*fig. 37*).

This magnificent discovery ought to inspire modesty: it reminds us that the Sahara doubtless still has some surprises in reserve for us, because in this vast ensemble that has yet to be explored completely, a single discovery can be enough to call our interpretative models into question.

Elephantine loves

We have already mentioned Elias and his uncle Amamellen, two mythical characters of the Tuaregs of the Aïr who inspired depictions in rock art. Among other groups, including the Tuaregs of the Hoggar and the Tassili n' Ajjer, their equivalents are Aniguran or Amerolqis for the uncle, and Batis or Adlesegh for his nephew, which led Henri Lhote to write that "there was thus a cultural substratum which linked the ancient horse-riding populations with the present-day Tuaregs."[63] The question is whether this substratum might not be even older, and whether it gave rise to illustrations among the most archaic rock images. To answer this question, one needs to return once again to the mythical therianthropes.

When the canid-headed examples in the Messak are depicted in the presence of

Fig. 38 - Detail of a large elephant engraved at I-n-Galgîwen in the Libyan Messak.

Facing page
Fig. 39 - Seated man holding in his hand his elephant mask (engraving of the Wadi Adroh, in the Libyan Messak). The vertical inscription in Tifinâgh characters with a light patina, in front of him, is much more recent.

[60] Almázy 1936, p. 79. [61] Le Quellec 1999 and 2001. [62] Hand stencils (or negative hands) are obtained by projecting paint around a hand placed against a wall, while positive hands are made by dipping a hand into paint before applying it to the wall. [63] Lhote 1972, p. 202.

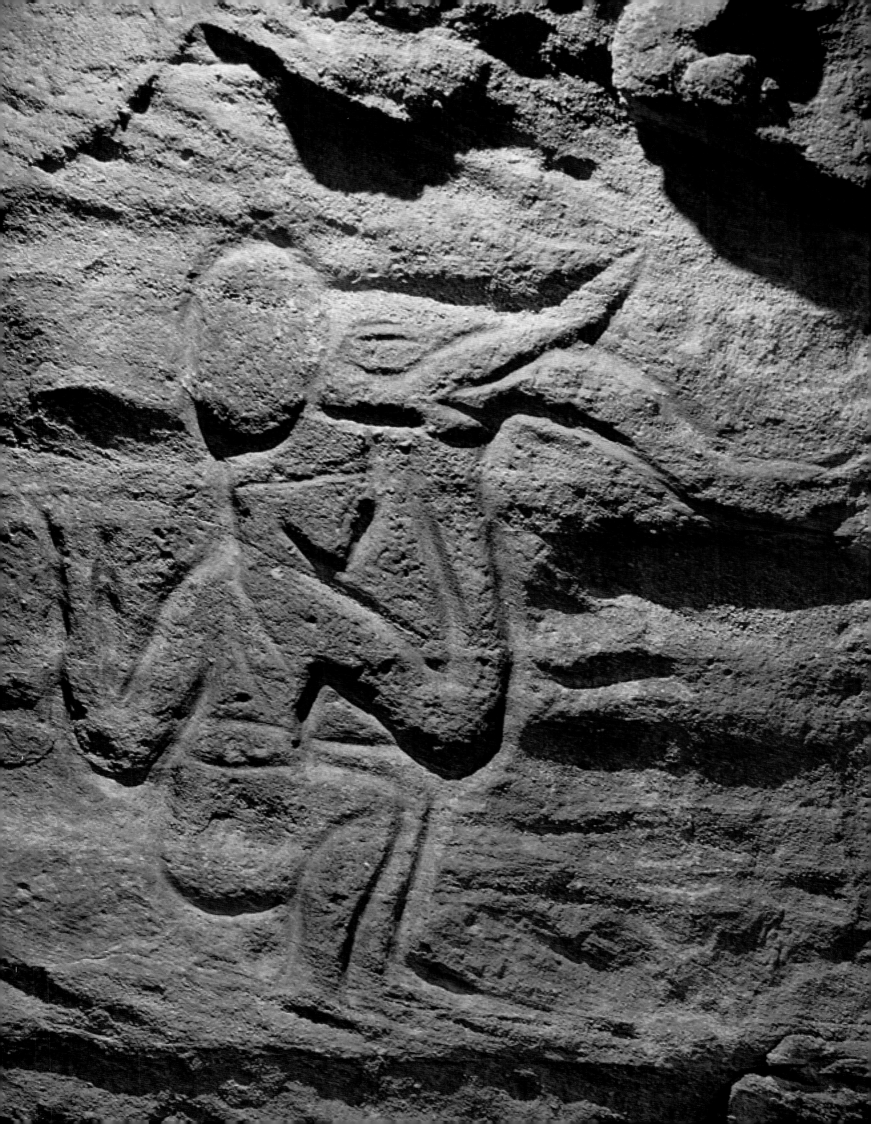

animals, these are most often elephants; so it is something of a surprise to discover that this pachyderm can be involved in assemblages with an obvious erotic connotation. This is the case, for example, with three scenes at Telizzâghen, which Barth had not seen: all three show ithyphallic figures or therianthropes having coitus with pachyderms (*fig. 34*). Outside the Messak, several depictions can be compared with these astonishing scenes: in the Wadi Zrêda (northern Fezzân), an apparently trapped pachyderm is touched by four people, one of which is approaching it sexually, *pecudum more* (doggy fashion), while at Taheouacht (in the far south of Morocco) another scene of zoophilia also links a man with an elephant. Two other works can also extend the inventory of similar figures: in the Acacûs, an ithyphallic man is rushing towards an elephant with an erection, and in Djerat a man with a big phallus is being "felt" by an elephant in a marked state of erection.[64]

Such engravings, showing acts of coitus between men and pachyderms, are inevitably nondescriptive, and ordinary men certainly do not find themselves in such a situation: these can only be supernatural giants, whether therianthropes or not. So it is of note that, in the oral traditions of the present-day Tuaregs, a mythical giant does indeed have a relationship with a female elephant. This is Amerolqis, a kind of Saharan Prometheus credited with the invention of the principal features of Tuareg society (writing, language, poetry, single-stringed violin, music). This hero is considered a giant: "he was a man who greatly surpassed men (in height), someone who was truly very, very big/abundant (*wullen wullen*)."[65]

In Tuareg tales, this hero's giantism is on a par with his highly dissolute behavior, enabling him to produce sexual performances that are well beyond those of ordinary humans, and disproportionate with regard to the possibilities of his partners, who cannot withstand the pregnancies that result from them. In order to make sure of an offspring, he was finally forced to copulate with the biggest creature in existence, and thus had coitus with a young female elephant, which alone was capable of surviving his assaults, which usually killed his human wives, since they burst. Here is the tale of Amerolqis, according to a version collected in 1975 by Mohammed Aghali Zakara and Jeanine Drouin, in the Azaouagh (Niger), from a blacksmith of the Kel Nag, by the name of Alkhussayni:

> He was just a ladies' man who spent every night with women. Amerolqis was big and strong. He had attained such a height that . . . this happened to him: when he had sought and found a woman, he said that he would marry her. This woman's mother said to him: "You will not marry her unless you copulate with a young female elephant who is the first of the elephants to go the pool." He spent the day watching the elephants at the pool. When the sun rose, the young female elephant was at the pool, and she was the first of the elephants there. He seized her by force and fornicated with her. When they came to the water the second time, this elephant which had been raped was in the middle of the herd. She was

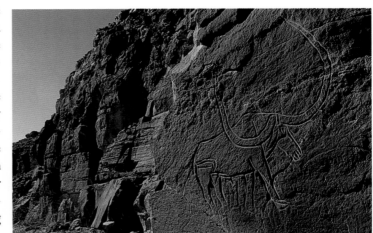
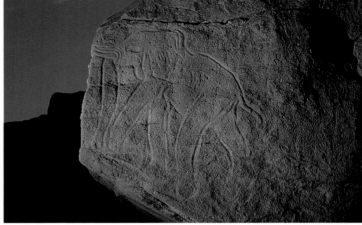

Fig. 40 and Fig. 41

Figs. 40 and 41 - A few of the tens of thousands of rock engravings in the Libyan Messak, as they appear today in their natural setting.

[64] Inventory and references in Le Quellec 1993. [65] Aghali Zakara & Drouin 1979, p. 36, n. 15.

Fig. 42 - Partial view of the ceiling of a rock shelter in the Tassili n' Ajjer (vicinity of Jabbaren) covered in recent paintings, mainly dromedaries associated with inscriptions in Tifinâgh. characters.

Fig. 43 - One of the groups of paintings of the "round heads" discovered at Jabbaren (Tassili n' Ajjer) by Lieutenant Brenans, who led Henri Lhote there in 1938.

Following page
Fig. 44 - A huge number of Saharan images resist interpretation, like this figure at I-n-Awanghet whose exact meaning is still unknown, even if it is very probably a masked man.

Fig. 42

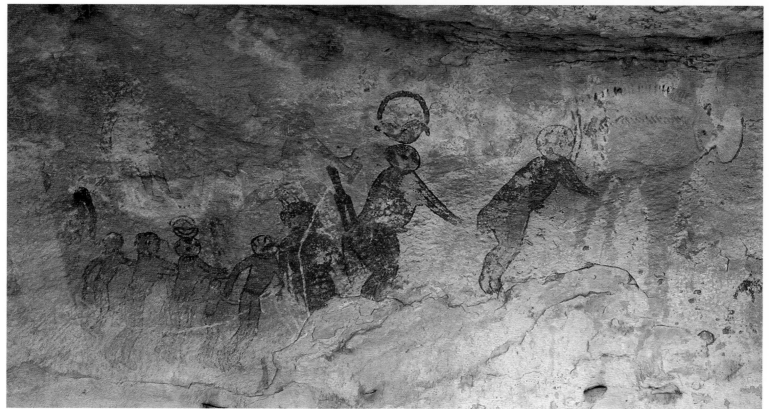

Fig. 43

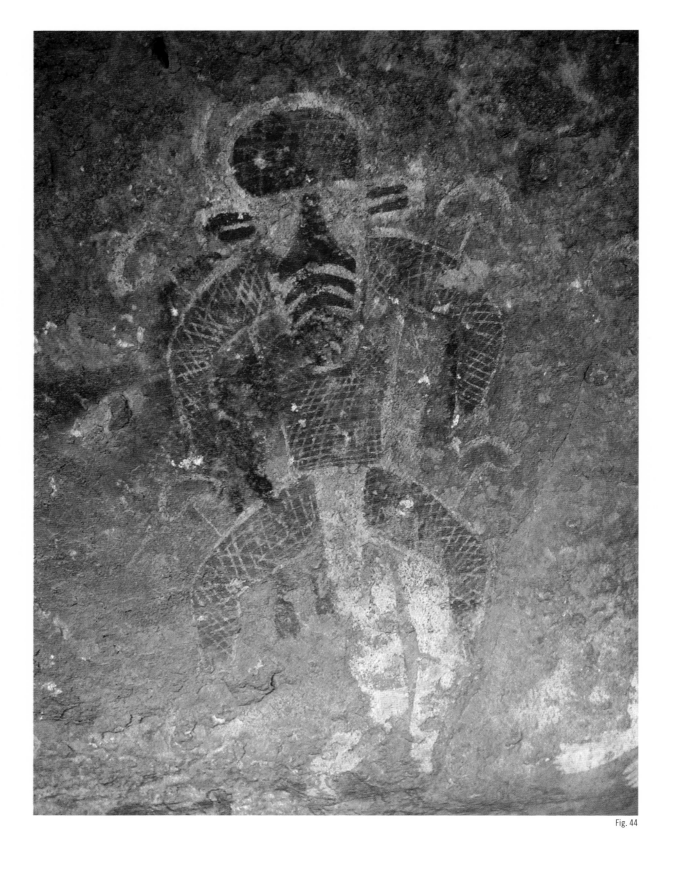

Fig. 44

Fig. 45 and Fig. 46

Fig. 45 - Even at the most famous sites, numerous figures remain to be discovered, as is proved by this strange painting that was recently spotted at Jabbaren (Tassili n' Ajjer). The subject depicted remains unknown to us, but one can at least recognize a kind of eared snake, undoubtedly mythical, bending to the right of the group.

Fig. 46 - Enigmatic head of one of the "giants" (*ijobbaren*) that gave its name to the site of Jabbaren in the Tassili n' Ajjer; originally, this figure was more than sixteen feet (5 m) high—it is now very eroded and only the face and shoulders are still clearly visible.

not the first because of the weight of Amerolqis's son. When they came to the water a third time, she was at the back. The fourth time, she did not come to the water. She was on the ground, lying on her back, and had burst because of Amerolqis's son. The child, look at the child which caused her to split, that young elephant which was going to the water the fourth time! She had not yet reached her term, and it was a ball. The girl's mother refused to let him have her, and told him: "You will not marry her, you will only be able to visit her at night as a lover." That is how it was. He was seized by anger. He went to the pool and began to wash in it. When he saw the women, the one he desired was among them; three of them were coming to the pool. Scarcely had he seen her when he ejaculated into the pool and got out of it. They entered the pool in their turn and began to wash in it. When they got out, they found themselves pregnant. After three days they burst.

In another episode, in which Amerolqis lusts after a female friend who is heading towards him, the narrator specifies that "when he had spotted them, then . . . he released in a stream beneath him the dreadful seminal fluid which made the camels collapse," but the woman would not consent to marry him.[66]

In Amerolqis, ancestor of the Tuaregs, one clearly has a mythical "master of animals and of fertility" whose union with animals, unlike that with humans, will in the end be fertile: he is the mythical initiator of the first fertile copulation. Without a doubt he is a cultural hero, of whom present-day storytellers claim: "Old people have told us that the violin, singing, and the flute are all imitations of Amerolqis. Nobody knows if he is a son of heaven or hell. Even the Marabouts are silent about him. Books do not say who he is." It is also said that "all women, even those who cannot give him a child, only show him their feelings of love when he sings. He has only to sing, and even the female donkeys, the nanny goats and cows rush towards him. The entire female sex loved him, including the female donkeys. It was he who invented poetry, singing, the violin, the Tifinâgh and the Tamajaq language."

It is quite remarkable that this legend is still told today by Tuaregs who for generations have not been able to see real elephants. While this species was present practically everywhere in the Sahara at the end of the Neolithic (*figs. 8, 41*), it only survived in North Africa until the end of the Roman period in clusters of residual fauna that were separated from the main African herd (although at the start of the twentieth century, a few river-dwelling Tuaregs in Niger were still able to hunt elephants with spears). An ancient tradition, reported by Lucian, claims that the Garamantes in the deserts of Libya hunted elephants that were capable of enduring thirst and the heat of the sun.[67] But Herodotus does not cite this fact when he speaks of the Garamantes, whereas he mentions elephants in the Berber domain. Is it possible that Lucian was merely repeating a mythical tale which he considered to be a historical fact, a

[66] *Ibid.*, p. 25–27. [67] *Dipsod.*, 2.

Facing page
Fig. 48 - The basics of Saharan prehistoric myths
will always escape us—for example, what role
could have been played by milk in the mythology of
the artists of the Libyan Messak who left us this
engraving in the Wadi Tiksatîn? We do not know,
but this "milking scene" is one of the oldest
in the world.

common fault in the historians and geographers of Antiquity? This question is all the
more interesting because the Garamantes are commonly considered to be the ances-
tors of the Tuaregs, having been in the Libyan Fezzân (where the ruins of their cap-
ital Jerma/Garama still survive) from the fifth century B.C.E. until their evangelization,
which occurred shortly before the arrival of the Arabs (seventh century C.E.). In
any case, in the first century C.E., Pliny the Elder, relating some remarks of King Juba
II (23 B.C.E.–25 C.E.), claimed that elephants can copulate with humans.[68]

While archaeology demonstrates that the Garamantes were paleo-Berbers—and
thus proto-Tuaregs—the myths of the Tuaregs specify that their ancestors were naïve
giants called Ijobbaren, Ixazamen, or Isebaten, who lived "in the time when stone
was soft," since the rocks only hardened definitively at the time when a founding hero
succeeded these mythical giants. One of the names given to this hero is Amerolqis, con-
nected to the name of the oldest poet in pre-Islamic Arabic literature, the Yemeni
Imru' al-Qays, who died between 530 and 550; some rather legendary characteristics,
which he shares with the Tuareg giant, have been attributed to him: pre-Islamism,
passion for women, invention of poetry, chivalrous spirit, and values inconsistent
with the Muslim ideal. The superhuman nature of the Tuareg Amerolqis is no less cer-
tain: not only can women, who flee him, not carry his child, but even a female elephant—
albeit belonging to the biggest known terrestrial species—bursts from the size of his
offspring. The name of Amerolqis, avatar of Imru' al-Qays, thus bears witness to the
partial Islamization of a fundamental Tuareg myth, by attributing the origin of rock engrav-
ings to giants who marked the rocks in the days when they were still soft. The hero
Aniguran/Amamellen/Amerolqis is justly credited with the invention of Tifinâgh,
that is to say, the writing that is still used today when its characters are engraved on
rocks close to water sources (*figs. 6, 23, 42, 46*).

Fig. 47 - This engraving in the Wadi Taleshut
(Libyan Messak) is a magnificent example
of an image illustrating a lost myth. Thanks to
comparisons with other related engravings,
one may rightly suppose that the mytheme
associated with it must have concerned an animal
metaphor of human fecundity, many of which
are known in the mythology of present-day
African shepherds.

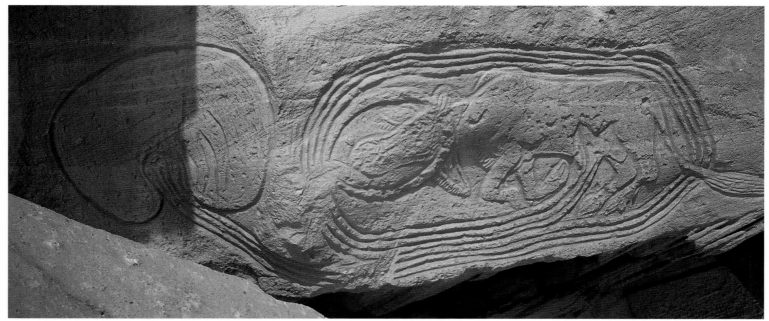

Fig. 47

68 *H. N.* VIII-1–12.

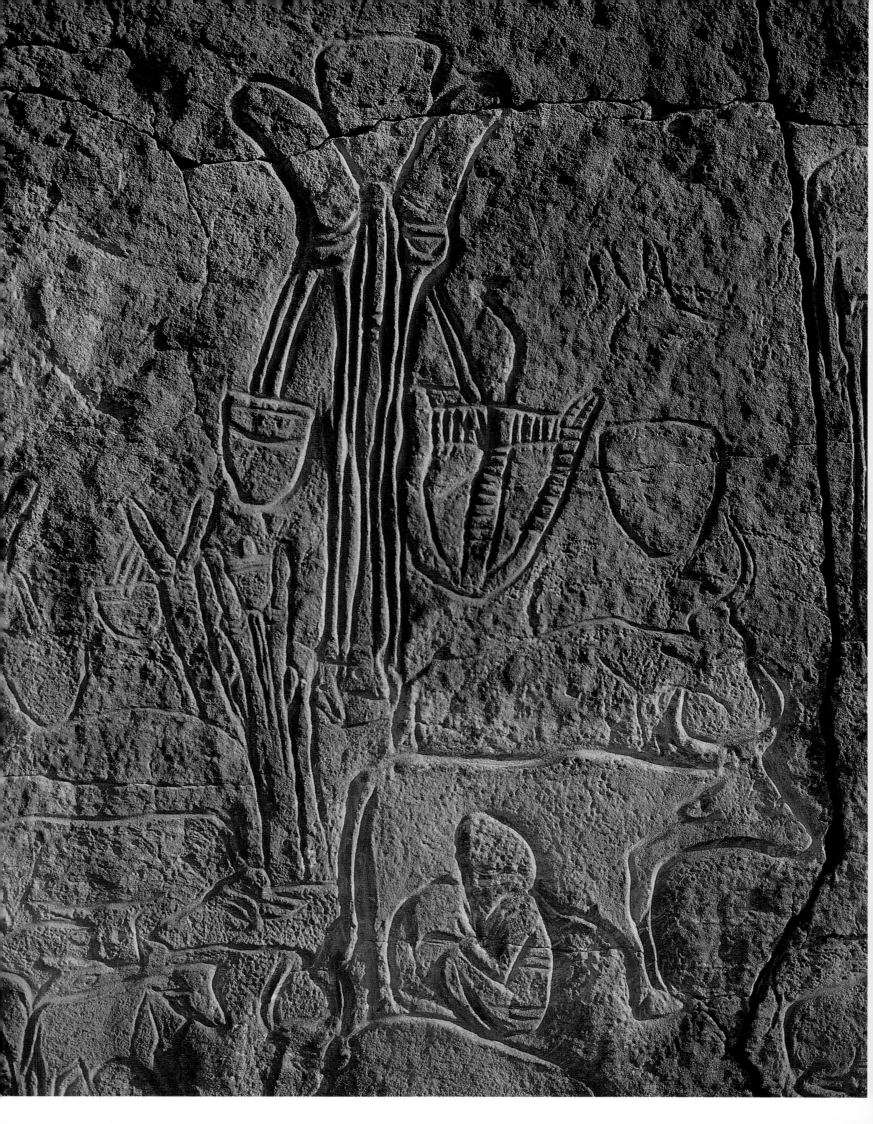

It is also not surprising that the Tuaregs frequently ascribe to their ancestral hero the wall engravings of all periods that are located next to present-day or recent inscriptions in Tifinâgh characters, and which are often considered as illustrations of his myth. Moreover, they often call the rock images in general *aniguran*, from the name of this mythical hero, and one of the best known rock art sites of the Tassili n'Ajjer, that of Jabbaren (*fig. 43*), bears one of the names given to the primordial giants (*ijobbaren*), because in it one can see depictions of gigantic people, including one the famous "great gods," the biggest of which measures about twenty feet (6 m) in height (*fig. 39*).

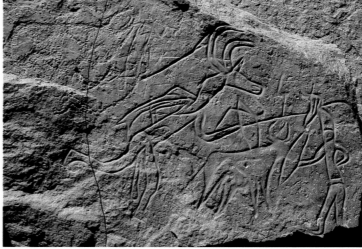

Fig. 50

One might suppose that Amerolqis's dealings with young female elephants are merely secondary tales, developed to explain certain rock art scenes noticed by the Tuaregs, but it would be astonishing if figures so limited in number and not very widespread could have motivated a myth that is so well constructed, so fundamental, and also so widespread. Moreover, the episode of Amerolqis's generative manifestation in the water where the women bathe—and hence a water that is both cleansing and a vehicle for being tainted—refers to an ambivalent and impregnating water symbolism that corresponds to an archaic pre-Islamic trait. The hypothesis that the paleo-Berbers, ancestors of the present-day Tuaregs, lived in a cultural milieu where myths of the same type were already in current use thus appears far more probable.

Moreover, the fact that the Berber hero's coupling is infertile with most women and fertile with female elephants constitutes a theme that akin to the prohibition (widespread in sub-Saharan Africa) that punishes with sterility those women who approach an elephant or see its trunk. More or less everywhere in Africa, in populations that are still today in contact with this animal, there is a relationship of

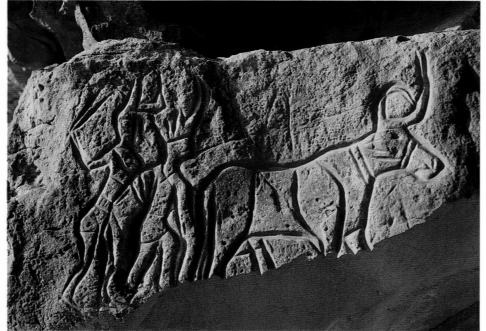

Fig. 49

Fig. 49 - In this Messak engraving, two people accompany a domestic bovine wearing a collar and a noseband. The fact that the men are both wearing a rhinoceros mask shows that this is not a simple pastoral scene.

Fig. 50 - The so-called "slab of the Garamante Apollo" in the Wadi Telizzâghen. Compare with Barth's drawing of it (see fig. 4).

Fig. 51 - Partial view of an engraved group in the Wadi Taleshut (Libyan Messak) that testifies above all to the important role played by women in rituals associated with bovines.

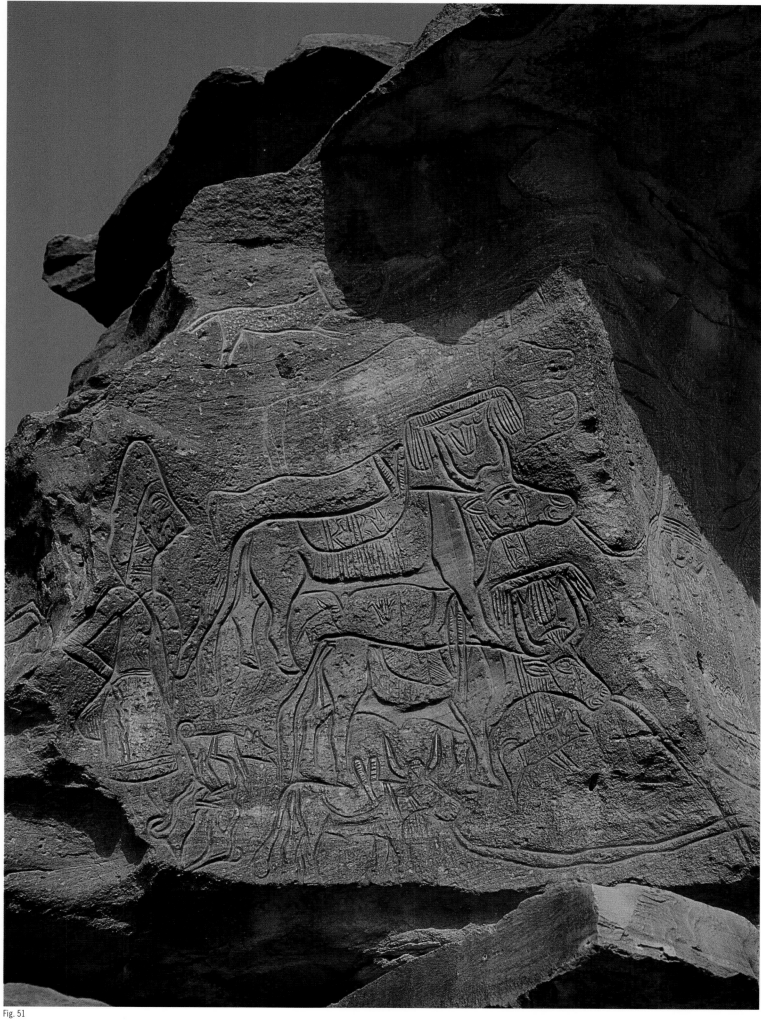

Fig. 51

exclusion between women and elephants that is linked to concepts concerning fertility. In general, women have to avoid seeing this animal. Hence, among the Ntumba, the Konda, and the Lia (Zaire), the *nzou* elephant is forbidden to young girls and all *mpo* children, that is, those born of a mother who was treated following repeated abortions. Among the Ntumba, it is even specified that if a woman eats some *nzou* elephant, she will miscarry. Furthermore, to the north of Bouaké, near the river N'zi, it is said that a woman who sees an elephant's trunk will become sterile; that is why, when the men cut up the game that the women have to carry to the village, they prevent them approaching before the trunk has been separated from the head and put aside. The long-ago disappearance of the elephant from the Maghreb and the Sahara makes it impossible in these regions to gather similar testimony, although the oral traditions of the Maghreb include giants endowed with magical powers and able to adopt a half-animal, half-human form: "they are described as having a body covered with hair . . . equipped with powerful jaws, and armed with tusks" Some myths collected at Filingué (north of Niamey, in a zone where elephants still came to drink around 1900) claim that such giants lived "in the time when the rocks were soft," and describe them as having big ears and big feet, and being capable of eating a giraffe in a single meal.[69]

All of this suggests the existence of an ancient cultural heritage that makes the elephant an important fertility symbol, a heritage that gave rise both to sub-Saharan belief and to Berber myth. Since the Islamization of the Tuaregs was not very effective before the fifteenth century, they could have retained these elements for a long time, well after the disappearance of the elephants and up until today, whereas the other Berber populations have absolutely no knowledge of them at present. But this could only have been achieved by means of a certain adaptation of these beliefs to the imperatives of Islamization, and to the customs of Tuareg society, especially through the borrowing of the name of Imru' al-Qays and through the emphasis placed on multiple female conquests.

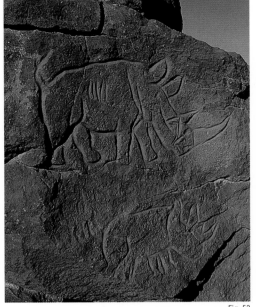

Fig. 53

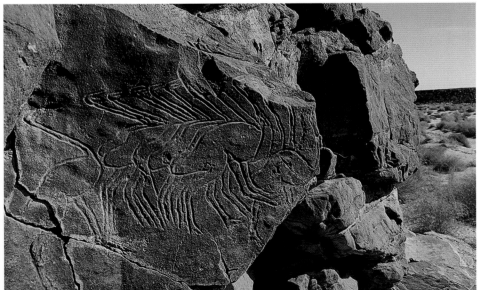

Fig. 52

Fig. 52 - Whatever the meaning of the images, their creators did have some aesthetic preoccupations. At this site in the Wadi Teknîwen in Libya, the engraver played with the lines of the necks and legs of a group of running ostriches to create an extremely elegant movement.

Fig. 53 - It is not uncommon that early images inspired more recent ones which are often less accomplished, as in this assemblage in the Libyan Messak.

69 Le Quellec 1998.

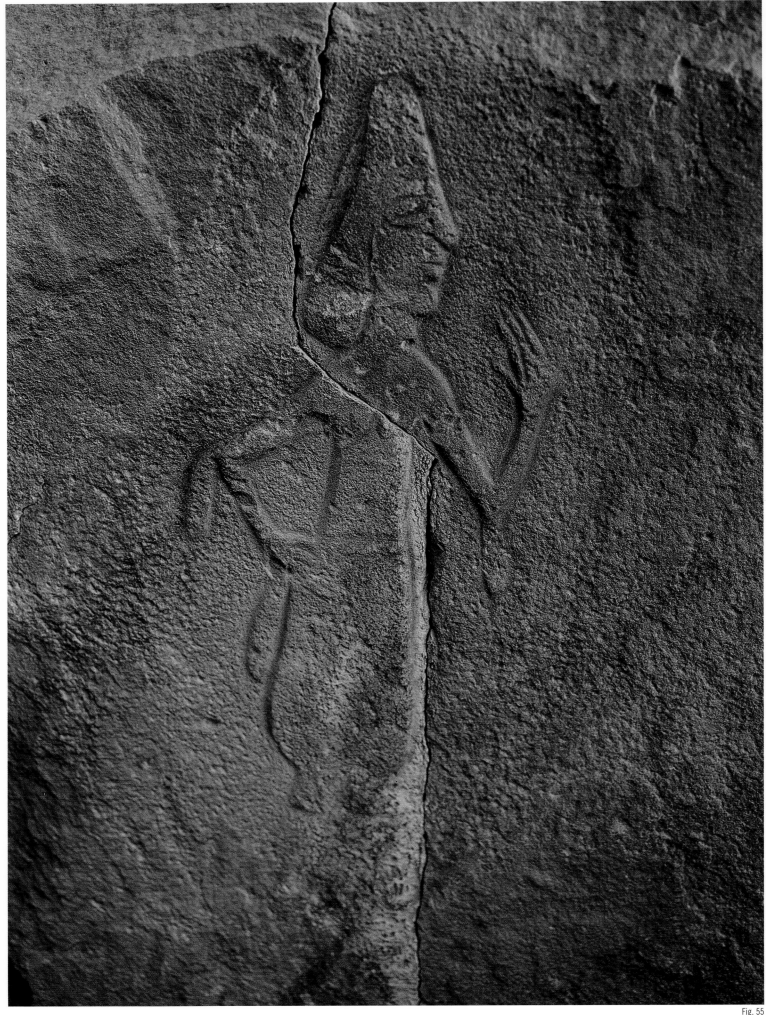

Fig. 55

52

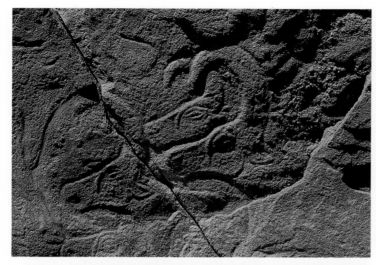

Fig. 56 and Fig. 57

Fig. 55 - Woman in a stereotypical posture comparable with that in fig. 44, but here engraved in false relief in an ovaloid that is entirely pecked on a block at the Wadi Imrâwen in the Libyan Messak.

Fig. 56 - The engravers of the Messak used artistic canons that were often close to our own. In this example, the bovine horns are clearly located in different planes.

Fig. 57 - The masterly use of the "double outline" by the Messak engravers produces striking effects of relief when the sun plays on the walls.

The important points on this subject can be summarized as follows:

1 In the Tuareg myth, the union of the giant ancestor is sterile with women, but fecund with a female elephant met near a pool.

2 In the central Sahara, giant therianthropes join with pachyderms in the Messak (of *p. 42*), and with women in the Acacûs (*fig. 23*). Several characters in the Messak are depicted with an elephant mask placed on their head (*fig. 39*). Moreover, a man in the Djerat displays a bent phallus, which is a characteristic of the elephant that was well observed by the Messak engravers.[70]

3 In African myths, the elephant is always linked with fecundity, and the sub-Saharan traditions prescribe a woman/elephant separation, since the mere sight of the latter by the former is said to cause sterility in women. Elephant masks are common among the Igbo of southeast Nigeria in masquerades linked to the cult of the gods. Another type of fruitful relationship between an ancestor and an elephant-woman is found in a widespread tale of which the following is a Ngambay version: A hunter surprises some young girls bathing after having left their skins on the river bank. He hides in order to observe them and discovers that when they put these skins on they are transformed into elephants. The next day, he returns to the same spot and steals the skin of the fairest. After her bath, she discovers she cannot leave with her companions and in despair starts to cry. The man approaches, gives her ordinary clothes and leads her to the village, to marry her, after hiding her elephant skin under the millet in the granary. They have children and one day many years later he forgets to give millet to his wife. She goes to look for it herself in the granary, discovers her old skin, cleans it, and again becomes a female elephant. Thereupon she disappears into the brush where, finding her husband, she catches him, tears him to pieces and throws him away.[71]

Once again taking up a Levi-Straussian perspective, it is remarkable that the Saharan tales concerning Amerolqis display similarities to, and inversions of, the sub-Saharan traditions that are all the more significant in that they reflect very different social practices:

[70] Lhote 1976b, vol. 2, p. 1359–1360. [71] According to Ruellan & Caprile 1993, p. 28–35.

Ngambay tale	Tuareg tale
An ordinary human hunter	A superman (Amerolqis), ancestor of all men
meets	meets
by chance	by necessity
on the bank of a river	on the edge of a pool
a supernatural	a natural
female elephant	female elephant
and forces it to copulate with him.	and forces it to copulate with him.
It has a child	It has a child
then resumes its original form and disapears.	and dies while giving birth.
Their descendants remain (and can be recognized by their big ears).	Their descendants remain (and are the Tuaregs).

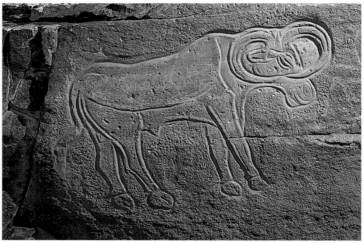

Fig. 58 and Fig. 59

Moreover, the real prohibition that in the sub-Saharan zone generally forces women to avoid elephants under pain of becoming infertile complies with the legendary infertility of Amerolqis with women, and the hyper-fertility of the female elephant with whom he copulates.

These concepts cannot be said to be universal, nor do they express a banal "symbolism" of the elephant; for instance, there is nothing similar to be found concerning the Asian elephant. This means that the myths and concepts behind the three assemblages studied (the Tuareg founding myth, the sub-Saharan rites or tales, and the prehistoric rock images of the Messak) belong to a specifically African ensemble. Yet the parallels and inversions noted between the first two cannot be explained through direct influences or recent borrowings; nor can a hypothesis of this type explain the prehistoric rock figures that illustrate these themes.

The issue of the possible relation between what the rock engravings can reveal to us of the meanings that inspired their creation and the various traditions that are remote from them (both in space and time) is therefore problematic, but there are nevertheless connections between the Saharan productions that one hesitates to put down to chance.

Even if one accepts the hypothesis of accidental encounters between traditions with no genetic connection, the foregoing analysis at least has shown that the rock figures cited above illustrate classic "mythemes." Thus, the image of the therianthrope illustrates a reflection on the animality of man and the humanity of the animal, and the scenes of zoophilia allude to the connections between human fecundity and animal fertility. So the whole ensemble forms part of a reflection that operated through organizing and designing images— that is to say, with different means than, but probably the same ends as, the myth, which likewise operates through the organization and design of symbols, but by means of speech.

Fig. 58 - This ewe in false-relief is engraved on a rock in the Messak. Images of domestic sheep cannot be earlier than the sixth millennium, and are therefore useful to the prehistorian for dating this art.

Fig. 59 - The whole inner surface of this aurochs engraved in the Wadi I-n-Haggâren (Messak) was carefully polished so as to accentuate the effect of relief created by the double outline.

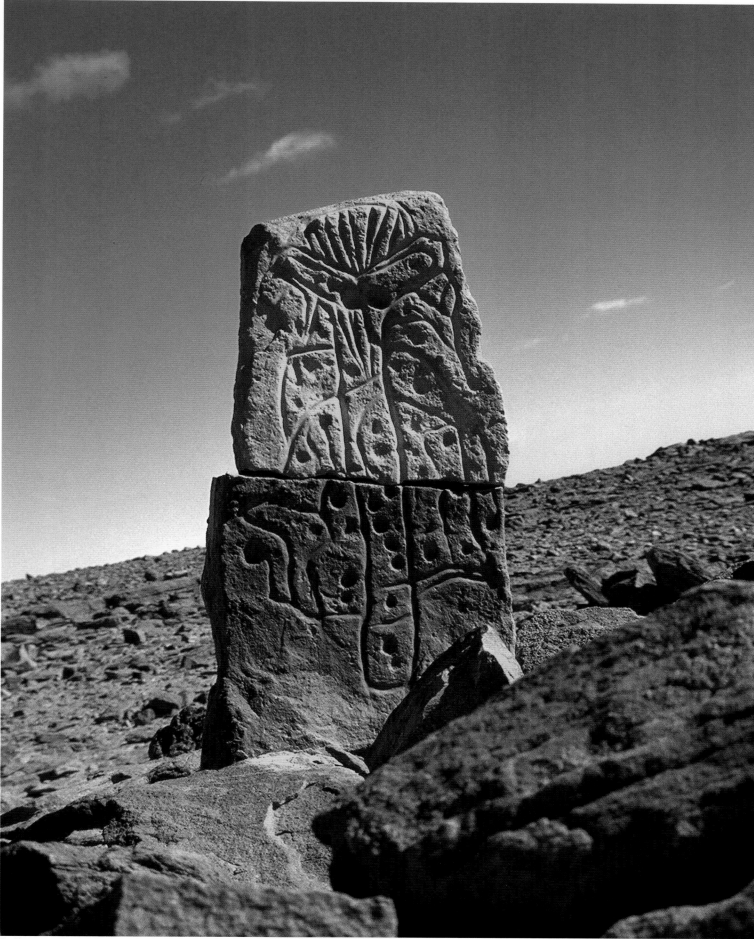

Fig. 60

The Intertropical Zone

*"When there was yet no living thing here on earth,
Chiuta made a man and a woman and sent them down.
They alighted on a rock called Kaphiri-ntiwa. That rock was still
soft and they left their footprints on the rock when they alighted.
These footprints can still be seen today."*

—(Chewa myth[1])

Fig. 1 and Fig. 2

The name we are using here is approximate and designates the immense zone located between the Zambezi and the Sahara (except for Azania), thus including the central part of the African uplands and almost the whole of the great forest. Although it corresponds roughly to the present-day extension of peoples speaking Niger-Kordofanian languages, this is not a homogeneous cultural area; but, from the point of view of rock art, it is distinguished from other regions by the predominance of a nonfigurative painted and engraved art, essentially made up of geometric figures quite often associated with images of metal objects. Clear depictions of anthropomorphs and zoomorphs remain far rarer here than everywhere else. As a whole, the rock art of this region is poorly known: the available documentation mostly concerns the Sahel zone, with almost nothing on the forests to the south of the savannah; today it is not known whether this distribution simply reflects the difficulties of exploration in the forest zone.

For several countries we have absolutely no information (e.g., Liberia, Guinea-Bissau) or else it is very poor. For example, one can only mention a small series of "signs" in the Djimini country of Ivory Coast,[2] and a few radiating circles at Takoutala in Senegal.[3] In Guinea, the "grooves" mentioned by Edmond Hue are merely small blocks with grids on them,[4] and the rock art sites in the vicinity of Sirakoro and Bagnagna-Takoutala have not been studied. Of more significance are the red paintings made on the quartzite blocks of Niodougou that depict recent animal species (canid, ostrich) next to horsemen carrying round shields marked with a cross.[5] In southern Niger, apart from those of Labbezenga on the river,[6] the engravings of Kourki in Gourma, reputedly made by the *dom borey* (or "people of before") mostly consist of circles with two diameters forming a cross, and horsemen, some of whom carry a round shield bearing this motif (*fig. 3*), called *gandyi hau* ("tie up the bush") by the Songhai of the vicinity, who use it for protective ends: "in drawing the cross, the magician paralyzes all the evil found in the four cardinal directions; in drawing the circle all around, he encloses the evil that remains (and which is less dangerous) in this circle;"[7] so it is not surprising to find the same design on this shield, which is a protective object par excellence.

The only published site in Sierra Leone consists of a few white schematic paintings—oval shapes filled with dots—recorded in a granite shelter at Wara Wara Bafodia, about six miles (10 km) southwest of Kakoya, a spot located in Limba country, to the northeast (*fig. 4*). The excavations carried out by John Atherton in this shelter yielded a small assemblage from the Late Stone Age, which could not be correlated with the paintings, but a text by E.R. Sayer, who visited the region at the beginning of the twentieth century, tells us that two wooden statuettes, "apparently very ancient," were then preserved in this place, and that dances took place there. We know nothing more of this assemblage, but it should be noted that the geological nature of their support, which exfoliates rapidly, implies a fairly recent age for the paintings of Wara Wara Bafodia, and that the Limba of the vicinity are perpetuating a tradition of schematic mural painting, since geometric drawings are still made by young girls on the house walls, as they emerge from the *bundu* ritual of female initiation.[8]

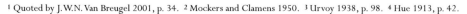

[1] Quoted by J.W.N. Van Breugel 2001, p. 34. [2] Mockers and Clamens 1950. [3] Urvoy 1938, p. 98. [4] Hue 1913, p. 42. [5] Desplagnes 1907, pp. 79–81. [6] Mauny 1953. [7] Rouch 1949, pp. 344–5. [8] DeCorse 1988.

8 in.

4 in.

Fig. 3 and Fig. 4

Fig. 3 - Engraving at Kourki (southern Niger): horseman with a feather in his hair holding a short lance and a round shield decorated with a cross.

Fig. 4 - White "abstract" paintings from the shelter of Wara Wara Bafodia in Sierra Leone.

Preceding pages
Fig. 1 - Map of the zone of the central territories, in which geometric figures predominate and where anthropomorphs and zoomorphs remain far rarer than everywhere else.

Fig. 2 - Group of archers painted in the region of Vumba (Mozambique); some are carrying their quiver on the shoulder.

In Ghana, a rock-shelter in the sandstone massif of Kintampo has yielded a circular incision that cannot really be considered an engraving, as it seems to be linked to a workshop for fabricating pestles that operated here until the end of the first millennium B.C.E. On the other hand, at the top of the inselberg where this shelter is located, there is a veritable engraving made up of a cupule surrounded by several circles, which has no known parallel anywhere else in the country, and which it has not been possible to explain or to correlate with the uses of the shelter.[9] At the border of Togo, a rock-shelter at the foot of the Gambaga escarpment contains paintings of mounted horses depicted in white and red, as well as a series of thirteen simple, double, or pointed circles, likewise in white and red, some of which seem to be held in the hand by people. One can also see what is probably a snake (with a thickening for its head), and a few geometric signs such as crosses, a series of dots, and an oval with internal separations (fig. 5). The same shelter also contains large clay structures that have been recognized as huts and granaries, some of which had been given a funerary function, and the assemblage has been compared to the Dogon layouts of Sanga described below.[10] Nevertheless, this comparison is limited by the fact that the images in the two sites are barely similar, and that the function of the Gambaga shelter remains poorly documented.

Fig. 5

Fig. 5 - Paintings in the shelter of Gambaga in Ghana; one can recognize a few people (perhaps with their shields) and something that strongly resembles a snake.

In Mali: Images of Dogon country

As far as Mali is concerned, the paintings—in red, black, and white—of the great shelter of Songo at Sanga (figs. 1, 6, and 7) were noticed by Augustin Marie Louis Desplagnes during his mission of 1903–06, and then seen by Leo Frobenius during his travels of 1906–07, before being studied in November 1931 by the members of the famous Dakar–Djibouti mission, who picked up several painted stones at the foot of the wall (fig. 8) just as Desplagnes had already done. On each of these occasions, photos were taken, and a study of these makes it clear that over a period of thirty years the shelter's decoration had seen fewer additions than repaintings; the latter consist mostly of complementary white lines: circles, highlightings, parallel lines, and internal details. It was facing this shelter wall that, every three or four years, the children of Sanga and of neighboring villages were circumcised, and on this occasion the elders redid the paintings, while explaining their meaning to the newly circumcised youngsters.[11] These images mostly depicted *ugulu* (lizards) and *waō* (monitor lizards) (fig. 9), as well as masks—especially *kanaga* (fig. 11), but also *dyalu, nige, sirige, walu* (fig. 10)—and various objects: brooches, fans, chopping boards, spatulas, whistles, and weapons (fig. 13), and also a kind of bag that is carried by men during the initiatory festivals of the *sigui* (fig. 14). To this list, must be added various anthropomorphous figures, some wearing *kalama nāngala* masks (fig. 12); a few animals— lion (fig. 15), crab, insect, and millipede—and some depictions of mythical beings, that is, *ginyu* or genies (fig. 16). Regarding the list of depicted masks, let us note that

9 Rahtz and Flight 1974, p. 13 10 Carter and Carter 1964. 11 Schaeffner 1933.

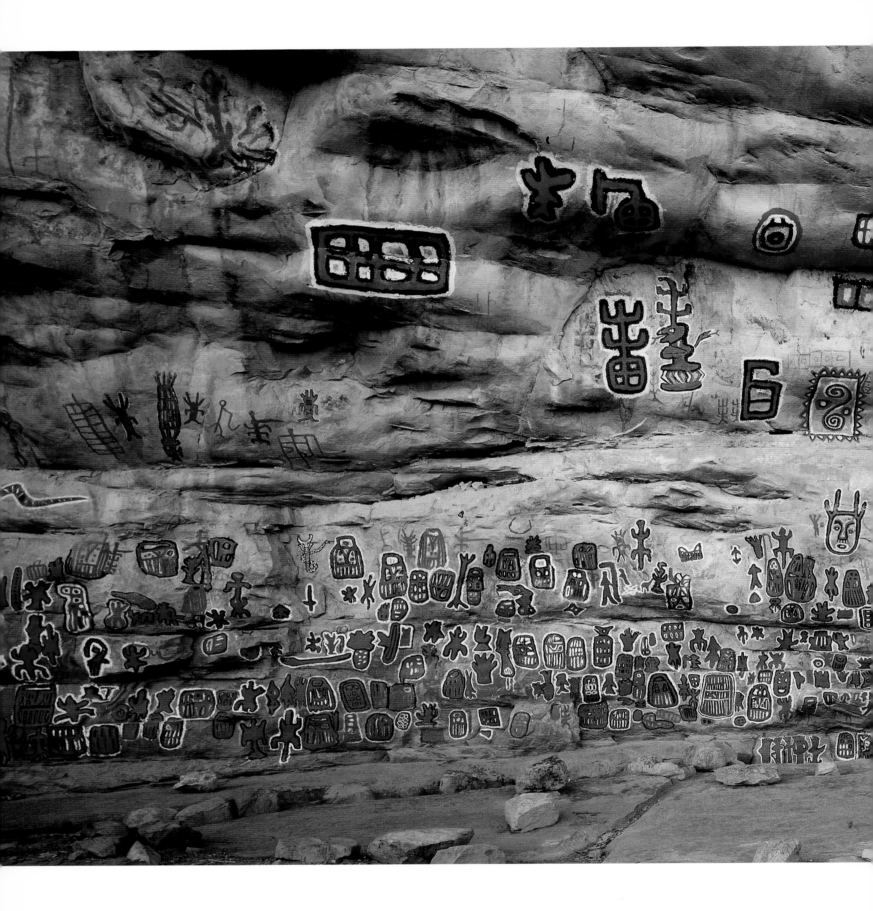

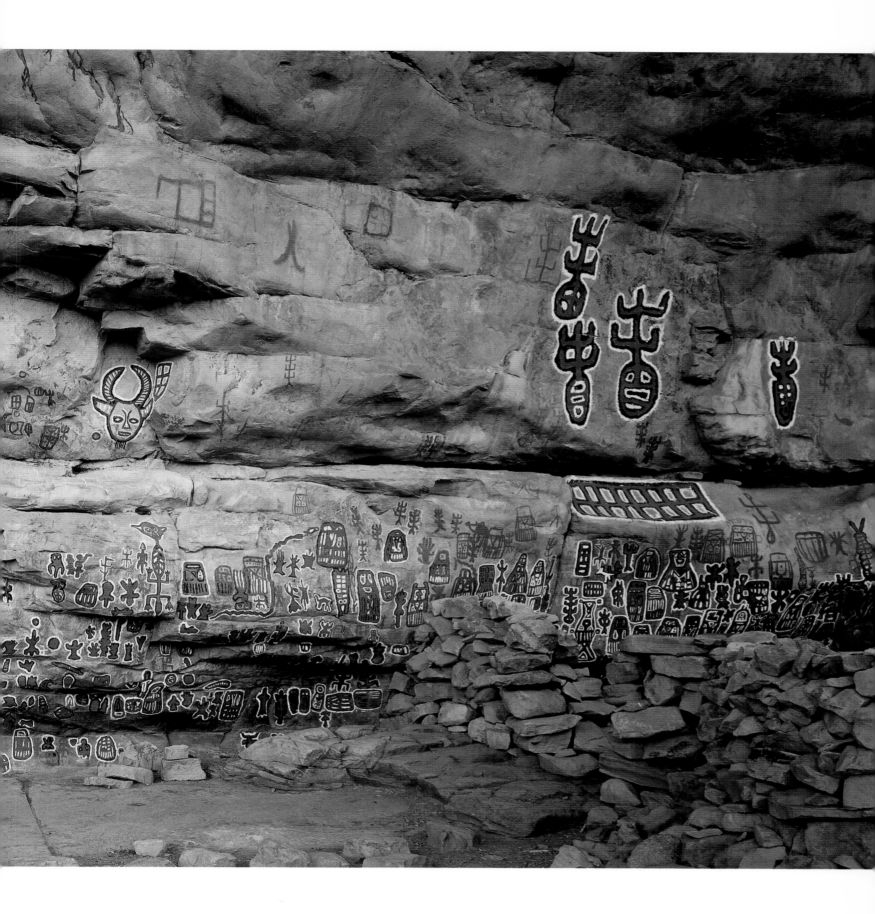

Fig. 6 - Current state of the great overhang of
Songo at Sanga (Mali), which should be compared
with the early photos (fig. 7).

Fig. 7

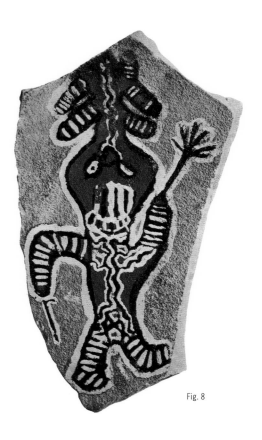

Fig. 8

Fig. 7 - The paintings of the great overhang
of Songo have often been photographed since the
early twentieth century. The top photo was taken
by Leo Frobenius in 1906–07, those at
the bottom were taken in November 1931 during
the Dakar-Djibouti mission by Leiris and
Schaeffner. At first sight, few things seem to have
changed, but a more careful examination shows
numerous additions, highlightings, and retouches.

Fig. 8 - One of the decorated stones picked up at
the foot of the overhang of Songo by the Dakar-
Djibouti mission and currently preserved at the
Musée de l'Homme in Paris.

at the start of the 1930s Ambibé Babadyi, then aged about ninety, had been told by his father that the *ammatã* mask, present among the shelter's paintings, had already practically disappeared before his own birth.[12]

The rock art of the Dogons has been the subject of numerous studies devoted to both its ancient and contemporary expressions, sometimes grouped with other neighboring graphic productions under the global name of "Mandingo group" (because they are perhaps connected to the ancient empire of Mali). But, in all known cases, the meaning of the works is never accessible without the help of the associated oral tradition.[13] The paintings are found in different shelters: those where the masks are stored, those where an essential part of the circumcision rites is carried out, the mortuary shelters, and finally the caves bearing secular graffiti.[14] The Dogons themselves distinguish two types of image: the *tonu*, generally white or black, which are often the work of young goatherds and are mainly found in the circumcision shelters or men's places of rest; and the *bammi*, of religious significance, images drawn in red by the elders (or by the adults they have mandated to do so) and whose complete name is *imina nyama bammi*, "paintings of the *nyama* of the masks." The association of these figures with the initiation rituals or the masks provides some indication of their function and even their meaning. Hence, the rock depictions of *kanaga* masks (*fig. 11*), inevitably referring to this ritual object, can only be related to the function and meaning of these masks, whose creation—intended to fix the *nyama* (strength) of the dead ancestor in the form of a snake—is, in the myth (in the language of the *Sigui*, recited by Ambibé Babadyi),[15] associated with its rock depiction in a shelter:

gyi wada igiru nene awa duno dyu sagya boy . . .
bige guina igiru nene ire kuru kommo yarabire tunyo boy

With rice and red earth they painted the Great Mask . . .
All the men with red earth painted the cavern of stone.

The rest of the myth is summarized as follows by Marcel Griaule:

the old men drew on the wall of stone an image representing the mythical snake of which they had a model before their eyes. To this effect they used the ocher that had received the blood of the sacrifice, and pronounced appropriate words. Then, once wood had been placed in contact with the rock, the latter became the definitive receptacle of the dangerous power.[16]

But this same mask is also interpreted as a depiction of the small bustard (*kommolo tebu*),[17] the *gyin* and *syenye* lizards, the *gan budu* gecko, or the *amba ene* egret,[18] when it is not read as the image of a crocodile. Such interpretations, apparently contradictory (at least to our eyes), have been explained by the fact that increasingly subtle interpretations of the same symbols are given to the initiates as their initiation progresses. So it should not be surprising if people who have attained different degrees of knowledge

[12] Griaule 1938, pp. 603–98. [13] Sanogo 1993. [14] Gallay 1964. [15] Griaule 1938, pp. 119–20 and 613–14.
[16] *Ibid.*, p. 614. [17] *Ibid.*, p. 470–75. [18] *Ibid.*, p. 477.

have made comments about the images that corresponded to their own level of initiation, and if these interpretations varied considerably, if not being contradictory at the deepest level.[19] So, there are two possibilities: either all the explanations gathered are correct but none by itself is sufficient; or some are erroneous, or at least exoteric, or even simply improvised so as to get rid of tiresome questioners. This is what Griaule thought when he noted that at the start of his investigations "false explanations were given about the mythical origin of the paintings."[20] Yet by way of example he cited a genuine myth, of how a woman "perceived the *kanaga* on the head of the *Adoumboulou* [mythical dwarfs] who were dancing, but she was unable to take it. She drew it on the ground; her husband reproduced its form on the rocks, and the mask was carved from this model." This type of tale can be integrated perfectly with the abundant series of those in which women are the original mistresses of culture, and more especially the introducers of masks, before men stole this knowledge from them.[21] It is all the more surprising that this explanation was seen as "false" by the famous ethnographer since, for the society where it is in current use, the mythical tale speaks the truth par excellence, and what's more, this same

Fig. 10

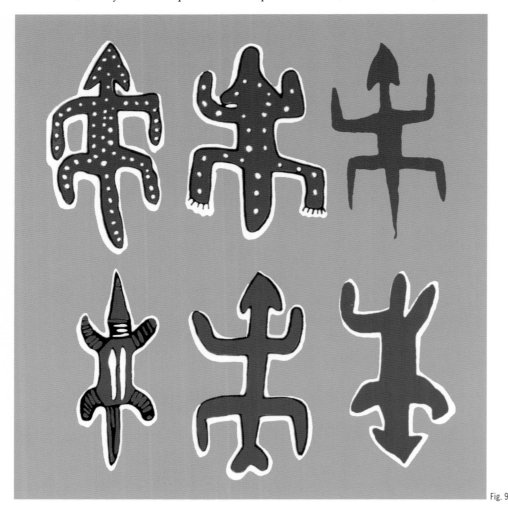

Fig. 9

Fig. 9 - Representations of more or less schematic lizards and monitors that were among the paintings in the great overhang of Songo during the visit by the Dakar-Djibouti mission.

Fig. 10 - Representation of the *walu* mask in the great overhang of Songo (whereas an "immediate" reading might interpret this image as a hand).

[19] Gallay 1964, p. [20] Griaule 1938, p. 614, n. 1. [21] Le Quellec and Sergent 2003, s.v. "Femmes maîtresses de la culture." 130.

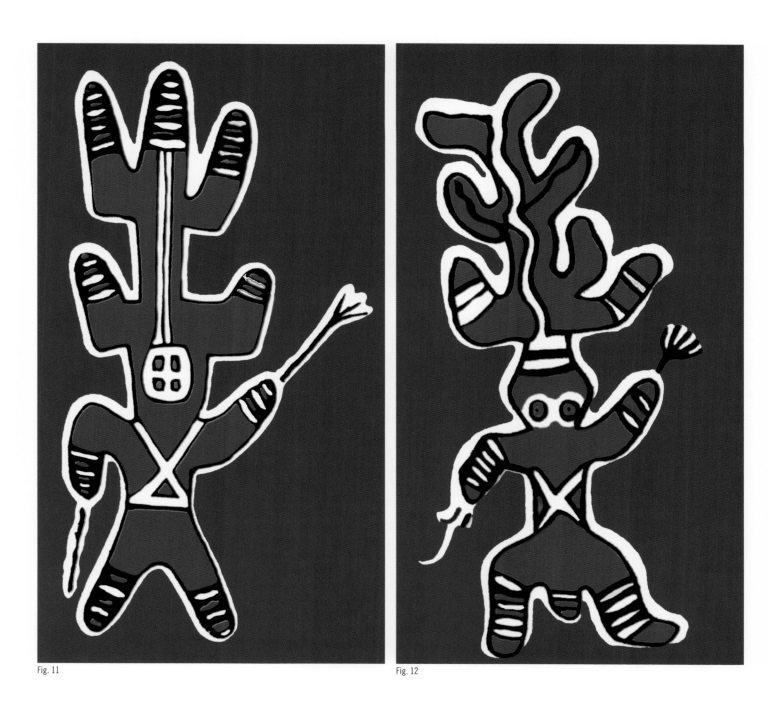

Fig. 11

Fig. 12

Fig. 11 - Representation of a dancer wearing the *kanaga* mask, in the great overhang of Songo.

Fig. 12 - Representation of a dancer wearing the *kalama nāngala* mask in the great overhang of Songo.

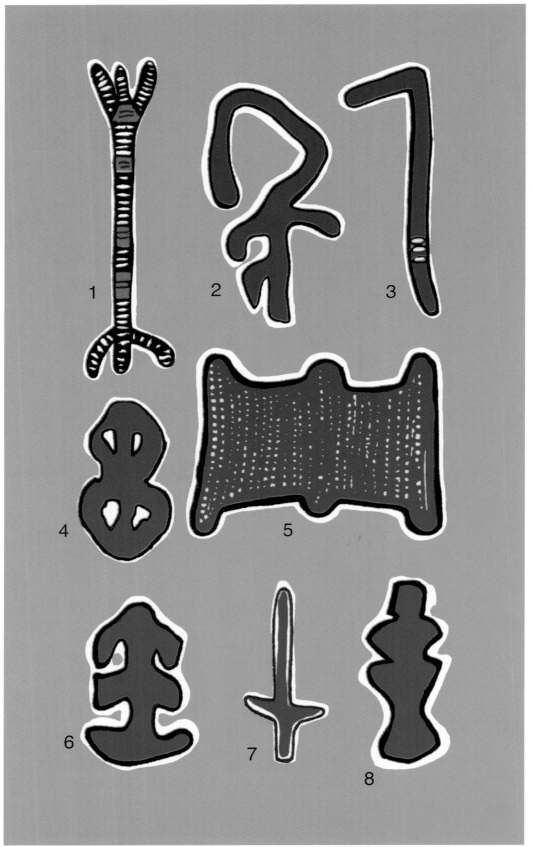

Fig. 13

Fig. 14

type of myth seems to have been collected frequently by Griaule in person. Indeed, he remarked that "the [rock] drawing is often explained as the need of the mythical person to teach people the form of the masks he had seen." So it is clear that at least certain rock images were conceived as intermediaries between the first original mask, a mythical "acheiropoïete" object par excellence,[22] and the false faces that artisans made from this model. Here one finds a mythical function that is pretty widespread for rock images: a message bequeathed to present-day humankind from the depths of ancient times, for its edification.

Whatever one makes of the comments collected by the ethnographer concerning Dogon art, their main lesson for the prehistorian is that the meaning of rock images can never be directly accessible without the help of either those who made them or knowledgeable people who belong to the culture in which the art has function and meaning. A few examples suffice to demonstrate this: Who, in figure 15, could immediately recognize the depiction of a lion? and that of the moon in the kind of "cockade" of figure 16? There is no point in piling up the examples, and these observations should invite the greatest prudence in the "reading" of rock art when it cannot be supported by an oral inquiry. Moreover, the research by Geneviève Calame-Griaule on the symbolic representation of speech in Dogon country,[23] and more particularly concerning the rock drawings made on the walls of their cave by the goatherds responsible for taking care of the newly circumcised boys, has fully confirmed the fact that the meaning of these figures can never be recovered from the image alone. This also emerges from the investigations of Solange de Ganay (1940) into the *bammi* (paintings) of war, the aim of which is protection from the *nyama* of victims killed in combat. Thus it was confirmed to her, in 1937, that the images called *inne nyama bammi* ("drawing of the *nyama* of man") could be made in the presence of the corpse, and that these drawings were meant to fix the *nyama* (*fig. 20*).

Other shelters decorated with painted geometric and anthropomorphous motifs have been reported near Bamako,[24] at Goundam and Fiko,[25] at Ouoro-Kourou (*fig. 21*) near Kita,[26] and at Sourkoudingueye near Sikasso,[27] but the function of these sites, generally poorly documented, remains obscure. Nevertheless, it is known that in the region of Bandiagara, the painted shelter of Goundaka —where there are "barbed" signs (anthropomorphs? lizard forms?) and ovals with dotted interiors, all painted in red and black— was used in connection with funerary rites; several human skulls and the remains of sacrifices were discovered in rock fissures here.[28] It is also known that the rite for the newly circumcised, which consists of reviving the ancient paintings, is still actually carried out at certain sites in Dogon country, such as the shelter of Modjodjé-Do (*figs. 22* and *23*).[29]

The excavations carried out by Eric Huysecom (1990) in the rock-shelter of Fanfannyégèné I (in Bambara *fanfan* means "cave" and *nyégèné* "decorated"), on the

Fig. 13 - Objects depicted in the overhang of Songo: (1) forked stick (*tuma dyaguru*) used to sweep millet stems and thorns in the fields; (2) iron hook (*dogu*) used to pick fruits that can't be reached by hand; (3) throwing stick (*dommolo*); (4) little bag (*dyembu*) for the fire lighter, drawn open; (5) fan of plaited grass (*tidu*); (6) shoemaker's cutting board; (7) spatula for churning milk; (8) wooden whistle (*songo*).

Fig. 14 - Representation of the bag ritually worn during the festivals of the *sigui* among the paintings in the overhang of Songo,.

22 *Acheiropoïete* means "not made by human hands." 23 Calame-Griaule 1965, p. 184–250.

24 Perois 1945. Szumowski 1953 and 1955. Dars 1955. 25 Szumowski 1956. 26 Jaeger 1953, p. 98.

27 Sommier 1950. 28 Szumowski 1956, p. 20. 29 Marchi 1999*a*.

territory of the National Park of the loop of the Baoulé, have made possible the study of rich lithic and ceramic materials attributed to a culture (neolithic facies of Baoulé), but unfortunately it has not been possible to link this directly with the engravings and paintings that decorate the site (where the dates obtained range from 2680 ± 120 B.P. to the fourteenth century C.E.). The oldest images are pecked engravings identified by local hunters as depictions of giraffes; moreover, one of the engravings seems to represent a schematized bucranium (*fig. 26*, right). Among the paintings, one sees figures of saurians (monitor lizards or crocodiles?) painted in shades ranging from pale yellow to gray. An animal interpreted as a "chelonian" by the author[30] is more comparable to the type of animal depictions known as "spread-eagled or bedside rug" (*fig. 26*, left). This group of more or less reptilian figures accompanied by uninterpretable geometric shapes is superimposed on the engravings, but is also partially obliterated by a group of large round-headed people made with white and red lines and dots that seem to be contemporaneous with signs (anchor shapes, cruciforms) in the same colors (*fig. 25*). Finally, the local artistic sequence seems to end with a group of red signs that look very fresh (compartmented ovals, squares and rectangles with compartmented or dotted interiors, clouds of dots, barbed signs), and with a human figure that recalls those of the previous period, albeit more elementary. Almost all the region's shelters are decorated, and the study of those of Fanfannyégèné II, Mukutaresifanfan, Kulubadéfanfan, and Sirikisifanfan has fully confirmed these chronological hypotheses. Currently it is accepted that the polished grooves and incised lines are the oldest markings; then come the dark red paintings (corniforms and meanders) sometimes obliterated by associated pecked engravings, which must be associated with the neolithic facies of Baoulé (end of the second to start of the first millennium B.C.E.). Among these engravings, one observes spoked circles or rayed circles,

Fig. 15

serpentiforms and figures of bovines with long horns and with their ears depicted, which can be reduced to the simple bucranium—like the "corniforms" of the Kita region, these works were doubtless produced at the time when populations arrived in the region that were fleeing the growing aridity of the southern Sahara.[31] Then come the yellowish gray paintings of lizard shapes and the round-headed people painted in red and white, as well as (probably) the geometric figures in red, white, and, more rarely, black. The sequence ends with the black graffiti, which often copy the earlier motifs.[32]

It is to the final phases that one can assign the assemblage of paintings of Aïré Soroba (Lake Débo, loop of the Niger), made up of horsemen using spears to hunt the ostrich, giraffe, or antelope. There are also inscriptions in Tifinâgh and Arabic characters, and three images of dromedaries—the southernmost in West Africa—the whole assemblage strongly resembling a southern extension of the

[30] Huysecom 1990, p. 53. [31] Huysecom and Marchi 1997. [32] Huysecom and Mayor 1991–92.

Fig. 16

Fig. 17

Fig. 15 - Image of a lion (*yara*) among the paintings of the great overhang of Songo. Without being initiated into the traditional reading of the images, one would never be able to recognize this animal.

Fig. 16 - Image of a *ginyu* (genie), among the paintings in the great overhang of Songo— a mythical being, that is, something eminently cultural and not recognizable outside Dogon culture. According to Marcel Griaule's informants, the bent appendage represents its arm, which nobody could have guessed.

Fig. 17 - Representation of the moon in the great overhang of Songo. Images of this kind are extremely common in rock art sites throughout the world, but there are very few cases where, as here, one has the benefit of a reading provided by the participants in the ritual that had involved the making of the paintings. This image is among those added to the overhang of Songo between Frobenius's visit and that of Griaule.

Fig. 18

Sahara's caballine and cameline productions, with the difference that here one finds depictions of boats. Such an extension seems confirmed by the presence, especially at Tondia, of rare schematic chariots comparable to those of the Mauritanian Adrar. Arabic sources help date to the eighteenth century C.E. the arrival in the region of Tuareg populations who introduced the dromedary and the use of Tifinâgh characters, and the growing influence of Islam can also be seen in an Arabic inscription at Aïré Soroba, which preserves the memory of a pilgrimage made to Mecca during the twelfth century.[33]

In Burkina Faso: Weapons, reptiles, and goblin prints

In Burkina Faso, the paintings are located in the west and southeast: the people on foot and horsemen of the rock-shelter of Kawara could date back to the seventeenth to fifteenth centuries, and the signs painted on walls at Yobri are similar to those that *gulmanceba* (*gulmancema* or *gourmantche*) diviners have been using for geomancy since the sixteenth century.[34] A great number of petroglyphs are also found at the foot of the cliff of Banfora, in the far southwest of the country.[35] The vast majority are geometric signs (concentric circles, circles of dots, rows of dots or lines, cupules, or "cup-and-ring" motifs) laid out on rocks or big sandstone slabs, and which are also sometimes found in caves. In a few engravings, objects can be recognized (*fig. 26*) that are still in use among the Tusia who inhabit the region, in particular the weapon known as a *sanégue*, or "iron in the form of a snake," as well as *kahakè* shields whose shape is peculiar to each matrilineal clan, and a *dókàhá*, which is the wooden stool that the men wearing masks use during the initiation rites in the cult of the god Dó. The only clearly identifiable animal forms are reptiles: Lizards—endowed with protective virtues among the Tusia—and snakes with a well-marked head, probably the python or the grass snake called *yonsín* or *yonsoho*, both of which still play a

Fig. 18 - Painting of the great *nige* (elephant) mask in a shelter located not far from the overhang of Songo. The right-hand appendage represents the trunk, the pectiniform protuberance on the left is the tail.

Fig. 19 - One of the members of the Dakar-Djibouti mission tracing the big painting of the elephant mask above.

Fig. 19

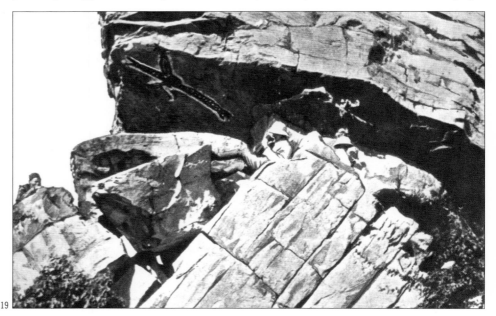

33 Marchi 1999*b*. 34 K. Millogo, in Vernet 2000, p. 41. 35 Haselberger 1968.

role in regional myths (*fig. 27*). Certain snakes seem to have been engraved with two heads, which makes it possible to recognize the python, *Calabaria reinhardti*, characterized by the very thick extremity of its tail. The precise meaning of these engraved groups seems to be lost, and the Tusia say they do not know who made them.[36]

Some geometric engravings have also been recorded in the shelters of the cliff of Borodougou. These are fine incisions, among which there are compartmented rectangles and barbed signs or lizard shapes, the latter being similar to decorations in the region's millet granaries, made with rolls of earth about one to one-and-a-half inches (2–4 cm) wide, and in which the present-day Bobo see images of monitor lizards. The decorated caves of this cliff are considered by the Bobo to be the ancient dwelling-place of the population of bearded dwarfs that preceded the settlement of their own ancestors. These little men were equipped with wings that enabled them to fly from the cliff's caves to the backwaters where they went to draw water, which they then brought up in canaries placed between their wings.[37] Several signs engraved in the shape of an arrow, perhaps to be associated with those of Aribinda,[38] seem to have been made by those hunters of Borodougou who in the 1960s still frequented the sacred places where in the course of a propitiatory ceremony they marked the rock with an arrow before setting off to the hunt. The investigation by Jean Henninger (1960) into the meaning of the other signs yielded multiple interpretations, even a polysemy of signs. Hence, a simple rectangle divided into twelve equal compartments produced two readings: According to the son of a village chief, it was a plan of the universe, with each compartment representing an element (sky, earth, stars and planets, sun, moon, men, animals, plants, genies, cereals, ancestral souls, and waters); whereas according to another informant it was a lunar calendar. Similarly, an asterisk sign represents "the cardinal points from which good or bad fortune blow," according to one source; whereas for the other it is a representation of the settlement of the Bobo in the region. These multiple interpretations reveal the limits of an inquiry that seeks only to "translate" the signs without placing them in their context, and that bases itself on the reading proposed by one or two individuals, ignoring the actualization and new meanings of the ancient symbols. In the course of his detailed research into the engravings of Aribinda, Jean Rouch (1961) was only able to collect one tradition about them, which attributed them to the *pote sâmba*, or "men of before," skilful warriors who were supposed to have lived on the granite hillocks where these works are located. The fact that to obtain rain a cult is dedicated on one of these engraving-hillocks to the serpentiform genie *pella domfe*, seems to have no direct link with the rock images, which are made up of two groups: numerous pecked horsemen, a gazelle and a bird on the one hand, and on the other, incised lances with identifiable metal blades (*fig. 28*).

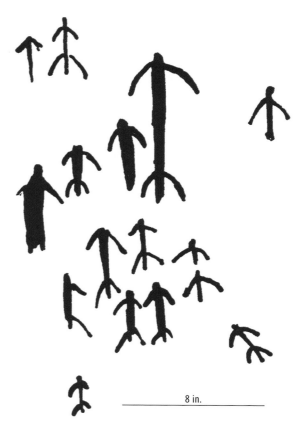

8 in.

Fig. 21

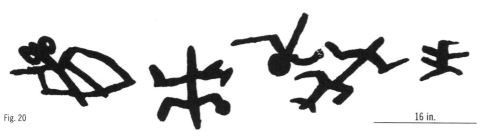

Fig. 20

16 in.

Fig. 20 - *Inne nyama bammi* ("painting of the *nyama* of man") made before 1937 at Bongo (Lower Sanga, Mali) to fix the *nyama* of war victims.

Fig. 21 - Group of people painted at Ouoro-Kourou near Kita (Mali).

Fig. 22 - People and geometric signs painted in the shelter of Modjodjé-Do in Mali's Dogon country. Until the final years of the twentieth century, these figures were regularly touched up by newly circumcised boys, but it seems their precise meaning was already lost.

Fig. 23 - Paintings in the shelter of Modjodjé-Do in Mali. They are made in red, white, and black, the colors most frequently used around the plateau of Bandiagara.

36 Bellin 1969–70. Trost 2000. 37 Henninger 1954, p. 97–9, and 1960, pl. I. 38 Urvoy 1941. Rouch 1961.

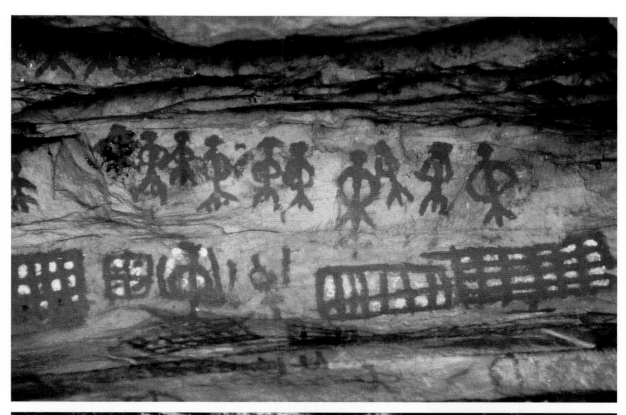

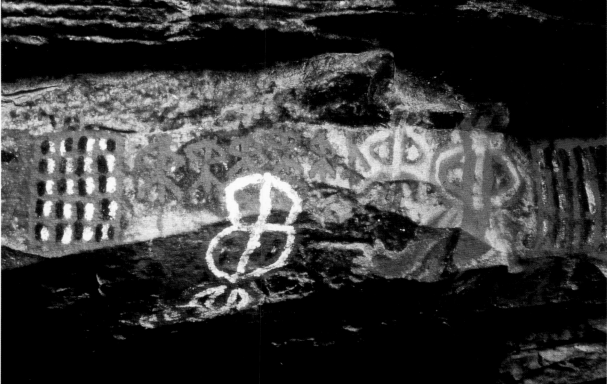

Fig. 22 and Fig. 23

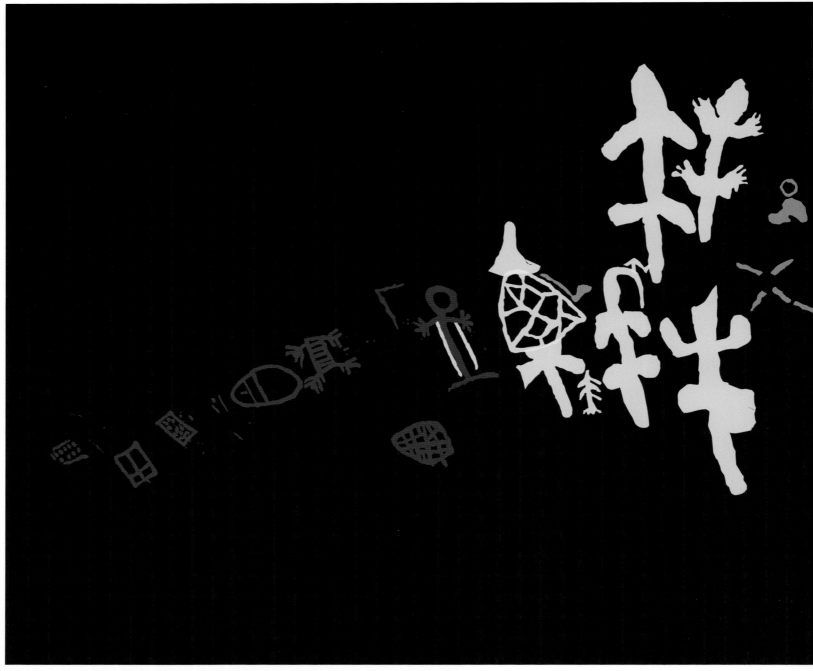

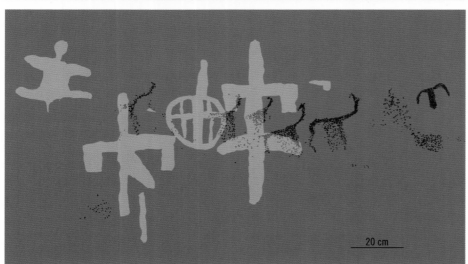

20 cm

Fig. 24

Fig. 24 - Rock paintings and engravings in the shelter of Fanfannyégèné (Mali). In black, pecked engraving that may depict giraffes and on the right a bucranium. These engravings are covered with paintings in which one can recognize a lizard form, a spread-eagled quadruped of the "bedside rug" type, and a geometric motif that recalls those which in Kenya have been plausibly interpreted as the depiction of the writing boards used in Koranic schools.

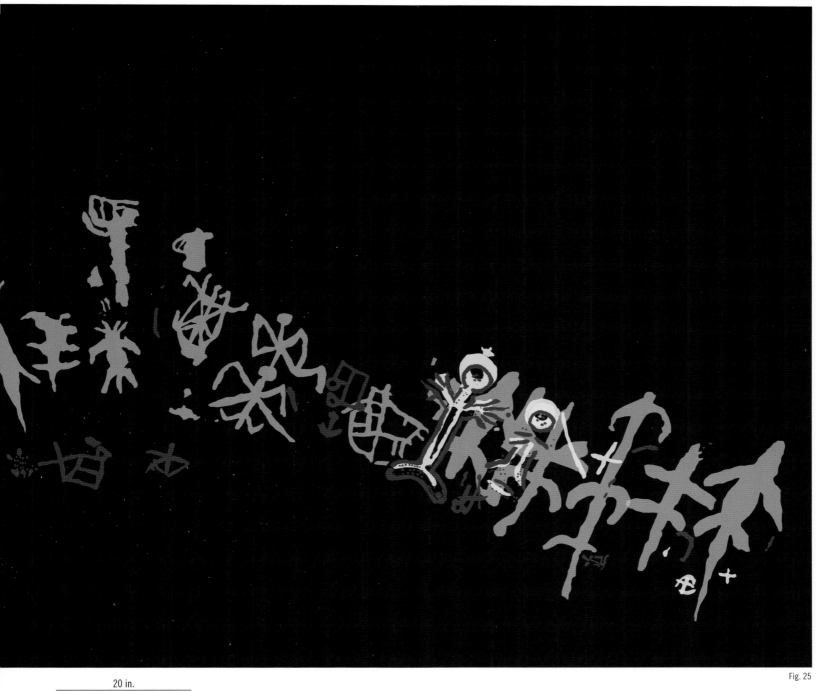

20 in.

Fig. 25

Fig. 25 - Rock paintings in the shelter of
Fanfannyégèné (Mali), whose superimpositions
contributed to the establishment of a regional
chronology.

In Nigeria: "Ceremony mountains," pictograms, and lithophones

In Nigeria, the rock paintings are often found next to lithophones, musical stones that are used as percussion instruments. This is the case in seven out of ten locations in Marghi country, and occurs systematically at Birnin Kudu—where the lithophones produce eleven different notes[39]—and likewise, to a lesser extent in the vicinity of the old city of Shira. Thus, in this latter, out of the six documented art sites (ten are known), only one is not associated with an instrument of this type. The link between rock art and music is also attested to by the name of one of these sites—Wurin Tambari, that is to say, "Place of the Drum"—where the neighborhood preserves an imprecise memory of ceremonies that took place, it is said, during the month of fasting. In the villages of Uvu and Womdi, James Vaughan (1962) studied the *mba* ceremonies, in the course of which boys and girls are promised to each other. The day before this rite, the boys, aged fourteen to seventeen, withdraw to the rock-shelters where the lithophones are located—this is the only time they are used—then, using a finger coated with a mixture of ocher and karite butter, they draw on the walls simple figures of weapons, shields, and pectiniform animals,[40] especially mounted horses. During the following week, the young couple is offered a ceremonial food made up of sesame seeds (with fertility value) that are ground in particular places on the mountain, where as a result of this activity, one finds mortars similar to those associated with certain rock art sites, such as Birnin Kudu. James Vaughan's investigation showed that within this context the role of the paintings is that of a signature attesting that the rite has been performed well. Long afterwards, the men can find the drawings that prove this rite of passage was performed correctly. Moreover, for some years now the custom has been evolving, and instead of making a drawing, the youngsters who are now literate have adopted the habit of writing their name accompanied by a date.

The association of rock paintings with lithophones is widespread in central Africa, and is found as far away as the island of Lolui, on Lake Victoria, where several of these instruments occur in the vicinity of red and white geometric paintings, mostly crosses, dots, concentric circles, and also a few positive hands.[41] The lithophones associated with the paintings are also linked with the female rituals that precede marriage at other Nigerian sites, such as Nok and Bokkos, and similar associations are known in the provinces of Sokoto, Zaria, Kano, Bauchi, and Bornu, and as far as northern Cameroon.

Some Nigerian painted sites bear a composite name (Mu Mba Muva, Mu Mba Zugubi, Mu Mba Fidgitem, Mu Mba Hudatau, Mu Mba Gubi, Mu Mba Diamu, etc.) indicating that these places were a theater of rituals, because these names are to be understood, in the language of the Marghi, as *mu* "mountain" [of the] *mba* "ceremony," this expression being followed by the name of the clan in question. At Uba, the creators of paintings that date back to the first half of the twentieth century were found and said that they had painted them during the *mba* ceremonies. The same applies to the region

<hr />

[39] Fagg 1957. [40] Extremely simple style, depicting quadrupeds in the form of a four-toothed comb.

[41] Jackson, Gartlan and Posnansky 1965.

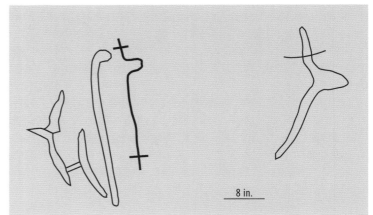

8 in.

8 in.

Fig. 26 and Fig. 27

Fig. 26 - Engravings made at the foot of the cliff of Bonfora (Burkina Faso) depicting throwing weapons still in use among the Tusia.

Fig. 27 - Engravings at Bonfora (Burkina Faso); one can recognize an anthropomorph and three snakes whose heads are well marked. This is probably the python or grass snake that is called *yonsín* or *yonsoho*, and still plays a role in local mythology.

Fig. 28 20 in.

of Hildi, specifically at Mu Mba Fidi Ngumi, where it is remembered that at least part of the paintings were produced during the initiation of about thirty boys. In the same region, the lithophone of Mu Mba Paragathla is only played in case of danger or at the end of an initiation (the last masculine initiation ceremony that took place in the decorated shelter dates back to April 15, 1980). A witness showed Hajara Njidda the painting he had made fifty-one years earlier (in 1943) in the shelter of Mu Mba Mukuvingyi Kyaapibi and explained that the initiated boys depicted themselves, while some added an image of their animals or their shield. Not far away, at Mu Mba Bula, a man called Bitrus was also able to identify his own painting, made at least twenty years earlier, which he described as the depiction of a four-roomed dwelling. Other images of this type were said to depict the house that the initiate planned to build after his marriage.[42]

The Nigerian graphic repertoire mostly consists of paintings of stick-figures and signs (crosses, "diabolo," compartmented squares and circles), but several sites contain animal depictions. That of Rumfar Kurosha comprises the image, repeated four times, of a cow without a hump and its calf (*fig. 30*, nos. 5 and 6), and other paintings of bovines without a hump occur at Birnin Kudu (State of Jigawa), as well as at Bauchi and Geji, respectively about 40 and 100 miles (65 and 160 km) from there. On the other hand, this type of bestiary is unknown in the graphic tradition of Marghi country, which is mostly geometric (although it also includes a small number of horsemen, comb-shaped quadrupeds, stick-figures, saurians or chelonians)—a tradition that extends for at least 250 miles (400 km) more to the east. The compartmented circles are locally interpreted as depictions of shields (*fig. 30*, no. 1), which could be linked with the phases of the *mba* rite during which the young initiates mark their passage by drawing weapons, and then use their shield as a percussion instrument to accompany the ritual songs. Certain other figures have been considered to be Koranic writing boards, although their internal divisions cannot always be explained this way

Fig. 28 - Engraving at Aribinda (Burkina Faso) depicting a very small human holding an enormous lance with a prominent metal blade.

Fig. 29 - Small human "footprints" on a rock outcrop at Fourougoula (Burkina Faso), where they are next to a circle and a throwing weapon. These are locally attributed to facetious mythical dwarfs who gave the whole region its name: *gbadegele handaha* "the desert of the imps."

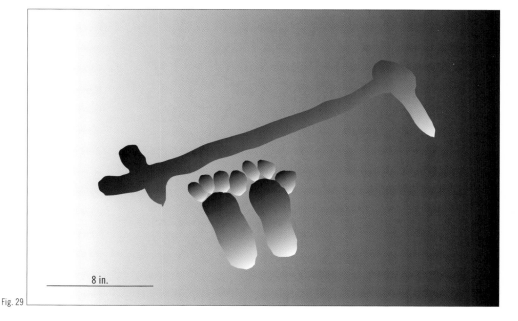

8 in.

Fig. 29

42 Njidda 1997, p. 91–3 and 98.

4 in.

Fig. 30

(fig. 30, nos. 7 and 8). If this interpretation were well founded, it would give us a good terminus post quem, making it possible to place the paintings after the arrival of Islam in the region, which the *Chronicle of Kano* dates to the mid-fourteenth century. For the moment, it has not been possible to establish a reliable succession of styles in Nigeria, although the depictions of bovines without a hump argue for certain animal figures being relatively ancient. One chief at Wamdeo who was consulted said that the crosses with equal branches *(fig. 30*, no. 2) were made by the boys to indicate that they had finished their *mba* initiation, but there is also a completely different type of cross which seems to testify to the Christianization of the region from the 1930s onward *(fig. 30*, no. 4).

In Marghi country, the paintings are made with *ghecidu*, a type of reddish clay found at the bottom of the river in the dry season. Once collected, it is cooked in a bowl (called *nki*) to brighten its color then mixed with karite butter. Since the clay (procured for the initiates by their mothers) is rare and thus expensive, in the poorest families it is replaced with charcoal or ashes, and the resulting paintings are then black. Hence the differences in color here are not related to chronology or symbolism but only to social status.[43]

An interesting case of giving new meaning to paintings concerns the hill of Dutzen Zane (a toponym meaning "painted rock," in Hawsa), near Geji, where a rock-shelter is today visited in the rainy season by Fulani herders who peck the paintings (a few anthropomorphous figures and especially antelopes made with ocher) to recuperate the pigment. When this pigment is ground and mixed with food for both humans and cattle, it ensures the fertility of the herd and the prosperity of the herders. When he passed through this place, Hamo Sassoon learned that certain Muslims of the region also mixed the powder from these paintings with the ink that they used to write on amulets. As for the villagers of Geji, they did not consider these paintings to have been made

Fig. 30 - Rock paintings of Nigeria recorded at Rumfar Kurosha (5 and 6: humpless cow and its calf) and in Marghi country (1: shield; 2: uninterpreted geometric signs; 4: Christian cross; 7 and 8: Koranic writing boards).

Fig. 31 - Engraved frontier-stone of Tsola-Ram on the plateau of Kangou at the limit of Fali and Lamidat country in northern Cameroon.

Fig. 31

43 *Ibid.*, p. 95–8.

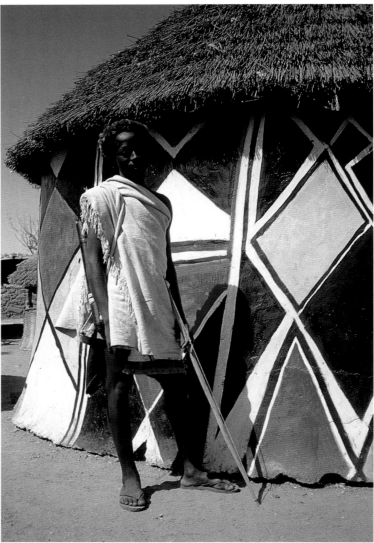

Fig. 32

Fig. 33

Fig. 32 - Decoration of a loincloth used as a coat of arms by the chief of the youngsters in the village of Puri (North Cameroon, 1961), and made up, like the frontier-stone of Kangou, of lozenges in a group of parallel lines.

Fig. 33 - Mural decoration in the hut of the *wuno* of Ngoutchoumi (North Cameron) in 1965.

by humans; in their eyes, they had emerged spontaneously from the rock, and if one obliterated them by pecking, they would reappear the following day.[44] Alas, the truth is quite different, and the use of the pigments in magic is so damaging for the paintings that out of the eleven depictions of antelopes (ten sable or roan antelopes and an oryx) identified by Sassoon in November 1957 only nine could be recorded about forty years later.[45] These practices provide supporting evidence for the mytheme—very widespread in sub-Saharan Africa—according to which the creators of rock art are seen as "people from before," endowed with great powers.

Fig. 34

Fig. 35

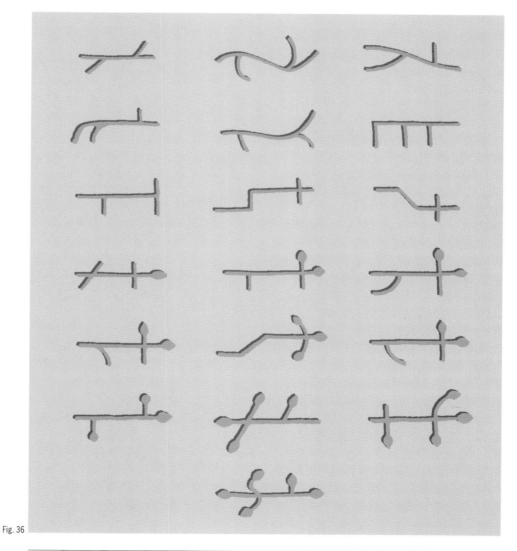

Fig. 36

Fig. 34 - Rock engraving in the region of Lovo (Lower Congo), evidence for the evangelization of the country.

Fig. 35 - Rock engraving in the region of Lovo showing a missionary holding his crucifix in his hand in an evangelizing gesture.

Fig. 36 - The different types of throwing knives common in the engravings of the Central African Republic.

44 Sassoon 1960, p. 70. 45 Mtaku 1997, p. 128.

Cameroon, Central African Republic, Congo, Gabon: Circles and lines, throwing knives, and chameleons

In northern Cameroon, no rock images are known south of the Adamawa plateau, which marks the limit between savannah and forest, and the site with engravings on marble slabs at Bidzar, near the frontier with Chad, has been destroyed to a large extent by the industrial exploitation of the rock. The graphic repertoire here consists of big circles, polygons, and simple or double lines (444 figures have been inventoried). The combinations used are limited to the accretion of small circles around big ones, with a concentric repetition of the procedure, the whole thing forming motifs that are sometimes joined together by lines.

The present-day inhabitants, descendants of Gidar groups (of the Chadic language) who arrived around 1700–1750 C.E., say that their ancestors found the engravings when they settled here, and do not lay claim to them.[46] The sandstone walls of the cave of Baitshi Manuy (Hosséré Béri, Tinguelin) are decorated with engraved networks that predate the arrival of the Fali, a group of the Niger-Kordofanian language who were established during the fifteenth to sixteenth centuries. All these figures are probably the work of Iron Age peoples, but their meaning remains obscure because it has not been possible to verify any of the hypotheses put forward about them (e.g., illustration of an emergence myth, cosmological depiction, or allusion to the funerary customs of the Kapsiki, whose graves are circular).[47] Other engraved

Fig. 38

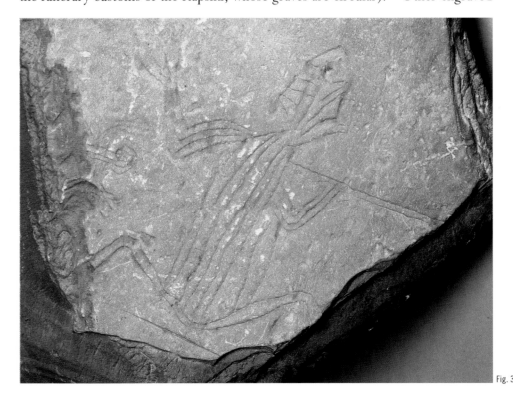

Fig. 37

[46] Marliac 1981, p. 117. [47] The thesis devoted to this site by Alain Marliac uses the concept of "mythogram" created by André Leroi-Gourhan (2003) who directed this research, but can only come to grief on the question of meaning.

Fig. 37 - Incised stone discovered in the bed of a tributary on the right bank of the Kwilu, about 47 miles (75 km) northeast of Matadi (Democratic Republic of Congo), representing enigmatic people in the form of batracians.

Fig. 38 - Rock engraving from Mount Gundu (Lower Congo) depicting an axe placed between two foot "prints," one of which has four toes.

Fig. 39

assemblages have been recorded in Fali country, on the sacred mountain of Béri, near Péné, in Kangou, and close to the remains of the village of Tsola-Ram. These are geometric drawings, especially grids, which the Fali attribute to the "Men without name." The decoration of the frontier-stone of Tsola-Ram (*fig. 31*), located at the boundary between the Fali and Lamidat (Fulani) lands, has been compared with that of men's loincloths, forming a kind of coat of arms peculiar to a clan, a lineage, or an individual (*fig. 32*), but in which the symbols have no fixed meaning: a simple circle can symbolize a woman, a hearth, a lineage, or a dance. These different meanings cannot be inferred from a mere examination of the images; their interpretation requires the support of oral tradition. The study of the mural paintings in present-day houses (*fig. 33*), which perpetuate the use of ancient codes, opens up some interesting perspectives, showing for example that the white dots scattered over the surface of depictions of wild game indicate that they are animals "of the night."[48]

In the north of the Central African Republic, there is a dominance of paintings in ocher, white, black, and red, mostly grouping dots and geometric motifs, anthropomorphs and animal figures. Whereas in the south one finds mostly engravings, often on slabs of laterite and forming geometric motifs, a few animal silhouettes (quadrupeds, birds), or depictions of metal weapons—mostly throwing knives of several dozen different types (*fig. 36*) but also a few lances with a triangular blade.[49] These latter assemblages make it possible to place most of the engravings of the Central African Republic in the late Iron Age (after 1000 C.E.). The paintings are probably more recent, as indicated by the presence of certain subjects (a plane was painted in white and ocher at Toulou), but also because the regional conditions make it impossible for them to be very ancient.[50] Although nothing certain is known about the meaning of these works, it is known that throwing knives were used in this country during ritual ceremonies, and that they were historically used as money among the Mangbetu.

In the Lower Congo, numerous rock images of Christian inspiration have been reported in the regions of Kinshasa-Matadi[51] and Lovo.[52] For example, along with enigmatic geometric figures (lines, circles, and grids), one can observe here depictions of objects (bows, arrows, and hoes) and rare animals (lizard shapes, antelope), a good number of Christian crosses (*fig. 34*) surrounded by people, some of whom are brandishing a crucifix in an evangelizing gesture, in assemblages that may date back to the sixteenth century (*fig. 35*). In the northeast of the country, the *manga*, or lateritic slab of the Limbuma plateau, which to the south borders the River Ango, has yielded a small series of rock engravings located near ancient iron deposits and mostly comprising throwing knives, lances with a metal blade, a footprint, and a four-spoked circle. In the course of his visit to the site, on August 8, 1959, Pierre Leroy, who was then

Fig. 39 - Another engraving found in the bed of a river close to Matadi (*cf.* fig. 37). One can recognize a human whose clothing is entirely striped with fine undulating lines.

48 Gauthier 1993. 49 Bayle des Hermens 1975, p. 265–77. 50 Clist 1991, p. 199–201. 51 Mortelmans and Monteyne 1961. 52 Raymaekers and Van Moorsel 1964. 53 Leroy 1961, p. 43 and photos 7–8.

governor of the eastern province, noticed "a small table for offerings on which they had placed provisions (manioc, maize, peanuts) to obtain rain."[53] Since the rock images are here considered, as often happens in Africa, to be the work of populations who preceded the present inhabitants without being related to them, one can recognize the motif of the "first men," former possessors of the land and lasting masters of the elements.

Other engravings of the same type (hoes, axes, throwing knives, footprints, cupules, lances with a metal blade) have been reported in the region of Uele, where the only image that has given rise to an interpretation by the present inhabitants is a kind of trident, considered (at least in the first half of the twentieth century) to be the depiction of a *ntuka* or altar of the ancestors similar to those then in use among the Azande.[54] Whether or not this reading is correct, it in any case integrates the rock art within the ritual universe, in the worldview of the local interpreters.

Among the engravings reported a long time ago, those recorded on Mount Gundu by A. de Calonne-Beaufaict associate axes with pairs of footprints, one of which has the particularity of lacking a toe (*fig. 38*). In this same region, the ancient Twa are considered to have been the first occupants of the land, and their bones were previously sought to serve as talisman—their fingers, in particular, were thrown into the fields to fertilize them. Is it possible that these engravings allude to a rite of this kind?[55] In view of the diversity of the motivations of the authors of graffiti—and as a contribution to the story of vandalism—let us recall that in 1877 the explorer Henry Mortimer Stanley, having discovered a decorated cave on the left bank of the River Congo near Stanley Falls, wrote in his journal: "A few natives had scrawled fantastic drawings, squares and cone shapes on the soft rock surface and following their example I wrote as high as I could the name of our expedition and the date of the discovery."[56]

The rock art of Gabon was only revealed to the public in 1987 by Richard Oslisly. It consists of engravings on outcrops of paragneiss, dating back to the dawn of the Christian era and left there by groups of metallurgists moving down the River Ogooué. A large part of the graphic repertoire—71 percent of which comprises simple circles, or circles arranged concentrically or in chains (*fig. 41*), sometimes with spirals and more rarely with "vulvar" marks (*fig. 42*), meanders or animal evocations (6.2 percent)— has analogues from Cameroon to Angola. It has therefore been suggested that these could well be marks left—often with metal burins—by the Bantu, "masters of iron," in the course of their expansion along the axis of the river. Moreover, at Elarmékora, some engravings evoke spearpoints, hatchets, and throwing knives whose shape recalls those used by the Kota and the Fang at the start of the twentieth century, while traces of sharpening have been detected at Kaya Kaya. Most of the engravings in the valley of the Ogooué probably date back to the Early Iron Age, dating from the fifth century B.C.E. to the seventeenth century C.E. Apart from the (very vague!) hypothesis of a "cosmogonic or even spiritual representation" and the claim that they have a "magico-mystical"[57] character, it has not been possible to put forward a convincing interpretation of these rock assemblages (which are unknown to the present-day local populations). Nevertheless the "vulvar" signs of Kaya Kaya have been compared with

[54] Van der Kerken 1942, p. 17–18. [55] Colette 1936, p. 1050.

[56] Stanley 1878, t. II, p. 242. [57] Oslisly and Peyrot 1993, pp. 25 and 90.

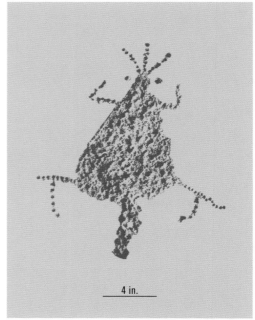

4 in.

Fig. 40

Fig. 40 - Animal engraving of Elarmékora in the valley of the Ogooué (Gabon). It could be a three-horned chameleon, judging by the two cup-marks that evoke this animal's exophthalmic look, the three lines representing its horns, its back legs ending in pincers, and its voluminous body ending in a very short tail.

Fig. 41 - Engravings at Kongo Boumba I in the valley of the Ogooué (Gabon). The lines, spirals and concentric circles (shown as lighter here) are partially obliterated by the more recent engravings "in a chain," which are shown as darker here.

Fig. 42 - "Vulvar" incisions of Kaya Kaya, in the valley of the Ogooué (Gabon).

Fig. 43 - Engraving of Elarmékora in the valley of the Ogooué (Gabon) representing a "spread-eagled" quadruped, of the "bedside rug" type.

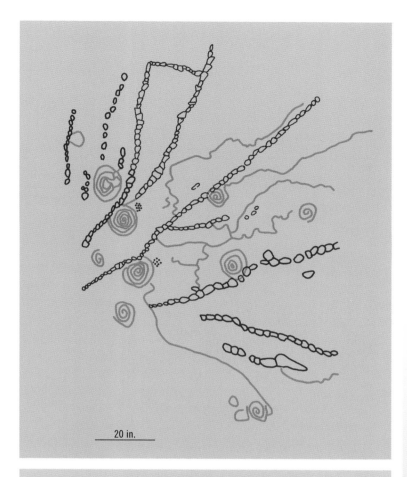

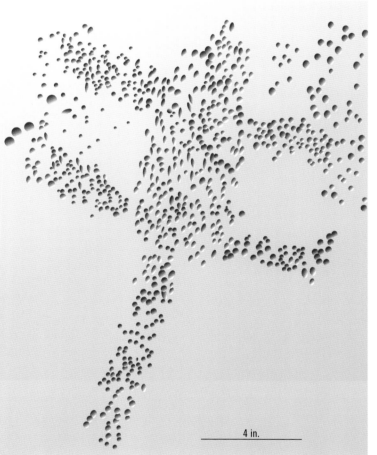

20 in.

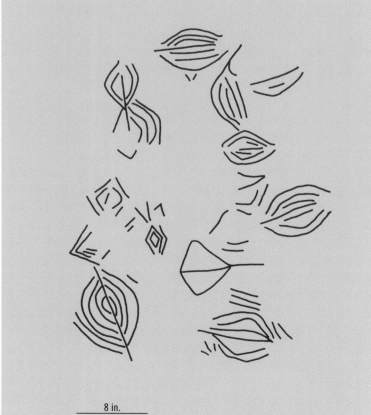

8 in.

Fig. 41 and Fig. 42

Fig. 43

4 in.

scarifications of a similar form made on the shoulders of the region's women to assist births. The "spread-eagled" figures of lizards or quadrupeds (*fig. 43*) at Elarmékora are of a type common to all the territories of central Africa, but one type peculiar to the Gabon is that of triangular animals seen from above (*fig. 40*), evoking the giant three-horned chameleon, *Chamæleo deremensis*, widespread from Cameroon to Tanzania, or other three-horned species such as *C. jacksonii* or *C. johnstonii*.

Democratic Republic of Congo (formerly Zaire), Angola: "Fetish stones," tattooed pebbles, sand images

In the Democratic Republic of Congo (formerly Zaire), the cave of Kiantapo (in the Kiluba tongue, *kya ntapo* means "the place where there are tattoos") located near Lubudi in the far southeast of the country, is decorated with a great quantity of incised or dotted engravings (the latter being made with a bow drill) that were first reported by Eugène Pittard (1935) and then the Abbé Breuil (1952). They are very simple anthropomorphs and zoomorphs (quadrupeds, birds, snakes, and perhaps fish) accompanied by a great number of geometric drawings (simple and multiple chevrons, circles and ovals that are barred or not, squares, triangles and rectangles, zigzags, scutiform motifs, arciforms and scalariforms, grids, spirals, "vulvar" signs, meanders [*fig. 44*]).

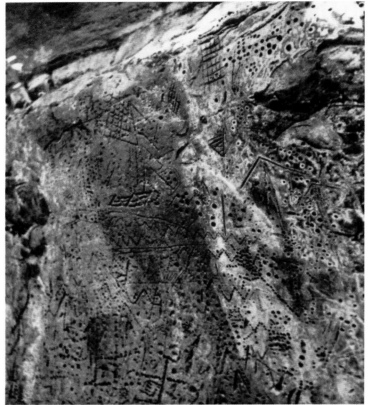

Fig. 44

One finds ornamentation of the same kind in the cave of Kiamakonde, a few miles north of the previous site, as well as on a slab at Kasaolwa, farther to the northwest. Here it seems possible to recognize some linear people amid an enigmatic tangle of lines on a surface sprinkled with dots. The incised hands and feet at Kaniembo are recent works by children from the village who amuse themselves by engraving the soft sandstone with a nail, and sometimes add their name. A few pale-red geometric paintings are known in a rock-shelter on Mount Kabwe, near Kala-Kalunga. Not far away, a sandstone block bearing engravings depicting tracks of the roan antelope (*pelembe*) and perhaps of felines, is locally called Wa Pelembe. P. Van den Brande, who first reported it, pointed out that this block "is a fetish venerated by the natives of the region."[58] Too often, alas, authors have contented themselves with providing laconic comments of this type without taking the trouble to teach us (and themselves) anything more.

In 1816, J. Tuckey, carrying out a reconnaissance on the Zaire River, noticed on its left bank a rock located in Angola (*fig. 45*) decorated with more than thirty modeled figures—zoomorphs, anthropomorphs, geometric shapes (*figs. 46* and *47*)—and for that reason was called (by the Portuguese) Pedra do Feitiço ("stone of the fetish"). The copies that we possess are the work of Lieutenant Hawkey who "could not learn from any inquiries he was able to make whether they had any connection with the religious notions of the people." Nevertheless, the commentary continues and reveals

58 Mortelmans 1952, p. 45.

Fig. 44 - Engravings in the cave of Kiantapo
in the Democratic Republic of Congo.

to us that this ornamentation was "the work of a learned priest of Nokki" and that "in several other places, figures of a similar kind were met with, cut into the face of the slaty rock, or into wood, or on the surface of gourds or pumpkins, most of which had something of the fetish or sacred character attached to them." As for the meaning of these drawings, the slightly more precise information provided by the expedition journal makes it possible to link them to local mythology, since it is noted that this rock was considered to be "the peculiar residence of Seembi, the spirit which presides over the river."[59]

At Pungo-a-Ndongo, another explorer, the Reverend David Livingstone, in 1854 mentioned some engravings depicting human and animal prints, locally interpreted as those of Queen Ginga or Jinga (1582–1663), who reigned over the Ngola and gave their name to the country. These prints, known as Pegadas de Rainha Jinga (*fig. 51*), were supposedly left by her as evidence of her exceptional power. Her exploits are still related today—it is said that she assassinated all her lovers after the first night—and near her "prints" there is an engraving interpreted as the trace of a dog that followed all this sovereign's movements. Queen Jinga is especially well known for having struggled against the Portuguese.[60]

Although rare and of unequal value, the available information on present-day perceptions of rock art in Angola indicates that some of these sites have an important place in local representations. At Caninguiri, a rock-shelter decorated with about eighty images and signs associated with almost two thousand dots is said to be defended by *najas* by day and by *ndala* or flying snakes by night.[61] In 1991, the rock engravings of Tchitundo-hulo—mostly concentric circles with meanders often linked together by lines—were explained to Manuel Gutierrez by the *soba* (traditional chief) of Virei, Iñacio Maceka, who said they dated back to before the settlement here of the Mukubal

Fig. 45 - General view of the Pedra do Feitiço ("Fetish Stone") noticed in Angola by J. Tuckey during an exploration on the Zaire river in 1816.

Following pages

Figs. 46 and 47 - Tracing by Lieutenant Hawkey of the figures decorating the Pedra do Feitiço, or "stone of the fetish" located on the left bank of the Zaire river.

Fig. 45

[59] Tuckey 1818, pp. 380–82. [60] Rudner and Rudner 1970, pp. 4–5. [61] Santos Júnior and Erdevosa 1971.

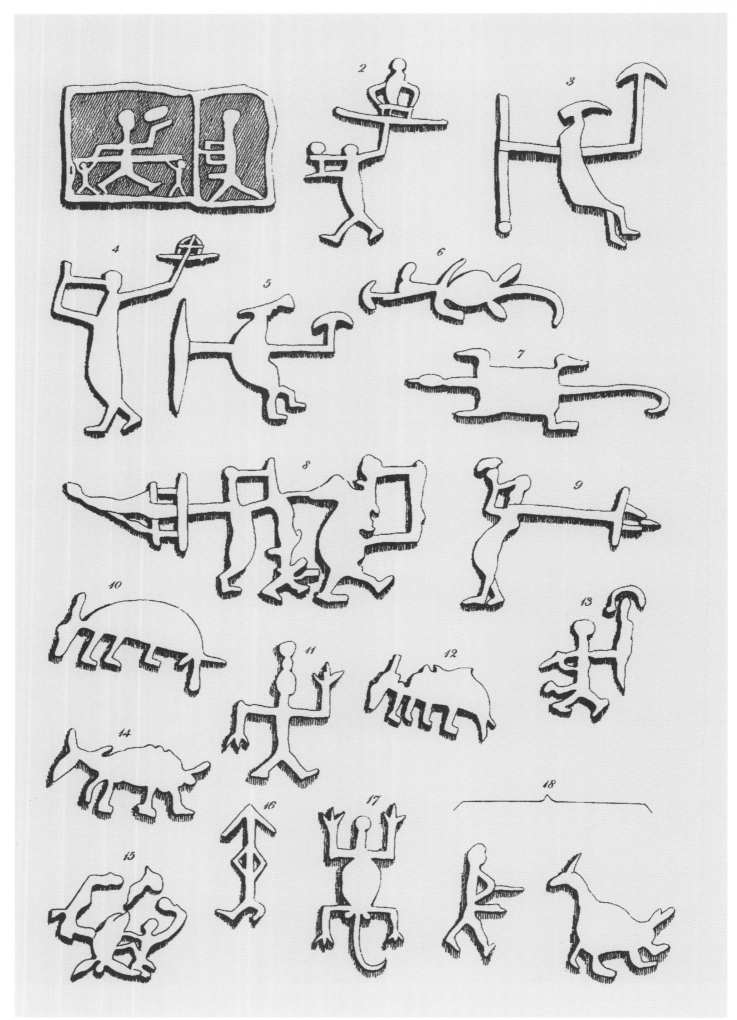

Fig. 46

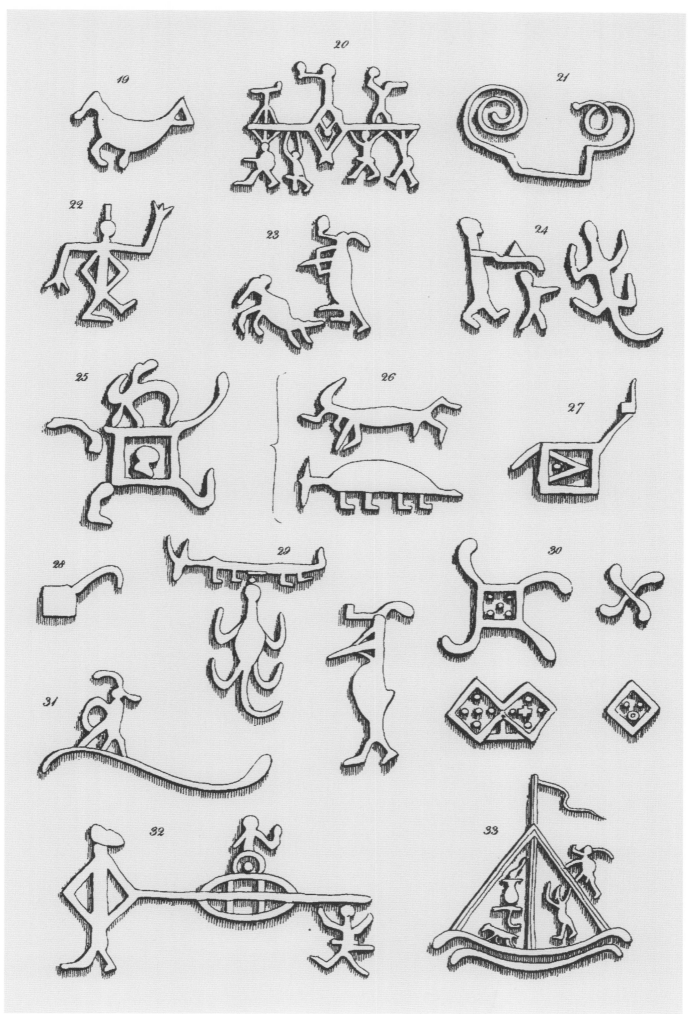

Fig. 47

(a Bantu group). According to the *soba*, when the Mukubal arrived in this unfamiliar region, they found their way around using these engravings as maps on which the circles were the villages linked together by lines indicating paths, while the serpentiform lines represented temporary streams:

> In ancient times, explained Iñacio Maceka, they were like maps, that is to say, people did not know [this] land, and it was said that there was water at such-and-such a place, and so a group of people was sent to see if there really was water there; and the people went, went, went to take water where it was [marked]. That was the deed [the action] of the map.[62]

This use of engravings as maps probably results from a new attribution of meaning, rather than reflecting any original significance, and yet it belongs to the group of traditions that treat rock-art signs as messages left by a mythical population for their successors, to transmit some superior knowledge to them. Tchitundo-hulo—meaning something like "Mountain of Heaven" or "Mound of the Souls"[63]—is a sacred mountain for the Kwadi (Khoisan neighbors of the Mukubal)[64] who even claim that whoever sets foot on it will be devoured by a lion.[65] So their ancestors could certainly have produced this rock art assemblage, but for reasons that have now been forgotten not only by the Kwadi but also the present-day Mukubal.

In the far east of the country, in Lunda territory, three assemblages of rock engravings have been described at Bambala (*fig. 48*), Capelo (*figs. 49* and *53*), and Calola, comprising meanders, lines, crosses, spoked circles, concentric circles sometimes joined by lines, and interlaced designs (at the first two sites only) always on horizontal slabs. Although the people of the region consider these images to be the product of divine actions, most of them are identical to Lunda tattoos, whose meaning is known (*fig. 50*). For example, the sign consisting of three circles joined together by double lines—found in both the engravings and tattoos—was read by the Lunda as depicting the daily journey of the sun (at dawn, midday, and sunset).[66] As for the meanders, they have been compared with drawings on sand made by the Lunda and their neighbors the Tchokwe (*figs. 52* and *53*). These drawings—called *tusona* (sing.: *kasona*) in the Ngangela languages of eastern Angola and *sona* (sing.: *lusona*) in Tchokwe—are a masculine activity connected with the institution of the *ndzango*, the circular pavilion for male assemblies. Sometimes they are painted on the walls of houses or granaries, but they are generally very ephemeral, and their author obliterates them as soon as they have been made and explained. Most of these drawings deal with important social institutions or represent elements associated with them. One of these figures (*fig. 54*), for example, is called *mukánda*, "the circumcision enclosure."[67] Another, named *zinkhata* and made up of two intersecting rings, is encountered in various ritual contexts among the Luchazi,

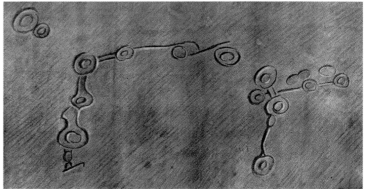

Fig. 48 and Fig. 49

Fig. 48 - Stamping of a group of engravings on a horizontal slab at Bambala in Angola.

Fig. 49 - Stamping of a group of engravings on a horizontal slab at Capelo in Angola.

[62] Gutierrez 1996, p. 284; and 1999, pp. 222–3. [63] Erdevosa 1980, p. 308–9. [64] *Cf.* Rudner and Rudner 1970, p. 5–6. [65] Wentzel 1961, p. 353. [66] Redinha 1948. [67] Kubik 1992.

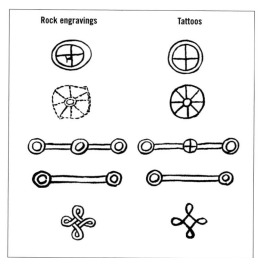

Fig. 50

the Lwena, and the Tchokwe (related populations). It appears that the petroglyphs of Lunda country and the world of the *tusona/sona* clearly belong to a single graphic tradition, whose area of distribution shows that it cannot be very ancient since it is identical among the Lunda and the Tchokwe (on whom the Lunda imposed their sovereignty in the seventeenth century), while remaining unknown among the other Bantu peoples of the region, notably the Luba to whom the Lunda are culturally indebted. So it is doubtless not older than the constitution of the ancient Lunda empire and could therefore date back to the start of the sixteenth century.

At Galanga, in the province of Huambo, there is a shelter decorated with more than a hundred paintings, known as Dj'ólè xilombo tchangôma or Dj'ólè xilombo quétângua, names in which *Dj'ólè* means "painting, painted thing," *tchangôma* means something like a "dancing place," and *quétângua* could be the name of a great war drum, which fits the local tradition that says this place was used to evoke the ancestors and to perform war dances before going off to combat. This does not mean that these engravings were not also reputedly a divine creation. One can observe people (including a man on horseback and groups of dancers), quadrupeds (some of which have a long tail and could depict canids), round-headed serpentiforms, lizard shapes (*fig. 56*), and geometric figures (arrows, rayed circles); everything painted in white and red. The excavations carried out at the foot of the decorated wall made it possible to obtain dates of 2600 ± 50 B.P. and 4115 ± 66 B.P., although it is not possible to relate the paintings to the material discovered.[68]

Mozambique, Malawi, Zambia: Ancestor cult and Nyau masquerades

Mozambique, located between Azania and southern Africa, is usually included in the latter region by geographers, but from the point of view of rock art it is a mixed zone. The first report of it dates back to 1771 and attributes to "Abyssinians" the same rock art signs that the defenders of a Mediterranean origin of the buildings of Zimbabwe would attribute to the Phoenicians at the beginning of the twentieth century. In this country, the first studies took place within the framework of what Robert Bednarik has denounced as "professional vandalism," as seen in the activities of German Captain J. Spring who, in 1909, explored the region of Tschikoloni (Chicolone) on behalf of the ethnologist P. Staudinger (1911). Spring sent the latter a few photos of this site's geometric paintings, explaining to his correspondent that:

4 in.

Fig. 51

> to be able to photograph this "inscription," he first had to wash the drawings of human and animal figures (perhaps the work of bushmen?) which were painted on the rock. . . . These drawings in the upper layer were easily washed, while others that were underneath remained indelible, because they must have been much older, and certainly the work of a totally different people.

Fig. 50 - Comparison between rock engravings and tattoos in Lunda country in Angola.

Fig. 51 - Footprint engraved at Pungo-a-Ndongo (Angola); locally, it is considered to be that of Queen Ginga or Jinga (1582–1663), sovereign of the Ngola who gave her name to the country.

68 Santos Júnior and Erdevosa 1978.

The map published by O.R. de Oliveira in 1971 indicates the existence of twenty-four rock art assemblages spread over the northern half of the country, where one finds all of the sites with geometric paintings (scalariforms, pectiniforms, circles, parallel and arborescent lines, grids, coupled lines, and groups of dots). Conversely, the shelters with so-called "naturalistic" paintings—because anthropomorphs (*fig. 2*) and animals (*fig. 57*) can be recognized in them—extend slightly into the center-west of the country (at Vumba, Navita, and Chimanimani).

All these assemblages are poorly documented, but some evidence from the first half of the twentieth century suggests that an in-depth investigation could provide useful information about the integration of rock images with present-day mythologies. Hence, the administrator Jaime Lino reported that the inhabitants of the Chauremba range on the left bank of the Luia considered the inscriptions to be the work of Mulungo, the supreme god, and placed offerings beside them—information which must be combined with the fact that among the geometric paintings of the shelter of Mount Churo one can observe several recent alphabetic inscriptions that include the word Mulungo. The site of Chifumbazi I, locally called Muala ulemba or "written stone," is considered in the region as a sanctuary for the ancestor cult, and the paintings that decorate it are understood to be *muzimbo*, or "souls of the dead." This also applies at another site, called Nicungo ("hole, shelter"), on a mountain whose name is a variant of that of the supreme god Molumbo. In this shelter, guarded by a big *mepôpo* snake, people come to evoke the soul of the dead by placing offerings of food and drink in terra-cotta vessels in honor of the spirits who would come and drink and eat.[69]

The data from Malawi are particularly interesting. In 1985, about sixty painted sites had been located on thirty-eight different hills, the greatest concentration being in the center of the country just north of Dedza (perhaps only due to the state of exploration). Two artistic groups were recognized: the white figures (*figs. 61*, left, 62 to 68, 72 and 73), among which one finds animals; and the red figures (*figs. 58, 60 and 61*, right), which are the most numerous and comprise geometric elements (parallel, usually vertical lines, concentric or rayed circles, empty ovals or ovals filled with vertical lines or grids, arches, loops and meanders, rows of dots, small lines, zigzag lines, scalariforms). The second group is the oldest, proved by recurrent superimpositions (at Mwana wa Chencherere, Namzeze, Ulazi, and Mikolongwe Hills) and the fact that the red paintings are often faded, whereas the white in a thick flatwash look much fresher, although they are in similar conditions of conservation (*figs. 61* and *62*). There are a few examples of paintings that

Fig. 53 and Fig. 54

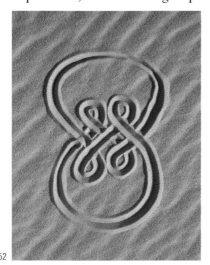

Fig. 52

[69] Santos Júnior 1952.

Fig. 52 - This geometric drawing is generally made on sand in Zambia, where it is called *liswa lyavandzili*, "the nest of the *ndzili* birds." The difficulties encountered in comparative studies of this type of drawing are illustrated by the fact that exactly the same drawing can be found around the second millennium B.C.E. on the walls of the ancient city of Mohenjo-Daro in Pakistan.

Fig. 53 - Rock engravings on horizontal slabs at Capelo (Angola). The motif in the foreground can also be found on the door of the *mukánda* circumcision enclosures where it is a magical device responsible for keeping away the lion-men, *vandumba zyavantu*.

Fig. 54 - *Tusona* or sand drawing made by men in eastern Angola.

Fig. 55

were subsequently engraved. Two occur at Bunda Hill, where red grids are marked with fine incisions filled with white material. In all other cases, the lines are generally as wide as a finger, and when they are thinner or thicker, it suggests the use of a tool.

The works are often found at some height, up to twenty feet (6 m) above the ground, which may be due to land erosion, but in several localities it is certain that scaffoldings were used. At Machemba the neighboring populations say that the painted symbols are the writing of God, but a recent Christian influence can sometimes be detected in these traditions—the site of Chigwenembe is reputed to have been inhabited by Adam and Eve. In other places it is said that the paintings were left by the Akafula or Twa, dwarfs who, according to the oral traditions, supposedly lived in Malawi before the Bantu migrations. It is supposed that they were hunter-gatherers who subsequently fled Malawi ahead of the arriving Chewa, or that they were progressively absorbed by the populations of farmers and disappeared by the mid-nineteenth century. The populations of Zambia attribute to them the rock paintings of Njazi and of the island of Kilwa in Lake Mweru, and indeed small skeletons have been discovered at Mount Hora in the shelter of Fingira and at Mwana wa Chencherere. Whatever the status of these remains, the vast distribution of red geometric signs (e.g., in Malawi, Mozambique, Zambia, and the Democratic Republic of Congo) suggests possible communications over large regions, which tally well with the movements of hunter-gatherers or of migrating peoples. It has been said that the meaning of the most visible paintings could simply be an affirmation of their authors' passage, but this "we've been here" theory cannot explain why thousands of little white dots were often placed on the red lines (by other artists perhaps?), nor why the images were sometimes made so high on the walls without any of these actions enhancing their visibility.

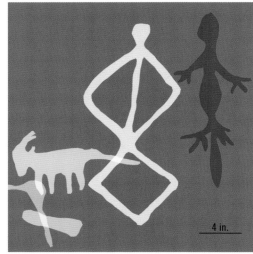

Fig. 57

Fig. 56

Fig. 56 - Panel in the region of Vumba (Mozambique), in which one can recognize the head of an antelope and some more recent people.

Fig. 57 - Rock painting in the shelter of Galanga with, from left to right, a horned quadruped, an anthropomorph, and a lizard-form (Angola).

Preceding page
Fig. 55 - Mural painting done on the interior clay wall of a Tchokwe dwelling (Angola). The upper frieze represents a rain dance; the dot above the head of the central figure indicates that he is the most important. The anthropomorph in red dots is Samuangi, male genie of the forests. The two arciform protuberances are his hips used by this giant to uproot trees, and indeed two fallen trunks lie at his feet. According to the author of this painting, the geometric motif at the bottom left is this genie's home. Once again, even in the case of the simplest anthropomorphs, it is impossible to guess the meaning of the figures without the help of the traditions reported by their authors.

Fig. 58 and Fig. 59

Elements for dating are rare and require confirmation. In the shelter of Chifubwa Stream (Zambia), a series of arches that were engraved and then painted red and black was partially covered by a layer of sand under which pieces of charcoal were found that were dated to 4000 B.C.E. In the shelter of Fingira on the plateau of Nyika, the paintings were made after the first millennium B.C.E.—the date when a big block fell down, exposing a surface that was subsequently painted. At Nakapapula (Zambia) it was possible to advance a date later than 800 C.E. for red geometric paintings on the eastern bank of the Luangwa because a block fell against the wall in the second half of the first millennium C.E. and the paintings were made around but not beneath it.[70] Finally, the amino acid method showed that schematic red paintings on Mounts Nunda and Namzeze, in the region of Dedza, were later than 200 C.E.

The clear break between the assemblage of recent white paintings and that of the older red paintings could indicate the arrival of a new group of people in Malawi. As there is no visible stylistic evolution nor common theme from one artistic "school" to the other, a comparison with historical data makes it possible to envisage two possibilities. Either the red paintings are the work of the pre-Bantu Twa/Akafula, whereas the white ones are attributable to the Chewa, who arrived in Malawi at the start of the second millennium C.E.; or the red drawings are the work of the first Chewa (of the Banda clan), and the white images were made by the more recent Chewa Maravi who began to settle in the country around the fifteenth century. The fact that the present-day Chewa know nothing about the red paintings, together with the vast distribution of the latter (indicating hunter-gatherers rather than farmers) make the first hypothesis more probable.

Oral traditions collected by W.H.J. Rangeley, J.-M. Schoffeleers, and N.E. Lindgren reveal the animosity of the Chewa toward the native Twa, and report numerous battles (at Mounts Chomo and Bembwe, at Mandawi, Nsadzu, and Mankhamba) between these two groups, but very few social relations between them. In the (probable) event of a temporary partial overlapping between the "school" of the most recent red paintings and that of the oldest white paintings, the big difference between the two styles could testify to this kind of social distance between the two societies to which the painters belonged.

In order to interpret the group of red paintings, it has been supposed that the vertical lines (*fig. 60*) could represent rain, as could a series of dots "falling" from oval signs that may depict clouds. It has been observed that the lines are often drawn in fours, but rather than seeing any great symbolism in this number, one must recognize the fact that they were made with four fingers. In support of the interpretation of these paintings within the framework of rain rites is the fact that close to Gwanda (Zimbabwe) such rites involve the stoning of rock paintings, and that red paintings were similarly stoned at Katolola in Zambia (*fig. 75*). As it is highly improbable

Fig. 58 - Red painting at Namzeze (Malawi) with concentric circles and vertical lines of unknown meaning.

Fig. 59 - Example of geometric paintings of Malawi, here at Mkuzi.

[70] Phillipson 1972.

that the authors of paintings stoned their own works, it would seem that this magical procedure should rather be considered as an example of the process, widespread in Africa, by which immigrants oppose a native population and end up supplanting them, while still believing them to have a powerful mastery over the elements and the soil.

With only a very few exceptions, the white paintings are mostly grouped in the region to the north of Dedza (shelters of Mwana wa Chencherere, Chibenthu, Namzeze, Chongoni, Ulazi, Bunda, Mtusi, Mphunzi, and Chigwenembe Hills). For the most part they are zoomorphs, most often with four, six, or eight limbs spread-eagled "like a bedside rug" (*fig. 64*), sometimes ending in three digits (*fig. 63*). Black finger marks the size of a thumbprint occasionally occur on their head (Chigwenembe), along their trunk (Mwana wa Chencherere), or over their whole body (Mphunzi). In many cases, their head has three protuberances, and their trunk seems swollen, but it can also be reduced to a line. At Chongoni there are a few animals seen in profile, alas partly obliterated, and displaying tails that extend in an arched shape, like that of a baboon. Other types are rarer: serpentiforms at Chongoni, Chibenthu, and Mtusi Hill, a possible scorpion in a shelter at Mphunzi, and wading birds at Namzeze (*figs. 61* and *72*). Some very comparable white paintings are also to be found in Zambia (*figs. 77* and *78*) and in the district of Iramba in Tanzania,[71] but those of the surrounding countries (Mozambique, Zimbabwe, Swaziland, Botswana) seem to belong to a different tradition. At a very few sites, such as Mwana wa Chencherere, Chongoni, and Miklongwe Hill, one can also see geometric signs painted in white (rows and columns of dots, finger marks forming a Maltese cross, rayed or dotted circles, a horizontal *S*, concentric arcs, indented arch, and *X* signs with the center missing).

It is certain that some white paintings were still being made in the first half of the twentieth century in a small region to the north of Dedza and in the Eastern Province of Zambia, in the course of the activities of the Nyau society, a male association of the Chewa, Nyanja, and Mang'anja. Among these images one can observe a zebu (*figs. 65* and *66*), several antelopes with an indented back (*figs. 65* to *68*), birds (*figs. 61* and *72*), a snake, and even an automobile (*figs. 65* to *68*).

All these paintings are clearly related to the Nyau cult, known in the central part of Malawi and in certain places in the south (the region between Chileka, Mwanza, Chikwawa, and Chiromo), as well as in the Eastern Province of Zambia and in that of Tete in Mozambique, east of the River Luangwa. Nyau is the name of a society of dancers who mostly appear at the end of funerary rites (about a year after the deceased's passing) and during initiation ceremonies (*figs. 69* to *71*). During these festivities, the nocturnal apparitions of masked people are very diversified, but are mostly characterized by the wearing of structures of plaited plants, known as *nyau yolemba* and comprising numerous different models: *mkhango* (the lion), *fisi* (hyena), *fulu* (tortoise), *nswala* (impala), *ng'ombe* (cow), *kasiya maliro* (eland nicknamed "he who abandons the dead" and thought to capture the spirits of the deceased), *kacala* (the fingers, which represents a sorcerer with a cone-shaped body, using his long fingers to dig into tombs to eat the flesh of his victims), and even *galimoto* (the automobile).

71 Odner 1971, fig. 18.

16 in.

Fig. 60

Fig. 60 - Red painting at Mwanambavi Hill near Mzimba (Malawi). Its upper part has been freely interpreted by a few commentators as an image of a pregnant woman, but nothing can confirm this reading.

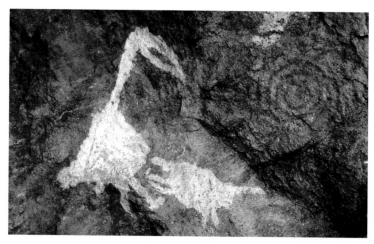

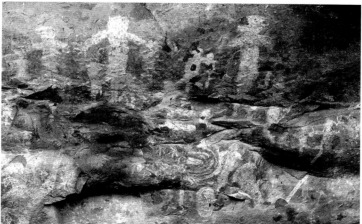

Fig. 61 and Fig. 62

During the night of the funerary ceremonies, *kasiya maliro* ("the eland") is led to the deceased's house where he captures the *ciwanda* ("the wandering spirit") of the dead person. He does not emerge until dawn, when he returns to the bush where he is immediately burned so that the *ciwanda* disappears with the smoke, enabling him to become an ancestral spirit (*mzimu*). The ritual processions involving these funerary structures correspond to the following myth collected by Kenji Yoshida in the mid-1980s:

> God (or the Creator, Mlengi) originally created humans and animals. Humans and animals therefore lived happily together in the very old days. Even when humans got hungry, they only had to look up in the sky and say "*Shomo mlengi*" (God have mercy) and animals would die of their own accord and provide meat. However, because humans started feeling jealous of one another and began using sorcery, God became angry and separated animals from humans. Since then, it has become necessary for humans to chase and hunt animals when they get hungry. Animals, on the other hand, started running away from humans, and if they encountered humans by chance, they began hurting them or causing them illness. But even today, during the *bona* rite, that is when the deceased return to God, animals remember the old days and come back to the village. Then they cry for the deceased together with humans.[72]

All the *nyau yolemba* structures represent dead people who come back amid the living, and though the myth makes it possible to understand why they represent wild animals suffering from nostalgia for the olden days, it is somewhat astonishing to find a domestic cow and an automobile among them. While the automobile is obviously a recent introduction, the same applies to the cow, since Ngoni herders only brought cattle to the Chewa at the end of the nineteenth century. These two elements, which were not originally part of Chewa culture, thus arrived from the "exterior," symbolized by the bush in this culture, and that is why they are placed in same category as the wild animals, and also why they appear among the *nyau yolemba* processional structures. This also applies to the masks of Europeans, which sometimes appear to lead the *galimotoqui* structure (*fig. 71*). Far from indicating some kind of dissolution of Chewa culture, these recent introductions instead attests to its its vitality and its capacity to evolve.

The comparison of the above-mentioned white paintings—with the form of the *nyau yolemba* that depict animals and which most often display a characteristic indentation of the dorsal line (*figs. 65 to 68*)—explains why the animals are painted with this indentation and especially without legs. It is because these are not real animals, but processional structures. This also explains the image of the automobile, which likewise does not

Fig. 61 - Detail of the wall at Namzeze (Malawi) where one can clearly observe the difference in conservation between the animal paintings in thick white flatwash and the geometric paintings in red. The particular shape of the beak of this wading bird indicates that it is a member of the Openbill species (*Anastomus lamelligerus*).

Fig. 62 - Painted wall at Mwana wa Chencherere (Malawi) with faded red geometric paintings and others, more recent, in white flatwash.

[72] Yoshida 1993, p. 42.

correspond to a real vehicle but rather to the last of these structures to appear (*figs. 67, 68,* and *71*). Since these objects are sacred and thought not to be fabricated by human hands but to have descended from the air or emerged spontaneously from waterholes or rivers, they are made and kept in places forbidden to the uninitiated, especially in cemeteries or in rock-shelters where members of the Nyau societies hold their meetings.

This Nyau cult, whose origin is disputed but which nevertheless is strongly linked to Chewa identity, already existed before the formation of the Maravi Empire in the sixteenth century. Certain myths suggest that the Nyau society and the rain cults were originally one and the same institution and that their separation came about only after an unfortunate incident in which a dozen young female initiates were drowned in a water source (or crushed under a rock) as they were taking their ceremonial bath.[73] From this arose a very strict taboo: the Nyau dances are forbidden in the neighborhood of the rain altars, and those who officiate at the rain cults must not take part in the Nyau dances, nor even see their plant structures or their masks. From this one can deduce that since the white paintings are motifs linked to recent Nyau societies, they cannot have been associated with rain cults, contrary to what one might suppose about the red paintings. And if the myths that mention an ancient association of the Nyau cults and the rain rituals specify that girls took part in them, this may be because they have preserved the memory of an association of these rain ceremonies with female initiation, as is still the case among certain present-day San, and it seems was generally the case in the past. So one cannot rule out the possibility that the red paintings, which are clearly older than the white, could perhaps have been made in the course of female initiations and/or rain rites, maybe by the predecessors of the Chewa, that is to say the Twa, and thus before the sixteenth century.[74]

Fig. 64

The most recent Nyau images, dating back to the 1970s, are charcoal graffiti made by adolescents who sometimes signed these figures by juxtaposing their name, for example on the wall of a dwelling and on the walls of shelters in the district of Dedza. These drawings thus represent the *kasiya maliro* structure, which plays a preponderant role in male initiation and hence is one of the most secret ceremonies. One of these graffiti even shows, through its transparency, that a person is working this structure from inside, thus betraying an essential secret of the Nyau society to the great displeasure of the elders of the region, and doubtless as an act of adolescent rebellion against traditional values.[75] It so happens that the most common subject in the paintings is

Fig. 63

8 in.

Fig. 63 - White painting at Mtusi Hill (Malawi) depicting an animal with a bloated stomach, perhaps a three-horned chameleon.

Fig. 64 - White painting at Mwana wa Chencherere (Malawi) depicting an animal of the "bedside rug" type, perhaps a three-horned chameleon.

Fig. 65 - White painting in a shelter at Namzeze (Malawi) showing a procession of the Nyau society. The human is being followed by a zebu and an antelope drawn without legs, since they depict plant structures worn by the officiants. Moreover, the antelope displays a dorsal indentation that is not natural but typical of these structures.

Fig. 66 - Tracing of the previous photo.

[73] Rangeley 1952, p. 34. [74] Lindgren and Schoffeleers 1985. [75] Smith 2001, p. 196.

Fig. 65 and Fig. 66

4 in.

also the *kasiya maliro* structure, but the location of these works is very different, far from public places, in shelters both secluded and difficult to reach. The use of pigments requires some preparation and not just a simple piece of charcoal indicating that these are carefully considered productions; and the existence of these images astonishes the present-day inhabitants, who can barely understand the point of depicting the masks this way, since the ceremony involves the use of their real models. Moreover, the Nyau rites as practiced today do not involve the production of paintings, so the latter seem to contradict the ethnographic data. D. W. Phillipson observed some time ago that in the Chewa zones of Zambia similar images had been laid out in towns during the 1960s, on bus shelters, in bar toilets, and on house walls; eminently public places contrary to what might be expected from the ritual usage of the symbols of a so-called "secret" association. An investigation by Benjamin W. Smith has made it possible to solve this apparent contradiction. Before Zambia's independence (in 1964), the Nyau cult had been prohibited by the colonial government, and these images thus corresponded to acts of resistance and of asserting identity. The fact that before this prohibition similar images were produced in isolated rock-shelters has been explained in a similar way: the Nyau cult was then being fought both by western missionaries and by the Ngoni invaders, an Nguni subgroup that came to settle in Zambia and Malawi in the 1840s and 1850s. The repression of the Nyau was then very violent, and mask-wearers were even executed by the Ngoni. So the cult could only survive by taking refuge in caves where the graphic depiction of the masks temporarily replaced their real usage, since their fabrication had become impossible.[76]

Having identified the authors of a certain number of white paintings as members of the Nyau society, it is tempting to try to attribute other kinds of characteristic works, such as the lizard-shaped figures with outspread limbs of the "bedside rug" type, sometimes considered to be anthropomorphs and sometimes spread-eagled zoomorphic figures. These beings are quite varied in their corpulence—some are more or less slender (*figs. 62* and *64*), others are bloated (*fig. 63*)—in the number of their limbs (four, six, or eight, or even more), and in the presence or absence of protuberances on the head. But a preliminary comparison can be made with the images drawn on the ground with clay or flour in the course of *yao* initiation

Fig. 68

Fig. 67

4 in.

[76] Smith 2001. [77] Yoshida 1993, pp. 43–4.

Fig. 67 - Tracing of the following photo.

Fig. 68 - On this white painting in the same shelter at Namzeze (Malawi), the incongruous image of an automobile followed by a person between two antelopes can be explained when one realizes that it is in fact a ritual outing of the Nyau society, whose members intervene during funerary ceremonies, hiding beneath plant structures, including *kasiya maliro* ("the eland") and *galimoto* ("the automobile"), in which the deceased is supposed to come back among the living, if he was a driver.

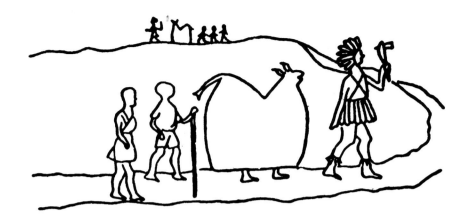

Fig. 69

Fig. 70

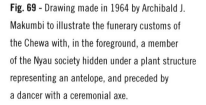

Fig. 69 - Drawing made in 1964 by Archibald J. Makumbi to illustrate the funerary customs of the Chewa with, in the foreground, a member of the Nyau society hidden under a plant structure representing an antelope, and preceded by a dancer with a ceremonial axe.

Fig. 70 - Drawing by Archibald J. Makumbi that depicts the plant structure representing the antelope worn during the processions of the Nyau society.

Fig. 71 - Another drawing by Archibald J. Makumbi showing an example of the *galimoto* processional structure led here by a mask of a European. This document shows that this type of evolution was already underway in the 1960s.

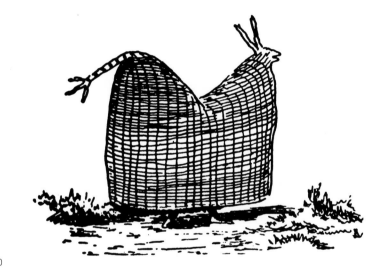

Fig. 71

ceremonies observed by G. M. Sanderson (1955), which include two mythical animals seen from above with similarly spread-eagled limbs on both sides of the body: *ngwena* (crocodile) and *nangungunmi* ("aquatic Mother of all men").

Until the 1940s, comparable images that also depict reptiles were modeled in clay on the ground by Chewa women on the occasion of the initiation of young girls, and their dotted decoration (in red, white, and black) was said to reproduce the skin of the python, considered to be a messenger (*wamthenga*) of the creator (*mlengi* or *cauta*), which brought the rain and ensured the fertility of the earth and the fecundity of women.[77] These comparisons do not relate to identification, but they do show that in all forms of regional art only reptiles are depicted from above, while all the other animals are shown in profile, both among the Yao and among the Chewa. Moreover, the presence of supernumerary legs leads one to consider these images as mythical beings; in the case of those that have a voluminous body and three protuberances on the head, if they are indeed reptiles, then their natural reference can only be the three-horned chameleon. The chameleon plays a crucial role in the Chewa creation myths; the first living being to be created, it was attracted by the fruits of a tree on which it gorged itself so much it swelled up and fell from the branches onto a rock where its stomach burst from the impact. From this emerged the first human couple and all the other animals, thus peopling the earth.[78] Apart from the fact that certain species of chameleons living in the region today display characteristics (e.g., big stomach, three horns) that correspond to what can be seen in the paintings, the mythical function of this animal in Chewa anthropogony would fully justify its evocation during initiation rites, but this is merely a hypothesis requiring confirmation.

Fig. 73

In Zambia, engravings, which are rarer than paintings, are particularly concentrated in the south of the provinces of Lusaka and in the center of the country, in the northwest around Solwezi and Mwinilunga, and in the valleys of the Luapula and the Zambezi.

Fig. 72

They are mostly geometric figures, but in the district of Lusaka one can also see outlines of hoes and axes comparable to the implements used in the region during the eighteenth and nineteenth centuries (*fig.* 77). Some rare painted engravings have been observed at Chifubwa Stream, in the district of Solwezi. Totally absent in the western part of the country, paintings are only present at a single site (Sikaunda), in the southern province where the rocks are generally friable or fragmented. Elsewhere they are found almost everywhere the surfaces permit (more than 700 sites were inventoried in 1997 in the district of Kasama alone).

In this vast assemblage, it has been possible to recognize four artistic traditions or stylistic schools. In the red animal style—ubiquitous but particularly well

Fig. 72 - White paintings at Namzeze in Malawi.

Fig. 73 - White painting at Namzeze (Malawi). The divisions inside this quadruped could indicate that it is a plant structure and not a real animal.

[78] Lindgren and Schoffeleers 1985, p. 44.

Fig. 74

4 in.

represented around Kasama—people are rare, and numerous images are covered with rows of dots from which they cannot be separated. The bestiary, in outlines or monochrome flatwash, comprises numerous species: elephant, rhinoceros, giraffe, buffalo, lion, hyena, leopard, and ostrich—but the antelope (eland, kudu) is the painters' favorite subject. The red geometric style, which is most commonly represented, is found everywhere at hundreds of sites. Its repertoire includes circles (simple, concentric, spoked, divided), scalariform signs, linear drawings, and groups of finger marks (*figs. 74* and *75*). The fact that some of these motifs are sometimes filled with white flatwash suggests that this tradition was initially bichrome, and that the white color, which is more fragile than the red, has most often disappeared. Comparable schematic paintings are found in southern and western Tanzania, eastern Angola, Malawi, and northern Mozambique, as well as in Zimbabwe and South Africa, where they have barely attracted the attention of researchers who are more attracted by "beautiful" images or those that appear a priori more "meaningful."

The tradition of the white "spread-eagled" (bedside rug) figures (comparable to those of Malawi and Tanzania) peculiar to the Eastern Province mostly presents animals of variable forms seen from above, often reaching a few feet (1 m) in length, and regularly accompanied by serpentiforms and circles, the whole thing rendered in very thick white paint, rarely outlined in red (*figs. 77* and *78*). Finally, the graphic repertoire of the tradition of white zoomorphs, likewise restricted to the Eastern Province, is made up of images of animals and people drawn by spreading the white paint with the finger and sometimes, in the most recent productions, by using charcoal. This tradition extends into Malawi and Mozambique, and the entire assemblage of white paintings seems to be linked to the arrival of Bantu farmers.[79]

Fig. 74 - Red geometric painting at Nachifuku in Zambia.

Fig. 75 - Red geometric paintings at Katolola in Zambia. Some of them have been interpreted as symbols of the rain (dotted vertical lines) falling from the clouds (elongated striped zones). This reading would be unconfirmed were it not for the fact that the painting displays the very clear marks of an ancient stoning, which occurs during rain rites.

Fig. 75

20 in.

[79] Smith 1997, p. 25.

In the shelter of Nakapapula, it has been possible to establish that the "red geometrics" that mostly cover the walls were drawn in the second half of the first millennium C.E. Farther north, the cave of Nsalu presents the biggest assemblage in the country, with geometric figures covering an area of about 1,000 square feet (100 m²). The oldest drawings here were made with a dry crayon of yellow-chestnut brown pigment. Grids, parallel lines, scalariforms, concentric circles, and elongated loops, all of them painted in yellow, seem to be contemporaneous, or more recent, but are obliterated by parallel finger tracings, grids, and red loops. Next there come bichrome drawings in red and white in which the most common motifs consist of two parallel white lines, with red filling the space between them, and white concentric circles with internal spokes whose interstices are also filled with red. Finally, the freshest paintings were made with a thick gray or off-white paint used to draw spoked circles, anthropomorphs, and also what resemble spread-eagled animal hides, of the

Fig. 76 - Painting at Katolola located not far from the previous examples. One can recognize an eland in a style that is closer to those of southern Africa and partially obliterating older geometric figures.

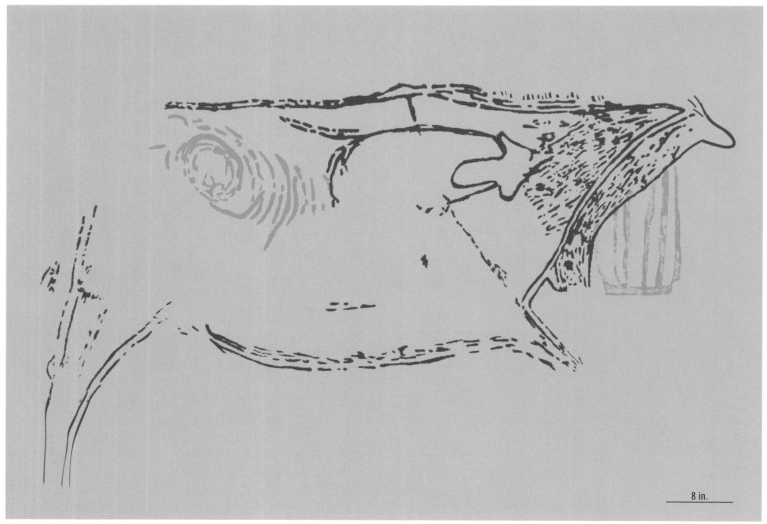

8 in.

Fig. 76

80 *Ibid.*, p. 17 and 48.

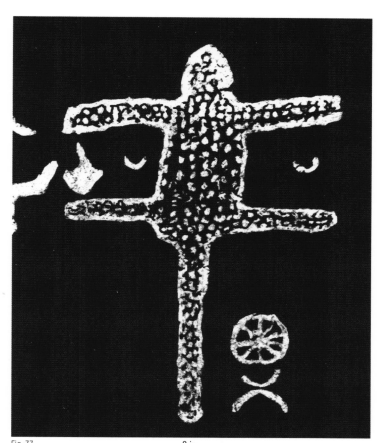

Fig. 77 8 in.

Fig. 77 - White painting at Chaingo, north of the district of Katete, in Zambia. To the left of the animal of "bedside rug" type there is the image of a metal hoe similar to those used in the region, which makes it possible to get a chronological fix on the assemblage.

"bedside rug" type. The cave of Nsalu thus confirms that the thick white drawings correspond to the last stage of the painting sequence attributable to the Chewa-Nyanja. The study of the superimpositions observed at other sites made it possible to demonstrate that where they exist the white paintings are always more recent than the red. Although one cannot separate the two styles of red paintings chronologically any more than the two styles of white paintings, the fact that they are always spatially distinct from each other suggests that they correspond to different traditions that are not peculiar to two neighboring ethnic groups but rather associated with specifically male and female rituals.[80]

Among the images that authors consider "naturalistic," one recognizable sub-assemblage is formed by the mammals in the "Nachitalo style;" animals in purple flatwash that can exceed a few feet (1 m) in length and are characterized by an elongated body with a rounded belly, a quasi-absent head, and limbs and tail reduced to stumps. Some have seen these as the depiction of pregnant females, perhaps to force the fecundity of the domestic animals. At the eponymous site of Nachitalo Hill, discovered in 1912 by J.E. Stephenson in the far west of the district of Mkushi, there are a dozen paintings of this type but they are pretty rare elsewhere.

A painted site at Katolola displays a remarkable eland, drawn in a fine purple line with legs that are too small but in which the animal's coat and characteristic dewlap are easily recognizable (*fig. 76*). This is one of the rare examples of superimposition in which a "naturalistic" engraving obliterates a schematic grid whereas the opposite is generally the case, a fact that could be explained by the simultaneous local presence of two groups of painters: the authors of the "naturalistic" representations (generally from the Late Stone Age) and those of the geometric drawings (of the Iron Age).

Where the images are relatively recent, ethnographic data can shed some light on them. This is the case with red motifs at Katolola (*fig. 75*), where vertical lines of dots that seem to "fall" from a scalariform motif have been compared with rain falling from a cloud.[81] This interpretation would have little value if it were not coupled with a concordant observation—the whole painted surface is covered with marks caused by a stoning that is quite ancient, as is shown by the patina of the points of impact. At the site of Gwanda, in neighboring Zimbabwe, throwing stones at rock paintings is an integral part of rain rituals.[82] This fact thus supports the hypothetical reading that was proposed. Besides, a fair number of Zambia's white paintings that depict animals without legs and often with an indented dorsal line are linked to the activities of the Nyau societies, as in Malawi.

Although the inhabitants confess total ignorance concerning the origin of the red schematic paintings, merely saying that "they have always been there," or that they are the work of spirits,[83] there is evidence that they were still being given attention very recently. J.H. Chaplin (1962) points out that during his visit to the rock art sites of

81 Phillipson 1972*a* and 1972*b*. 82 Cooke 1963. 83 Smith 1997, p. 30. 84 Phillipson 1972*a* and 1972*b*.

Sakwe in 1958 he noticed one of the paintings had been very recently retouched with clay. Later observations revealed that some of the Sakwe paintings had been scraped. It was then reported that this had been done by people seeking raw materials for traditional medications. Moreover, in the northern province, certain shelters with walls decorated with rock paintings are today considered sacred.[84] The red paintings, earlier than the white, can be attributed to populations of Twa hunters who were present here before the arrival of the ancestors of the Chewa, and who, according to legend, were bearded troglodytic dwarfs believed to have great power over rainfall. Besides, Chewa traditions collected in eastern Zambia and in Malawi declare that the Chewa rain rituals were inherited from the Twa, an affirmation confirmed by the ethnologists who discovered that the Chewa "altars" used at Kapirintiwa, M'bona, and Khope Hill to induce rainfall were located on ancient Twa sites.[85]

At Thandwe (between Chipata and Katete), bichrome zoomorphic paintings have been obliterated by a series of white paintings, particularly depictions of hoes and what seem to be vessels for grain. At the same site one also finds a large animal of the "bedside rug" type, with no outline, slightly erased, and partially obliterated by a series of drawings in a lighter white whose circular motifs together with a depiction of an automobile indicate the very recent age of this last stratum (*fig. 78*). The people of the region say that these images have a sexual meaning, and that they were made within the context of puberty ceremonies of Nsenga girls, which always include the production on the ground of very similar drawings, usually with gruel.[86]

The so-called theme of the "leopard," which also occurs at Chaingo (north of the district of Katete), was called thus by authors because it evokes the spreading out of the spotted hide of a feline, but in fact it may have nothing to do with this animal. J.H. Chaplin (1962) and R. Athrope (1962) pointed out the close resemblance between these paintings (*figs. 77* and *78*) and the spotted genet figures used by girls during puberty ceremonies in Nsenga and Petauke country. It has been possible to find other parallels between the zoomorphic paintings and the images used for the *inyago* (male initiation) of the Yao of Malawi.[87] The hypothesis that the white animal figures of the "bedside rug" type were made by women during the *chinamwali* initiatory ceremony—organized when girls reach puberty or when a woman is pregnant for the first time—seems to be confirmed by the fact that the rock-shelters where these images occur are today used as *tsimba* ("places of retreat or teaching") for the *chinamwali* ceremonies.[88]

Throughout the world, geometric "signs" and drawings, being so elementary, either "resist" interpretation, or give rise—depending on the current fad—to uncontrollable readings (astral, calendrical, shamanic, etc). Already in 1910, regarding newly discovered rock paintings in the vicinity of Bamako, J.-P. Lafitte issued a warning to F. de Zeltner, who was seeking analogies for them in the

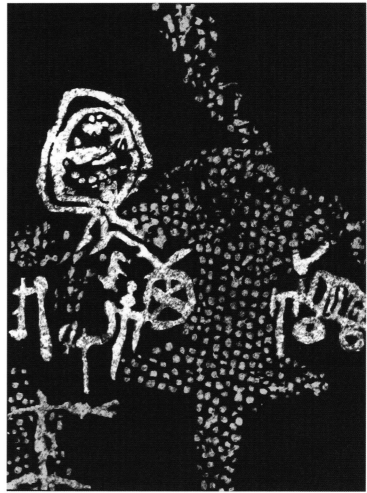

<div style="text-align:right">8 in. Fig. 78</div>

Fig. 78 - White paintings at Thandwe, in the district of Katete in Zambia. The animal of the "bedside rug" type made with finger markings is the oldest, being partially obliterated by lighter motifs, including the image of an automobile.

[85] Smith 1997, p. 44. [86] Athrope 1962. [87] Stannus 1922. Stannus and Davey 1913. [88] Smith 1997, p. 26.

Franco-Cantabrian domain: "These resemblances are undeniable but one should not let oneself be hypnotized by them. There are other resemblances in these pictographs which cannot be called 'universal.'" That is, the universality in question was in no way archetypal or genetic, but simply inevitable when one is dealing with signs of the simplest sort decorating a two-dimensional surface. And Lafitte's conclusion is thus still highly pertinent: "These considerations must make one extremely skeptical of excessively facile hypotheses about the origin or borrowings of the signs one observes. And if one is not careful, one can easily get carried away, as has already occurred, and seek the source of the rock engravings of New Caledonia in Brittany."[89]

Fig. 79

Fig. 79 - Rock engravings of geometric motifs in the vicinity of the stream of Munwa, in the district of Kawambwa in Zambia. Motifs in the geometric drawings painted and pecked on horizontal slabs: grids, scalariforms, loops, circles with complex subdivisions; everything totally patinated and very eroded. These signs have been linked to the *butwa* cult, a religious organization of which little is known, but were supposedly borrowed from an earlier population by the people of the end of the Iron Age.

[89] Lafitte 1910, p. 86.

Azania

"Ka' araa né esiso;
Hos'aà di'na handikatsho?"

"It is said, they were really there;
Look! Did they not write on the rocks?"

—Told to Eric Ten Raa by the Sandawe, concerning the legendary N/íni dwarfs,
considered the authors of the region's rock art

Fig. 1 and Fig. 2

"Azania" is the name given in Antiquity to the eastern regions of Africa, from the Ethiopian coast (now Eritrea, Djibouti, and Somalia) to present-day Tanzania, and it has been preserved as the title of the journal of the British Institute of History and Archaeology of East Africa. So this is a practical name by which to designate the area made up of the "Horn" of Africa (Ethiopia, Eritrea, Djibouti, and Somalia) and the countries surrounding Lake Victoria (Kenya, Tanzania, and Uganda).

The first paintings in the Horn were reported in 1929 by the adventurer and author Henri de Monfreid and the paleontologist (and Jesuit theologian) Pierre Teilhard de Chardin. While exploring the Harar, they dug a test pit in the so-called Cave of the Porcupine (*fig. 3*), where they noticed figures painted in red, yellow, and black, and alerted the archaeologist Abbé Breuil, who went there to make a partial tracing with the help of his disciple, the prehistorian Paul Wernert. These were mostly very simple depictions of bovids and enigmatic signs (*figs. 4* and *5*), and probably also people (*fig. 6*). The whole assemblage is currently very difficult to recognize because of water flow and smoke-black (since this cave like many others in the region, was, until very recently, used as a shelter by people who lit fires in it).

In 1923, Dr. Czakanowski, an ethnologist on the Duke of Mecklenberg's scientific expedition to Tanzania, published copies of stylized human figures painted in red that were discovered in 1908 by missionaries working at Buanja, near Bukoba, on the western bank of Lake Nyanza. These were the first rock art figures ever reported in East Africa.[1] The same year, the English explorer Bagshawe published the first article on the rock paintings to the west of Lake Eyasi, notably the human figures of Kondoa Irangi and an apparently pregnant female eland, painted at Kisana, which all seemed to him to bear a great resemblance to images that south of the Zambezi are attributed to the San. In 1929, the anthropologist T.A.M. Nash discovered other paintings close to Kondoa:

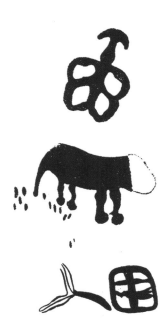

Fig. 4

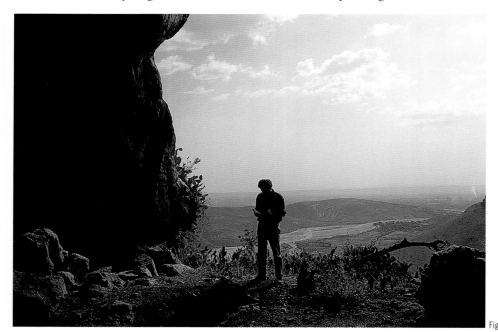

Fig. 3

Fig. 3 - The landscape visible from Porcupine Cave in Harar (Ethiopia).

Fig. 4 - One of the tracings made by Abbé Breuil in Porcupine Cave (see fig. 5).

Preceding pages

Fig. 1 - Detail of the paintings at Pahi (Kondoa, Tanzania) showing a person close to the "Kolo style" (see fig. 8) that has been nicknamed "the flute player" although it is in no way certain that it is performing any kind of musical activity.

Fig. 2 - General view of the site of Chabbè (Ethiopia).

[1] Leakey 1983.

an elephant followed by a human figure, two giraffes, and a possible quadruped that according to the author was hit by bolas.

A great number of other decorated shelters have since been reported in the region. In 1931, near Dodoma, A.T. Culwick noticed paintings that R.D.H. Arundell (1936) was to study in more detail later. In the same period, Culwick also tells us that in the vicinity of Ilongero there is a hill that the people of the region were careful not to climb as it was reputed to be the residence of a malevolent spirit whose name is unknown—since Culwick unfortunately translated its local designation simply as "devil." Having nevertheless scaled this hill, he discovered halfway up a shelter of more than sixty-five feet by ten feet (20 m by 3 m) entirely covered with paintings, the existence of which was totally unknown to the inhabitants. These were mostly animals—predominantly antelope, then also giraffes, with a few other species represented by a single example: a feline (leopard?), a hyena (?), an elephant drawn on its back, a "tree with long roots," and also what seemed to him to be a trap. The only thing the inhabitants knew about this spot was that certain Masai were in the habit of coming there to make sacrifices.[2] In the course of an expedition carried out from 1934 to 1936, a couple of German explorers, Ludwig and Margit Kohl-Larsen, subsequently inventoried a great number of sites in the vicinity of Kondoa and published tracings of them.[3] In the 1940s, the sociologist Henry Fosbrooke and his wife, who were living at Kondoa, also undertook a systematic recording of the sites in the vicinity,[4] and a few rock-art layouts were also documented by P.M.H. Fozzard.[5]

The whole of the region was meticulously explored by the Leakey family, who in 1935, 1947, and at the beginning of the 1950s, inventoried more than 180 sites; several hundred others have been discovered since then. Louis and Mary Leakey proposed a classification of the images in some nineteen styles, but today it appears that

Fig. 5

Fig. 6

Fig. 5 - Photo showing the present state of the paintings traced by Abbé Breuil in Porcupine Cave (see fig. 4).

Fig. 6 - Schematic filiform person painted in Porcupine Cave. The *ard* that he is holding in his hand (and which resembles those still used today in the region) is in a brighter red, which probably indicates an addition made at a later date.

[2] Culwick 1931b, p. 445. [3] Kohl-Larsen 1938 and 1958. [4] Fosbrooke 1950. Fosbrooke, Ginner and Leakey 1950.
[5] Fozzard 1959.

most of these were very badly defined, and hence of very little use. In his thesis on the prehistory of central Tanzania, Fidelis Taliwawa Masao retains only four of them ("stylized representations," "naturalistic representations," "semi-naturalistic silhouettes in white," and "abstract and geometric figures"), while regretting that the observable superimpositions are not sufficient to organize them chronologically. And yet the depictions of humped bovines cannot have preceded the introduction of these animals into the zone, and it is certain that the white geometric figures of the style called "white Bantu" are among the most recent, as is also the case in central Africa.

The rock art of eastern Africa can be characterized in three ways: (1) engravings are rarer than paintings; (2) monochrome images dominate, with bichrome ones being the next most common (although the range of paints included several colors, in particular red, but also black, white, and yellow, and less frequently chestnut brown, grey, orange, and violet); and (3) the works often consist of apparently isolated figures, rarely organized into coherent scenes or friezes. A style peculiar to Tanzania coined by Mary Leakey as the "streaky style," it consists of anthropomorphs or animals (and a hand) represented by a simple outline and a finely streaked "endoperigraphic" surface (*figs. 7, 9, 10,* and *14*). Another remarkable style is the one called "Kolo," from the site of the same name. It is characterized by very long people painted in red with a streaky or gridded body (which links them to "streaky style" animals) and an often filiform head with an imposing hairstyle that can be made up of parallel curved lines (*fig. 9,* right), an oval or bilobed blob, in flatwash or streaky (*figs. 1* and *12,* right), or concentric circles (*fig. 8*)—all images that often give the impression of depicting plaits. The sexual characteristics of the human figures are almost never indicated, and clothes (a kind of kaross, loincloths, false tails) are rare, which makes interpretation even more difficult. There are archers, but they are very rarely involved in hunting scenes. Certain anthropomorphs with an elongated object at their mouths have been uncertainly interpreted as being musicians (*fig. 1*), but several others are wearing long masks of fibers,[6] which proves that certain paintings at least must depict rituals (*fig. 11*).

A few images might represent plants (*fig. 13*), the Borassus palm and Euphorbia candelabrum, a theme rarely included in rock art apart from sites in Zimbabwe. All the images called "symbols" remain even more enigmatic: concentric circles (*figs. 9* and *12*), rayed or not (which have inevitably been seen as "solar symbols"), and lines of dots or dashes, which have been seen as counting systems (e.g., *fig. 34,* above and below).

All these discoveries were made in Tanzania; there were no published findings in Kenya before 1946, when Joy Adamson reported the engravings at the water source of Surima. Fifteen years later, Richard Wright (1961) published

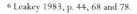

Fig. 7

Fig. 8

Fig. 7 - Detail of the ceiling of Pahi 27 (Kondoa, Tanzania) showing a series of wading birds in the "streaky style."

Fig. 8 - People in the "Kolo style" with heads made of concentric circles, recorded in the Kondoa region in Tanzania.

6 Leakey 1983, p. 44, 68 and 78.

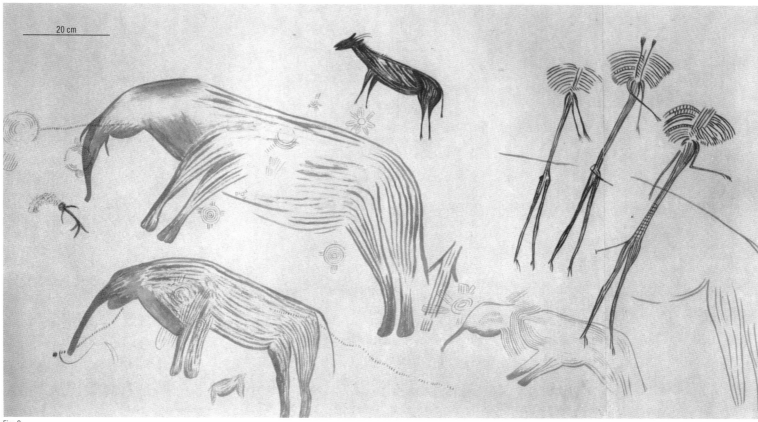

20 cm

Fig. 9

Fig. 9 - Painted panel at Kolo (Kondoa, Tanzania), comprising notably three elephants, an antelope, and three people whose hairstyle, slender fingers, false tail and very elongated body with vertical stripes are typical of the "Kolo style." Several concentric circles with or without spokes are also visible, but their faded color suggests that they are older.

Fig. 10 - Tracing of paintings discovered at Pahi (Kondoa, Tanzania) by Mary Leakey. There are several figures in the "streaky style" here.

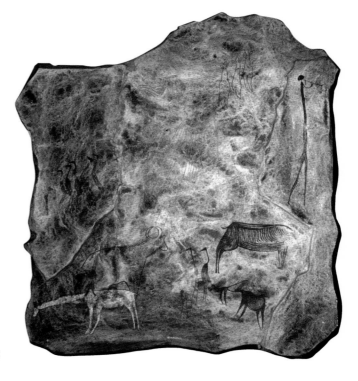

Fig. 10

the paintings of a shelter ("Tweedie's shelter") on Mount Elgon that recall those of the so-called Ethiopian-Arabian style at Laga Oda and Genda-Biftu in Ethiopia. In 1968 Robert Soper reported the engravings of Porr Hill, but it was necessary to await the works of Osaga Odak to have an idea of the distribution of this country's rock images. This art predominantly consists of geometric forms (scalariform and claviform signs, meanders, circles—often concentric or spoked—and spirals), and in the 1970s nearly all of these drawings (154 out of 160) were still recognized by the Turkana as being their "property signs."[7] One can also observe assemblages of cupules (isolated, in twos, in lines or in circles) that are far from all being interpretable as tables for the game of *bao*, a type of regional mankala. On Mount Pare, in the region of Kilimanjaro, some of these cupules had been used as mortars for fragmenting iron coins,[8] but they cannot all be explained in this way. As for the stellar interpretation that is sometimes put forward for other cupule sites, it has never been supported by any convincing arguments.[9] The anthropomorphs are linear and the fauna, depicted very simply, include elephants, rhinoceroses, giraffes, oryx and/or gazelles, and ostriches—and these too are often linear, being pecked or painted in red, black, yellow, or white, sometimes with bichrome elements.

Boophilia in the kingdom of coffee

In Sidamo (Ethiopia), a particular school of engravings, called Chabbè-Galma, was first identified in the 1960s at the site of Chabbè (also called Mancheti), where there is a remarkable series of humpless bovines depicted in false relief[10] (*figs. 15* to *19*), and then at that of Galma or Anchimaltcho Kinjo (*fig. 20*), which contains images that are comparable in style and technique.[11] One can also compare them with the engravings discovered since then in Wolayta (shelter of Akirsa and Azga Rock). These engraved images have been linked with paintings in the shelter of Laga Oda (*figs. 22* to *24*, *26* and *27*) to form a style called "Ethiopian-Arabian,"[12] although they differ from them in a number of ways. But despite their variety, the paintings and engravings all indicate a marked interest in bovines, dating since before the introduction of the zebu; in this regard, the hypertrophy of the udders on the engraved cows is all the more remarkable because most of the sites are at the edge of rivers, in steep places that no bovine could ever reach. The extolling of udders, and hence of cows (to the detriment of bulls), is an interesting cultural trait that, though far from universal among herders,

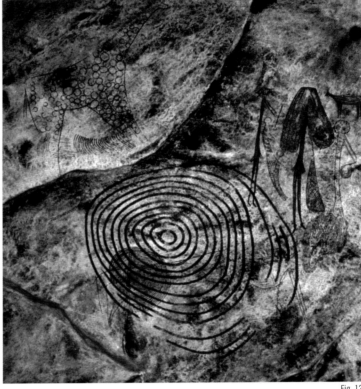

Fig. 12

Fig. 11 - Painting at Kinyasi 14 (east of Kolo, in the Kondoa region, Tanzania) showing a person apparently wearing a fiber mask.

Fig. 12 - Partial view of the paintings at Kisese 2, the biggest shelter in the Kondoa region (Tanzania). One can see a giraffe with circles indicating the patches on its hide, four people two of whom are in "Kolo style" and two who are certainly women (indication of breasts) as well as about fifteen concentric circles drawn with the finger. Twenty-nine others, much finer, were later added to the previous ones.

Fig. 11

7 Lynch and Robbins 1977. 8 Fosbrooke 1954. 9 Odak 1992*b* and 1992*c*. 10 Anfray 1967.
11 Anfray 1976. Joussaume, Barbier and Gutherz 1994. 12 Cervicek 1971.

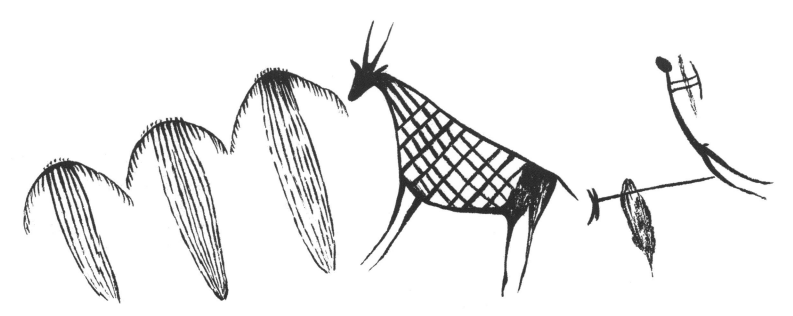

Fig. 13

Fig. 14

Fig. 13 - Painting at Chora I (north of Kondoa, in Tanzania) showing an antelope with a reticulated body, facing three motifs that are most often interpreted as plants. An archer stands on the right.

Fig. 14 - Elephant in "streaky style" painted in the Singida region in Tanzania.

is found, for example, among the present-day Hima of Tanzania, who attach far less importance to their bulls than to their cows, and only give honorary names to the cows, not to the bulls.[13] The "boophilia" ("love of bovines"), displayed in various pictorial styles (*figs. 27, 31*, and *32*), is confirmed in recently discovered engravings of the same school, for example at Soka Dibitcha (*fig. 21*), at Godana Kinjo (*fig.25*), at Ejerssa Gara Mallo (*fig. 28*), and at Laga Harro.[14]

The latter site, located only 330 yards (300 m) north of Chabbè / Mancheti, comprises an isolated rock bearing engravings of two bovines, one of which seems to be mounting the other, although one cannot definitely call it a coitus; an anthropomorph holding a lance with an apparently metal blade; and a *jäbäna* (the Amharic name for the "coffee pot" of recognizable shape that is currently used in the country) next to six cups in two rows (*fig. 29*). The anthropomorph and the coffee pot accompanied by its cups have no known point of comparison at present, but the coffee pot brings some precious chronological information—the word *jäbäna*, which designates an object associated with the preparation of coffee by decoction, is of Arabic origin, like this object itself as well as the preparation it makes possible. The study of the travelers' texts of the nineteenth and twentieth centuries, and that of the history of coffee consumption in Ethiopia,[15] shows that this type of object, whose distribution is linked to Amhara influence, could certainly not have appeared in the region that interests us before the twentieth century, since the Arabic way of drinking coffee, which was originally reserved for rich townspeople, only spread outside the capital after the 1920s and especially the 1930s.

Certainly, it may be that the engravings of the two bovines and the lancer that accompany the *jäbäna* of Laga Harro are not all by the same hand; but nothing from a technical or stylistic point of view allows us to claim that the realization of these images would have stretched over a long period of time. The most important point is that the engraved *jäbäna* is evidence for a tradition that was still current in the region only a few decades ago. So it is urgent to carry out some inquiries about this. While the triple theme of this block certainly corresponds with intentions both recent and coherent, a question arises about its interpretation: what link could exist among the Guji (who populate the region) between coffee, bovines, and lancer? Since the lance is a war weapon, the answer doubtless lies in the rituals of the Guji warriors, which would be

13 Chaplin 1974, p. 38. 14 Le Quellec and Abegaz 2001. 15 Pankhurst 1997.

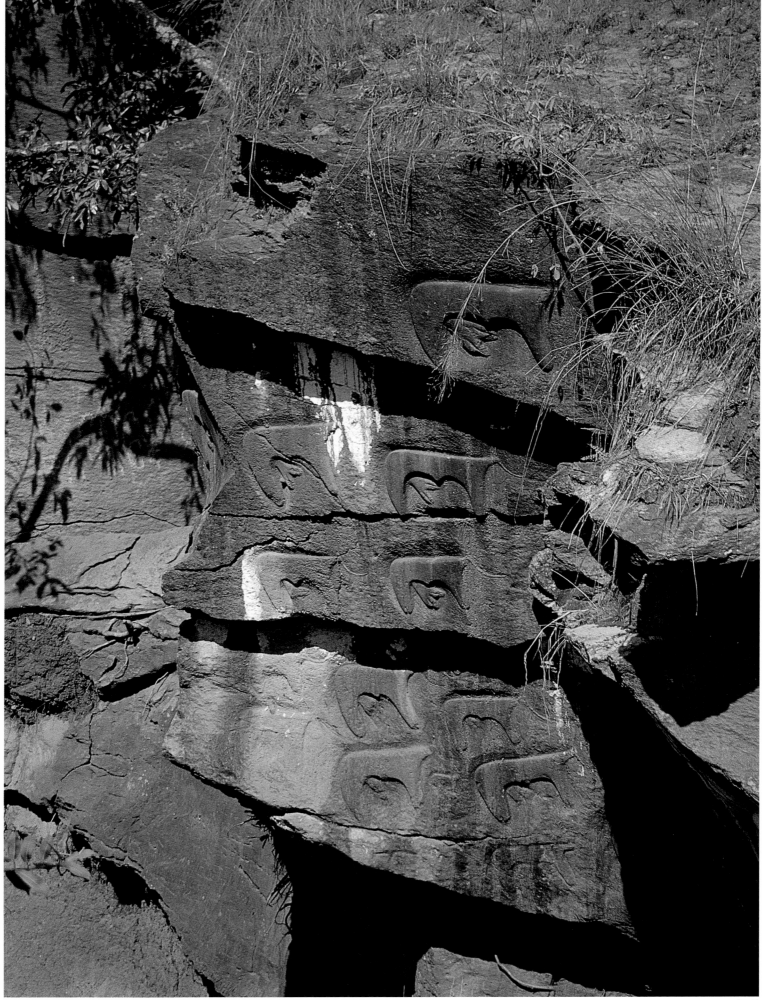

Fig. 15

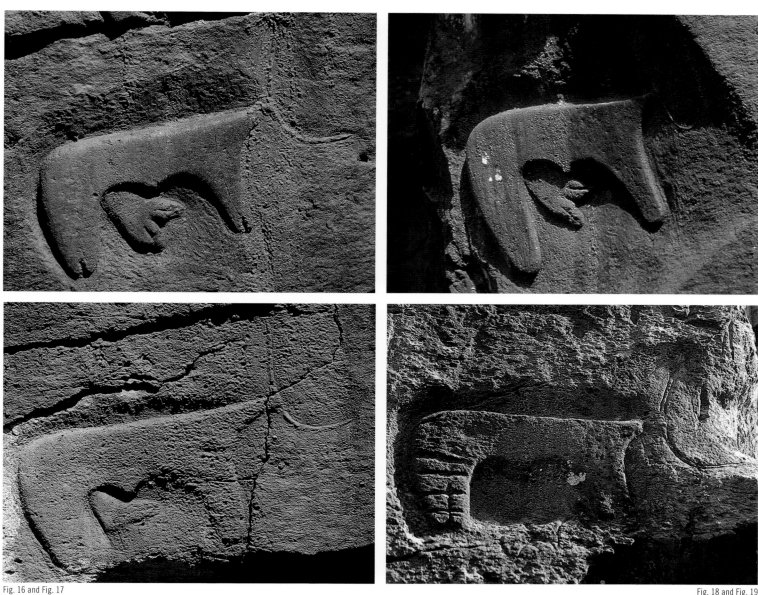

Fig. 16 and Fig. 17 Fig. 18 and Fig. 19

Fig. 15 - (Left page) One of the principal assemblages of humpless cattle engraved in false relief at Chabbè (Ethiopia).

Fig. 16 - Humpless cow engraved at Chabbè (Ethiopia). Note the very careful polish of the animal's body, the emphasis of the udder, the triangular object hanging from the upper horn, and the pendant beneath the neck.

Fig. 17 - Another detail of the engravings in false relief at the site of Chabbè (Ethiopia). Flowing water and fissures in the rock are a threat to the conservation of the assemblage.

Fig. 18 - Another cow at the site of Chabbè (Ethiopia). It displays the usual local stylistic characteristics and, in addition, its upper horn is decorated with a triangular object, but there is no pendant under the neck.

Fig. 19 - Only one of the bovines at the site of Chabbè (Ethiopia) has horizontal lines on its hind legs. This could represent a ligature like those used today by various Ethiopian herders to hobble their animals, especially at cow-milking times. Nevertheless, this engraving does not display the enormous udder visible on most of the others.

115

worth studying in this regard. Until well into the twentieth century, these warriors maintained traditions of battles joined for cattle raiding (which for them is a mark of status). The rituals devoted to the "killers" on their return from combat included the sacrifice of an ox and the preparation of coffee. Moreover, several pieces of data gathered among them makes it possible to establish an equivalence between bovine and coffee: the propitiatory ceremony called *bada* is carried out either by ritually preparing coffee or by sacrificing an ox with a lance in a similar ritual framework and with a similar result.[16] The "sacrifice of the coffee" (or *bunna qalu*) is an essential ceremony among the Konso, the Burgi, the Arboré, the Sidamo, and the Darassa. During this sacrifice—with strong Islamic connotations and considered a true substitute for the sacrifice of cattle—they cut, one by one, the end of the coffee berries which still contain their seeds, "as if they were cutting an animal's throat," and only then is this coffee boiled with butter and milk.[17]

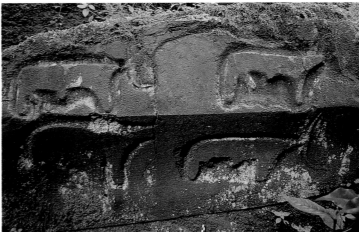

Fig. 20

Attempts at attribution

In Tanzania, the regions richest in rock art are the districts of Iramba, Dodoma, Singida, and Kondoa, in the center of the country. The paintings of this zone have often been compared with those of southern Africa, although they are some 930 miles (1500 km) away.[18] Indeed, one can recognize therianthropes (*fig. 33*, left), people dancing, encircled elephants recalling the "elephants in boxes" of certain South African paintings surrounded by people who do not seem to be hunters, and images of elands (though their style differs from those of southern Africa), as well as an anthropomorph with legs apart and a distended abdomen (giving birth) whose head is in contact with a partitioned oval surrounded by "flakes"—perhaps a hive and bees (*fig. 36*). But a large part of the region's art—about a third of the images—is made up of abstract drawings (circles, lines of dots) which, for David Lewis-Williams (1987), are of course to be interpreted as depictions of entoptic signs (*figs. 9, 12,* and *34*). But whatever their meanings, from the stylistic point of view as well as through their color and their technique, these images link part of the Tanzanian assemblage to the rock-art traditions of Zambia and Malawi. The central zone also contains images of anthropomorphs, reptiles, and perhaps fish, in off-white applied in thick flatwash in a late style (always superimposed on the others) known as "Bantu white."

So who made all these works, why, and when? In rock art studies, the general tendency is to make things older, perhaps thanks to a fascination for the question of origins. Hence in Tanzania, Emmanuel Anati, relying on evidence that is utterly unconvincing (ocher crayons of unknown function), wants to date the oldest paintings back to "more than 50,000 years."[19] Yet it is known that some of the paintings and engravings along the track from Moótho to Mangas'ta, which are so eroded as to be barely visible, and which one would thus think quite ancient, are in reality the work of children who,

[16] Abebaw Bogale 1986. Duba Gololca 1987. Tadesse Berisso 1988. [17] Pankhurst 1997. [18] Fosbrooke 1950. Odner 1971. Masao 1979. Leakey 1983. Lewis-Williams 1987. Garlake 2001. [19] Anati 1997, p. 217–19.

Fig. 20 - One of the engraved rocks at Galma or Anchimaltcho Kinjo in Sidamo (southern Ethiopia) that depicts some of the bovines that helped to define the Chabbè-Galma style.

at the end of the 1940s, began to paint and draw on the rocks as a result of the interest manifested by Henry Fosbrooke's in local rock art during his stay in the region.[20] One of the images is even a caricature of this researcher! Moreover, the depictions of heart-shaped metal hoes, known for example in the region of Mwanza and in Sandawe country, are of the same type as those still made by the Sukuma blacksmiths of the vicinity, and must therefore be relatively recent.[21]

The painted serpentiforms in the region of Bukoba have been compared with the snakes that the Hima paint on their huts and have been associated with the cult of the python that was until recently very strong in the lakeside regions of Uganda around Masaka. At Iyindi Matongo, near Isanzu, a painting of a big snake locally interpreted as a python was made (at an unknown date) in a cave currently used for rain rites. This association of snake and rain recalls a type of myth common in southern Africa, particularly among the San. But it is not certain that all the serpentiform drawings actually depict reptiles: at Rukurongo, some intertwined zigzag lines could represent the *kasanda*, a divinatory object in use among the Nyamwezi and made up of several pieces of wood.[22]

The paintings of bovines that occur at Endebes and Bukoba (*fig. 35*), that is, at the northern and southern extremities of Lake Victoria,[23] seem to be evidence that for the painters cattle were as important as they are today in the same region among the Hima and the Karamoja (with their system of clan marks on cattle, divisions of time centered on pastoral occupations, honorary names given to cows, etc.), but one cannot know if the paintings of Bukoba are the work of direct ancestors of these populations or of an earlier pastoral ensemble that has no connection with them.

Fig. 21

Fig. 21 - Engraved block at Soka Dibitcha in Sidamo (southern Ethiopia) depicting bovines in the Chabbè-Galma style.

[20] Ten Raa 1974, p. 13. [21] Soper and Golden 1969, p. 49. [22] Chaplin 1974, p. 39. [23] Chaplin 1974.

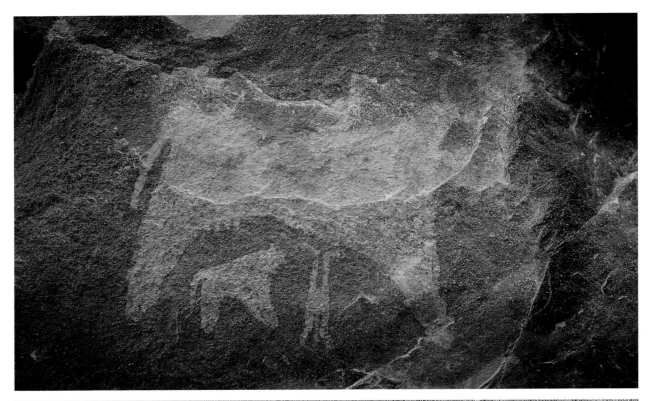

Fig. 22 and Fig. 23

Fig. 24

The magical drawings of the Sandawe

The ethnologist Eric Ten Raa[24] while accompanying a Sandawe giraffe hunter in the 1960s saw him make a painting at Swaga-Swaga (*fig. 37*) without being asked to do so, proof that rock imagery was still very much a living tradition. One morning before leaving, this hunter drew a giraffe on a rock using ocher that had been ground between two stones, and thinned in the water from his gourd mixed with spit. (The Sandawe have a whole vocabulary for spit because it can play a ritual role; hence the terms *pú'é* or *pú'um'sé*, "to spit sacrificially," produced the word *pumpu'sé*: "to make a sacrifice.") The hunter applied the paint to the rock with his fingers, with the help of a spatula-shaped stick. On seeing this, the ethnologist decided to pursue his investigation in Sandawe country, just over thirty miles (50 km) southwest of Kondoa. Eric Ten Raa then had the opportunity to see Sandawe drawing animals in the sand, or making clay effigies of them, before leaving for the hunt. In numerous Sandawe houses, he observed mural paintings of animals identical to those in the region's rock art, and several times the owners told him they had been made before they went hunting. In one case, the fresco was linked to a storytelling session; another time, a young Sandawe drew images of kudu on his house before leaving to hunt this animal. Since his hunt did not prove successful, he conceded that his drawing had not been very good— thus making very clear the image's magical role.

The Sandawe go to high places far from their dwellings seeking big rocks and overhangs where fissures and crevasses serve as residences for the spirits. In order to avoid disturbing these spirits, custom forbids hunting, cutting trees, breaking branches, cutting grass, bringing cattle to graze, or cultivating the soil in these places. The only sounds that are allowed are prayers, which are said aloud so the spirits can hear them clearly. In these places, domestic animals are sacrificed to ensure the cooperation of the spirits in obtaining rain or food. Their blood and the contents of their stomachs are spread out on the rocks; but blood and chyme disappear quite quickly. In order to leave more enduring traces, those officiating sometimes draw the sacrificed animal. The rock painting thus produced therefore plays the same role as the blood and chyme spread around during sacrifices, but with a more lasting effect.[25]

In 1966, at //'o//'á di ("the Rock of the Baboon"), Eric Ten Raa was also able to record a painting that his guide had indicated to him depicting the guide's grandfather drawn near the sacrificial ox, the whole thing painted in red flatwash. This image had been made in the presence of the grandson in 1921 or 1922. Nearby there were also paintings of giraffes, elephants, and zebras, in black and no doubt older, all decorating a cave that is still a place of sacrifice for the Habe clan. The depictions of wild animals cannot represent sacrificed animals, and thus suggest that the site was also frequented by hunters.

At Merebú, the inhabitants of the village located below the site of the paintings (*fig. 38*) explained that a human figure in white flatwash represents a lion-dancer

Fig. 22 - Painting in the shelter of Laga Oda in the Harar (Ethiopia). This is a cow in white flatwash accompanied by its calf and a schematic human.

Fig. 23 - Very elongated bovine with deformed horns painted in the shelter of Laga Oda in the Harar (Ethiopia).

Fig. 24 - Detail of the main wall in the shelter of Laga Oda in the Harar (Ethiopia). Behind the long-horned animal in white flatwash, one can see in particular a bovine in black flatwash with striped oval signs on its rump and shoulder.

24 Ten Raa 1966, p. 197–8. 25 Ten Raa 1971, p. 43–5.

taking part in a typical Sandawe possession ritual, the *simbó*. While possessed, the dancers officiating during this rite climb trees and look in the soil for noxious substances; they then enclose these in oryx horns and go to bury them on the mountain. Eric Ten Raa observed *simbó* dancers climbing up to this rock art site. Today, the site is not considered sacrificial, and it is mostly used for hiding the foods (meat, honey, beer) that they do not wish to share with undesirable visitors. Nevertheless, the series of human figures painted in black here (*fig. 38*) were interpreted by the villagers as a depiction of a *simbó* ceremony: the male on the right would then be a possessed dancer, moving around in front of the women on the left who are busy singing. The undulating lines would be the horns used by the dancers, and the broken oval, visible under the women, would be a bowl of beer, the usual drink of the latter. Furthermore, the white person on the left, superimposed on an ancient figure in red flatwash, could be a lion-dancer.

At Tákamase ("[the place] with drawings"), there is a whole group of red animal figures, as well as humans, the best preserved of which display body decoration, and wear ritual headdresses of animal hair (*sangu*)—the attribute of courageous hunters.

Out of sixteen sites examined by Eric Ten Raa, only six apparently had no link with present-day Sandawe traditions. In the rare cases where acts related to a "hunting magic" could be proved, the authors of the paintings were known and spoke about them, or they were observed in action. Such acts are personal, not collective, and the key to the images is thus known only to their authors. Conversely, the sacrificial sites, although located in places of reserved access, involve the whole community, and everyone knows they exist, even if they do not know the details about them. Links between the practice of a hunting magic and rock art are all the more difficult to prove because even where there is such a link actual paintings are not always made. For many hunters, ritually spitting a bit of beer suffices. A Sandawe hunter even told the investigator: "If a hunter draws a picture in the sand at home, why should he have to make yet another one in the hills?"

These observations and comparisons by Eric Ten Raa[26] are of great importance, they prove that paintings were made very recently, and that rock figures still have significance for the Sandawe. Whatever their original meaning may have been.

Nevertheless, one should not attribute all the region's rock paintings to the Sandawe or the proto-Sandawe. While it is certainly true that some display striking similarities with the Sandawe's present-day traditions, it is also true that one can find links to other traditions in the region's rock art. For example, a mural painting of a giraffe in a present-day Burunge house at Gwandi (and thus in a Burunge zone, of the Iraqw language, whose inhabitants apparently have no link with the Sandawe) is almost identical to a flatwash rock painting of a giraffe located at Di Zanga, as well as to the one which Eric Ten Raa saw a hunter paint at Swaga-Swaga (*fig. 37*). Moreover, one can see highly comparable images on the walls of certain dwellings of the Rimi, who are Bantu and western neighbors of the Sandawe. Hence it is not necessarily contemporary

26 Ten Raa 1971 and 1974.

Fig. 25

Fig. 25 - Two of the engravings at Godana Kinjo (Sidamo, Ethiopia). These are cattle which, in terms of style, are related to those of Chabbè-Galma, although their finish is far less careful.

Fig. 26 - One of the painted cows at Laga Oda in the Harar (Ethiopia), apparently drawn with the finger and with its body filled in with streaks, in a different style from the previous images.

Fig. 27 - Herd painted in the lower shelter of Laga Oda in the Harar (Ethiopia). Here, the schematization of the cattle, already perceptible in the previous images, attains its ultimate degree—they are represented only by simple arches.

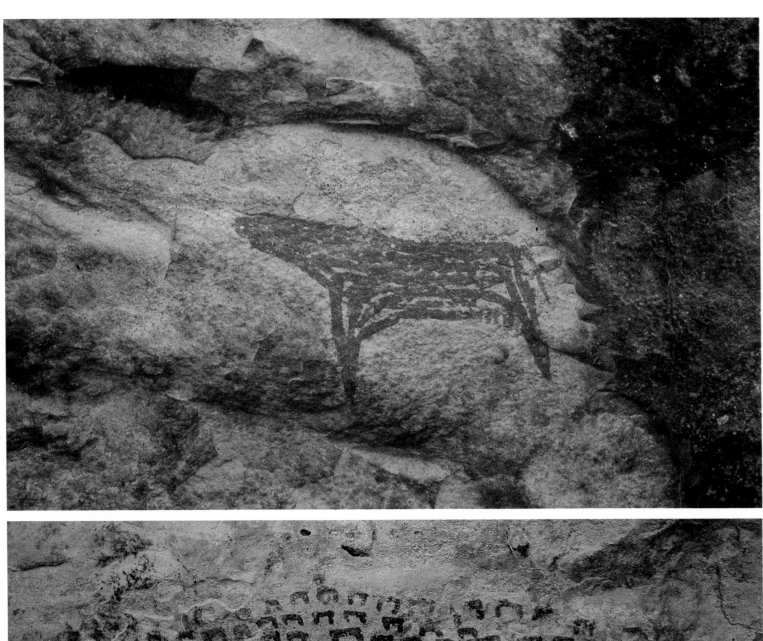

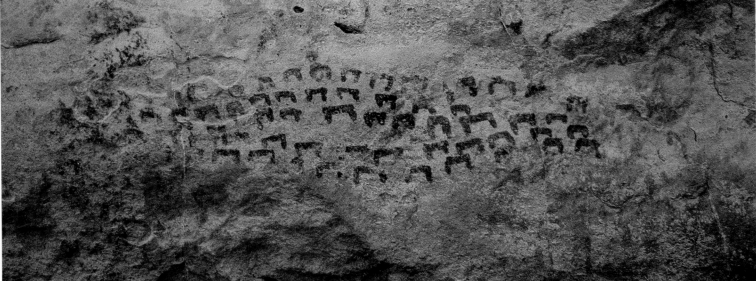

Fig. 26 and Fig. 27

Sandawe art that always most resembles Sandawe rock art; as the images in question are very simple, it is not surprising to find cases of convergence.

Without seeking an ethnic dimension for the paintings, Eric Ten Raa demonstrates that a rock art tradition that is still alive may escape ethnological investigations (as was long the case for the Sandawe) because it does not correspond to a school and does not fit the framework of traditions handed down in a formal way. Its essence is not artistic, but lies in the belief system that includes it, and it is not unreasonable to suppose that the same applies to many other examples of rock art. Comparable observations have been made at Bulemela, near Malilo, in the region of Mwanza. Here there is a rock some twenty-five feet (7 m) high, filled with natural cavities, one of which, at the top, is occupied by bees whose honey is considered poisonous. This block is also the seat of forces that inspire various rituals, in particular the throwing of stones into the cavities, and the application of dung to its surface for propitiatory purposes. In the 1960s, a "painting" was made on this block with dung that depicted a zebu mounted by a human and being touched on the head by another. In view of the medium used here, it cannot be doubted that this drawing was recent, and that it was made within the context of the rituals associated with the rock of Bulemela.[27]

Moreover, ethnographic observations demonstrate that a single site can have a variety of meanings, none of which could be deduced simply from artistic analysis, since only the cultural context could provide information about this. To observe that at some period a particular site was ritually used by hunters on a journey, and that at another period it was a place of sacrifice integrated into initiatory rituals for adolescents, does not imply any ethnic change, contrary to what might be claimed from analyses that systematically associate style with ethnic group.

These examples open up many avenues of research that should be pursued if there is still time to do so! But one can already note that at least a part of the paintings of Kondoa can be attributed to the Sandawe. So the region's graphic production is partially linked to hunting customs, initiation ceremonies, funerary rituals, and rain mythology.

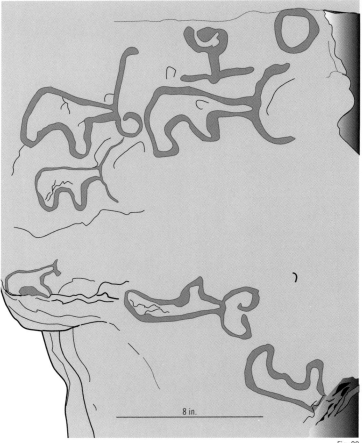

Fig. 28

Fig. 28 - Engraved assemblage at Ejerssa Gara Mallo (Sidamo, Ethiopia) made up of six hump-less cattle and a schematic human which seems to be jumping over the biggest animal (see fig. 30).

[27] Soper and Golden 1969, fig. 9.

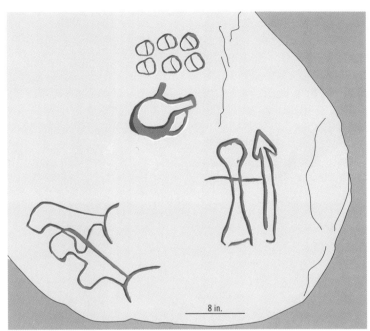

8 in.

Fig. 29

Ethnogony and images of the dead

It is nevertheless true that certain peoples associate rock art with their origin myths. There is a good example at Mlima wa Mzale, Mlima wa Bahi, and Nyigiri, three rock-shelters northeast of Bahi (Tanzania). In 1930, in order to explain the paintings that decorate their walls, an elder called Faudi, son of Kamyuka, told Culwick (1931) the following ethnogonic myth:

The earliest ancestor of ours whom we know about was called Kimanchambogo. He came from Gurui.[28] When he arrived here a chief called Wamia, whose language he did not understand, was occupying this country, and was helped by a powerful headman called Amankara. These two, when they found Kimanchambogo hunting over their territory, drove him away. Later Kimanchambogo returned and defeated Wamia, who fled, and since those days we have held the country round Bahi. When Wamia fled, everyone went with him except a small girl called Manze who was left behind and forgotten in the rush. Kimanchambogo treated her kindly and used to see her as he passed by her house when going out to hunt. I expect this was because he wanted to marry her! Then there came a day when Manze became pregnant because of Kimanchambogo, and later she bore a son. Our ancestor then married her—he had never married previously—and she lived with him from then on. The son's name was Samani and he succeeded Kimanchambogo as *Mtemi*. Now it has been passed down from Kimanchambogo himself that the white paintings were painted by Wamia and Amankara, who used to sacrifice cows in these rock-shelters. After eating, they used to prepare fat from the inside of the beasts and with it paint these signs on the rock. The signs were connected with Wamia's religion, but exactly how I do not know. We WaGogo hold that these spots are sacred and we still "tambika"[29] at Mlima wa Bahi and Nyigiri. When we do this we pray to Mulungu for rain and we get it. When we "tambika" we use the fat of the beast sacrificed and with this we brush over the ancient signs, following the lines drawn by Wamia. As to what the pictures represent and why they were painted, we do not know now. Only Wamia and his people knew and they have gone.

Fig. 30

In the eyes of the WaGogo, this in no way prevents the ritual from being

Fig. 29 - Engraved rock at Laga Harro (Sidamo, Ethiopia) on which there are two cattle in a style close to that of Chabbè-Galma, a human with a lance, and a coffee pot of *jäbäna* type accompanied by six cups.

Fig. 30 - Initiation rite still practiced by the Hamar/Bachada, which consists of jumping over the back of an ox (see fig. 28).

28 Culwick specifies that it is Mount Hanang, close to Mbulu. 29 The word *tambika* designates the act of practicing a particular type of sacrifice, during which the entrails of the sacrificed animals are extracted and thrown onto the sacred object. I render this term untranslatable by turning it into English.

effective, and with regard to this type of sacrifice, old Faudi added: "When we 'tambika' we get all we ask for, be it children or rain or anything else."

According to the local genealogies, Kimanchambogo supposedly reached Bahi around 1680, and so the paintings would be older than this. At present, the Wamia have dispersed, and a certain number of them live near the River Ruaha. The WaGogo say that originally they were hunters living around Bahi and that they then started to raise cattle raided from the Masai. But in their own origin stories, the Wamia claim to be a branch of the Masai that separated off to go and live at Uhehe before emigrating to Ukimbu. Here, their cattle were ravaged by an epidemic, and a great number of people left for Bahi without animals, which forced them to resume hunting. Be that as it may, the present-day Wamia maintain a particular funerary ritual, which involves the interpretation of rock paintings. When a man or woman of importance dies, a particular rock is "tambika'd" by all the elders, who gather to drink the local beer, which they spit onto the rock. The fat of the sacrificed animals, bovines or sheep, is mixed in a pot, and a paintbrush is fashioned by beating the end of a stick. The chief elder then takes this brush, soaks it in the fat, and draws the deceased's portrait on the rock. He also depicts some of the dead person's property, such as cattle, gourds, pestles and mortars, personal ornaments, etc. This painting is then completely covered with branches and the elders call all the inhabitants. A great quantity of beer is brewed and there is dancing. All this cannot but be compared to the fact that the paintings in the vicinity of Bahi indeed comprise depictions of people (*fig. 41*) and objects that could be understood as their property: stool, hoe, gourd, arrow, bracelets (*fig. 39*), livestock (*fig. 40*). It was specified to Culwick that in the case of a hunter's death he was always depicted in the form of a snake—a motif that also appears in the Bahi paintings (*fig. 39*). Here, one perhaps has an acceptable explanation for a good number of the paintings in the vicinity of Bahi. There is even less cause to doubt when we consider that during his visit Culwick noticed that those of Mlima wa Bahi had recently been retouched, which had given them a waxy appearance. The one that seemed to him to have been the last to undergo this treatment had been covered with branches whose leaves had fallen since then, an indication of the very recent nature of the operation.

It is not impossible that similar ceremonies lie at the origin of certain of the enigmatic symbols that we cannot interpret and that, for Sonia Cole, could be conventional signs depicting weapons, ornaments, and the domestic goods accompanying the dead.[30]

Caves of spirits and rainmakers

On a wooded slope at Mungoni wa Kolo, near Kolo, two rock-shelters were discovered in 1923 by Bagshawe, who reported that the inhabitants called them the "caves of spirits." When Miss Fosbrooke visited the upper cavity, she saw the remains of a sacrifice carried out by the local rainmakers. This site is decorated: one can see three elongated

[30] Cole 1954, p. 251.

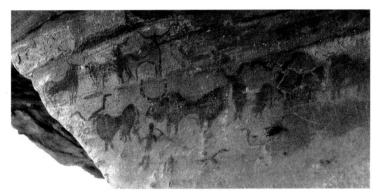
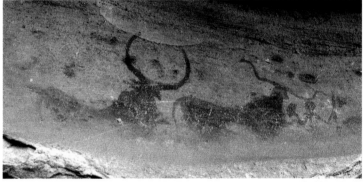

Fig. 31 and Fig. 32

Fig. 31 - Assemblage of rock paintings discovered in 1998 at Anza (Tigré, Ethiopia) in a rock shelter measuring 65 x 33 x 16 ft. (20 x 10 x 5 m). It contains at least forty-two cattle accompanied by a few people.

Fig. 32 - Two of the cattle painted in the shelter of Anza (Tigré, Ethiopia); in front of them stands a human who seems to be holding a lance and shield.

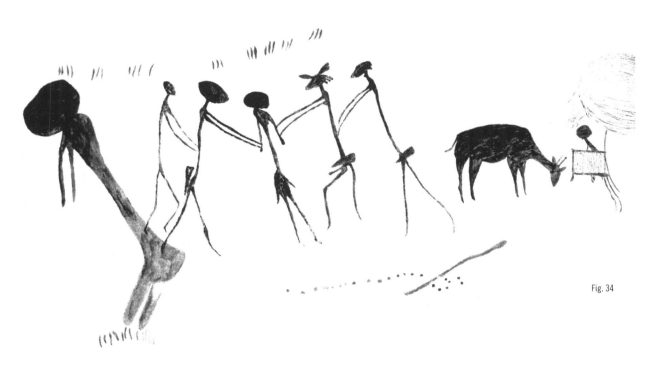

Fig. 34

Fig. 33 - Painting at Cheke 3, north of Kondoa (Tanzania), comprising an ostrich in red flatwash and a line-drawn therianthrope.

Fig. 34 - Painted assemblage at Kolo I, north of Kondoa (Tanzania), whose central scene was sometimes interpreted as the abduction of a woman by four men, whereas it could just as well depict some ritual. Since the assemblage was copied in 1951, the big human at on the left has been severely damaged.

8 in.

Fig. 33

people, with curious hairstyles, about two feet (60 cm) long, as well as a painting that was often reproduced by authors who nicknamed it "Abduction Scene" (*fig. 34*) because it depicts a woman in the center held by two men on the left and on the right by two masked people, one of whom may be ithyphallic.[31] It is not known whether there is any connection between these figures and the rituals carried out in the shelter, and it is regrettable that the prehistorians who visited this site in the first half of the twentieth century did not bother to obtain more precise information about the local traditions, while some still limit themselves to evoking vague "magico-religious beliefs" as an explanation. Yet it is obvious that rock images were sometimes made within the context of certain rituals, particularly those of initiation. Hence, Sonia Cole reports that on the lower slopes of Kilimanjaro, in the zone occupied by the Chagga, four large blocks covered in engraved meanders and a few cupules had been used in the final stage of initiation ceremonies. The initiates would camp in the bush, naked and without shelter, and they were taught the knowledge and duties that pertained to their age group. This is when they—and only they—had knowledge of the engravings on stone disclosed to them. Each age group engraved a line on the rock: hence the number of lines currently engraved here bears witness to the passage of a great number of generations.[32] Another example of ritual production of rock art is known among the Masai, and involves geometric signs: for when cattle are sacrificed in a rock-shelter, the brand marks are reproduced on the walls.[33]

Similarly, in Kenya in 1973, elders of the district of Kitui explained to Osaga Odak[34] that a rain ceremony was organized annually in the rock-shelter of Kavea, decorated with paintings locally considered to be "acheiropoïete" (i.e., not humanly made) and associated with this ritual. The attribution of a supernatural origin to rock figures is known elsewhere in Africa, for example at Tsodilo Hills, where the !Kung say the paintings are the work of the gods.[35] In the 1970s, the decorated shelter of Nyero, just north of Lake Victoria, was also used for rain rites.[36] The site of Itone, on Mfango island on Lake Victoria, has paintings in red ocher and is only visited by the Suba in cases of epidemic or lack of rainfall, to carry out sacrifices to the ancestral spirits. It is forbidden to cut grass or gather wood there, or to cultivate in the surrounding area. An origin myth tells that one day a young man chased away an old woman warming

[31] *Ibid.*, p. 263. [32] *Ibid.*, p. 265. [33] Harlow 1974, p. 46. [34] Odak 1992a, p. 38. [35] Biesele 1974, p. 6. [36] Chaplin 1974, p. 40.

125

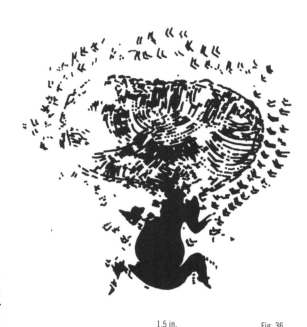

herself by a fire lit in this shelter and took her place after sending her out into the rain. The woman cursed him, so that part of the shelter collapsed and crushed the young man, and the paintings were born of his blood.[37] The Bukusu myth of the origin of circumcision claims that this custom was born at the painted site of Kakapeli (*fig. 42*), which is considered sacred, and this can be compared with the numerous decorated shelters that are still today used during initiation ceremonies, where the novices sometimes have to make paintings, for example among the Samburu and the Masai.

Funerary signs

One cannot emphasize enough the importance of studying rock art from both an ethnological *and* archaeological point of view. An ancient, even prehistoric art can thus be integrated with present-day practices that can shed light on it, just as the rock art itself can shed light on the representations, lost or not, that underlay the production of the works. This method, however, has its limits when one is dealing with an ancient, geometric art that would appear to have no link with the present populations, and which thus resists all attempts at interpretation. This is the case, for example, with the thousand or so engravings of Namoratunga, just west of the River Kerio, which flows into Lake Turkana, in northwest Kenya. These drawings are located on two small volcanic hills about a half a mile (1 km) apart that contain two cemeteries dated to the fourth century B.C.E. that were founded by herders of bovines, goats, and sheep (whose remains have been found in the tombs). No less than 142 different geometric signs have been recorded here, both on the rocky outcrops and on the basalt stelae that mark 38 of the 162 tombs (*fig. 44*). The connection between the engraved assemblages and the tombs is confirmed by their respective orientation. Hence, in the first cemetery (*fig. 43*), the engravings are grouped in four little assemblages in the north, east, south,

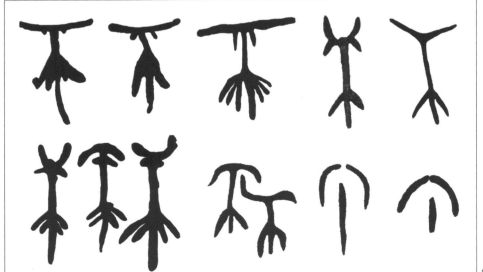

Fig. 35

Fig. 35 - Example of schematic cattle painted at Bukoba on the western shore of Lake Nyanza. Several of these images were long considered to be filiform people, but some of them display two horns, two ears, four legs, and a tail. These are schematic cattle seen from above—the extreme simplification of these images produces arches (for horns) with an indentation symbolizing the rest of the body, and culminates in the so-called "corniform" sign, which is found in the rock art of the Horn.

Fig. 36 - Painting copied in the district of Swera (Tanzania) that seems to represent an anthropomorph beside a hive.

37 Odak 1992*c*.

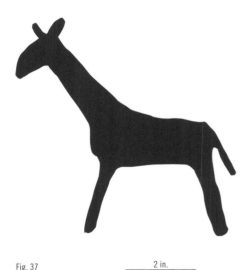

Fig. 37 _____ 2 in. _____

and west—the intermediate rocks, albeit very suitable for receiving engravings, have never been decorated. The cemetery itself is oriented according to the four cardinal points, as are the tombs: for example, the deceased in the northeast quarter all have their heads to the north or east, those of the southeast quarter have their heads to the south or east, and so on. One can only conclude that the cemetery was organized so that the tombs of each quarter were associated with a different engraved assemblage. In the other cemetery, the engravings are grouped at three points—northeast, northwest, and south— but the assemblage does not appear organized; due perhaps to the very small number of tombs (eleven), even though these too are oriented to the four cardinal points.

Although some engravings look quite recent, the Turkana herders, who have been present in the region since roughly 1600, declare that cemeteries and engravings were there before their arrival. Moreover, their funerary customs bear absolutely no resemblance to the rituals that can be seen in the excavations at Namoratunga. However, 99 of the 142 signs recognized at Namoratunga are still used by the Turkana as cattle brands, inherited from the father, and thus refer to patrilineages. In the region, this usage is shared by other pastoralists—Pokot, Samburu, Masai—and one can thus suppose that the engravings could have been used for similar brands. One confirmation of this might lie in the fact that in the two cemeteries only the male tombs are marked with them, and those which have similar signs cluster together in groups. It should be recalled that even today the cattle brand marks have a function of social distinction: the Masai use the brand marks that individualize their favorite bovine to decorate their shields and to carry out their own bodily marks, in order to indicate their age group and their clan identity. So how can one take the analysis farther? B. Mark Lynch and R. Donahue (1980) had the idea of classifying the engravings by degree of patina ("fresh," "medium," "total") and subjecting them to a statistical study. It thus appears that over time the two cemeteries have become gradually differentiated in their graphic repertoire, indicating an increasing social distance between the two groups using them, which indirectly confirms the fact that these signs were linked to the social organization of the people of Namoratunga. As for rediscovering the associated myths, this is an impossible task for the moment. There are numerous difficulties: the Pokot of the vicinity of

Fig. 37 - Painting made with ochreocher in 1960 at Swaga-Swaga (Tanzania) by a Sandawe hunter in the presence of the ethnologist Eric Ten Raa.

Fig. 38 - Assemblage of paintings at Merebún, in Sandawe country (Tanzania), a part of which is locally interpreted as the representation of a *simbó* ceremony: in black, at upper right, the male person is thought to be a possessed dancer moving in front of singing women in a line; the pointed undulating lines under this group supposedly depict the horns used by the dancers.

4 in.

Fig. 38

Kanyao share 14 percent of their cattle brands with the Turkana, and investigations show that new brands could be acquired during cattle raids.[38]

Harla, Germans, Portuguese, and other savages

In Ethiopia, no particular practices are known that are associated with rock images, but in the Harar the latter are generally attributed to an ancient people of giants. That is the case with the paintings in a shelter at Gafra Golla Dofa, located in the bed of the River Gafra (region of Grawa, Gara Mullata, southwest of the Harar), of which it is said that they were made by a people of rich and powerful giants who, according to the legend, occupied the Harar before the Oromo, and who were exterminated by a catastrophe of divine origin, as a punishment for their excessive pride. A village even bears the name of these mythical beings: Harla, located near Dir_ Dawa where, on June 16, 1999, during a visit with my companions Bertrand Poissonnier and Ato Tekle Hagos, the inhabitants, knowing of our interest in rock art, insisted on showing us the "footprint of the Harla." This is a plant formation whose natural development has produced—vaguely and by chance—the shape of a reddish human footprint of normal size on a rock that dominates the whole region (*fig. 45*). As we were astonished by the verticality of this "footprint," a group of inhabitants explained to us that the village of Harla was the "center" of the habitation area of ancient giants who also used to live at Goda Okote (literally the "cave of the Pottery"), at Goda Kataba (literally the "cave of the Writings"), and at Laga Oda. The "pottery" of the first place seems to allude to ancient tombs, and this cave is also reputed to contain diamonds. The name of Goda Kataba refers to the presence of rock paintings, and the peasants say that this cavity contains gold and diamonds, but that people have died looking for them. Laga Oda, finally, is a famous painted shelter, remarkably documented by Pavel Cervícek (*figs. 22 to 26, 26 and 27*). As for the Harla, we were repeatedly told that they were very rich, even hugely wealthy, so that they behaved in scandalous fashion with utter contempt for work and gain. According to the people of the village, their original name was Rilla, which was then extended to Ha-Rilla, from which comes the ethnonym Harla. They were pastoralists who came from Ogaden, but their idleness was such that they let their cows' milk go to the river and passed their time going from marriage to marriage, trampling the plantations of sorghum and teff.

In their excessive pride, they eventually committed various sacrileges: they refused to practice ritual fasting, and even began to translate the holy Koran into the Harla language. In short,

Fig. 40

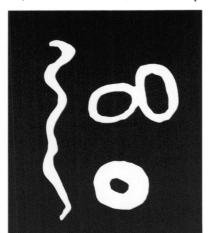

Fig. 39

38 Lynch and Robbins 1977.

Fig. 39 - Painting at Mlima wa Bahi (Tanzania) representing a snake considered to be the depiction or the incarnation of the spirit of a dead healer, associated with circles interpreted as the schematization of personal objects (gourd, bracelets …) which belonged to him.

Fig. 40 - Painting at Mlima wa Bahi (Tanzania) representing a zebu.

Fig. 41

they committed so many excesses and impieties that divine punishment was not slow to manifest itself: they were cursed and disappeared. And since then, in the Harar, all the rock paintings have commonly been attributed to these same Harla, whose name seems to be mentioned for the first time in the fourteenth century in a chronicle of the emperor of Ethiopia 'Amda Seyon. A study of clan names and of oral traditions shows that these Harla very probably represent the Islamized populations of Harari and Somali origin who partially survived the Oromo conquerors of the sixteenth and seventeenth centuries.[39] It would need more detailed research to document the relations between the oral traditions of the vicinity of Harla and the local archaeological riches, of whose importance the inhabitants are well aware (fig. 46).

Quite frequently, the local populations attribute rock images of unknown origin to a supernatural action—for example to the supreme divinity, in the case of the geometric images of Chauga in Tanzania[40]—when they do not consider them to be the work of peoples very different from themselves. In the latter case, the images' authors are characterized by the greatest possible remoteness, which can be temporal—as when they are identified with the "first men" of the anthropogonic myths—or spatial and "ethnic," as in the case of the paintings of the island of Mamba (Lake Victoria), which are locally attributed to Germans.[41] Similarly, on the island of Ukerewe, comparable geometric drawings, recorded in 1957 by Philip Mawhood, were attributed to "Chinese Europeans" (!). As for the natural marks of Kolose Di, Erémasa, and Afuma Di (North-Tanzania), which the Sandawe interpret as footprints—the latter two sites also containing rock paintings—they are attributed to the Wareno, the Bantu name for the Portuguese, whereas nothing indicates that the latter ever came anywhere near these regions.[42]

Antecedents, new uses, meanings

Certain images might represent antecedents of present-day traditions, but it is difficult to go beyond mere speculation in this regard. Hence, in Ethiopia, the deformation of bovine horns both in paintings (fig. 23) and in engravings (figs. 16 to 21, 28 and 29) is in general asymmetrical, with one horn sticking up and the other pointing downward, which corresponds to the type of deformation that the present-day Hamar/Bachada still practice, and which they call kamara.[43] Among the assemblage of humpless bovines with horns deformed in this way that are engraved at the site of Ejerssa Gara Mallo, there is one over which a human is jumping (fig. 28). So this figure is performing an act corresponding to the ritual jump still practiced today by these same Hamar/Bachada, but over a zebu (fig. 30), only ninety miles (150 km) southwest of this site.[44]

Finally, in Azania as elsewhere, there is a frequent process of attaching new uses to the art. One of the most remarkable examples occurs in Eritrea where near the village of Bardà, fourteen miles (23 km) south of Asmara (Hamasién), the shelter of Ba'attì Mariam is decorated with a frieze of about fifteen people in bas relief (fig. 48) in a style that is also known in the same region at Daarò Caulòs, about sixty miles (10 km) from

Fig. 41 - Painting at Mlima wa Bahi (Tanzania) which may depict a horned human, or a stylizsed bovine similar to those at Bukoba (see fig. 35).

39 Cervícek and Braukämper 1975. 40 Shorter 1967, p. 49. 41 Tanner 1953, p. 65. 42 Ten Raa 1974, p. 13.

43 Lydall and Strecker 1979, p. 202, n. 123. 44 Haberland 1959, pl. 45, fig. 2. Lydall and Strecker 1979, p. 175, n. 31. Mohaupt 1995.

there. But at Ba'attì Mariam, the site is sacred to Christians, who associate it with the Virgin Mary, as its name indicates. In 1933, Fesseha-Tsion Tedla, an inhabitant of Bardà who was then aged seventy-four, told the myth to Giulio Calegari:

> I heard this legend from one of my ancestors. During the war [not specified] the country was invaded by enemies. Hence our ancestors were forced to hide the *Tabot* [wooden altar tablet, bearing the sculpted depiction of the patron of the church] in a secret place. After the war, the people, our ancestors, looked in vain for the hidden *Tabot*. Incapable of finding it, they were in despair. One day, they saw a dove come out of a rock-shelter, holding in its beak a thread of the fabric which had been used to cover the *Tabot*. So this is how they were able to discover the secret place where the sacred object had been hidden [it was the shelter where the bas-reliefs are located]. They took it out and replaced it in the church which had been deprived of it for so many years.[45]

Fig. 43

Another interesting new use concerns one of the rock-shelters in Nyamwezi country, which has a wall (called Makolo) decorated with ancient red, geometric paintings (concentric circles, rayed or not, parallel lines, and perhaps a few filiform people), while the opposite wall contains the recent ritual paintings of the society of Nunguli ("of the porcupine") hunters, made on a layer of white flatwash, and whose meaning has not been divulged. According to initiates into the Nunguli, the ancient paintings are acheiropoïètes

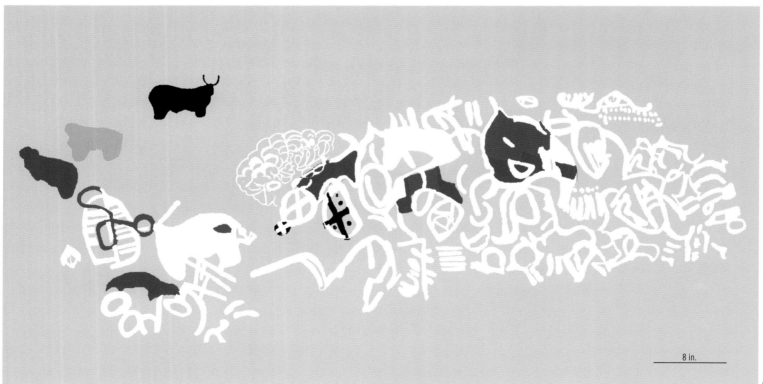

8 in.

Fig. 42

45 Calegari 1999, p. 40.

Fig. 42 - Assemblage of rock paintings including humpless cattle made in the shelter of Kakapeli (Busia region, western Kenya), which is still used for initiation ceremonies, since a Bukusu myth claims that this is the place where circumcision originated.

Fig. 43 - The main cemetery (see the purple diamond) of Namoratunga (fourth century B.C.E.) is oriented to the four cardinal points and the tombs in each quarter (see the orange areas) are associated with a different engraved assemblage.

Fig. 44 - Repertoire of the signs engraved in the cemeteries at Namoratunga, in north-west Kenya; ninety-nine of them are still used by the present-day Turkana as cattle brands associated with patrilineages.

Fig. 44

(not humanly made), but nevertheless include symbols that are meaningful to their society. They have taken great care not to obliterate them with new figures, although the Makolo wall is smoother than the others and would thus be easier to paint. This shows that the Nyamwezi, who arrived in the region three to five centuries ago, "cobbled together" the symbolism of the ancient figures that already existed before they came. Moreover, these figures display two different shades of red, and could therefore correspond to two chronological phases earlier than the arrival of the Nyamwezi.[46]

In 1976, Michael Kenny ventured a general interpretation of all the rock art of East Africa. In his eyes, the concentric circles are solar symbols and the spiral is a variation of this. In Kenya-Tanzania, the spiral—materialized, among other means, by a Conus shell cut in a special way—is associated with chieftainship, particularly among the Unyamwezi, the Kimbu, and the Sukuma, where the chief does indeed have solar connotations. In the study of rock art, the pertinence of this chain of associations [sun—spiral (or concentric circles)—chieftainship], linked to the function of master of the weather, finds some confirmation in the fact that among the Kuria (a Bantu group located at the frontier of Kenya and Tanzania) a single verb is used to designate the sun's action and the act of drawing or, by extension, writing. The author adds that the symbolism of the royal colors (white, black, red) corresponds to the chromatism of the paintings and links the serpentiform rock images with the initiatory practices of the *bugoyangi* or *buyeye* society which, among the Nyamwezi and the Sukuma, is made up of snake charmers who still produce on the walls of their dwellings a parietal art that essentially illustrates myths. But if truth be told, the style of these figures is not comparable to that of the rock images, and this society does not appear to use rock-shelters.[47] However, there is a description of the initiatory lodges used for the same purposes, which shows them decorated with geometric symbols (dots, circles, grids in white and black) that are very close to the rock paintings found in Kimbu country, at Chauga.[48] This comparison, which might only be formal, has a good chance of being significant since it is supported by a common mythological point: the localized legends of Chauga speak of a giant called Idimungala, who lived in the forest and was in the habit of putting one foot on the hill of Chauga and the other on the neighboring hill of Kimpulu, while shouting in a terrifying voice. This same giant is known to the Nyamwezi, who call him Limdimi, and also to the Kimbu, who call him Mudini; they all make him a great hunter, master of wild animals, and, what is more, they all give this detail: it was he who punished those who violated the secret of the *bugoyangi* or *buyeye* societies by driving them insane.[49]

Another approach that does not aim to rediscover the precise meaning of signs (if indeed they ever had just one) but simply seeks to show that they had an unknown symbolic significance, was favored by J. H. Chaplin. According to this researcher, concentric circles are fairly rare in Tanzania in the decoration of ancient and recent pottery, and present-day decorative motifs are mostly angular. Today, concentric half-circles are common only in body decoration and shields, and the use of concentric circles, often in three colors (red, white, black), is only widespread in ritual contexts. Chaplin therefore concluded that "evidence mounts to suggest the strong possibility that these drawings have a symbolic significance."[50]

[46] Collinson 1970. [47] Cory 1953. Collinson 1970, p. 62. [48] Carnochan and Adamson 1937, p. 275. [50] Chaplin 1974, p. 40. [49] Shorter 1967, pp. 49 and 55.

Fig. 45

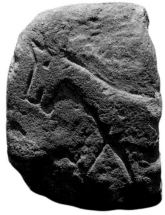

Fig. 46

Fig. 45 - Position of the "footprint of the Harla" on a rock dominating the village of Harlaa in the Harar, in Ethiopia. These legendary giants are popularly credited with the production of the rock paintings of the whole Harar. The "print of the Harla" placed vertically on a rock, is the result of a natural plant formation that by chance has taken the form of a footprint.

Fig. 46 - Engraving of a horse preserved by the villagers of Harlaa (Harar, Ethiopia); the exact provenance is not known.

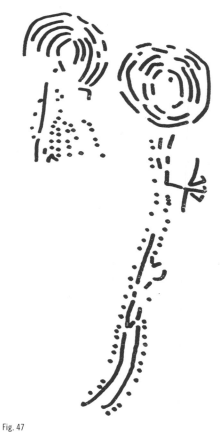

Fig. 47

Contrary to Pager and Willcox, who thought (correctly) that images of circles are simply too widespread in world rock art for anyone to see in them, everywhere, the trace of an ubiquitous and extremely vague "solar cult," J.D.H. Collinson believed that, "in the absence of a better alternative, we can at least consider as a hypothesis that such obvious symbols of the sun as depicted on Makalo rock hold religious significance, and were once connected with sun worship."[51] He pursued this argument by saying that if rayed circles are indeed the sun, then concentric circles could depict the moon and its halo, and little circles would be stars while admitting that simple circles could just as easily be huts.

Although none of this is absolutely impossible, this kind of interpretation is based on what remain highly tenuous speculations without the slightest hint of proof, and mostly deals with very simple signs that occur in the rock art of the whole world. But, whether or not they are "solar" people symbolizing chiefs, the very lanky anthropomorphs with a head made of concentric circles, fairly common in the paintings of Tanzania (*fig. 8*), have no analogues in other zones, except in Uganda[52] and farther away on the walls of the shelter of Goda Allele in the Harar, in Ethiopia (*fig. 47*). Similarly, schematic bovines seen from above, as well as the simple "corniform" (*fig. 35*), are known from Eritrea-Ethiopia to Tanzania.[53] The sporadic presence over such a vast zone of such particular stylistic types unknown outside Azania constitutes a remarkable fact that can testify to an ancient connection, the nature of which still needs to be specified.

Without trying to revive the old theory of "art for art's sake" (according to which rock images can be explained simply by a kind of "graphic impulse" leading painters and engravers to "pass the time" and/or "make something pretty"), it is important to remember that even the simplest graphic signs can have aesthetic motivations, whatever their other functions and meanings may have been. The data collected by Harold Schneider among the Wanyaturu, in the heart of the rock painting zone of central Tanzania, are particularly

Fig. 47 - Rock painting depicting lanky people with heads formed of concentric circles.

Fig. 48 - Partial view of the assemblage engraved in false relief in the shelter of Ba'attì Mariam, near the village of Bardà, fourteen miles (23 km) south of Asmara, in Eritrea (the people are about twenty inches [50 cm] high). This place is considered sacred by the region's Christians, who associate it with the Virgin Mary.

Fig. 48

[51] Collinson 1970, p. 61. [52] Masao 1991a, p. 134.
[53] For example Graziosi 1964a, fig. 10 ; 1964b, fig. 3c, 4-7. Calegari 1999 *passim*. Chaplin 1974, fig. 2.

Fig. 49 - Phallic stela engraved with an enigmatic motif, at Tutitti in Sidamo (Ethiopia), where there are thousands of this type of undated monument.

enlightening in this regard. Among the Wanyaturu, the concept of *luhida* ("beautiful, pleasant") may apply to any agreeable decoration as long as it is made up of drawings that are geometric and/or arranged in a rhythmic, symmetrical, balanced way but has no precise meaning. It can be used to refer to human creations (the decoration of a wall, for example) or to naturally occurring patterns. One could consider the coat of a giraffe or the hide of a bovine as *luhida*. At the same time, this concept is linked to a vocabulary and an aesthetic hierarchy of geometric motifs. For example, the motif called *madone*, which designates a whole series of dots, blobs, or round motifs (e.g., 000000), is more *luhida* than the one called *nsale*, made up of a series of parallel lines (e.g., ///////).[54] So one cannot rule out the possibility that similar concepts played a role in the development of the geometric decoration of certain sites in the same region, even in the case of descriptive paintings: the *nsale* motif would then correspond to the "streaky style," while the motif which is more *luhida*, and therefore preferred, would be associated with the hide of the giraffe, the animal which is by far the most common in the region's paintings.

Other elements collected by Schneider during his investigation make it possible to go further, because in giving as an example of a *madone* motif an ornament made of alternating red and white beads, he specifies that the Wanyaturu have no word for "color," but that their vocabulary can designate seven shades of the spectrum that differ from the colors we ourselves habitually attribute to the rainbow: yellow, light blue and green, dark blue, green and grey, black, red and orange, and white. This makes it possible to draw attention to a point that, curiously, seems to have escaped all specialists in rock paintings—namely, that the recognition of the color spectrum varies from culture to culture, and that some of our stylistic attributions could well be based on color criteria that were totally meaningless to the works' authors. Conversely, it is equally possible that works we group in the same category may have been distinguished by their authors in accordance with chromatic criteria we judge to be insignificant. Hence, in Ethiopia, the only words for color available to the Mursi are the following: *golonyi*: reddish brown; *biley*: yellowish brown; *chagi*: slate, ashy grey; *rege*: coffee-colored; *lumumi*: brown; *sirwai*: reddish-black brown; *koroi*: black; *gidang*: dirty white, grey; *holi*: white. And, of course, dozens of other examples could be cited in other languages.[55]

What is certain is that from the point of view of rock art, Azania displays its own stylistic and thematic features ("Ethiopian-Arabian" style in the Horn; schematic bovines seen from above; "corniforms" and lanky people with heads of concentric circles occurring from Ethiopia to Tanzania), while at the same time also displaying points in common with other regions: an abundance everywhere of nonfigurative geometric motifs recalling the intertropical zone, and with poorly studied extensions in Zambia and as far as South Africa; images of antelopes—especially of elands—make one think of southern Africa. But one can hardly see how one might make sense of such an incredible tangle without the help of detailed oral investigations and much fuller inventories.

Fig. 49

Facing page

Fig. 50 - The tumulus of Tuto Fela in Sidamo (Ethiopia) had several hundred stelae on top of it, most of which were decorated. The engravings decorating those which are clearly phallic may represent the stigmata of real practices: scarifications and subincision.

[54] Schneider 1966. [55] Tornay 1978.

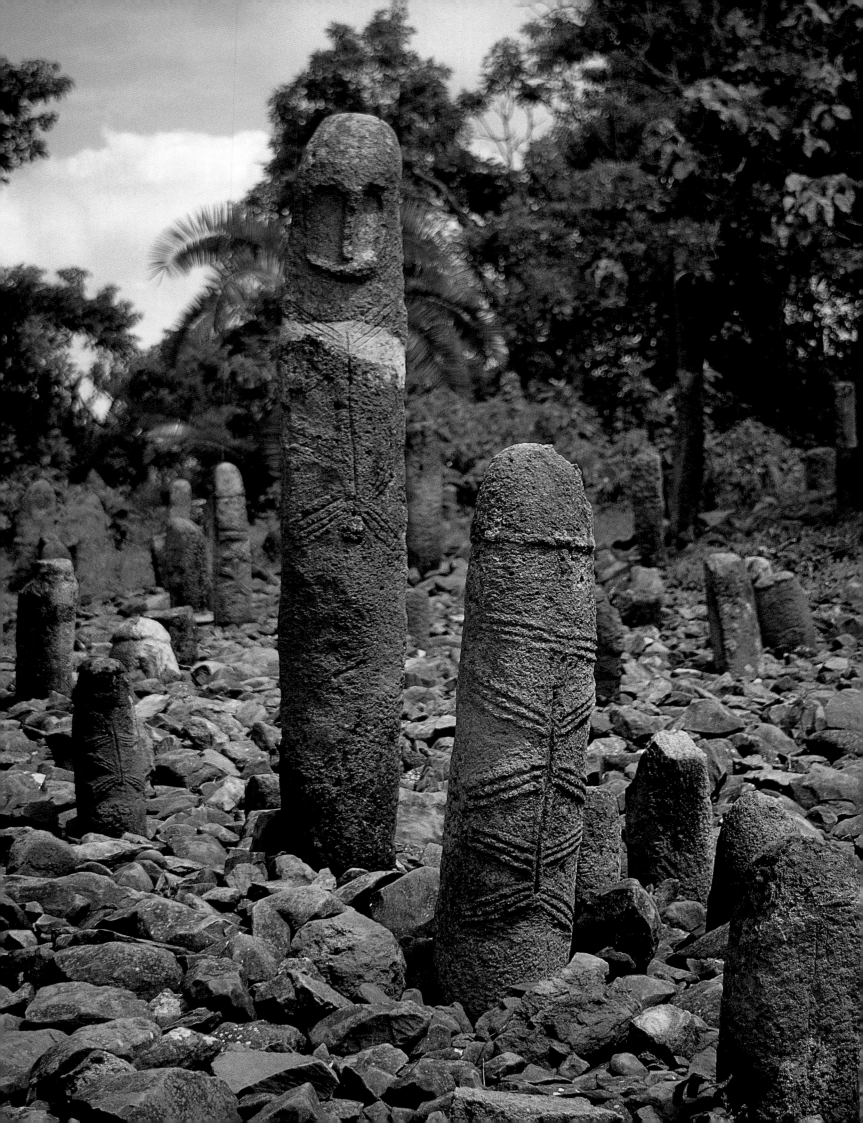

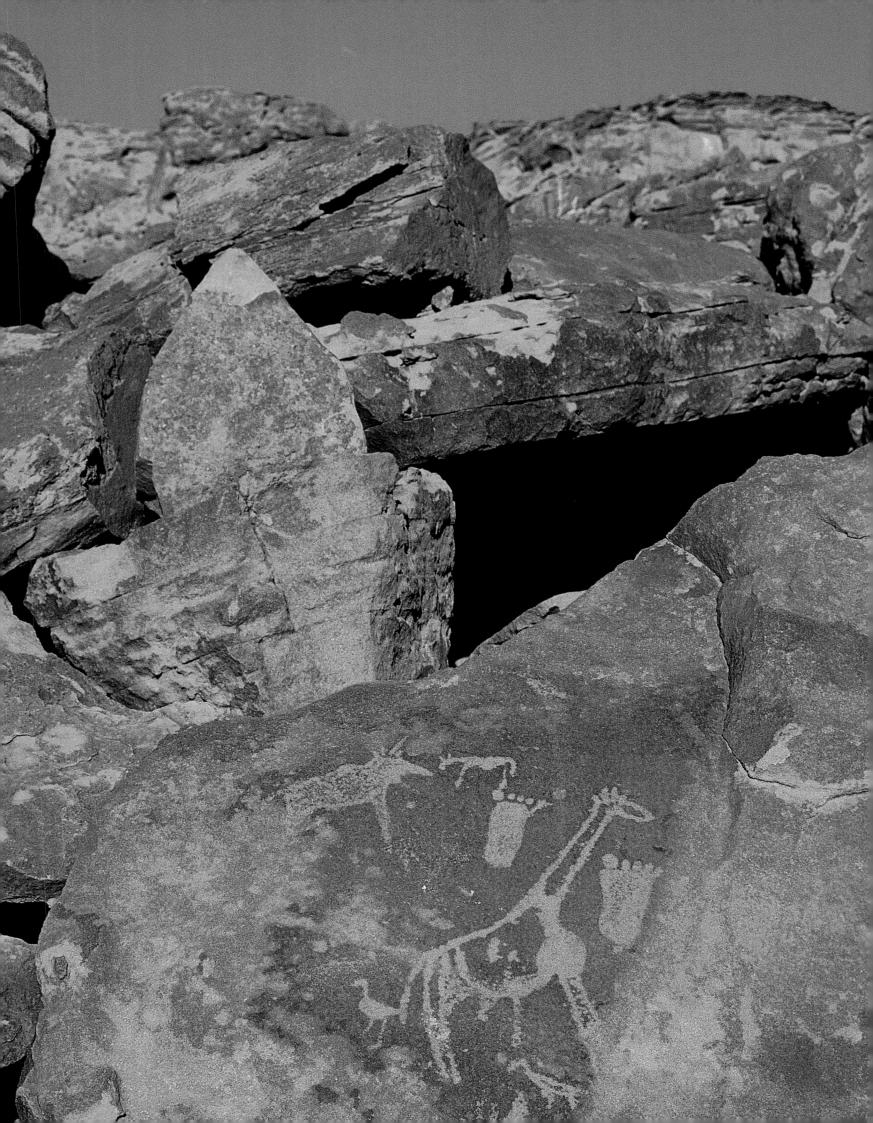

Southern Africa

"My artwork is the knowledge I carry in my mind from my previous life."

—**Katala Flai Shipipa,** a San painter born at Longa (Angola) in 1954 (as told to Marlene Sullivan Winberg in 2000)[1]

Fig. 1 and Fig. 2

First approaches

This zone is unquestionably one of the world's richest rock art areas. Westerners have known about these paintings since at least 1685, when Captain Van der Stel wrote that he had discovered "crude" figures north of the Cape, and declared himself absolutely astonished to see that "at the present time [they are] as perfect as if the colors had been applied yesterday."[2] In 1721, in a report to the Royal Academy of History in Lisbon, an ecclesiastic in the Portuguese colony of Mozambique mentioned paintings of animals on rocks.[3] Hence, an interest in rock art seems to date as far back in southern Africa as it does in Europe. Indeed, it was only in November 1879 that Maria, the daughter of Spanish archaeologist don Marcelino Sanz de Sautuola, while exploring a cave with her father, looked up at its ceiling to discover the rock paintings of Altamira, near Santander—yet this cave had been known about since 1868. This early recognition was no accident. In Africa, rock art is found mostly in the open air or on the walls of rock shelters and is thus more easily discovered than in Europe. In 1752, explorers guided by Ensign August Frederick Beutler, noticed rock paintings in the valley of the Great Fish River (eastern Cape) and recognized them as the work of the "Little Chinese," the name Europeans at that time gave to the "Bushmen"—the latter a derogatory term implying that all the ancient non-farming and non-herding inhabitants of southern Africa were seen as "savages." The Boer word *boschjesman* (attested in 1685), from the Dutch *bosjeman*, "bush man," was introduced into English in the form Boschees-men by A. Sparrman in his *Voyage to the Cape of Good Hope* (1785–86), and then in the form "bushman." The peoples who were given this name were for a long time massacred by the Boers, who treated them as "vermin" while hoping to solve by terror a "bushman problem" that in reality they had created themselves. Those who survived were forced to work for the whites. These names have now been abandoned due to their racist overtones, and although the different groups in question speak Khoisan languages that are often not understandable to each other and use no communal name for themselves, ethnologists conventionally call them by the ethnic term "San," borrowed from the Nama language. The latter term, however, is also contemptuous, since it means "thieves," "vagabonds," and "pilferers," and has been used to designate all the non-Nama, including whites! Nevertheless, and for want of something better, we shall maintain this usage here, and the terms bushman and Bushmen will be kept in the quotations from authors who employ them.

Hendrick Jacob Wikar, a Swede traveling along the Orange River in 1778, made the earliest mention of a rock art site in the northern Cape, when he reported "the spoor of animals" on a flat rock. At more or less the same time, in 1777–78, the first known copies of rock art in the whole of Africa were made during an expedition led by Governor Joachim Van Plettenberg to the *Sneeuwbergen* (Snowy Mountains) of the eastern Cape. They were made by Colonel Robert Jacob Gordon and his draftsman Johannes Schumacher.[4] The latter had already made a few sketches in 1777, during

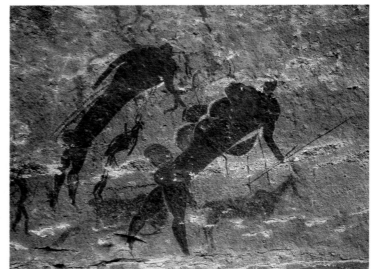

Fig. 3

Fig. 3 - Rock paintings in Main Caves at Giant's Castle (Drakensberg, South Africa). The two big figures are eland-headed therianthropes. The one on the right has three heads, two on top and one at the waist.

Preceding pages

Fig. 1 - Engravings at Twyfelfontein in Namibia.

Fig. 2 - Tracing of the "White Lady" of the Brandberg (Namibia) by Harald Pager.

[1] Winberg 2001, p. 96–97. [2] Ego 2000, p. 173. [3] Ritchie 1979, p. 27. Bahn 1998, p. 24. [4] Macfarlane 1954.

a previous expedition led by the Governor's son. He attributed these *tekeningen* (drawings) to the Chinese *boschjesman* (Bushmen): "Here for the first time I saw their drawings on the rocks. Some of them were fair but as a whole they were poor and exaggerated. They had drawn different animals, mostly in black or red and yellow; some people too. I can easily understand why it is said that they have drawn unknown animals because one had to make many guesses as to what they were. Made a drawing of the best" These copies, which for the most part have remained unpublished, are housed in Amsterdam's Rijksmuseum (*fig. 5*).

In 1790–91, Jacob Van Reenen noted in his travel diary: "on a rocky cliff the Bushmen had made a great many paintings or representations of wildebeeste, very natural, and also of a soldier with a grenadier's cap."[5] In this same period, the French traveler Le Vaillant published a book on South Africa in which he called these paintings "caricatures," and added of those in a cave in the eastern Cape: "The Dutchmen believe them to be a century or two old and allege that the Bushmen worship them, but though it is quite possible, there is no evidence to show it."[6] A very different attitude was that

Fig. 4 - Rock paintings at Tandjesberg at Ladybrand (Free State, South Africa). One can recognize a big eland and a whole series of elongated people, including therianthropes.

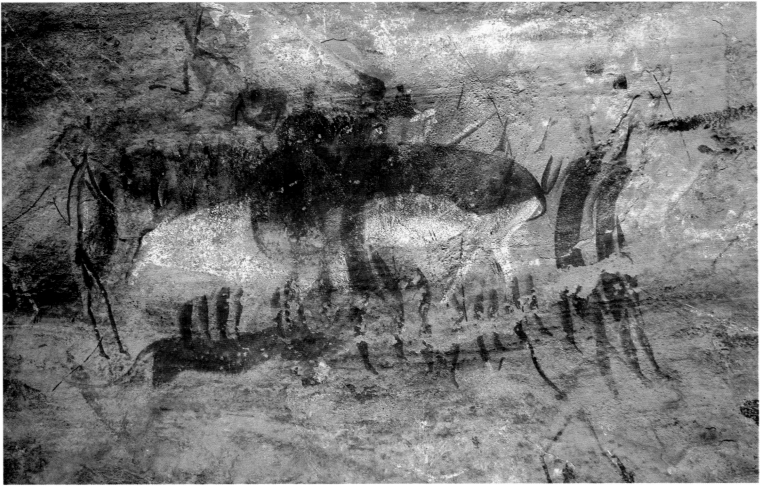

Fig. 4

[5] Bahn 1998, p. 25. [6] *Ibid.*

of Sir John Barrow, secretary to the Governor of Cape Colony, who traveled throughout the territory in 1797–98 and was amazed that the paintings could have been produced by people whom a writer in 1731 had described as "Troops of abandon'd Wretches" lacking laws, fixed abodes and region. Here is what Barrow had to say:

In the course of traveling, I had frequently heard the peasantry mention the drawings in the mountains behind the Sneuwberg . . . but I took it for granted they were caricatures only, similar to those on the doors and walls of uninhabited buildings, the works of idle boys; and it was no disagreeable disappointment to find them very much the reverse . . . In one place was a very large and curious cavern formed by a waterfall . . . a little on one side of the cavern, and under a long projecting ridge, of smooth white sand-stone, were several sketches of animals, and satirical attempts to represent the colonists in ridiculous situations and attitudes . . . The long-necked cameloparadalis was easily distinguished among the rest; as was also the rhinoceros and the elephant . . . Among the several thousand figures of animals that, in the course of the journey, we had met with, none had the appearance of being monstrous, none that could be considered as works of the imagination, 'creatures of the brain'; on the contrary, they were generally as faithful representations of nature as the talents of the artist would allow . . . On the smooth sides of the cavern were drawings of several animals that had been made from time to time by these savages. Many of them were caricatures; but others were too well executed not to arrest attention. The different antelope that were there delineated had each their character so well discriminated, that the originals, from whence the representations had been taken, could, without any difficulty, be ascertained. Among the numerous animals that were drawn, was the figure of a zebra remarkably well done; all the marks and characters of this animal were

Fig. 6

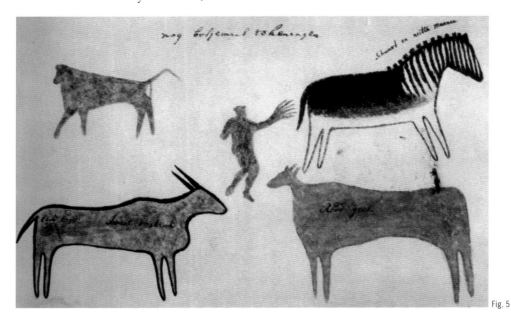

Fig. 5

Fig. 6 - The first "copy" of African rock art ever published, by John Barrow in 1801. Very probably an antelope image, the engraver reinterpreted it as a unicorn under the obvious influence of myths that in his own culture required that the legendary beasts were widespread within the limits of the known world.

Fig. 5 -Facsimile of a drawing made in 1777 in South Africa by Colonel Robert Jacob Gordon and reproducing, according to his handwritten caption, *tekeningen* (drawings) made by the *boschjesman* (bushmen), currently known as San.

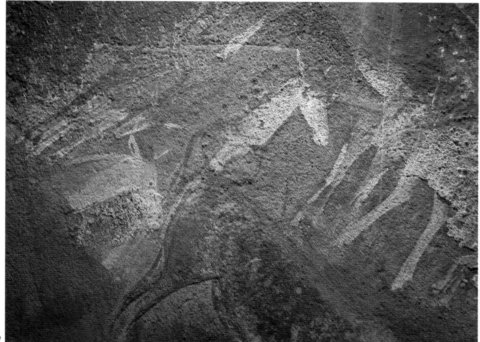

Fig. 7

accurately represented, and the proportions were seemingly correct. The force and spirit of the drawings, given to them by bold touches judiciously applied and by the effect of light and shadow, could not be expected from savages . . . The materials with which they had been executed were . . . charcoal, pipe-clay, and the different ochres. The animals represented were zebras, qua-chas,[7] gemsboks,[8] springboks,[9] reeboks,[10] eland,[11] baboons and ostriches . . . Several crosses, circles, points, and lines, were placed in a long rank as if intended to express some meaning; but no other attempt appeared at the representation of inanimate objects.[12]

In 1801, Barrow published a book containing the image of an animal head that is the first copy of African rock art ever published (*fig. 6*); the author thought it was a kind of unicorn:

We came at length to a very high and concealed kloof,[13] at the head of which was a deep cave covered in front by thick shrubbery. One of the party . . . gave us notice that the sides of the cavern were covered with drawings. After clearing away the bushes to let in the light, and examining the numerous drawings, some of which were tolerably well executed, and others caricatures, part of a figure was discovered that was certainly intended as the representation of a beast with a single horn projecting from the forehead . . . The body and legs had been erased to give place to the figure of an elephant.

[7] *Hippotigris quagga quagga?* [8] Antelope *Oryx gazella.* [9] Gazelle *Antidorcas marsupialis.* [10] Antelope *Pelea capreolus.*

[11] Antelope *Taurotragus oryx,* in English "Eland." In the rest of the text, we use the term "eland." [12] *In* Bahn 1998, p. 25–28.

[13] Boer term meaning "gorge" or "ravine."

The beauty of this art led Barrow to think that the Bushmen had been rendered more savage by the conduct of the European settlers. As for his reading of the works, one can see that it was influenced here by the explorer's mythological education since, faced with the drawing of an antelope, he thought he could recognize a unicorn, and published an image of it which would not have been out of place in illuminated medieval bestiaries. In 1867, the geologist George William Stow (1822–1882), fearing that they would disappear, began systematically to copy the rock paintings and engravings in the Orange Free State. He showed them to an old San called 'Ko-ri'na and his wife 'Kou-'ke, the last survivors of an annihilated group, who declared that these images were made by their people, commented on them, sang and danced at the sight of the dancing scenes, and explained a number of obscure details. For example, the fact that the lines on the head of some people represent arrows stuck into the hair, a common practice among San men. In 1870, Stow wrote to a friend:

> I have been making pilgrimages to the various old Bushmen caves among the mountains in this part of the Colony [Queenstown] and Kaffraria; and as their paintings are becoming obliterated very fast, it struck me that it would be well to make copies of them before these interesting relics of an almost extinct race are entirely destroyed. This gave rise to the idea in my mind of collecting material enough to complete a history of the manners and customs of the Bushmen as depicted by themselves. I have fortunately been able to procure many facsimile copies of hunting scenes, dances, fightings, etc., showing the modes of warfare, the chase, weapons, disguises, etc.[14]

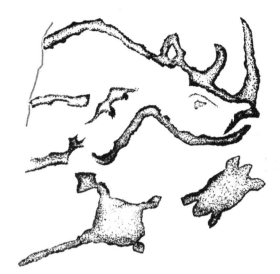

Fig. 9

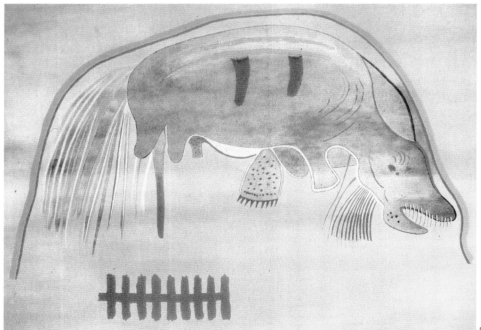

Fig. 8

Fig. 8 - Copy by George Stow of a painting at Rouxville. In 1874, W. Bleek and Miss Lloyd showed this document, which is faithful to the original, to some San, who recognized a "She-rain with the rainbow over her."

Fig. 9 - Rock engraving at Riverton (south of the Orange) known only from the tracing made by George William Stow, as the site was submerged after the construction of a dam.

[14] Bleek 1930, p. 26.

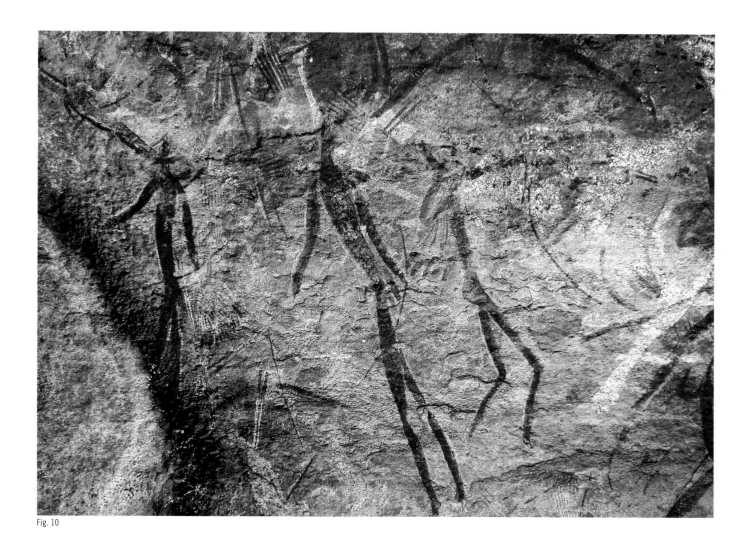

Fig. 10

Fig. 10 - Detail of the rock images at
Tandjesberg, on the farm of Tripolitania or
San Cottage (Free State, South Africa). Apart
from some big, very elongated people, which
are common in the region's art, one can also
see lots of details, sometimes minute, and a
whole assemblage of superimpoisitions that
make tracing difficult.

Stow was the first person to think of making copies in a systematic way. He traveled from site to site in an ox cart and colored his drawings with ochers and earths that he found at the very places he was studying. But to save paper he unfortunately adopted the habit of not drawing all the works, and sometimes grouped images from different sites on the same sheet. To describe these figures, Stow spoke of "mystic symbols," "symbolic drawings" and other "hieroglyphical emblems," as he was convinced that each image had a specific meaning (and only one) which had to be deciphered with the help of the region's inhabitants. They, out of politeness, tried to answer all his questions. It should be noted that some of the images, of which copies or stampings were bought by Miss Lloyd on Stow's death in 1882, had never been rediscovered in the field. This was often because, as he had foreseen, they had disappeared from the sites he had visited, either through erosion or through having enriched the collection of some amateur or museum (including the Musée de l'Homme in Paris)[15] or even through being submerged by the waters of a dam, as was the case for the engravings at a site in Kimberton engulfed in 1906, but that Stow had drawn beforehand (*fig. 9*). Fortunately, a large proportion of Stow's copies were published by Dorothea Bleek in 1930. Comparison of several of them with the original parietal paintings, rediscovered by Bert Woodhouse (1992), shows that they do not meet the standards of present-day researchers, but also confirms the fact that one would be wrong not to take these "beautiful but unfaithful" copies into account (*figs. 43, 46, 58, 59, 67, 80, 81*, for example) when the original paintings have disappeared or been partially obliterated. This applies

Fig. 11

Fig. 11 - The working methods of Emil Holub, using sledgehammers, wedges, thermal shock, and large bars to extract rock engravings in the Orange Free State in order to send them to Vienna, led him to vandalize the sites in an irreparable way. Today, Dr. Holub, who published this illustration in 1890, would fall foul of the laws protecting heritage.

15 Wilman 1968, p. 4–5. Ritchie 1979, p. 32. Woodhouse 2002, p. 24.

Fig. 12

Fig. 12 - Drawing by Mark Hutchinson, depicting
an immense rock shelter in the Drakensberg,
inhabited by San, some of whom are skinning an
antelope while others are decorating a large
inclined block with their paintings. In 1876,
the date when Hutchinson committed this
romantic vision to paper, the San still lived in the
Drakensberg, and, although it is idealized, this
picture was perhaps inspired by scenes which the
artist actually witnessed.

particularly to figure 8, which in the nineteenth century was clearly identified by the San to whom it was shown as a "She-rain with the rainbow over her."[16]

The first photograph of African rock art was taken in 1885 by von Bonde; it inaugurated a practice that would soon become very widespread. This technique made it possible to effect a partial escape from the subjectivity of manual recordings, but it also had its own limits. A photograph would certainly have been preferable to the romantic interpretation of Mark Hutchinson, who in 1876 drew some San busy painting a rock in a rock shelter at "Main Cave," in the Drakensberg ("mountain of the Dragon") whose Bantu name is uKahlamba (fig. 12).

In the same year that Hutchinson was sketching in the Drakensberg, the Colonial and Indian Exhibition presented an authentic "bushman painting" in London, depicting two eland on a block that had been removed by the geologist E. J. Dunn.[17] This was doubtless the first rock painting to travel in this way and, unfortunately, many others were to undergo the same fate. In 1893, for example, Louis E. Tylor removed paintings from the shelters in the Drakensberg to send them to Oxford to enrich the collections of the Pitt-Rivers Museum. Similarly, Emil Holub, a doctor and collector who traveled a great deal in the Orange Free State, managed to amass a large collection of rock art, while accumulating observations at the same time. Hence, during his first journey, he wrote with some satisfaction: "I have managed to obtain several of the curious tools that were used to make the engravings, and which consist simply of triangular flint flakes."[18] When he died, his collection was dispersed among numerous European museums, most notably to Vienna, which has several paintings and numerous engravings,[19] of which his friend J. V. I. Zelízko later published a series of copies (1925). In one of Holub's books, an engraving illustrates the techniques he used in his work: one can see the collector himself supervising an assistant who is pouring buckets of cold water onto an engraved rock, below which a fire has been lit, in the hope that the rock would shatter but spare the image. Elsewhere, another man is trying to detach a rock figure by forcing a fissure with a chisel. One of their companions is using a sledgehammer to insert wedges around a third work, while others are using large bars to lever off an image half emerged from the ground (fig. 11). For every engraving that reached the Vienna museum to which Holub sent them, how many were destroyed?

In Zimbabwe, where thousands of sites are known today, the earliest mention of rock art was by J. Theodore Bent, who made a few sketches of paintings at Mutoko, in Mashonaland, in 1891, although he considered their content to be of no importance.[20] From that period until 1936, Lionel Cripps, who thought the local artists had certainly not made their works "as a way of passing the time," traveled throughout the country to copy rock images, amassing the great asset of eleven big volumes of copies that are today preserved at the Museum of Human Science in Harare.[21]

In 1896, on a visit to Vryburg, S. Schönland described the rock engravings located on vertical walls at Lochnagar and Maribogo, and read a paper to the South African Philosophical Society in which he declared: "The peculiarity of them was that, instead of being, as usual, simply representations of animals, they resembled designs that seemed to indicate the existence of some kind of writing among the Bushmen hitherto entirely

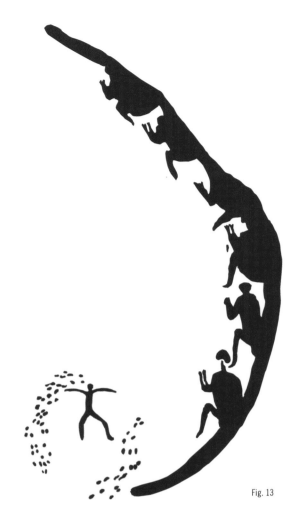

Fig. 13

Fig. 13 - One of the copies of rock paintings made by Helen Tongue at Mount Victory, near Dordrecht, in the Cape (South Africa). Taking into account the opposition of farfat-female / thin-male, which is traditional within San societies, the apparently enigmatic arc-of-a-circle motif could represent a group of women leaning their backs against a windbreak, and clapping to encourage the solitary dancer.

Fig. 14 - Block from Klerksdorp (western Transvaal) engraved in such a way that the eland depicted is harmoniously integrated with its surface. The technique used—a simple pecking—made it possible to indicate even the folds visible under the neck and at the top of the forelegs.

Fig. 15 - Detail of the immense painted wall in the cave of Mtoko in Zimbabwe, copied as a watercolor by Joachim Lutz, an artist who was part of the expedition led by Leo Frobenius in southern Africa in 1928–1930.

16 Stow & Bleek 1930, pl. 34 ; cf. Woodhouse 1992, fig. 21 for the original.17 Ritchie 1979, p. 36. 18 Holub 1881, vol. 2, p. 439. 19 Wilman 1968, p. 3. 20 Garlake 1993.21 Parry 2000, p. 23.

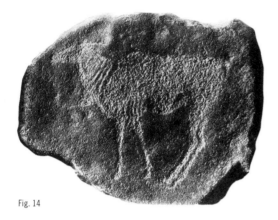

Fig. 14

unsuspected."[22] But this hypothesis of a proto-writing, which has often been put forward since then in relation to the incomprehensible signs in the rock art of the whole world, was erroneous.

In 1909, the German Lieutenant von Jochmann reported paintings in the Brandberg, the Erongo, and the Spitzkoppe, and published a few reproductions in the January 15th edition of *DieWoche*, a popular German weekly. These paintings were to inspire the vocation of Reinhard Maack, discoverer of the "White Lady" of the Brandberg. The same year, Helen Tongue published her beautiful collection of "bushman Paintings." On contemplating the reproductions that were presented in it (e.g., *figs. 13, 64, 65,* and *71*), the English art critic Roger Fry was amazed that images endowed with such "perfection of vision" could have been made by "the lowest of savages." He deduced that "the concepts were not so clearly grasped as to have begun to interfere with perception," and thus conjured up a racist theory which was to prove very durable: the painters had "a peculiar power of visualization" thanks to which "the retinal image passed into a clear memory picture with scarcely any intervening mental process."[23] Hence, his fascination with the so-called "artist-savage" led him to invent the curious idea of an art produced outside culture and arising only from a natural sense that is particularly well developed among these same "savages," in short, from a quasi-animal frame of mind. From this point of view, the question of the art's meaning obviously had no purpose!

In 1929, Leo Frobenius mounted an expedition to Rhodesia and South Africa, receiving from these countries a grant of £5,000 and the possibility of free transportation on the railways. He was accompanied by a team of seven artists who were responsible for

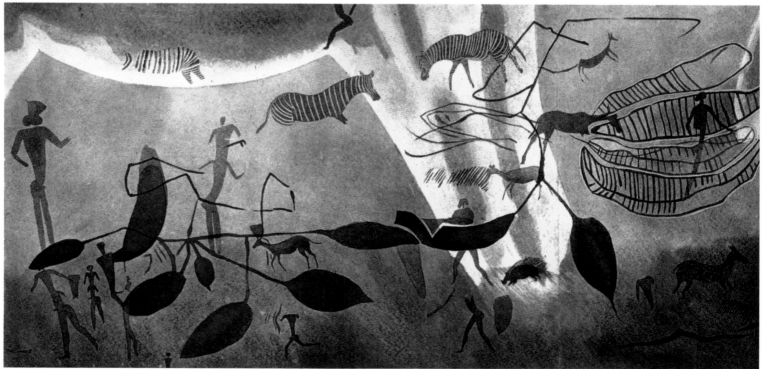

Fig. 15

22 Schönland 1895–1897. See Wilman 1968, p. 6, fig. 1. 23 Fry 1910.

copying the rock images, and the result—watercolors, pencil drawings, stampings, and photos—would be published in two sumptuous volumes: *Madsimu Dsangara* and *Erythräa* (*fig. 15*). Although only a small portion of the copies they made were published (there were more than 1,100, most of which were destroyed during the bombing of Berlin), and although these works did not have the expected repercussions (because they were not translated from the German), the Frobenius expedition marked the start of the great study campaigns and the systematic copying by well-known researchers, such as the Abbé Breuil, who had already been anointed "Pope of prehistory" when he began to take an interest in southern Africa (*figs. 16* and *17*).

The myth of the "White Lady"

Dâures, the "burning mountain"—rechristened Brandberg by the colonial cartographers—is the highest massif in Namibia (altitude 8,440 ft. [2,573 m]), on the edge of the Namib Desert. Offering relatively favorable living conditions, this zone has attracted people throughout the ages; and the rocky reservoirs in which rain water is conserved in the dry season make it a haven for all living creatures. At the limit between the semi-desert zone to the west and the savannah to the east, it is one of the most important rock art sites of southern Africa. It was in this massif that, very early on, an image was noticed that was to inspire voluminous commentary—the "White Lady of the Brandberg" (*figs. 18* to *22*, *25*). Ernst Rudolf Scherz, a chemist by profession but also a great rock art enthusiast, guided the Abbé Breuil to her. Here is the account of his discovery, as told by the Abbé Breuil:

> In the course of a topographical mission in 1917, a German, Mr. Reinhard Maack, who was in the service of the geodesic office of Windhoek and entrusted with drawing up a map of the Brandberg massif, spent several weeks among its peaks, where supplies of water and food must have been particularly precarious. Having finished his work, he descended—with the hope of finding a water source there—the precipitous slope of the great ravine that cuts the massif almost in two, from the southwest to the northeast, where he emerged onto the plain of the Ugab River. He was dying of hunger and thirst. It was at the end of this descent that, completely by chance, he encountered the painted shelter that has brought fame to this place and to the discoverer's name. Despite his physical destitution, he was able partially to grasp its importance and, in his topographic notebook, he recorded sketches of the main figures, obviously without being able to wet them since he lacked water, which prevented him from appreciating all the details of color and subtlety. He also took its measurements and on returning to Windhoek made a scaled transfer of his drawings; he made several copies of this, and later distributed them among several museums in the Union, including the University of Johannesburg. It was there, in 1929, that I was to see it and, despite the obvious imperfection of the tracing, I was profoundly struck by it. I was not the only one; Miss Marie Weyersberg, one of the best artists in the Frobenius team, came in her turn, in 1928, to study the painted rocks of the country, including this one. She made a far better copy

Fig. 16

Fig. 16 - Abbé Breuil tracing a painted wall with the help of Miss Boyle and Dr. Scherz.

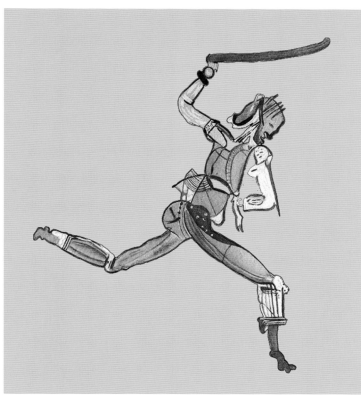

Fig. 17

of it in the course of a difficult excursion, cut short by the time lost in searching for the site, and a lack of provisions. In 1932, Messrs Obermaier and H. Kühn also published Maack's plates without much in the way of commentary. Mrs. Alice Bowler Kelley, on a year's trip to South Africa, came to Windhoek with the aim of returning to the site and taking some good photographs of it. She was able to do this thanks to the help of the German Dr. Ernst Scherz, but not without great difficulties in finding the rock. Events prevented my knowing the results of this expedition before 1943, when, at the invitation of Field Marshal Smuts, I came to the Archaeological Survey de Johannesburg, directed by my friend Professor C. Van Riet Lowe. There I found a series of enlargements of the photographs of the Maack shelter taken during Mrs. Bowler Kelley's expedition. It was then that I discovered the extraordinary profile of the principal figure which was also, quite independently, recognized by my secretary, Miss M.E. Boyle. This face was that of a woman of a clearly defined Mediterranean race, dressed in shorts, like the young girls in Cretan bullfights. I had to get this off my chest. I notified Marshal Smuts and after the war, in 1947, he obtained the means for us to go there. A stay of a couple of weeks, guided by Dr. Scherz, was made, which enabled me to make an exhaustive tracing, and enabled Mr. Scherz to take numerous excellent photographs.[24]

The image quickly elicited a wide variety of opinions. According to Maack, its discoverer (*fig. 19*), it was of an "Egyptian-Mediterranean style."[25] For Mary E. Boyle, the Abbé Breuil's collaborator, the image was of a "Cretan woman." Marie Weyersberg declared: "this cultural document cannot be squared with bushman mentality;" agreeing with Leo Frobenius, she added that one had to see a Mesopotamian influence in it. And in the 1930s, Colonel Imker Hoogenhout, administrator of South West Africa (which has since become Namibia), declared on visiting the site: "You are quite right, this is not a bushman painting, it is Great Art."

What was the Abbé Breuil's conclusion after spending two weeks at the site, and thus having plenty of time to examine it closely? His account includes some clearly racist opinions, declaring that, through "numerous retouches" they had changed, for example, "the racial type of one of the people, with a Mediterranean profile; the secondary restoration gave it a crude Negroid nose."[26] Elsewhere he wrote: "The academic perfection of certain human drawings of the South-East in harsh contrast, in Léribé (Basutoland), to the hideousness of the little Bushmen, with their paunch as if after a long period of feeding on locusts, might suggest that they could represent the continuation of the beautiful art of the South-West, though somewhat degenerate."[27] He also sent Smuts, who was then Prime Minister of South Africa, a letter informing him of "his" discovery: "I have sent you the portrait of a charming girl who had been awaiting us on a rock of the Brandberg for perhaps three thousand years." He went as far as to compare the Brandberg landscape with the ruins of a Greek city.

Then he described the image in question, which in his opinion formed part of a

Fig. 17 - Tracing by Abbé Breuil of a painted human in the shelter of Chehonondo (Zimbabwe), eighteen inches (45.5 cm) high, which he nicknamed "The Warrior."

[24] Breuil 1965, p. 129–30. [25] Maack 1966. [26] Breuil 1965, p. 130. [27] *Ibid.*, p. 15.

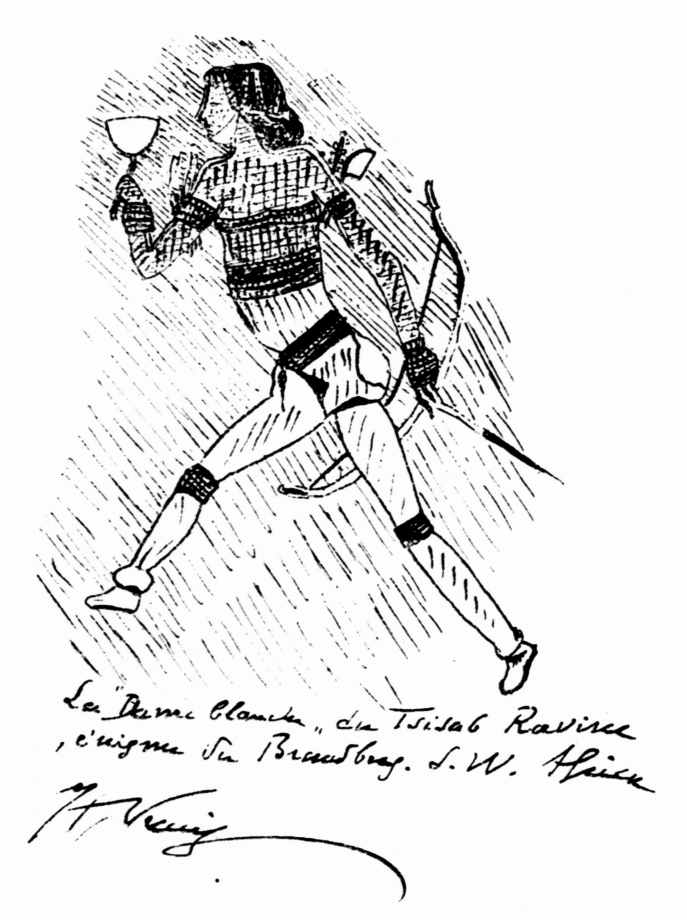

La "Dame Blanche" du Tsisab Ravine, énigme du Brandberg. S.W. Afrika

Fig. 18

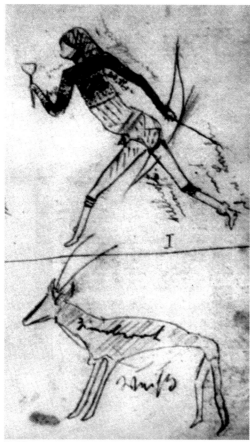

Fig. 19

"ceremonial procession" in which two people playing musical bows were taking part: "In the centre, with a light step, walks the very young girl that I have called the White Lady. In front of her she is holding something like a big white lotus (?) flower [if it is not an ostrich egg cup] and behind her a taut bow with an arrow ready to be fired. Her garment is close-fitting, and highly decorated, as is her red hair. On her left hand, she wears an archer's gauntlet, like several of her companions; the latter are carrying bows and arrows and wear gauntlets, but none of them is ready to fire, except an adolescent with a very small bow, a kind of page-boy walking before the White Lady; he displays Egyptian shoulder straps, and is of that racial type with a dark coloring."[28] The Abbé next described the other people in the scene, among which he included a man "made up as a skeleton," a "woman of African appearance," a masked archer, another "archer of clearly Nubian character," six people "of Europoid Mediterranean type," six others who "are certainly blacks," but, he added, "none of them is a bushman or Hottentot." And he concluded: "Hence, mixed population, including white elements, and other negro elements, with an obvious Egyptoid flavour,"[29] but not including an "australoid" element. Moreover, he declared that the face of the so-called "White Lady" had "nothing native" about it, whereas her gender—female—was quite definite.[30]

The observer's culture overrode observation, since the "very young girl" described by Breuil is in reality a man, whose penis is clearly visible. What's more: this penis is infibulated (or equipped with a penis sheath decorated with protuberances), which provides some important ethnographic information. The conclusions that Breuil drew from his pseudo-observations of "foreign," "Semitic," or "Nilotic" people, led him to assume a migration as far as the far south of Africa by Nilotic painters, and he added: "the art that they brought is closely related to the frescoes of Libya and the southeastern Sahara; it is highly superior—especially with regard to human types—to that of the preexisting African natives; one sees here the same taste for the episodic incidents of ordinary life as in the Tassili n'Ajjer, for example." All the same, he did not go so far as to assume a migration from Egypt, but he liked to imagine a "branch detached from the Libyan trunk, like the Egyptians and perhaps as far back as them, before the drying out of the Sahara."[31] As for the "White Lady" herself, he saw in her a depiction of Diana or Isis![32]

Some of these ideas were to prove durable. In 1965, Burchard Brentjes—although he recognized that this painting was not a "lady" but "a heavily made-up man wearing a mask, holding a bow in one hand and a goblet or a flower in the other," and although he rejected the declaration of a Cretan origin of this person's costume nevertheless still considered it to be "ascribable to Hamitic peoples or their influence" (*fig. 22*).[33] As for the so-called lady's "Mediterranean" profile, it scarcely appears on the image and, apart from the fact that there are Africans with a profile like this, it has been suggested that the Abbé Breuil could have been deceived by a nasal ornament of a type still being worn by certain San at the beginning of the twentieth century.[34]

This is how the "White Lady"—who is neither a lady nor white—became "a solitary jewel"[35] artificially isolated, whereas in reality she forms part of a panel filled with equally interesting figures and in which there are numerous South African cultural traits.[36] Her fame is totally unjustified, since there are thousands of similar figures in the Brandberg. Her story bears witness to the orthodox opinion held among the rare authors who took

[28] *Ibid.*, p. 130. [29] *Ibid.*, p.131. [30] Breuil 1948, p. 7. [31] Breuil 1965, p. 22–23. [32] Breuil 1948, p. 9–10.
[33] Brentjes 1970, p. 22. [34] Harding 1967, p. 31. [35] Kuper 1996, p. VI. [36] Jacobson 1980.

Fig. 18 - Drawing by the Abbé Breuil to which he gave the caption: "The White Lady of the Tsisab Ravine, enigma of the Brandberg."

Fig. 19 - Page from the 1917 sketchbook in which Reinhard Maack noted his discovery of the "White Lady" of the Brandberg Mountains who was going to achieve great fame.

this art seriously, that within the rock art of southern Africa the most "beautiful" should be attributed to Cretan, Hamitic, or Egyptian influences or invasions. So one can understand Peter Garlake's outrage over Breuil's work in southern Africa, the hegemony of which became even further entrenched when Breuil became president of the South African Archaeological Society in 1947: "Breuil's work in Rhodesia is a sad and cautionary tale of the results of fame, of decades of unchallenged authority leading to dogmatic assertions, derived from cursory examinations, inaccurate copying, complete lack of systematic comparative studies and the isolation of tendentiously selected items from their contexts."[37]

But we should not be too unforgiving toward the Abbé Breuil, the promoter of the myth of the "White Lady" of the Brandberg—which still fools the tourists—because, although he also believed, wrongly, that he had recognized the Mastodon (a fossil cousin of the elephant) in the paintings of Elephant Cave, he was nevertheless the first person (in 1954) to obtain radiocarbon dates that he tried to relate to Namibia's rock art. This involved pieces of charcoal from the excavation of a decorated cave called Philips Cave that yielded an age of 3370 B.P. In reality, these remains merely gave an idea of the age of the layer from which they were taken and did not date the art. After Breuil, other authors tried in vain to trace back certain rock images in southern Africa to Egyptian mythological sources. For instance, Raymond Dart who in 1963 studied apparent hippopotamus figures recorded in the Cape—images that today are known to evoke a mythical "rain animal" and not the real amphibian. Dart supposed that they corresponded to a mytheme related to the Egyptian cult of the goddess Thoeris, but his speculations are now forgotten.

When he left southern Africa for good, Breuil handed over to Scherz, his volunteer guide, the assegai he had kept with him during his sojourn, telling him: "I surrender you my weapons." Subsequently, Scherz undertook a campaign of systematic copying, and broke with Breuil's habit of only publishing works selected according to personal criteria. Scherz traced the paintings directly onto plastic sheets placed against the walls, and then transcribed them onto paper, thus obtaining far more exact copies than the simple sketches that most authors had painted freehand until then. Moreover, his wife, a photographer, completed this documentation by taking thousands of shots. Together they documented more than four hundred sites, purposely avoiding all interpretation and contenting themselves with modestly preparing a corpus that made possible all later serious and precise studies.

Corpus and statistics

From 1958 onward, Gerhard Jürgen Fock, the first archaeologist ever employed by a South African museum, spent all his leisure time copying the rock paintings and especially engravings of the northern Cape, helped by his wife Dora. He used photographs and stampings and was careful to draw up maps of the sites visited. On Gerhard's death in 1990, the fruits of their work comprised twenty thousand documents deposited at the McGregor Museum in Kimberley, and also a series of publications that far surpassed everything

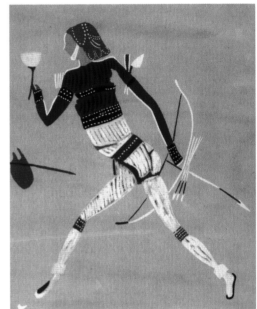

Fig. 20

Fig. 20 - Tracing of the "White Lady," published by Jalmar and Ione Rudner as the frontispiece of their book of 1970—beautiful but not faithful!

Fig. 21 - Tracing of the same painting in the book the Abbé Breuil devoted to her.

[37] Garlake 1993, p. 15.

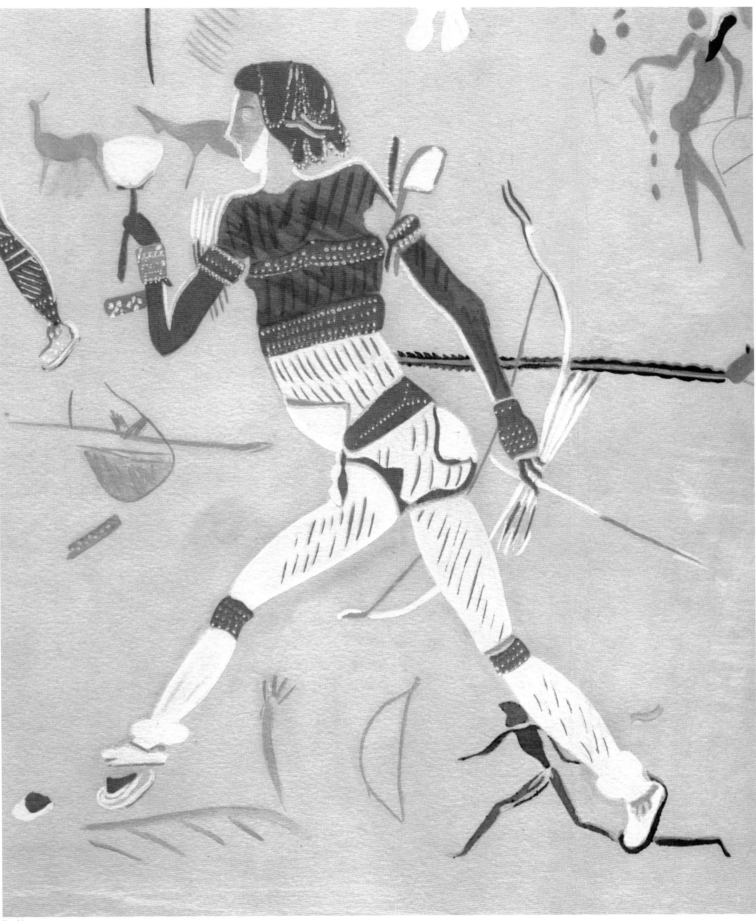

Fig. 21

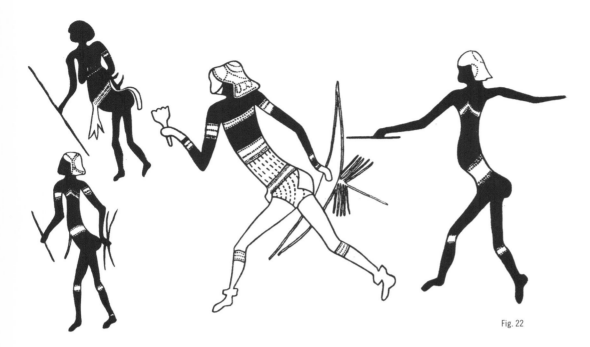

Fig. 22

done previously, thanks to both the quality of the illustrations and the care taken to use a precise terminology in the inventories.[38] While the paintings had already received a great deal of media coverage, their work showed that an entire world—that of the rock engravings—had been largely forsaken and deserved to be a subject of interest. There thus began a new phase of research, one that aimed to accumulate corpora, inventories, and quantifications aiming at an approach less likely to be affected by the observer's mythology than had previously been the case, even if it left aside the question of myths peculiar to the creators' culture. A certain Jalmar Rudner, a curator at the South African Museum, and his wife Iona, employed by the same institution, applied themselves to a task of this type. They acquired expertise in the rock art of the whole of southern Africa and published copies of paintings in the Upper Brandberg,[39] an assemblage of sites at an altitude of more than 6,000 feet (1,800 m) (examples of their copies: *figs. 21*, *25*, and *69*).

Harald Pager, who also took part in this phase of research, was an amateur, but his documentation of the paintings of Ndedema Gorge in the Drakensberg, in South Africa, published in 1971, brought him unanimous recognition in the scientific world. His vocation came to him when he noticed that Scherz had become old and could not finish copying all the paintings of the Brandberg. He therefore decided to take over this task, estimating that at most it would take two years of work. In reality, he had greatly underestimated the size of the task that remained to be accomplished, and after spending eight years alone copying the paintings of this massif, within the framework of a project of the DFG (German Scientific Foundation), he died prematurely in July 1985, before he had been able to finish copying the Upper Brandberg. But the work he did accomplish is exemplary. For each site, Pager drew up a plan of location and elevation at a scale of 1 : 100, marking the exact position of all the decorated panels. In addition, he noted the location of water sources, studied the regional flora, and recorded its climatic particulars. He also traced each panel in pencil, marking information about colors with the help of a personal system based on the Munsell chart used by geologists to note rock colors. While he was producing his copies, his two assistants, Angula Shipau and Johannes Toivo, searched for other sites in the surrounding area. These three tireless researchers located more than a thousand of them, 879 of which were copied completely, making a total of some 43,000 figures that were faithfully drawn—constituting the most important documentation of rock art in the world. It is currently being published by the Barth Institute

Fig. 23

Fig. 22 - "Tracing" of the same panel of the "White Lady," published by Burchard Brentjes in 1965. The comparison of this image with the previous two and fig. 24, shows how much rock art studies are dependent on the quality of the documentation.

Fig. 23 - Undulating antelope-headed snake painted in red on a bulging rock at Karoab in the Upper Brandberg.

[38] Fock 1979. Fock & Fock 1984 and 1989. [39] Rudner & Rudner 1970.

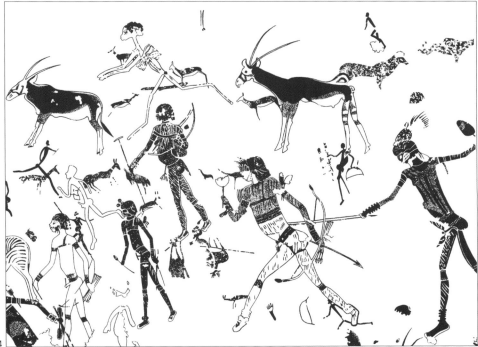

Fig. 24

of Cologne under the careful supervision of Tilman Lenssen-Erz. In this institute, whose name pays tribute to the discoverer of the first Saharan engravings ever reported in Europe, professional draftsmen reduce the original tracings to a quarter size, then ink them according to the color code proposed by Pager. The whole thing is then published in a series of sumptuous volumes, among the most beautiful ever devoted to a rock art province. Thanks to Harald Pager, for the first time the original images were considered as documents to be established, and his work can be considered as an analysis of the works. It is highly desirable that equally scrupulous analyses should be undertaken at other rock art sites throughout the world (e.g., *figs. 24, 25, 33, 51, 53, 55*).

Pager's work, comprising complete annotated, contextualized tracings, magnificently fulfilled the recommendations of Patricia Vinnicombe and Tim Maggs who, from 1967 onwards, pleaded for a statistical study of the subjects depicted. Hence, in Namibia, anthropomorphs dominate in the paintings, where animals account for only about 20 percent of the images. In the Upper Brandberg, abstract motifs are rare, and animals— most often depicted in a very naturalistic way that displays a keen sense of observation— are savannah species: antelope (especially springbok), giraffes, zebras, and elephants. The virtuosity in their draftsmanship shows that most of these images originated from an artistic "profession." Were their authors also storytellers? Chroniclers? In any case, they must have been specialized "officiants." But how can one make their works speak? In the 1970s, it was thought that only the statistical approach was capable of letting one glimpse their meaning objectively. In fact, the study of the numerical distribution of subjects does enable one, if not to "read" the rock art sites, then at least to correct certain ways of looking at them that had prevailed until then. Hence, one can no longer say that the art's essential function was to illustrate everyday life, because meticulous excavations have shown that the artists' diet must have comprised small animals (tortoises, small mammals), ostrich eggs, and especially plants (which make up 60 to 80 percent of the food of the present-day San groups of the Kalahari), as well as fish and shellfish for the coastal populations. These elements are rarely represented in the art—never, as far shellfish are concerned. The most numerous drawings in the Brandberg are anthropomorphs, which constitute from 55 to 78 percent of the figures depending on the site: men with bows and arrows, women carrying bags and baskets. But dwellings are rarely

Fig. 24 - Detail of the panel of the so-called "White Lady" at Tsisab Gorge in the Brandberg. The degree of precision of this tracing, owed to the talent and the patience of Harald Pager, is immediately apparent through a simple comparison with those by his predecessors. As a result one can appreciate the necessity of establishing and analyzing rock art documentation, just as a historian must do for his sources, whatever their nature.

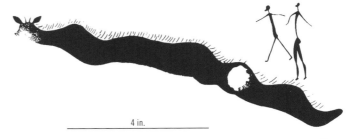

4 in.

Fig. 25

depicted, and landscapes almost never. Equally rare are collective scenes that can be interpreted with certainty as depicting hunting activities, dances, or fights. In general, the sites are close to water sources in the high zones of the massif, often near a plateau. The paintings are placed at the back of protective granite shelters, and the great majority of them are close to living places; yet in some locations they are quite inaccessible and thus assumed to have some function other than being purely decorative. The figures are painted on the rock with no primer, and their colors mostly come from earths (ocher for the reds and yellows, manganese for the black), charcoal, and gypsum. It is assumed that the binders may have included blood, egg, fat, casein, or even bone glue or the latex of certain plants. Extending Pager's work, Tilman Lenssen-Erz has drawn up an inventory of the Brandberg images, using simple criteria to define animals, people, activities (running, carrying, holding), objects (bag, bow, stick, etc.) and characteristics (shape, color, dimensions), so as to be able to produce a standardized description of the works in order to subsequently make comparisons between elements such as "running giraffe," "woman carrying a basket," "man carrying a bow," and so on, a method that produces descriptions and comparisons relatively free from interpretation.[40]

Certain critics have vigorously rejected these "empiricist" approaches,[41] and denounced their neopositivist pretensions to objectivity, since the elements compiled by the Focks, Scherz, Pager, or Lenssen-Erz do not constitute raw data, but are the product of personal readings and interpretations, and because their criteria of formal analysis also arise from a series of choices. The fact that these remarks are perfectly justified should not make one forget that the "empiricists" never claimed to be achieving absolute objectivity, and that the same criticisms can just as well be applied to the work of those who make them, while displaying a very casual attitude toward factual data. Above all, the scientific study of rock art responds better to incomplete objectivity—taking on its share of subjectivity through the use of verifiable procedures than to the total subjectivity of those who over-interpret a handful of carefully chosen images, removed from their context, with the sole aim of illustrating their personal convictions.

From image to myth

Mythologies are revealed through enigmatic figures such as therianthropes and snakes with ears (*figs. 23, 25,* and *69*), some of which can be several yards long (16 ft [5 m] at Gumubahwe Cave in the Matopos), or (as in the Brandberg paintings) reptiles with ears and with hair on their backs (*fig. 25*). Other images of giant snakes could, in a pinch, represent naturalistic observations, if only they were not accompanied by flying mythical beings (called *alites*) in the Eastern Cape (*fig. 26*), of if they did not display a dotted ornamentation, with no natural equivalent, at Mutoko in Zimbabwe (*fig. 29*). Although statistically a tiny minority (0.5 percent in the Brandberg), these images are extremely interesting because they are direct evidence of the mythology that inspired the painters (in at least part of their production), and because they make possible very revealing

Fig. 26

Fig. 25 - Giant snake with antelope ears, two small horns, and a mane standing on end all along its back, accompanied by two filiform people. Painting in the Bemani shelter in the region of Cathedral Park in South Africa.

Fig. 26 - Snake drawn vertically near two flying beings ("alites") which establish the mythical character of this assemblage, painted at Sunnyside, near Salem in the eastern Cape.

Fig. 27 - Rock paintings at Tandjesberg at Ladybrand (Free State, South Africa). Detail showing a small dancer superimposed on other older paintings.

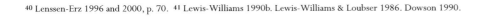

40 Lenssen-Erz 1996 and 2000, p. 70. 41 Lewis-Williams 1990b. Lewis-Williams & Loubser 1986. Dowson 1990.

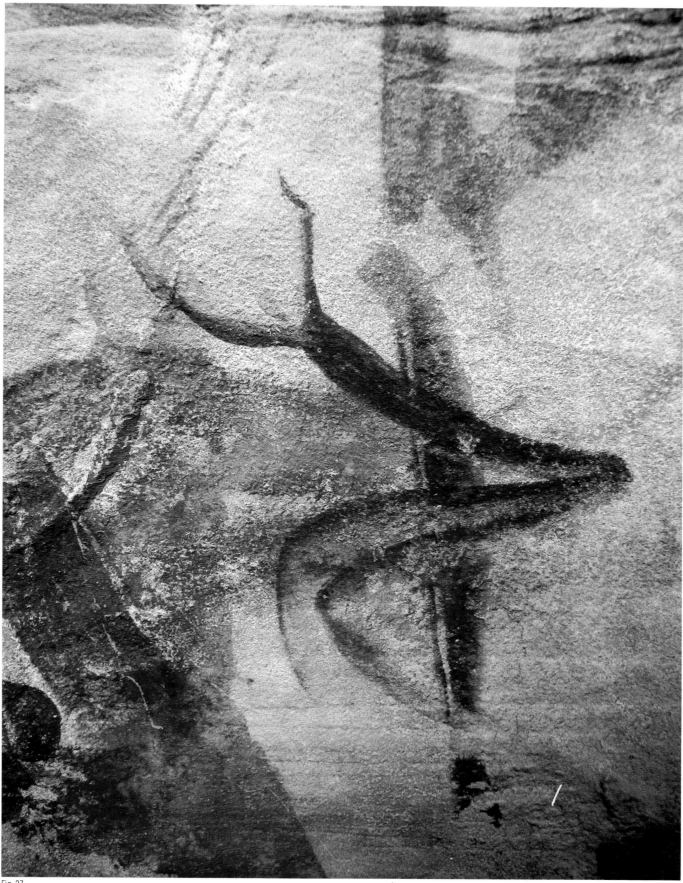

Fig. 27

comparisons with oral traditions that even today allude to similar mythical beings—considered quite real by certain peoples of southern Africa.

For example, Stow recorded (in 1905) an old San woman's description of a horned, aquatic snake, about thirty-two feet (10 m) long; and a myth recorded in the Matopo (or Matobo) Hills[42] speaks of an immense snake whose head rested on the summit of Balla Balla, while its tail was still about nineteen miles (30 km) away. It was also in the Matopos, during the first half of the twentieth century, that people spoke of a legendary giant snake, the Muhlambela, twelve feet long with feathers growing on its head and able to bleat like an antelope to attract people[43]—a tradition one cannot help comparing with the very big antelope-headed snakes (even bird-headed snakes in the Matopos) depicted in rock paintings. Other tales from Zimbabwe tell of a snake carrying both the mountains and their human and animal inhabitants on its back.[44] A rock painting from the Matopo Hills (preserved in the Bulawayo museum) represents a python from which numerous creatures are springing up. Might not this image illustrate a cosmogonic myth such as the tale recorded among the Venda, according to which: "Originally, men and the whole of creation sat inside the belly of the Python, which vomited them out"? It is conceivable, particularly as there is evidence that the Venda sojourned in this region.[45] In the Drakensberg, the Hlubi say a giant snake called Inkanyamba haunts the summit of Mount Mpendle, where it brings rain. It has an antelope head and a mane on its back, and it goes from mountain to mountain to copulate in water sources.[46] The Transkei San tell of ritual hunts where one dove into water to look for reptiles, which were then used for powerful remedies as well as for ingredients for paintings.[47] Among the San of Lake Chrissie, in order to become a

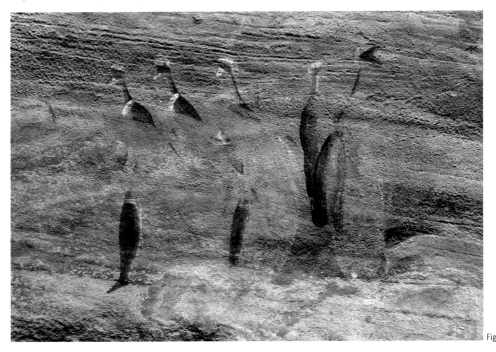

Fig. 28

Fig. 28 - Rock paintings at Tandjesberg at Ladybrand (Free State, South Africa), showing a frieze of four people whose *karosses* (hide garments), painted in white, have disappeared because of the fragility of the pigment used. The figures in this image have sometimes been interpreted as depicting birds, but they are more likely therianthropes.

[42] Taking their name from the Kalanga word *matopo*, "hill." [43] Wolhuter 1950, p. 135. [44] Cooke 1963. Woodhouse 1969, p. 7. [45] Roumeguère-Eberhardt 1986, p. 18.

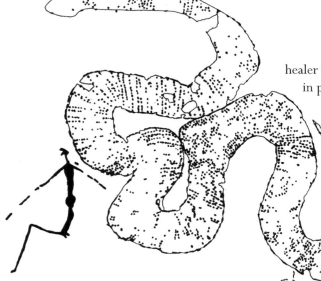

Fig. 29

healer one had to dive into a water source to capture a very big snake, skin it, then dance in public with its skin.[48]

In southern Africa, as elsewhere, it sometimes happens that images are reused in a mythical framework other than the one that provided their original meaning. Toponymy and local legends can also reveal a rich mythical context. Such is the case at Tombo-la-Ndu ("Rock of the Elephant") in the Soutpansberg, in South Africa, where, in front of a block decorated with a giraffe head painted in red, an engraving of a complete giraffe and six elephants painted in red (three of which are defecating), various votive offerings are regularly placed: buttons, fabrics, locks of hair, coins, and copper bracelets of the type worn by women. In the 1980s, two Venda men familiar with the place explained that these offerings were intended to make images appear on the rock surface. According to them, these images are not painted: they are *midzimu* ("ancestral spirits") that are part of the rock, and that can either sink into it or become more or less visible on its surface. In the local mythology, these *midzimu* are either *vhafhasi* ("chthonian spirits"), or *vho ngwanipo* ("ancient inhabitants of the place"), and thus a kind of *genii loci*. Should one show them a lack of respect or neglect to give them offerings, the *midzimu* punish the offender by sending them a supernatural snake.[49]

Other new mythological uses of images can be found in Zimbabwe, in the Matopo Hills (*figs. 31* and *32*). This granitic zone is very rich in rock paintings (more than 30,000 sites known) and has been turned into a national park (Matopos National Park). Made up of hills rising to 3,000 feet (900 m) in altitude above the valleys, it enjoys abundant rainfall. One remarkable characteristic of this region's art is the relative frequency of plant figures (present at about forty sites), unlike the rest of Africa. These hills were used as a refuge by the Karanga (southern Shona) fleeing the Ndebele

Fig. 29 - Giant snake (judging by the size of the human next to it) painted at Mutoko in north-east Zimbabwe. Its spotted decoration does not correspond to any real species, and therefore probably depicts the immense mythical snake of the legends of southern Africa.

Fig. 30 - Close to lake Matopo (Zimbabwe).

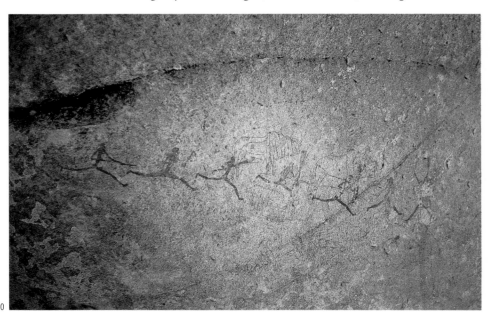

Fig. 30

[46] Blundell 2002. [47] Jolly 1986, p. 7. [48] Potgieter 1955, p. 30. [49] Loubser et Dowson 1987.

invasion in 1838, and then by the Ndebele themselves fleeing the whites. Until 1893 they constituted a sacred place for the Ndebele who, in their desire to obtain rain, made offerings there to a divinity called Mlimo.[50] The highest point in the region is the hill of Njelele, associated with the cult of the supreme god Ngwali wa Matopo, "god of the Matopo" and creator of the Universe. It is said that when this god jumped over the Matopo Hills and landed on the hill of Njelele, he left the imprint of his foot between Mounts Kalanyoni and Nswatugi, at a spot called "the place of the jump."[51] So it would be interesting to know if this "imprint" is an interpretation of natural marking, or if it is a true rock engraving, insofar as engraved prints—of a zebras, antelope, lions, and humans—are common in Zimbabwe. Some of them occur in sites that today are believed to have a sacred value, and play a role in present-day creation myths.[52] Moreover, we have already seen that the earliest mention of an engraving in the northern Cape was that of animal prints on a flat rock, which Hendrick Jacob Wikar learned about during his journey on the Orange River in 1778. This engraved rock played a role in the origin myth of the cattle of the Nama herders of the vicinity.[53] Similarly, concerning a site in Botswana, the missionary Robert Moffat wrote in 1842: "According to the natives' testimony, Morimo, like man and all animal species, came out of a cave or a hole in the Bakone region . . . where, they say, their prints are still visible in the hard rock which, at the time, was sand."[54]

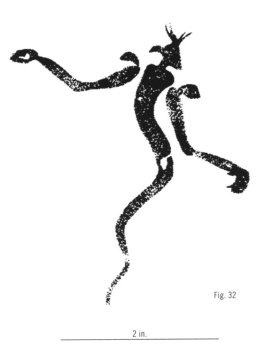

Fig. 32

2 in.

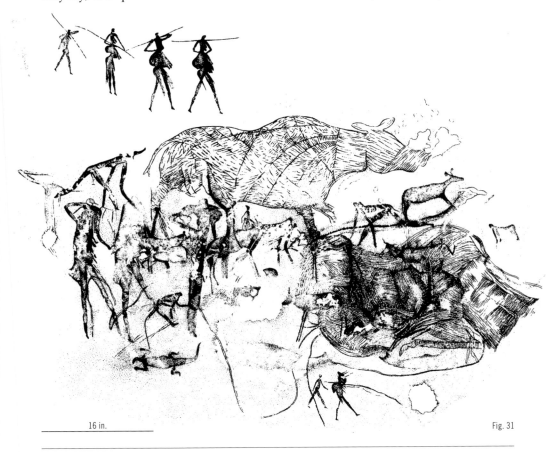

16 in.

Fig. 31

Fig. 31 - Painted panel in the Matopo Hills (Zimbabwe). The two rhinoceros horns finally disappeared as a result of the scrapings aimed at recuperating pigments for therapeutic ends.

Fig. 32 - An "anguiped" human (i.e., with serpentiform legs) about four inches (10 cm) high, painted in the Matopo Hills (Zimbabwe) and known locally by the name of Isotokwane, a malevolent mythical being.

[50] Walker 1994. [51] Parry 2000, p. 37. [52] Walker 1987, p. 137–39. [53] Mossop 1935, p. 95–7. [54] Moffat 1842, p. 262–3.

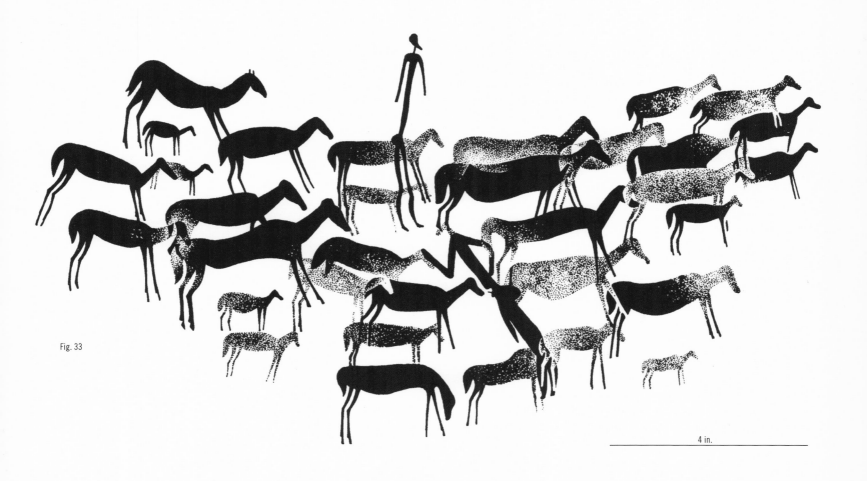

Fig. 33

4 in.

Fig. 33 - Filiform people with a flock of fat-tailed sheep. Painting in the Vimy Ridge shelter, near Bergville in South Africa.

Andrew Lang took pleasure in being ironic about the encounter between this missionary and those whose beliefs he wanted to fight against:

> Mr Moffat was unable to believe this marvellous tale, but the natives, for their part, could not believe his version of the creation, which they judged to be fantastic, extravagant, and absurd. Since Mr Moffat was not in the vicinity of Paradise, he could not provide proof similar to that of his bushman adversaries, who told him "I will show you the footprints of the first man."[55]

The important point here is that around the hole, and apparently emerging from it, there are a series of human prints and tracks of baboon, zebra, eland, kudu, and other antelope, artificially engraved in the stone, in a layout that one also finds at several other sites.[56] This chthonian emergence of primordial humankind (that is, before the second creation that definitively separated men from animals) can be found in San myths, for //Kabbo, one of Wilhelm Bleek's informants, told Bleek of a "great hole in the ground" into which humans and animals go after death, specifying that the path one follows to get there is also "the First bushman's path"—that is, the one that guided the steps of the first men.[57]

Among the paintings in these same Matopo Hills, the two horns of a rhinoceros figure have completely disappeared through being constantly scraped by traditional N'anga practitioners who used the resulting powder in rituals clearly appealing to the symbolic power of rhinoceros horns (*fig. 31*), which may be connected to their

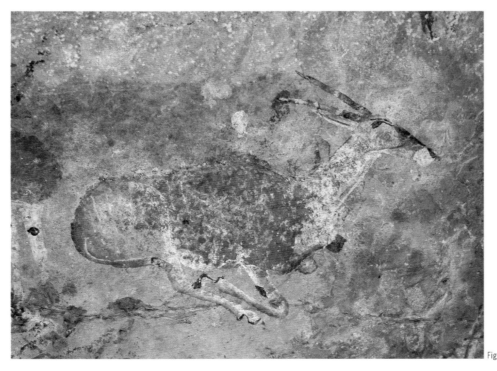

Fig. 34

Fig. 34 - One of the magnificent recumbent eland in Burley Cave at Barkly East (South Africa).

Fig. 35 - Detail of the fresco in the great shelter of Dinorbin at Barkly East (Eastern Cape, South Africa) in which, on a wall about 130 feet (40 m) long, there are several hundred subjects, with numerous antelopes, collective scenes with people, and a few therianthropes.

Fig. 35

[55] Lang 1896, p. 161–2. [56] Ouzman 1995, p. 60. [57] *Apud* Solomon 1999b, p. 14.

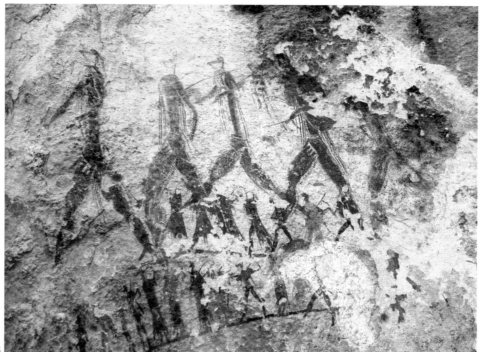

Fig. 36

ritual use by Tswana rainmakers.[58] In the provinces of KwaZulu-Natal and Eastern Cape, the Nguni are Bantus who consider the San to be mediators between the living and the dead, and still today make offerings and libations to San spirits in rock shelters decorated with ancient paintings. In these two provinces, many samples have been removed from the paintings to make potions (*mhuti*) that will benefit from the magico-religious renown the San enjoy throughout the subcontinent. Certain paintings in the Drakensberg have been used in this way to make talismans for protection from bullets in regions where conflicts were common. It has been observed that such removals of paint particularly affect images of therianthropes, a fact that can be explained by the belief in the existence of spirit helpers of sorcerers such as Tikoloshe or Impundulu, reputed to be half-human and half-animal.[59] Cases are even known were the reinterpretations of the works and the updating of their function have been extended so as to integrate on an old site with engravings of rhinoceros, eland, therianthropes, and people, some Bantu graphic signs (circles and dots, schematic lizards or saurians), and then, more recently, a Christian cross, evidence of the occupation of the place by Tswana members of the Zionist Christian Church, who come to pray there to the Christian God to send rain.[60]

These observations suffice to show that in southern Africa rock art is frequently integrated with the mythology of the surrounding peoples, even if they did not create the works, and that new mythical meanings are very common. But there is a very different problem—that of knowing whether ancient myths (related to more recent ones or not) governed the creation of at least some of these same works. Before attempting to answer this question, it is necessary to be able to assess the art's chronology.

Fig. 36 - Rock paintings at "Procession Rock" at Cathedral Peak (Drakensberg, South Africa). This rock takes itis name from a "procession" of red and black therianthropes, walking along a red line and partially obliterating two other lines of small people, located one above the other, the lower ones walking on a black line.

58 Ouzman 1995, p. 60. 59 Prins 1996a. 60 Ouzman 1995, p. 62.

Dates

About 10 percent of the paintings of the Upper Brandberg involve superimpositions, the analysis of which can help to build a relative chronology. Other elements then make it possible to anchor this periodization with absolute dates. Hence, in South Africa, representations of Europeans are obviously later than 1487, those of canids probably after 600,[61] and those of sheep later than the first century (*fig. 25*).[62] Certainly, the best situation is one that permits direct dating, but only two such examples are known in southern Africa: the "Red Giant" of the Brandberg (*fig. 38*) and the cave of Apollo 11.

The "Red Giant" of Amis Gorge (*fig. 38*) is so called because of its dimensions. This painting presents the peculiarity of having been stoned for some unknown reason (ritual? iconoclasm?), which resulted in the loss of numerous flakes. An excavation carried out at its feet retrieved about thirty of these fragments, bearing traces of red paint; one of them was a perfect fit for a small human figure painted below the giant. As this piece was found in a layer that also yielded charcoal dated to 2760 ± 50 B.P. and 2710 ± 50 B.P., the study of its context made it possible to demonstrate that the said "Giant" was slightly older and that it was painted around 3000 years ago, which confirms the opinion that most of the images were made between 2000 and 4000 B.P.[63]

On July 24, 1969, Wolfgang Erich Wendt was excavating an anonymous cave in the Huns Mountains in southern Namibia, when he heard on the radio news about the return of the Apollo 11 space capsule, bringing the first man to walk on the

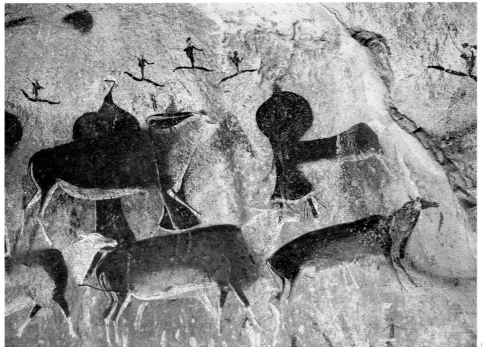

Fig. 37

Fig 37 - Detail of the wall of Game Pass Shelter at Kamberg (Drakensberg, South Africa). The elands were made above the big people wearing karosses, the latter being in a very different style from the series of little running men, at the top.

Fig. 38 - The "Red Giant" of the Brandberg. The part indicated by the arrow in the frieze of people under the giant is where a flake of the rock found during excavations at the foot of the wall fits perfectly. This flake bore the front part of one of the humans, which makes it possible to date the production of this frieze to at least 2700 B.C.E.

[61] Lee 1999, p. 8. [62] Henshilwood 1996. [63] Lenssen-Erz 2000, fig. 108.

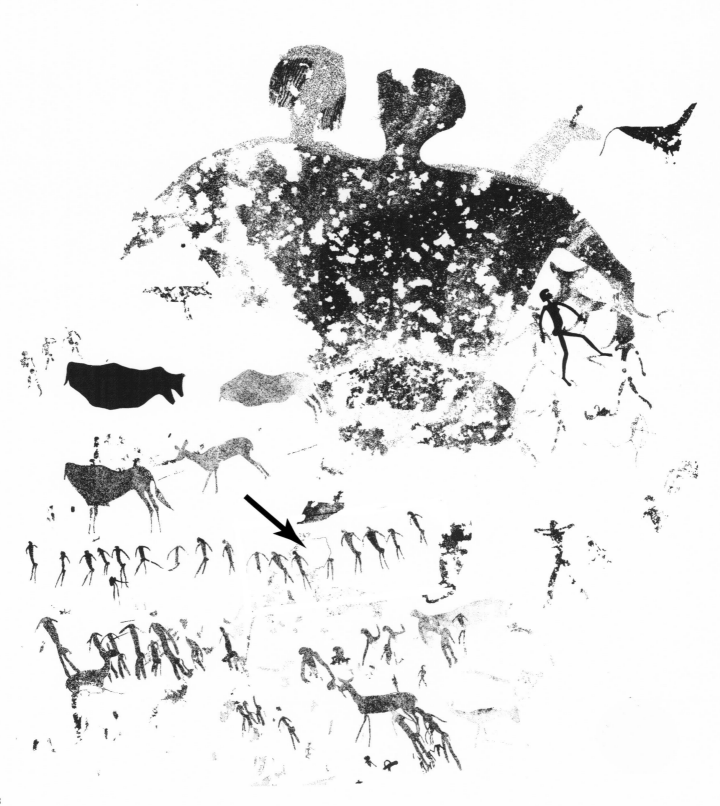

Fig. 38

moon back to Earth. He had the idea of calling this site "Apollo 11 Cave," and the name has stuck. Wendt wanted to date the remains of paintings on the walls of this cave, thinking that some of them might underlie datable archaeological layers, but upon excavation this proved to be a futile hope. On the other hand, the excavation revealed a major surprise: the exceptional stratigraphy spanned a very long period, since it yielded a sequence of thirty-nine dates extending from 320 ± 40 B.P. (layer A) to more than 49,500 B.P. for level G, in the deepest layer. Above all, in the upper layer of the "Middle Stone Age," dated to 26700 ± 650 B.P., Wendt discovered a series of painted flakes: one bore a rhinoceros figure, another what seems to be a zebra, and a third a feline with back legs that slightly resemble human legs (*fig. 40*). Even today, these are the oldest examples of animal art in Africa, dating to only a few thousand years after Chauvet Cave.[64]

Ten years after this discovery, Francis and Anne Thackeray (1981) found in the vast Wonderwerk Cave (Kimberley) some small blocks of dolomite and haematite less than four inches (10 cm) long, covered with fine incisions forming grids, parallel lines, and scalariform signs. On the oldest of these fragments, which dates back to 10,200 ± 90 B.P., there is an incomplete engraving of a large quadruped, perhaps an antelope. On another, dating to 3990 ± 60 B.P. and unfortunately broken, one can easily recognized the hindquarters of a zebra (*fig. 41*).

Rock engravings are, in general, much more difficult to date than paintings, but traces of organic elements found in the patinas of those at Klipfontein (northern Cape) have yielded dates spanning a period from 10,000 B.P. to the present day.[65] Nevertheless, nothing proves that these elements were contemporary with the production of the art.

Fragments of ocher bearing scratches showing that they had been used as a pigment were discovered in the caves of Bambata and Pomongwe (Zimbabwe), in levels at least 125,000 years old, but it is not known what they were used for—perhaps for making rock images, coloring objects, or making body paintings.[66] In the cave of Pomongwe, a flake of granite bearing remains of paint—probably the bent arm of a small human figure—was unearthed in a layer dating to 4810 ± 80 B.P., and a second flake, displaying what looks like the torso and head of another anthropomorph, dates back to at least 9520 ± 120

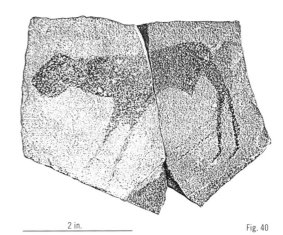

2 in. Fig. 40

Fig. 39

[64] Wendt 1974. [65] Whitley & Annegarn 1994. [66] Walker 1987, p. 142.

166

Fig. 39 - Piece of ocher with a geometric decoration, found during excavations in Blombos Cave at the Cape (South Africa), and at least 65,000 years old, making it the oldest trace of intentional graphic activity known in the world.

Fig. 40 - One of the plaquetteflakes decorated with animal paintings, found during excavations in Apollo 11 Cave (Namibia), and dated to about 27,000 B.C.E. The animal's hind legs resemble legs with "feet;" this image has sometimes been considered the oldest known African therianthrope.

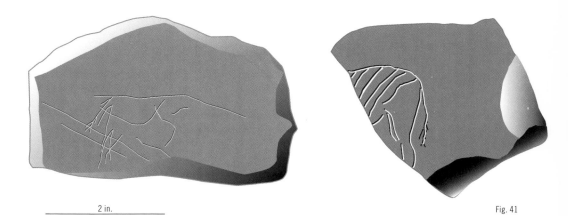

2 in.

Fig. 41

B.P. By compiling all the available data (dates, associated industries, subjects depicted, erosion, superimpositions, etc.) Nicholas J. Walker was able to put forward a chronology valid for the whole of Zimbabwe.[67] Within this general framework, the oldest images date back at least to the tenth millennium, and involve only monochrome (especially yellow) depictions of large fauna (hippopotamuses, rhinoceroses, zebras, big antelope). Bichrome images did not appear before 9500 B.P., when the repertoire of themes was expanded to include birds, plants and hybrid beings. The colors used after that were mostly reds, but also orange, yellow, and, more rarely, black. From 8000 B.P. onward, scenes become much more common, as do people and therianthropes, while white was added to the painters' palette. After 6000 B.P., elephants, giraffes, and ostriches are among the most represented animals, and small species such as monkeys and the Cape hare appear, but people are always the most abundant by far. Domestic animals, in particular the dog, are only present after 2000 B.P., while the art returns to monochrome figures, predominantly red. Finally, from 1500 B.P. to the twentieth century C.E., the images, monochrome and drawn with the finger, no longer depict humans except rarely, and one sees goats start to appear, as well as lizards or geometric signs, in white, red, and black.

The excavation of Blombos Cave, a vast undecorated cave, located 115 feet (35 m) above the Indian Ocean at the southern extremity of the Cape, has yielded materials belonging to the "Late Stone Age" (dating locally from 300 B.P. to the early years C.E.) and to the "Middle Stone Age," separated from the more recent levels by a layer of sterile aeolian sand dated by luminescence to about 65,000 to 70,000 B.P. Among more than 8,500 fragments of red ocher found in the early layer, most of them display traces of scratches, and, especially, two pieces decorated with geometric designs (*fig. 39*) represent the oldest traces of intentional graphic activity known in the world.[68]

As can be seen, only part of the art of southern Africa is thus attributable to the San, in zones where artistic practices have lasted until the present era. In the Southwest (Namibia), this tradition was already extinct before the arrival of the first Europeans, and there is no oral testimony that would allow one to identify the paintings. In the Drakensberg, most authors reckon that the majority of the works are less than three hundred years old. But the first direct dates just determined that some of them are at least 3000 years old, and those of the Western Cape even younger. In the Brandberg, most of the paintings must date back to the last two millennia B.C.E., and there is little chance that they are attributable to a single group working over such a long time span. So it would seem

Fig. 41 - Two of the engraved plaquetteflakes from Wonderwerk Cave (Kimberley), one showing an incomplete quadruped, the other—alas broken—the hindquarters of a zebra. The first is about 10,200 years old, the second has been dated to 3990 B.C.E.

67 *Ibid.*, p. 146. 68 d'Errico, Henshilwood & Nilssen 2001.

highly risky to build a "bridge" between present-day oral traditions and paintings dating back several thousand years. But can one minimize this risk?

The quest for meaning

Basing themselves first on ethnographic documents—some 12,000 pages!—collected at the end of the nineteenth century from a San group (the /Xam) by the linguist Wilhelm Heinrich Immanuel Bleek (1827–1875) and his sister-in-law Lucy Lloyd (1834–1914), documents completed by the work of the magistrate Joseph Millerd Orpen (1874–1919) on the San of the Maluti hills (Lesotho), and then on research carried out more recently on the rites of various San groups of the Kalahari,[69] Patricia Vinnicombe and, later, James David Lewis-Williams tried to understand South African rock art in the light of modern San oral traditions, thus pursuing an avenue of interpretation that had been opened up by Bleek, but that had been practically abandoned since his death in 1875. Over about twenty years, Lewis-Williams, director of the Rock Art Research Centre at the University of the Witwatersrand, in Johannesburg, developed a reading of South Africa's rock art that sees it as the graphic transcription of a series of traditional metaphors of trance, known as !kia in the Kalahari.

One of the most important starting points, and one which has been the subject of numerous discussions, is the enigmatic commentary by a San called Qing (!King, in Wilhelm Bleek's transcription), collected by Orpen in the 1870s, concerning a painting at Medikane showing what seems to be three antelope-headed men, leaning forward; two of them are each leaning on two sticks, the whole thing evoking a ceremonial group (fig. 42). !King, a survivor of an almost exterminated San group, saw in it "men who had died and now lived in rivers, and were spoilt at the same time as the eland and by the dances of which you have seen paintings."[70] Although !King explicitly mentions dead people living in an aquatic Other World, Lewis-Williams preferred to see it as a metaphor of trance, experienced as the act of diving, and then living in water and "spoiling" the dancers.

Moreover, several engravings of the Carnarvon District show people dancing next to living wild animals (eland, elephant), which is impossible in reality. For Thomas Arthur Dowson, this enigma could be explained by two orders of facts.[71] First, oral documents collected in the nineteenth century which evoke "shamans" trembling in their sleep while their spirit had left their body for an out-of-body journey, a journey that could occur in animal form. In addition, other ethnographic testimony collected among different San groups suggests that the animals are supposed to possess the energy that the dancers are trying to appropriate. During the dance, the women clap their hands to make the rhythm of songs that speak of this animal "power." According to some testimony collected in Botswana

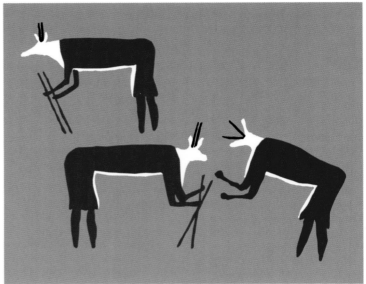

Fig. 42

Fig. 42 - Painting from the cave of Medikane (Lesotho), first copied by Joseph Millerd Orpen who, in 1873, showed his tracing to a San by the name of !King, who immediately recognized the depiction of an aquatic Other World peopled by mythical beings.

69 See for example the works of: Isaac Shapera (1963), Richard B. Lee (1979), Jir O. Tanaka (1980), George Silberbauer (1981), Richard Katz (1982), Alan J. Barnard (1992), Lorna Marshall (1999). 70 Orpen 1919, p. 141. 71 Dowson 1992, p. 15.

Fig. 43 - The copy, by George Stow, of this painting at Pietersberg, near Genaadeberg (South Africa), was shown in 1874 to a San who recognized the central therianthrope as a depiction of /Kaggen, a trickster demiurge who can take on multiple forms, from the praying mantis to the bubal antelope, his horns recalling an insect's antennae. The oblong figure seems to be what remains of a depiction of the "rain snake," red below and light-colored above.

in 1971 by Megan Biesele (1975) from a San named K'xau, some of these songs attracted animals. Hence, on listening to the "song of the eland," antelope were irresistibly drawn toward the singer. In certain engravings, one can indeed see women clapping around a dancer carrying a stick and fly-whisks, objects used during trance rituals. In fact, in the Kalahari, fly-whisks are only used during these rituals.[72] This reading of the works finds some confirmation in certain postures adopted by the dancers who, in the rock art depictions, have their arms pulled back. A shaman of the Kalahari explained to Lewis-Williams that this posture was adopted to ask the divinity to let power enter the dancer's body.[73] Another gesture that can be seen in the rock images, the hand raised to the nose or face, also corresponds to a movement that becomes meaningful in this context, since the shamans were said to expel illnesses through the nose. The word for nose can even be used

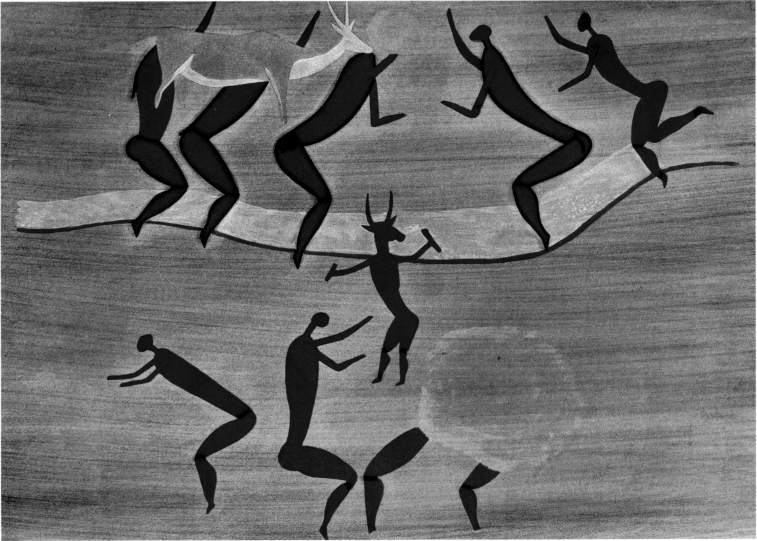

Fig. 43

[72] *Ibid.*, p. 18. [73] Lewis-Williams 1981b, p. 88.

Fig. 45

metaphorically to designate healing power. So the rock images in question supposedly allude to this power.

Even if one admits that the men depicted in this way could be in a trance, another enigma then presents itself: sometimes they are next to images of antelope that might be thought to be dying. Here again, San oral traditions may give the key; they compare entering trance with the death of an antelope hit by a poisoned arrow; both the animal and the man in trance tremble violently, stagger, lower the head, bleed from the nose, sweat profusely, and finally fall unconscious. At the end, the animal's hairs are sticking up and the San say that hairs grow on the back of men in trance. So the trance is seen as a temporary death, a little death or "half-death," to use a metaphor expressed in rock art by the juxtaposition of dying antelope and officiants in trance. Thus a man in ecstasy could have been represented in the form of a dying antelope. Yet the presence of images of therianthropes, in particular of anthropomorphs with eland heads or legs ending in antelope hooves instead of feet, make it possible to suppose that another step has been taken in the symbolizing, to show how the dancer has been "trance-formed," to use Dowson's term.[74] In San conceptions, the eland is not the only animal metaphor of trance, and Lewis-Williams points out that swarms of bees are traditionally reputed to possess the power coveted by the shamans; this could explain a few paintings depicting such swarms above the head of dancers.[75] It is true that the painters clearly took an interest in these insects (*figs. 52 to 54*): in Zimbabwe, more than 150 sites include paintings depicting hives or bees and Harald Pager showed that in the Drakensberg this theme is in third place after eland and therianthropes—these three motifs often appearing together, to the extent that Pager even spoke of them as a "trinity."[76] It is important to note that the same triad of therianthrope-eland-apiaries occurs in a San myth about the origin of the eland, in which the Mantis

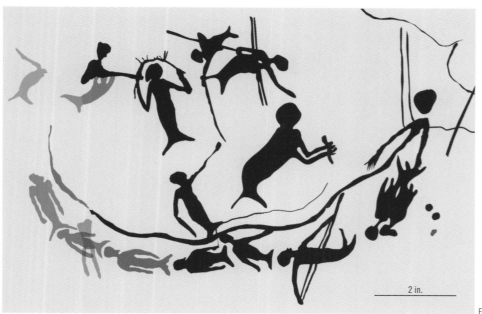

Fig. 44

Fig. 44 - This scene, recorded at Ezeljagdspoort in the Cape (South Africa) has been the subject of various interpretations: some see it as depicting mythical mermaid-like beings, others as shamans transformed into birds!

Fig. 45 - San dancer Naron wearing an eland mask on his head, whose horns are simply represented by two pointed sticks tied to his head.

74 Dowson 1992, p. 67. 75 Lewis-Williams 1983, p. 6. 76 Pager 1975, p. 74.

(a protean being that transcends animal identities) attracted the first eland out of the reeds where it was hiding by *presenting it with honey*.[77] In fact, the San believe that Mantis—who is none other than the demiurge /Kaggen—can take the form of the bubal antelope[78] whose long horns become the formal counterparts of the insect's antennae (*fig. 43*).[79]

According to the theory linking rock art with trance, another metaphor links trance with the feeling of being projected into the air. A Zu/'hõasi told Richard Katz: "When I pick up *n/um* [supernatural power],[80] it explodes and throws me up in the air."[81] This refers to a phenomenon that actually happens when entering into trance is so abrupt it provokes a violent start. So in the rock images, people who seem to be jumping over eland would be expressing a "projection" of this kind, concomitant with the acquisition of this animal's powers. This may perhaps be the case in an engraving in the Vryburg District, in which several people surround an eland and some of them seem to be jumping over it: one of these men holds his hand to his nose, which has been interpreted as an indication of trance.[82] But jumping in the air serves as a prelude to flying, and the acquisition of bird characteristics, mostly feathers, could have been the motivation for the images of bird-head therianthropes, which have indeed been interpreted as graphic transcriptions of this other metaphor (*figs. 27, 50*).[83] Other details—lines

Fig. 46 - Painting traced by George Stow in a cave opening onto the Sand Spruit, a tributary of the Kornet Spruit (South Africa). When questioned about this painting in 1874, a San recognized the "water bull" accompanied by a snake called 'Kanga wai, and specified that the latter was speckled. The same applies to the bull, and bodies spotted in this way seem to be a monopoly of mythical beings (see figs. 4, 20, 44 and 45).

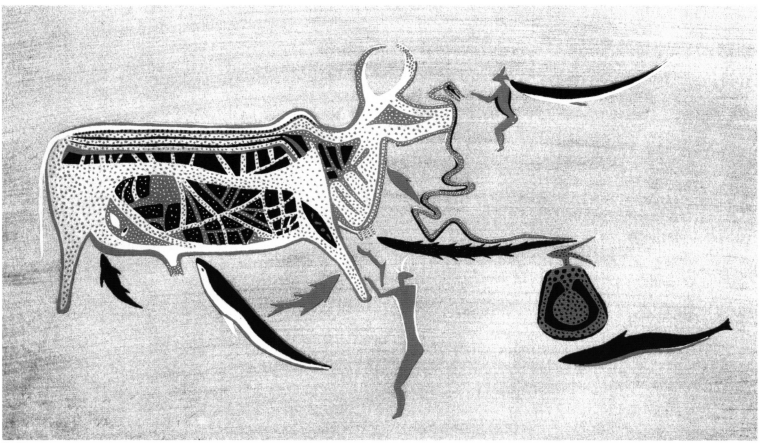

Fig. 46

77 Bleek & Lloyd 2000, pp. 145-151. 78 Hartebeest, *Alcephalus buselaphus.* 79 Stow & Bleek 1930, pl. 50 and 52. 80 Katz 1982, p. 61. 81 This power or magical "force" is called *n/um* by the Zu/'hõasi of the Kalahari, and *!gi* by the /Xam. 82 Dowson 1992, p. 110. 83 *Ibid.*, p. 74 and fig. 111.

emerging from the head, bodily elongation (*figs. 4, 10, 44*), especially in the engravings of Kerlksdorp District and Vryburg District—have been "read" as notations of the physical sensations that accompany trance.[84]

Because of a buzzing in the ear, altered vision, and the sensation of weightlessness accompanying ecstasy, entering trance can be conceived of in terms of diving into water, and the /Xam myths collected by Bleek and Lloyd describe waterholes as being the kingdom of the spirits of the dead. Other data allude to crossing an aquatic world beyond which is the land of the dead. So, according to the "reading" summarized here, people in trance could well have been depicted in the form of "swimmers" (*fig. 32*)—which are, moreover, difficult to distinguish from "flying" men, since rock art always leaves out the ground-line and the water surface.

Red lines covered in white dots sometimes link the people, or join them to animals. This detail has been interpreted as a way of representing the power obtained by ecstasy.[85] Finally, certain animals depicted in the paintings have been recognized by the San as being "rain animals" (*figs. 9, 45, 61-62*) related to traditions comparable to those conveyed to us by the documents of Bleek and Lloyd that involve the

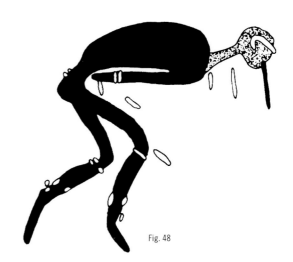

Fig. 48

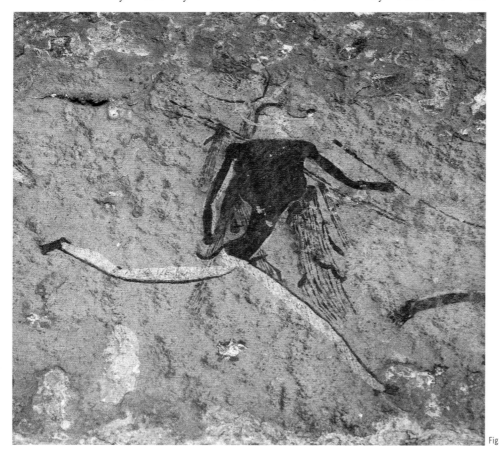

Fig. 47

Fig. 47 - Detail of a painted panel on a rock at Cathedral Peak (Drakensberg, South Africa). Above the red blob that corresponds to an ancient eland figure, a therianthrope of a particular kind was painted in a brownish color. This is one of those mythical beings with an antelope head, a bird body, and long, parallel filiform wings, for which Harald Pager proposed the name "alites."

Fig. 48 - Painting at Halstone, Barkly East (South Africa). The dark vertical line emerging from the face is interpreted as a nose bleed by Lewis-Williams, who sees it as a sign of trance.

84 *Ibid.*, fig. 112–14. 85 Lewis-Williams 1981a. Eastwood 1999.

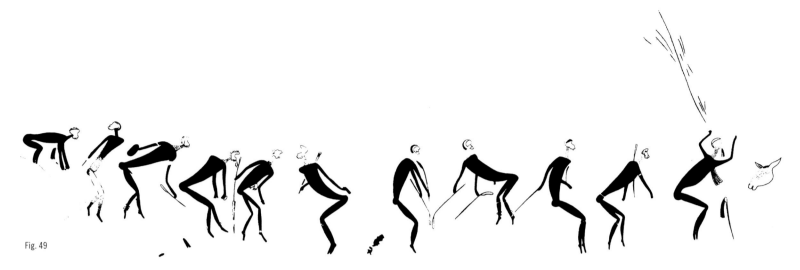

Fig. 49

sacrifice of such an animal at the top of a mountain, with the victim's blood falling in the form of awaited precipitation, or with rain falling on the place touched by the discharge of blood.[86] A San named Diä!kwain confided to Wilhelm Bleek in 1874: "The people who are at home see the rain clouds and say to each other: the [medicine-men] really seem to have their hands upon the rain-bull, for you see that the rain clouds come gliding along." Another San, /Han≠Kasso, specified in 1878: "A very long time ago, a man hunted !Kwa, the Rain. . . . At that time, the Rain was like an Eland." This information at least confirms the largely symbolic nature of the art, insofar as, whatever the real meaning of these works, the animals that we recognize in them (like the eland) can represent something other than themselves (e.g., rain), which is myth's distinguishing feature. In the Drakensberg, for example, paintings showing pre-copulatory activity of eland have been associated by Lewis-Williams, in a very convincing way, with female rites of passage at puberty, insofar as on this occasion the present-day !Kung and Naron perform a dance during which this animal's sexual behavior is mimed, with men making wooden horns to imitate the male antelope (*fig. 45*). It is known that the girls are explicitly compared with eland (because they are fat like the animals), that fat is commonly associated with sexuality,[87] and that girls are reputed to be capable of attracting rainfall. A comparable metaphor, but one that concerns another species, can be seen in the Brandberg, where paintings show springboks in pre-copulatory activity (especially the typical position of males sniffing the females' urine). Since the mating season of these antelope "depends on when rainfall brings on a flush of new plant growth,"[88] one finds again a relationship between rain and sexuality.

A few doubts …

These readings, which appear highly coherent and of great explanatory power, constitute the most generally accepted interpretative framework for the rock art of South Africa. Following the success achieved by this kind of interpretation amid the general public—a success that overlaps with that of neo-shamanism in the "New Age" syncretism—similar readings have been proposed for the rock art of the whole of southern Africa, particularly Zimbabwe,[89] the Western Cape,[90] the Free State,[91] and Cederberg.[92] The theory was then wrongly extended to the Sahara, and henceforth applied to almost all the rock art of Africa. But is all of this as solid as it appears?

In the explanatory scheme thus proposed for South Africa—the area to which

Fig. 49 - Painting at Fetcani, Barkly East District (South Africa), showing eleven people dancing in front of an antelope head during a ritual for which archaeology has revealed the material evidence.

86 Lewis-Williams 1992, p. 57. 87 Lewis-Williams 1981b, p. 44–53. 88 Apps 1992, p. 154. 89 Huffman 1983.
90 Parkington, Manhire & Yates 1996. 91 Sven Ouzman. 92 Janette Deacon.

it is preferable to limit ourselves here—a veritable "key" to reading (from which everything else follows) is the depiction in rock images of the phenomenon of epistaxis, that is, bleeding from the nose, considered to be characteristic of trance (*fig. 48*). The San healers paint the bodies of the sick with the blood obtained in this way. For Lewis-Williams, bleeding from the nose dictates an interpretation of therianthropes as depicting something other than simple hunters in an animal disguise, and enables one to see them as men in trance.[93] But ethnography provides examples of traditions in which bleeding from the nose is ritually provoked—for example in the male initiation of the Gahuku-Kama of New Guinea, in which trance plays no part at all.[94] Among the Sambia, the initiation of young boys includes flagellation with nettles and the provocation of nosebleeds intended to liberate them from liquids that are considered feminine and thus liable to prevent their development.[95] Similarly, in Europe, there is a tradition that consists of inserting a leaf of *Achillea millefolium* L. (popularly called "nosebleed," *segne-nàes*, in the Vendée region of France)[96] into the nostril as an ordeal; in Sussex, depending on whether this insertion provoked a nosebleed or not, girls deduced whether their suitors loved them or not.[97] But in these cases, no trance accompanies the ritual bleedings. Bleeding from the nose can also occur in mythology, as shown in Malawi by the tradition that the initiate who betrays the secrets of the Nyau yolemba masks by revealing to a non-initiate that they are ordinary men in disguise and not dead people returning to the village, is condemned to die through an endless nosebleed.[98] Even better, !King himself associated this phenomenon with mythical people, in his commentary on the paintings of Medikane.[99]

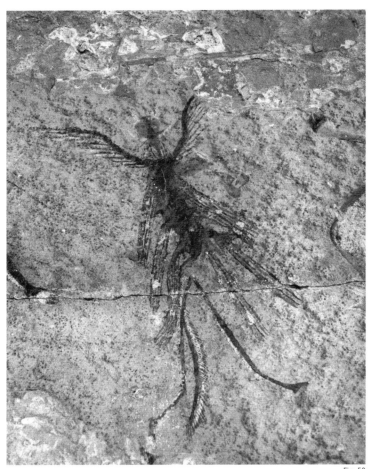

Fig. 50

Thus to say, like Lewis-Willliams and Dowson, that such bleedings imply a state of trance involves a risk that is made all the greater by the fact that other readings are possible, since the lines "emerging" from the noses of human figures or from animal muzzles could just as well represent their breath or even the emanation of rain, in the case of the "rain animals." Moreover, out of the thirty-nine San ritual dances attended by Lorna Marshall, an ethnographer of the Zu/'hõasi, not one included any kind of nosebleed; and the only case of nosebleed she had heard of concerned a man who had fallen into a trance and been struck by epistaxis because of a lion that had terrorized him—and thus completely outside of any shamanic context.[100]

It remains perfectly possible that, in certain cases, lines emerging from the face could have been intended to depict an epistaxis linked to trance; but recognizing a nosebleed in these images does not explain very much. For example, Lewis-Williams published a composition from Fetcani Glen (Barkly East, in South Africa) that he interprets as a trance scene. According to him, four of the eleven dancers in a line in this assemblage are bleeding from the nose.[101] But on the tracing made of this by Harald Pager

[93] Lewis-Williams 1987, p. 172. [94] Read 1952. Guiart 1962, p. 138. [95] Herdt 1982. [96] *Cf.* Pivetea 1996, p. 254. [97] Higgins 1984, p. 103. [98] Yoshida 1993, p. 35. [99] Orpen 1874 [1919], p. 146. [100] Marshall 1999, p. 62. [101] Lewis-Williams 1981b, fig. 19.

Fig. 50 - Another therianthrope from the same frieze on the block removed from Wartrail (Barkly East District, South Africa). This being looks human overall, but an "alite" is sitting on its very animal head!

(*fig. 49*)—far more precise than that of Lewis-Williams—only two people display lines (one of them at chin level, the other at nose level) that could possibly be interpreted as a flow of blood. Rather than stressing this enigmatic detail, Harald Pager saw correctly that the feature that gives this assemblage its entire meaning is none other than the antelope head in front of which the eleven men are dancing. In a remarkable article, he reminded us that several rock depictions in southern Africa represent groups of antelope heads. There is also a group of more than sixty heads near Harare in Zimbabwe, and forty-six in the Pokane shelter, in Lesotho. In South Africa there are fifty-eight in a shelter at Ferngrove, twelve at Mount Tyndal, and three other groups of the same type are known in the Brandberg. These artistic assemblages constitute established facts, like the heap of several hundred skulls of *Alcephalus boselaphus* and Bontebok discovered in 1837 by William Cornwallis Harris near the River Modder.[102] These two series of concordant data—graphic and archaeological—can be explained by a tradition of ritual hunting which Oswin Köhler was fortunate enough to be able to observe in 1962 and 1971 among the San Kxoé of Namibia, but which must have been widespread in the past. This kind of hunting differs from ordinary hunting expeditions: once the antelope has been killed and carved up, the hunter carries its head to a place where the skulls of the previous victims are kept; this trophy is then decorated with beads and other objects, and then adorned with colored lines on its forehead and under its eyes, while the officiant draws similar lines on his own forehead (a detail which can be seen on certain rock images). The game's meat is then boiled, and small pieces of it are pressed against the animal's head while the ancestors are asked to accept this offering; the rest is only shared out after the consent of these ancestors. This ritual has to be carried out when game becomes rare, because, according to the myth, all the large animals are the property of Kxyàní, the supreme divinity of the Kxoé, and so it is necessary to obtain the ancestors' intercession before hunters can kill another antelope.[103] It is very probably the last phase of a ritual of this kind that is depicted in scenes like the one painted at Fetcani Glen; other images may also be related to it: at Dreilochhöhle, in the Brandberg, a man is depicted striding along, holding a severed antelope head in both hands; at Eland Cave, in the Drakensberg, twenty-two "antelope-men" dance next to sixteen antelope heads which are also severed. When the dance is performed by ordinary men, the painting doubtless depicts the ceremony itself, but when the participants are therianthropes, it is probable that they represent the ancestors—half-men, half-animals—coming to accept the offering made to them. Thus there is no need to call on the shamanic hypothesis to read these images in the light of San traditions.

One problem that is often dodged in the shamanic readings of South African rock art is that of chronology. Reference is made to the rock paintings in general or, more rarely, to the engravings, as if they formed a coherent assemblage, which is not the case. Hence, for the rock engravings of Klipfontein, three series of direct cation-ratio dates have been obtained from forty-four patina samples. The first series involves geometric engravings (zigzags, crosses, "chains" of circles, grids, undulating

Fig. 51

Fig. 51 - Elephant-man hybrid, or person who seems to be wearing a mask or a hide of a small elephant—indeed, an eyewitness account dating back to 1889 described a San dance where the officiant wore "an elephant's head with trunk." Site of Mount Paul near Harrismith in South Africa.

4 in.

102 Harris 1839, p. 257. 103 Köhler 1973.

lines), which span a period from 8400 B.P. to the present day; the second involves fully pecked engravings, depicting several animal species (elephants and antelope—especially eland), spanning a period from 10,000 B.P. to 2100 B.P.; the third involves line engravings, anthropomorphs and animals (hippopotamuses, eland), from the period 9400 B.P. to 1200 B.P. So the whole of the Holocene appears to be covered by these three types of engravings, which does not fit Lewis-Williams's hypothesis, according to which they are motivated by one single type of trance culture. If one considers the average dates, the geometric type is slightly more recent, in accordance with the hypotheses constructed earlier on the basis of geomorphology and through internal analysis of the depictions. These average dates are about 5700 B.P. for the geometric type, 7000 B.P. for the line figures, and 7500 B.P. for the fully pecked depictions.[104] And if it is difficult to project concepts that have only been verified for a small number of nineteenth-century San onto the whole of the Holocene and all of southern Africa, it is far more difficult to do this for works that date back several tens of thousands of years, as at Apollo 11 Cave. So one should therefore resist the temptation of an achronological and ahistoric reading of rock images.

In rock art studies one needs to take into account not only variations in time (chronology) but also spatial variations (areology), which have every likelihood of corresponding to local evolutions or to different groups, whose interactions require examination. This is true both for themes and for the techniques used. Hence, for example, very finely incised engravings ("hairline engravings") are only numerous in the Karoo; handprints are more common on the coast of the Western Cape;[105] people are in general far rarer in engravings than in paintings; and depictions of eland become rarer from east to west, giving way, in Namibia, to giraffes, ostriches, and zebras, while in the Richtersveld the elephant becomes preponderant. In engravings, geometric signs form only 6 percent of the assemblages of Kinderdam (near Vryburg), but

Fig. 52

Fig. 52 - Assemblage on the block removed from Ebusingata and conserved at the Natal Museum in Pietermaritzburg (South Africa). One can still make out, at lower right, the elephant-headed therianthrope surrounded by bees, traced by Pager (see fig.53). The latter's admirable work saved a great deal of information that would be impossible to gather today.

Fig. 53 - Painting representing an elephant-man, probably mythical and surrounded by bees, on a damaged wall at Ebusingata (Kwazulu-Natal, South Africa). In 1947, on the occasion of an exhibition organized for a visit by England's royal family, it was removed and deposited in the Museum of the Royal Natal National Park (see fig.52).

104 Whitley & Annegarn 1994.

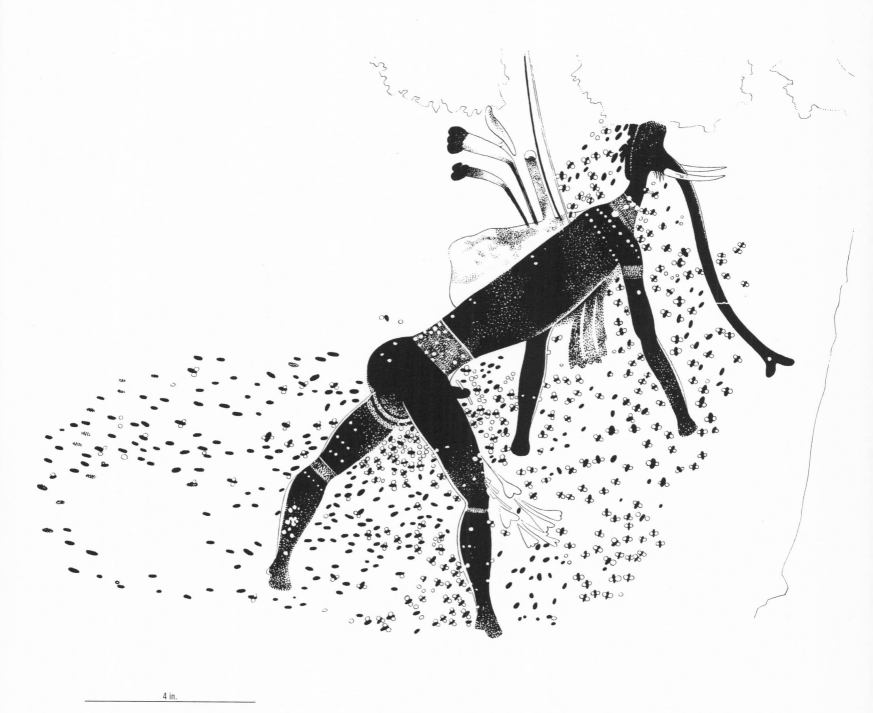

4 in.

Fig. 53

11 percent of those of the Upper Karoo, 38 percent of those of Klipfontein, and up to more than 90 percent of those of Dreikopseiland.[106] A correlation has been noticed between the distribution of these signs and the proximity of water, and certain geometric symbols bear a very close resemblance to the body decoration used to mark G/wi girls at puberty—and in fact these decorations are related to rain.[107] Using the same explanatory canvas for the whole of southern Africa, while employing ethnographic comparisons based on analogies between, on the one hand, the twentieth-century traditions of the Nharo of Botswana or the Zu/'hõasi of Namibia, while adding in those of the nineteenth-century /Xam of South Africa, and, on the other hand, rock paintings spanning several millennia, while ignoring or hushing up differences, constitutes an approach that risks overrating the shared features—which really do exist—to the detriment of the variety of situations.[108] Hence, although the Zu/'hõasi and the /Xam all recognize a "great creator god" and an evil minor divinity, the latter can appear in the form of a "rain animal" (an eland) called *!khwa-ka xoro* among the /Xam, whereas the Zu/'hõasi never credit him with an animal appearance. The type of comparison that consists of only seeking analogies leads one to "hand pick" from the sites to find images judged significant in an explanatory framework chosen a priori, whereas it is preferable to compare not selected elements, but entire assemblages, taking their natural context into account.

The situation in the Tsodilo Hills, for example, is quite particular. In this group of four isolated inselbergs in the far north of Botswana, more than 3,000 rock paintings have been inventoried, distributed in 350 sites within less than 3 square miles (5 km). About half of these works, which are generally monochrome (in red, yellow, or white), represent animals (mostly eland, giraffes, and rhinoceros, but also elephants, hippopotamuses, felines, zebras, hyenas, ostriches, cattle, snakes, and various antelope), while about a third are geometric signs (lines, scalariform motifs, gridded ovals or rectangles, dotted motifs) and rather few (12 percent) are human depictions, generally linear and ithyphallic, to which one can add a dozen supernatural beings. This distribution forms a clear contrast with that of the paintings of the Drakensberg, the Matopo Hills, and the Brandberg, where more than half of the subjects are human figures (nonlinear and non-ithyphallic), and where geometric motifs are almost absent. The paintings of the Tsodilo Hills seem to occupy an intermediate place between the schematic art of Central Africa and the more dynamic compositions of Cape Province. Locally, two styles predominate: that of the simple-outline animals (especially cattle, eland, and zebras), and that of the "silhouette" animals (rhinoceroses, elephants, gemsboks, and giraffes). Superimpositions indicate that the difference between the two was mythical, and not chronological. None of these paintings has been directly dated, but the oral traditions of the Bantu-speaking Hambukushu, who still live on the edge of the Okavango, confirm that their ancestors produced most of them. Given the presence of painted cattle, and knowing that domestic cattle scarcely appear locally before 550, only taking on true economic importance after 850, it might be thought that most of the works in the Tsodilo Hills date back to around 800 to 1100. However, a few white paintings showing horsemen cannot be earlier than 1852.[109]

The example of the portable engravings discovered at Springbokoog (Upper Karoo)

Fig. 54

1.5 in.

Fig. 54 - Rock painting located not far from the elephant-headed therianthrope of fig. 38, before the latter was removed. Unfortunately, the relative placement of these works is not known, but they bear witness to the mythical importance of honey and bees for the painters. This person, around whom the bees are buzzing and who is carrying honey cakes like a waiter carries a tray, seems to be wearing an antelope mask on his head.

105 Manhire & Parkington 1983. 106 Morris 1988. 107 Fock 1969. 108 Solomon 2001. 109 Walter 1993. Campbell, Denbow & Wilmsen 1994.

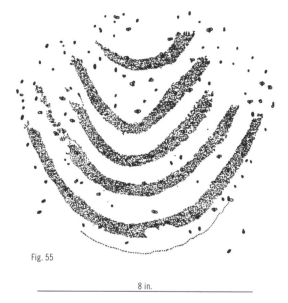

Fig. 55

8 in.

Fig. 55 - Copy, by Harald Pager (1971) of a painting at Eland Cave (Drakensberg, South Africa) showing a cross-section of a wild hive. This type of concentric arches design is often read as an "entoptic sign" by the supporters of a reading of rock art using a shamanic key. But here the presence of the bees, clearly drawn, contradicts these interpretations. Some have nevertheless tried to insist by assuming the buzzing of the insects could have provoked the state of trance!

is also eloquent. In them, one can observe anthropomorphs and various animals, including the omnipresent eland, but also species that are less often cited, such as the lion, the ostrich, and especially the elephant. Their dates are uncertain: those obtained from tests on ostrich eggs found on the surface are 410 ± 45 B.P. and 670 ± 50 B.P., and an excavation yielded remains of specularite, a pigment used to produce the black for the paintings, and usually transported in such shells, at dates of 2520 ± 60 B.P. and 2710 ± 50 B.P. It is known that dates obtained from carbonated materials are not very reliable, but these have been compared with those of 2700 and 1600 B.P. obtained at the rock engraving site of Jagt Pan, nineteen miles (30 km) farther south. Where our subject is concerned, the important point here is the presence of elephants among the rock images: this animal having disappeared from the region at the beginning of the nineteenth century. It is therefore absent from the series of mythical animals mentioned in the traditions collected by Wilhelm Bleek and Miss Lloyd from the 1870s onward, contrary to the lions and antelope that are near them in the rock depictions and that have survived to the present day. This discrepancy highlights one of the limits of ethnographic comparisons for the interpretation of art.[110]

The supposition that the whole of southern Africa's rock art was motivated by shamanic practices that remained unchanged from the twenty-seventh millennium B.C.E. to the second millennium C.E. thus in no way takes into account the archaeological discoveries that testify to various socioeconomic changes that occurred over the ages, especially during the first two millennia C.E., for example with the diffusion of pastoralism or the introduction of pottery (which appeared in the early years C.E. in the Brandberg). The excavations carried out in the Brandberg invalidate locally the model of an immigration of herders putting the native hunter-gatherers to flight, and on the contrary prove an in situ evolution of these natives toward pastoralism, with integration of a long-distance exchange system—which is hard to reconcile with the ahistoric position of the cognitivist school founded by Lewis-Williams.[111] Even for researchers who happily accept the hypothesis of a pan-San shamanism, it seems that the healing practices that were given this name were constituted quite recently in response to social changes of this kind.[112] Moreover, some distributions point to cultural variations: in the Western Cape, the paintings of the mountainous zones of the interior include sheep, whereas on the shores of the Atlantic there are images of cattle, and especially of numerous handprints that are never found in the interior. Conversely, along the shores of the Indian Ocean, sheep are on the coast and cattle in the interior.[113]

A first critique of the "trance hypothesis" was put forward by the empiricist Alexander Robert Willcox, but in its place he was scarcely able to propose more than a watered-down version of the principle of "art for art's sake." "In my opinion," he wrote:

the minimum hypotheses as the raisons d'être of the *representational* rock art of southern Africa . . . are the following: (1) to record important or pleasant events in the life of the community or in the experience of the artist; (2) to instruct the young or illustrate folktales; (3) to give pleasure to the artist through his work and his re-creation on the rock, to be seen again, of what pleased him at first view, coupled with the satisfaction of sharing the aesthetic

110 Morris & Beaumont 1994. 111 Kinahan 1995, p. 88. 112 Kinahan 1991. 113 Garlake 2001, p. 655.

experience and receiving admiration for his skill. This motive I take to account for the great bulk of the art, and it does not conflict with, but would accompany Reasons 1 and 2. . . . The importance of the pleasure principle can hardly be overstated.[114]

If there is one point about which Lewis-Williams is certainly right, it is that most of the rock art of southern Africa fulfilled some need other than that of entertaining its authors and observers through aesthetic interpretations of daily life. The painters and engravers had preoccupations other than education—even if a number of their works can teach us much about the way of life of the ancient inhabitants—and the dull reading of the art as a reflection of life can no longer be defended. In the paintings, it is antelope which dominate, not the small animals and plants, and more than half of the antelope are eland.[115] Clearly, this animal had a spiritual importance that bears no comparison to its role in daily life.[116]

By contrast, in the sites with rock engravings at Twyfelfontein, in the region of the Brandberg (*figs. 1, 56, 57*), the animal most often depicted is the giraffe, with 316 examples out of a total of about 2,500 (mostly animal) figures, but one can also note the presence of elephants, rhinoceroses, zebras, and antelope. There are also twenty-seven anthropomorphs and a few geometric signs (circles, lines, arches), as well as a high number of engravings that imitate hoof prints (gemsbok, kudu, zebras, giraffes, springbok, lions, and other felines). These prints are sometimes isolated, and sometimes added to the image of the whole animal. There is even an engraving of a lion whose legs and tail end in the characteristic prints of this feline (*fig. 57*). Among all these images, one can also observe the presence of human footprints. Apart from these engravings, the site also includes painted shelters; and, in a few places, paintings and engravings are found together, which is exceptional in southern Africa.[117]

Fig. 56

Fig. 56 - General view of the site of Twyfelfontein in Namibia.

114 Willcox 1983, p. 538–40. 115 Vinnicombe 1976. 116 Lewis-Williams 1984. 117 Dowson 1992.

Fig. 57

Incidentally, although hunting may be of more symbolic than nutritional importance, these observations are the final nail in the coffin of the theories that saw rock art only as a technique of magic for hunting. Besides, these theories in no way take into account the thematic variety of the works: the statistics produced by Harald Pager at Ndedema Gorge showed that out of 2,860 human and animal figures, only twenty-nine are involved in a hunting scene, with no more than seven archers aiming at an animal. Another example: at Crane Rock, there are five bird figures out of 3,942 subjects painted, whereas birds constituted about 11 percent of the diet of the San of the central Kalahari.[118] So hunting and food concerns were doubtless not the artists' primary motivations. And, even if a very few images are known that illustrate the use of the musical bow—even a painting showing a man smearing his arrows with poison[119]—one would seek in vain any works depicting people eating, weaving baskets, tanning hides, making a bow . . . in short, busy performing most of the activities that made up the daily life of a group of hunter-gatherers.

Trance of therianthropes or dance of masked men?

In the famous painting of Medikane (*fig. 42*) that constitutes one of the images of "shamans in trance" that is most often cited, the head of the "therianthropes" is clearly delimited by a line that separates it from the rest of the body, and the legs visibly emerge from what seems to be a garment (a kaross). So in reality, these pseudotherianthropes are just ordinary men dressed in animal hides, within the context of an undetermined ceremony. When a tracing of this painting was shown to the last representative of the Transkei San, she saw it as nothing other than healers dancing,[120] just as one of Wilhelm Bleek's informants had more than a century earlier: "The paintings from the cave of Medikane are thought [by the San questioned by Bleek] to represent sorcerers wearing gemsbok's horns, two of them with sticks in their hands."[121] In 1936, Dorothea Bleek published the testimony of a man who said of a San called !Grrirtandé, that he "used to cut off the springbok head. He also cut off the scalp, he thus sewed a scalp cap, which looked like a thing's ears when he put it on;"[122] and we also have the testimony of a traveler who, in 1889, saw a San dancing in a jackal skin "complete with head and ears," or wearing "an elephant's head with trunk,"[123] which also exists in the "elephant-men" of certain rock paintings. So it would be excessive to interpret all of them as shamans in the process of "trance-formation." One of them (*fig. 51*) could well be a masked man, but another with animal extremities, who is curiously surrounded by a swarm of bees, could just as well evoke a mythical being (*fig. 53*). It is known that honey is involved in the San's origin myths, and the San believe that supernatural beings are very fond of honey, that the supreme god of the !Kung is the protector of bees, and that his wife is "the mother of bees."[124] Moreover, the expression "to eat honey" is a San metaphor for the sexual act, and the fact that Mantis offers

Fig. 57 - Rock engravings at Twyfelfontein (Namibia). It is by no means certain that these images are only motivated by the wish to depict reality, since the lion at the bottom has legs ending in "prints," the front one having five digits (like men, not felines), while its tail also ends in another "print."

118 Pager 1975, p. 34. 119 Woodhouse 1969, p. 5-6. 120 Jolly 1986, p. 8. 121 Bleek 1919, p. 155. 122 Bleek 1936, p. 144. 123 Thackeray 1984. 124 Pager 1974 and 1975, p. 74. Woodhouse 1989.

some to the primordial eland in that animal's origin myth, is surely not immaterial. So one can see that the ethnographic and mythographic data from the San about honey and bees is sufficient to shed light on the depictions in which these elements are involved (*figs. 53 to 55*), without any need to suppose, as Lewis-Williams does, that these images are evidence for trance states during which shamans believed that "they were both seeing and hearing bees swarming over honeycombs"![125]

In addition, the dance of the eland performed by various San groups (!Kung, Naron) involves the wearing of antelope masks in which the horns are simply two sticks carved into a point, and maintained on the dancers' head with leather straps (*fig. 45*). When presented with two of Stow's tracings showing dances of animal-headed people (*figs. 58* and *59*), Diä!kwain explained to W. Bleek and Miss Lloyd: "The things which the people here have put on are caps that they have made for themselves of young gemsboks' heads. . . . At the time when they do the 'ken [dance] they wear such caps. The rings which they have put on are the 'ken's rings."[126] When one examines the images that these comments refer to, it is obvious that Diä!kwain was right, because in many of the figures one can clearly see the human head sticking out below the animal-head mask. These facts show that the interpretation that sees every therianthrope as a person in trance is the result of an incorrect generalization. Besides, when in 1974 Lewis-Williams showed a series of tracings of rock paintings to some Zu/'hõasi from the vicinity of Maun, he was very impressed by the fact that they were all perfectly capable of recognizing not only the eland, but also their gender (from the shape of the neck), and certain details of their behavior in accordance with the period of the year. However, when presented with the image of a group of three people with an antelope headdress (and not head)—which Lewis-Williams always

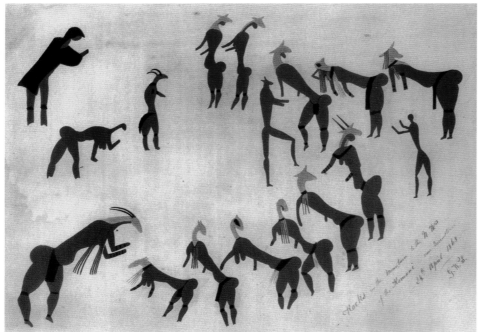

Fig. 58

[125] Lewis-Williams 2002a, p. 148. [126] Stow & Bleek 1930, pl. 13–14.

Figs. 58 and 59 - Tracings by Stow of paintings at Tiffin Kloof (Queenstown, South Africa) showing dances by animal-headed people, and on which, Diä!kwain, one of the San informants of W. Bleek and Miss Lloyd, commented by explaining that the dancers here are wearing "caps which they have made for themselves of young gemsboks' heads."

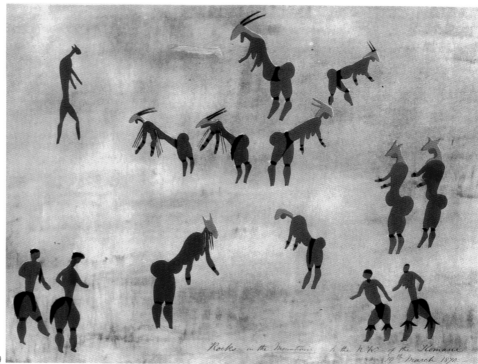

Fig. 59

wanted to see as "shamans" (*fig. 61*)—they declared that these were *//gawasi* ("spirits of the dead"), a statement that so clearly contradicted the theory of our impromptu ethnographer that he concluded: "There is . . . nothing to be gained from asking the !Kung to 'explain' enigmatic activity groups of conflations; their guesses are no better than ours."[127] In other words, and put more bluntly, the declarations and suppositions of the San are only "good" when they can be used by the interpreter to confirm his theories, but one can get nothing out of them when they contradict them!

Yet, despite all this, we are not forced to choose between the shamanic reading of therianthropes, the interpretation of them as a personification of the dead, and the fact that they can also represent masked pantomimes such as are still known among the San. On the contrary, !King's commentary on the paintings presented to him by Orpen shows that these three components can perfectly well be linked. It is important to quote *in extenso* a passage from !King's statement concerning a painting at Mangolong (Sehonghong) (*figs. 62-63*), which has been curiously neglected by commentators:

> The men with rhebok's heads, Haqwe and Canate, and the tailed men, Qweqwete, live mostly under water, they tame eland and snakes. That animal which the men are catching is a snake! They are holding out charms to it, and catching it with a long rein. They are all under water, and those strokes are things growing under water. They are people spoilt by the . . . dance,[128] because their noses bleed. Cagn[129] gave us the song of this dance, and told us to dance it,

Fig. 59 - Rediscovered by Bert Woodhouse, the scenes recorded by Stow at Tiffin Kloof have almost totally disappeared, but what remains of them suffices to show that Stow's tracings are reliable, especially where the dancers' caps are concerned.

127 Lewis-Williams 1981b, p. 36. 128 Orpen here left a blank corresponding to the name of this particular dance.

129 Kaggen according to Bleek's transcription.

and people would die from it, and he would give them charms to raise them again. It is a circular dance of men and women following each other, and it is danced all night. Some fall down, some become as if mad and sick, blood runs from the noses of others whose charms are weak, and they eat charm medicine, in which there is burnt snake powder. When a man is sick, this dance is danced round him, and the dancers put both hands under their arm-pits, and press their hands on him, and when he coughs the initiates put out their hands and receive what has injured him—secret things.[130]

In this testimony, bleeding from the nose is certainly associated with an ecstatic healing dance, but this occurs only among those "whose charms are weak," and only with reference to Haqwe, Canate, and Qweqwete, veritable mythical therianthropes living underwater in the world of the dead, whose cattle are made up of eland and snakes.

In addition, the painting containing the animal described by !King in the early 1870s as a snake that is seized by the people in the myth was later shown by W. Bleek to Diä!kwain, who recognized it as an aquatic bovine taken out of the water by men to provoke rainfall. To our eyes this animal looks like a sort of hippopotamus with unnatural characteristics—in particular something resembling hairs growing above the nose (incidentally, it is lines of this type that, when found under the nose, are interpreted by some as epistaxis). All authors are now in agreement that this is a "rain animal" like those in the myths of the San and the Nama that are described sometimes as

Fig. 60 - This photo by Malcolm Pearse, exhibited at Winterton Musueum (South Africa), shows that the usual analysis of the paintings at Fetcani Bend is based on an extremely selective tracing. One should note in particular that the third person from the right is not a shaman "trance-forming" into a therianthrope, but a man wearing a headdress with animal ears.

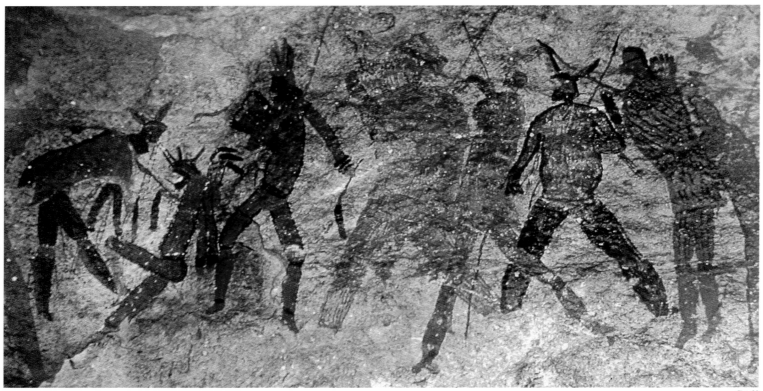

Fig. 60

[130] Orpen [1874] 1919, p. 151–52.

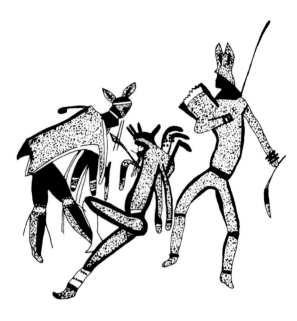

Fig. 61

a snake and sometimes as a bovine, and sometimes even as a being capable of taking on either form. For example, the Gai-//khaun say it has the form of a snake when it is in the water, but that it adopts the shape of a bovine when it emerges from the water.[131] Whether they are reptiles or cattle, mythical animals of this type are widespread in southern Africa, where they have numerous features in common: they are sometimes found in the sky but most often in water, from which they emerge at night to graze before returning there at dawn to hide during the daytime. They draw people into water with the help of invisible "threads" (sometimes identified with their beard), and are associated with rain and rainmakers (who are supposed to capture and sacrifice them). During the initiation of girls, a real or symbolic union of these aquatic spirits and the girls is often evoked.[132] After examining the documentation concerning these beings, Sigrid Schmidt (1979), noting that the myth of the "aquatic/rain bovine" was no doubt introduced into southern Africa by stock-breeders, and that its distribution is far less widespread than that of its serpentiform analogue, deduced that the latter is older. But two facts seem to contradict this reasoning: the snake rarely appears in the rain rites collected among the San, and antelope generally dominate the rock drawings. The solution to this enigma probably lies in a San myth about the origin of the rain dance, collected by M. Biesele; a myth in which the eland plays a central role, since the Trickster uses its horns to bring a storm.[133] The association of the Trickster and the eland in a symbolic constellation comprising the moon, horns, and lightning—the whole thing denoting fertility—clearly shows the primordial role played by antelope in the ancient cosmogonies of South African hunter-gatherers before domestic cattle replaced them by gradually increasing in importance.[134] Moreover, a few tales are known in which it is an antelope and not a bovine that lives in the water sources, and analogous myths refer both to the snake and the antelope. The legendary "rainbow" *likongoro* of the Okavango resembles a horned snake when it is in water, but a koudou when it comes out.[135] Above all, a number of South African rock art sites contain paintings of immense snakes with the head, mane and/or ears of an antelope (*figs. 19, 20,* and *51*) that strongly recall the ears of the mythical snakes still spoken of both among the Herero and in Kenya. Consequently, it is hardly surprising that a great number of people declare that the cry of the aquatic snakes is a bleating or lowing. In the last century, "rain animals" were recognized by the San in rock paintings—without their help we would still be wondering why cattle are surrounded by fish (*figs. 65* and *66*), one of them also being in contact with a snake (*fig. 46*). As for the association of the mythical (eared) snake and the antelope, it can also be found in the rock paintings (*fig. 69*).

Given all this, the fact that on the wall at Mangolong the painters depicted the rain snake (or bovine) in the form of an animal that does not resemble either species but rather looks like a hippopotamus, can doubtless be linked to the fact that the latter

Fig. 61 - Painting at Fetcani, Barkly East (South Africa), often cited by Lewis-Williams as an illustration of his shamanic interpretation of the rock art of southern Africa. For, according to him, the central person, in a trance, would collapse with a nose bleed. It is clear in any case that these three people are not therianthropes nor shamans in the process of transformation, but that they are wearing headdresses or masks made with the hides of real animals.

131 Among the /Khoebesin (who emigrated from the south of the Orange River at the beginning of the nineteenth century), *Turos* is the name of a legendary aquatic cow, whereas among the Gai-//khaun it is that of a serpent that can take on a bovine form once it has left the water. Farther north, in Dama country, *Turos* is none other than a serpent. As for the Luyi of the upper Zambezi, they tell of an enormous serpent called *liombe-kalala*, which lives in the water; the first part of its name (*liombe*: "big head of cattle") refers to the fact that this reptile is reputed to low like a bull. 132 Hoff 1997. 133 Biesele 1975, vol. 1, p. 178. 134 Schmidt 1977–78. 135 Schmidt 1979, p. 212.

animal, although aquatic, emerges from water at night to graze far from the rivers, just as the mythical beings are supposed to do. In all periods, when people approached water during the day in order to see the famous rain being, they obviously did not see a giant snake or an aquatic bovine, but they did see hippopotamuses. Hence, although the rock images may be faithful both to zoological realities and to mythology, one should not lose sight of the fact that even if the beast depicted may resemble some living animal or other it is above all a mythical being, with no exact equivalent in nature. This example alone should encourage interpreters to avoid any monolithic explanation of the region's art.

One painting has caused a great deal to be written: that of Tepelkop, in the district of Fouriesburg (South Africa), which represents a giant snake on whose back big people seem to be walking toward its head (*fig. 70*). Facing the reptile, another person appears to hold the corpse of a small antelope out to it; the whole thing has been described as a scene of an offering to a rain snake.[136] There is hardly any doubt that this is a "rain animal" because the rain is depicted in the form of fine parallel lines falling from the reptile's body in several places. Above this snake's head there is what has most often been interpreted as a comet: one can clearly see its long trajectory, and the starred circle at its extremity.[137] Some people have even seen it as a double comet, because this trajectory ends in a second similar "star," which makes it tempting to link this image with a phenomenon like that of comet P/Biela, which broke in two in 1846. The oral traditions of the Nama and the /Xam of the same region evoke "water snakes" with a head like a horse. These reptiles, which are masters of rain, have a luminous star on their foreheads that they use to guide themselves when they leave the water to go and feed at night, like hippopotamuses (which are also water "horses"!). For the /Xam, the Griqua,[138] and the Korana, this star was liable to be struck by lightning, and the reptile could deposit it in the ground in the form of a sparkling stone like a diamond. Certain daring individuals could then seize it in order to acquire great powers. As the Fouriesburg image represents a giant—and thus mythical—snake, it is very probable that it refers not so much to a real comet as to concepts that associate shooting stars with mythical snakes. Consequently, rather than seeking which precise comet it could allude to, and far from reading these two star figures as "entoptic signs" that appeared in the framework of a shamanic trance, it seems preferable to listen across the years to the voice of Diä!kwain, a San from the Katkop mountains, who declared to Wilhelm Bleek: "Our mothers used to say, that when a sorcerer dies, his heart falls down from the sky, it goes into a water pit . . . That is why our mothers used to say when a star fell, 'A sorcerer seems to have died here.' . . . When a sorcerer who brings illness has died, then a star falls down."[139] So the Fouriesburg image could show a group of men going to seek the water snake's star to acquire its power, especially as this asteroid is divided into two. Because, again according to Diä!kwain, when the star falls into a water pit, "it sounds like a quiver. [Our mothers] said: we hear it as it sounds like rain pouring down, when it

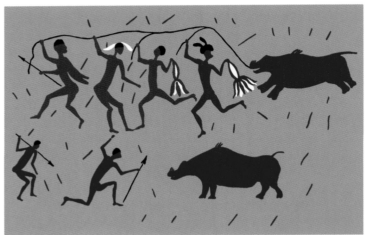

Fig. 62

136 Woodhouse 1992, p. 10. 137 Woodhouse 1986*a* and 1986*b*. 138 Another name for the Xiri. 139 Bleek 1935, pp. 28–29.

Fig. 62 - Tracing, made by Joseph Millerd Orpen in the 1870s, of a painting in the cave of Mangolong (Lesotho), which his guide !King interpreted and commented on as being a scene of the capture of a "rain animal." (see fig.63).

pours into the water pit, *when it divides*[140] in the water pit."[141] As for the mythical snakes, clearly depicted in the paintings, present-day Griqua, Nama, and /Xam remain convinced of their existence; they fear them, revere them, associate them with water sources and rain, and still integrate them into their rites of passage, which are in no way shamanic. It is highly probable that "rain animals" were indeed depicted in the rock paintings, but it would be a mistake to consider them a priori as "hallucinatory creatures" seen during trance,[142] because they may simply be representations of mythical beings of the same type as those that exist in art throughout the world. The mythical nature of several of the snakes just mentioned is also confirmed by their color, which does not correspond to any real species. That of Tepelkop, for example (*fig. 70*), is two-tone, with a red belly and a light back, coloring that corresponds to that of the line surmounting the "rain beast" of Rouxville (*fig. 8*), recognized as a rainbow by a San, and which fits a text published by Dorothea Bleek: "The Rainbow is yellow in that part which lies above; the piece which seems red lies below."[143]

Not just the San!

Pieter Jolly (1995) considers that the shamanic hypothesis underestimates the participation of influences attributable to the myths of the southern Bantu, Nguni, and Sotho, whose cosmology could be partially illustrated by rock art, because it has very probably been infused into San testimony collected in the past. As we have seen, the /Xam,

Fig. 63 - The painting at Mangolong (see fig. 43), traced by Patricia Vinnicombe.

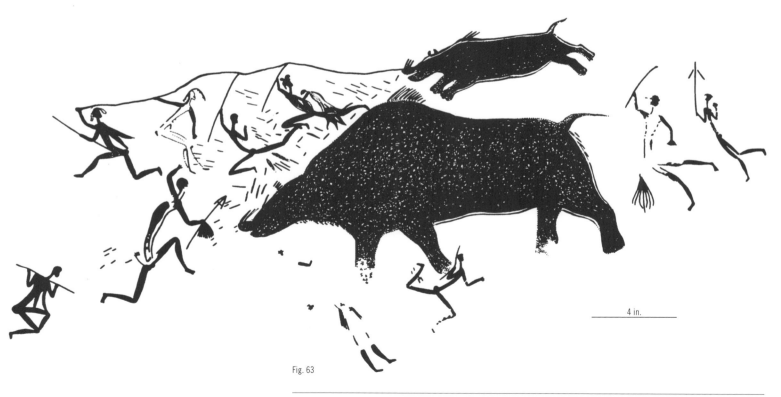

Fig. 63

4 in.

140 My emphasis. 141 Bleek 1935, p. 27. 142 Lewis-Williams 1985, fig. 8, 1998*b*, p. 200. 143 Bleek 1923, p. 66

the Nama, and Griqua all have traditions of mythical snakes corresponding perfectly to certain rock paintings, but many other examples could be given showing that mythical elements recognizable in rock art nourish the oral traditions of the San, the Khoekhoe, and the Bantu. Hence, several paintings depicting rhebok in a vertical position with heads downward—in particular at Grootgontein, north of George (South Africa), where a frieze of these animals seems to be descending vertically (or falling), the first few being curiously long and slender (*fig. 72*)—correspond beautifully to the Bantu vocabulary associated with this antelope, known as *lehele*, where *ihele* designates a line of animals; and in Sotho *helkehle* means "to descend a steep slope" and *hele* "to fall," while *lehelehele* can designate both a "long and slender animal" and "a steep descent, a precipice."[144]

In Lesotho, we saw that the paintings in the cave of Medikane in reality represent people bending over and leaning on sticks (*fig. 42*) in a posture that is identical to the Nguni diviners, who likewise lean on such sticks and ritually wear antelope hides and antelope masks.[145] Certainly, the Medikane painting on which !King commented on which, bears a strong resemblance to the photograph taken at Logagani (southern Botswana) by W. H. C. Taylor in 1934.[146] In this photo, a Sotho-Tswana diviner (*mokoma*) is wearing an antelope head and hide and is bent over at a right angle to lean on two sticks,[147] a posture that is found among Xhosa diviners. Another photograph, taken in 1904, shows a Zulu female diviner (*isangoma*) bending over at a right angle and leaning on two sticks. The similarity of the position—officiants bending forward and leaning on sticks—among the San, the Zulu, and the Xhosa is reinforced by the fact that the San word *!gi:xa*, "medicine man" or "sorcerer" according to Dorothea Bleek (1956), has a phonetic echo in the Xhosa term *igqirha*, "diviner," which suggests the possibility of a connection or a borrowing. Ethnographic data published in 1915 even specify that one of the sticks used by the officiants has a positive connotation, whereas the other is associated with evil.[148] The reader will recall that in the painting at Ezeljadgspoort (*fig. 44*), sticks are likewise held by people bending forward, just as in a painting at Orange Spring, in which five dancers are using sticks in the same way, to the rhythm of women clapping hands, and perhaps also like the *!goin !goin* ("bullroarer")[149] that causes a man located in front of a seated human, who is applauding (*fig. 71 to 73*), to roar. Another photo, taken in the 1990s, shows that in the Eastern Cape Nguni diviners still dance in decorated shelters while leaning on two sticks.[150]

As for the paintings produced during the last five hundred years by the pastoralists and farmers of the zone between the Northern Cape and KwaZulu-Natal, which contain numerous figures of cattle, sheep, animal hides, and various types of shields,

[144] Thackeray 1994, p. 230–31. [145] Walton 1957 *in* Jolly 1995, p. 72. [146] As far as can be judged from the published copies: Orpen's was corrected by Bert Woodhouse (1967, fig. 2) who points out that: (a) the person on the right seems in reality to be sitting on the ground; (b) what the person at bottom left is holding does not resemble two sticks but one short one, together with a long enigmatic object; (c) only the person at the top seems to be holding two sticks, but shorter than in Orpen's copy. Nevertheless, one can only remain sceptical insofar as in his "tracing" Woodhouse has ignored the filiform humans armed with lances who run above the others, as well as the big quadruped underlying the whole thing. On the other hand these appear on the document published by Patricia Vinnicombe (1976), which was reproduced by L. J. Botha and J. F. Thackeray (1987, fig. 2). This copy shows each figure carrying two sticks, but only those held by the person at top left are long enough to lean on. [147] Thackeray 1999. [148] Botha & Thackeray 1987. [149] Implement used ritually by the San, and also to imitate the flight of bees. [150] Prins 1996b, fig. 9.

Fig. 64

as well as shapes that are not directly interpretable (circles), it would be futile to try and understand them only on the basis of San traditions since they were produced by the Sotho, Nguni, and Tswana.[151] Conversely, it would be foolhardy to accept unreservedly all the /Xam texts collected by Bleek as extracts from "the" San mythology—it is known that at least one of his informants had a Korana mother. Finally, many present-day Bantu consider that their traditions concerning the art of provoking rain and aquatic snakes come to them from the San; and Nguni diviners often reuse old San rock art sites, attributing their power to the presence of the paintings of these "ancestors."[152]

The legend of the blue ostriches

There are a small number of rock drawings that prove the use of animal disguises for hunting in the society of some of the painters, and these have been used to deny that the therianthropes were shamans or supernatural beings—they are just ordinary men disguised for the hunt. The most famous case is also the oldest. It is the copy made by Stow, in the 1860s and 1870s, of a painting in the present-day Transkei that has never been rediscovered, and in which two of the ostriches depicted are curiously bluish in color (*fig. 67*). Hence Dowson, Tobias, and Lewis-Williams have accused Stow of having made up this work, through the inspiration of an engraving illustrating Moffat's book, *Missionary Labours and Scenes in South Africa* (1842). This accusation weighs heavily in the debates over the interpretation of the rock art of southern Africa. For a long time now, the debate has pitted the supporters of an essentially descriptive art

Fig. 64 - Rock paintings in a shelter located above the Modderpoort Mission (Free State, South Africa). The main scene, doubtless made by a Makhomokholo artist (a local San group), represents two confronted elands, facing various people; but, although it has been listed since 1936, the assemblage has suffered a great deal.

[151] Maags 1995 [152] Prins 1996*b*, and personal investigations in the Drakensberg

(depicting only scenes of real, everyday life) against those who support a symbolic or religious art. This latter group includes the defenders of a metaphorical reading of the images, which supposedly evoke the world and the activities of shamans—a position that is essentially that of the people who denounce Stow as a forger.

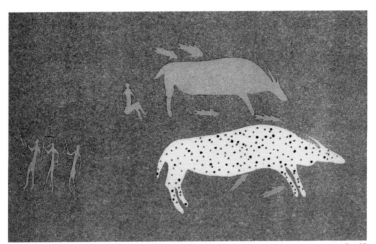

Fig. 65

Certainly we do have old descriptions of hunting camouflage, especially from the pen of Hendrick Jacob Wikar,[153] James Alexander,[154] and Robert Moffat.[155] Nobody questions their authenticity, and they are accompanied by engravings showing an archer disguised as an ostrich in order to approach gnu (Alexander) or a group of five ostriches (Moffat). Dowson, Tobias, and Lewis-Williams showed convincingly that Stow's "tracing" bears a curious resemblance to a reversed image of an engraving in Moffat's book, which Stow was aware of, and that the original of Stow's drawing shows retouching which could have been intended to improve its resemblance to the engraving published by Moffat. These authors' suspicion grew when they failed, they say, to find examples of rock images showing authentic hunting disguises. They reject the engraved examples mentioned by Fock,[156] only refer in passing to those mentioned by Woodhouse and Lee,[157] point out that the one cited by Willcox[158] is not accompanied by an illustration, and finally quote the opinion of Patricia Vinnicombe: "Apart from the celebrated scene copied by Stow in which a hunter conceals himself under the skin of an ostrich in order to approach his quarry more closely, I have seen no clear illustration of 'disguised' or therianthropic figures actually participating in a hunt."[159] QED: if the *only* image of a therianthrope liable to be an ordinary man hunting is a fake, this reinforces the theory that all therianthropes are shamans.

It is amusing to note that a new development in this controversy is due to the work of the "empiricists" who have been so harshly criticized by Dowson and Lewis-Williams (see above). Because these empiricists—imperturbably continuing their ant-like work of carefully publishing corpuses containing all the available images (and not only the ones that support their own theories)—have recently made known some very detailed paintings traced by Pager in the Upper Brandberg that show, without any possible doubt, a frieze of three archers disguised as ostriches (*fig. 68*). And to dispel any shadow of a doubt, a photo of the scene has been published by Lenssen-Erz.[160] Hence, through a kind of divine retribution, it is the heavily disparaged work of the empiricists that makes it possible to close the debate with a fact that should always have been obvious: There is no doubt that there are mythical therianthropes, but this does not rule out the existence of simple men wearing masks for hunting and/or ritual reasons. These practices survived until a very recent period—sometimes in the form of a game, as, for example, recalled by Tuoi Stefaans Samcuia, a San born in 1950 at Eenhana, in Namibia, whose father was a hunter: "We played many games in the veld. We could put the ostrich skin and head on a stick above our heads and pretend that we were the ostrich in the grass. Sometimes even the ostriches

[153] Wikar 1935, p. 179. [154] Alexander 1837, vol. 2, p. 145–47. [155] Moffat 1842, p. 17–18. [156] Fock 1979, p. 52, pl. 5 and 103. [157] Woodhouse & Lee 1970, fig. 42–44 and 49. [158] Willcox 1963, p. 26. [159] Vinnicombe 1976, p. 330. [160] Lenssen-Erz 2000, fig. 76.

Fig. 65 - Tracing by Helen Tongue of a painting at Willow Grove, Wodehouse District (South Africa), depicting "water bovids" (here elands) surrounded by fish, one of which has the spotted hide peculiar to certain mythical beings.

did not know the difference between us and them."[161] The existence of such disguises is confirmed by another image from the Brandberg, showing an archer wearing a head of the gazelle *Antidorcas marsupialis* (*fig. 74*), and closely following one of these animals. As for the mythical therianthropes associated with nosebleed, one can only recall this passage in the explanation given to Orpen by !King concerning paintings that show a kind of giant: "The big people you have seen painted with deformities are the Qobe . . . they were cannibals, they cut people's heads off, they killed women and drew blood out of their noses."[162] Therefore, epistaxis does not always have to be evidence for shamanism, it can also result from the activity of certain mythical characters.

Consequently, it is important not to see all therianthropes as images of shamans (as do the defenders of a pan-shamanism in rock art) or as masked men (as do the supporters of rock art as a "reflection" of society), since a reading of this kind amounts to turning them into a single category, without taking into account their typology (antelope-men, elephant-men, bird-men, etc.) and neglecting the likelihood that their morphological variety could reveal not only different human activities but also the evocation of supernatural beings of various categories (spirits, souls, demons, ancestors, divinities, heroes, living-dead, etc.).

Fig. 66 - "Water bovids" painted at Clarksdale, Wodehouse District (South Africa), near which there are groups of fish, as traced by Helen Tongue.

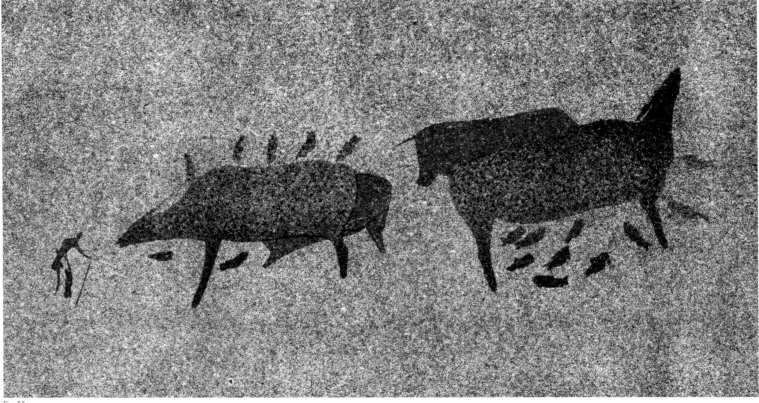

Fig. 66

[161] Winberg 2001, p. 90. [162] Orpen [1874] 1919, p. 146.

Mermaids, water maidens, and aquatic dead people

A painting copied at Ezeljagdspoort, in the vicinity of the present-day locality of Oudtshoorn, in the Cape, and published by Sir James Alexander,[163] represents beings whose "amphibious nature" he had noticed, and the interpretation of which is still the subject of debate (*fig. 44*). For Lewis-Williams, they are "rain shamans," whose piscine appearance is the result of the metaphor that links trance to diving into water. Taking his inspiration from certain statements made by Diä!kwain, Lucy Lloyd's informant, this same author has also suggested that these beings could have a tail—not a fish's tail, but that of a swallow or "rain bird"—thus, these images would represent swallows sent by shamans, or would be shamans transformed into birds.[164] None of these interpretations can be tested, because, any animal that can be seen in the paintings could be a transformed man, but we cannot confirm this and will never confirm it. Through a different reading of this image, Anne Solomon links these "mermaids" with female initiation, insofar as /Xam tales say that in water holes one can still see former female initiates who were recalcitrant, kidnapped by the rain divinity, and then drowned.

Fig. 67 - The "blue ostriches" that George William Stow attributed to a site that was never rediscovered, and has been suspected of being a fake inspired by an illustrated work of the nineteenth century. Nevertheless, it remains true that this type of approach-camouflage is attested to elsewhere, including in rock art, as is proved by fig. 51.

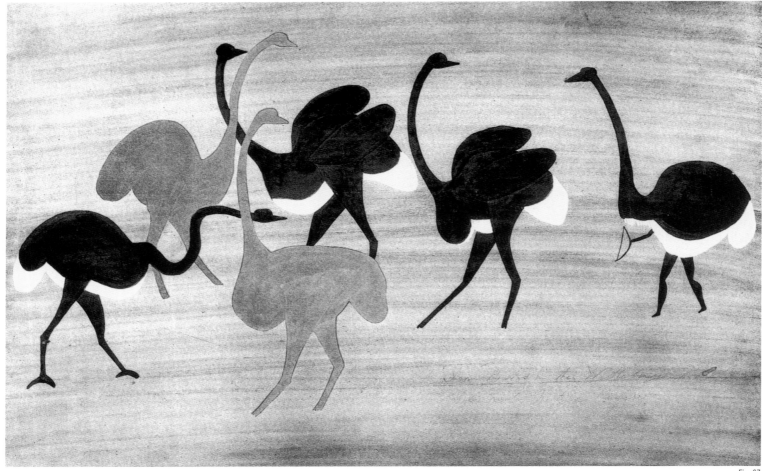

Fig. 67

163 Alexander 1837, vol. 1, p. 316. 164 Lewis-Williams, Dowson & Deacon 1993

Fig. 68

A paragraph of a report published in 1875 by Wilhelm Bleek tells us that the theme of this image "was explained in a fine old legend to Mr. D. Ballot by a very old bushman." This text, which was long thought lost, was rediscovered by J. Leewenburg (1969) in a batch of papers that had once belonged to Lucy Lloyd. In it, one learns that when Ballot asked "an old bushman who appear[ed] to be between 70 or 80 years of age" if he believed in the "water maidens," the latter replied:

> I know many stories of water women that my mother has told me . . . There was once a girl who all the people said was so good looking. One day this girl went out to walk along the river, and came to a large waterhole over which a *krantz* was hanging . . . she stopped at the hole to look at some attractive flowers that were drifting near her, till at last one of them came so close that she stooped over the water to pluck it. Hardly had she touched the flower when she was caught by the hand and dragged into the water.

Not seeing her daughter return, the mother followed her tracks and, seeing these disappear near the water, immediately understood that her daughter had been captured by the water women. She threw into the river some powder from a plant that these women are very fond of, and was thus able to obtain the return of her daughter, who declared to her mother that "the people who live under the water had such fine houses, and . . . live in great abundance." So this myth introduces us to a female aquatic people characterized by their wealth. The aquatic domain where the water women live is in reality the world of the dead, as can be seen by the fact that, according to the storyteller, if the girl was able to return it was because she remembered in time her mother's warning against the machinations of the water women: "If they ask you: 'What will you eat, fish or meat?' you must say: 'I eat neither, give me bread to eat'" (which is impossible underwater). Here one can recognize the motif of the "food of the Other World," the consumption of which forbids any return to the world of the living.[165]

Some have expressed doubts about whether the people in the Ezeljadgspoort painting really have fish tails, since a reading of this kind risks owing more to the western myth of the mermaid than to truly San concepts,[166] but two of the people in this work are carrying short sticks and one of them is bending forward, exactly like in the Medikane painting mentioned above (*fig. 42*). It will be recalled that, for !King, it represented "men who had died and now lived in rivers." The fact that these two paintings refer to an apparently aquatic world peopled by creatures that are half-man and half-animal is thus best explained by the concepts and myths about the dead and the Other World—widespread among all the San[167]—without any need whatsoever to resort to some kind of South African shamanism. Especially as the existence of mermaid-like beings is attested among the San[168]: a /Xam girl told Ansie Hoff how she succeeded one day in secretly spying on a "water woman," which she described as half-woman and half-fish. It is generally said among the /Xam that the people (boys or girls) who are married by the "water snake," which takes them to its aquatic

Fig. 68 - Painting in the Brandberg (Namibia), which is exceptional for two reasons: It represents a person painted in white flatwash, and it is the best preserved in a frieze of three men disguised as ostriches for the hunt. Wearing a bird skin, the hunter is holding in one hand an object imitating the neck and head of the creature, while in the other he carries his bow and arrows with crescent-shaped heads. The red dots on the legs correspond to a characteristic of the male ostrich.

165 This is motif MT C211.1 in the international classification of Stith Thompson (1966), known elsewhere in Africa: *cf* Le Quellec & Sergent, s.v. "food taboo." 166 Lewis-Williams 1977. 167 Solomon 1997 168 It has even been the subject of a thesis: Van Vreeden 1957.

dwelling, go wild and become alien to humans: the lower part of their body changes into a snake or fish, while their limbs grow shorter and become serpentiform. It would be hard to find a better description of the beings depicted in the rock image at Ezeljadgspoort.[169]

Curiously, objections have been raised to this on the grounds that in reality one has no idea at all what the image analyzed in this way actually represents. If one supposes that the old narrator of this legend may have been influenced by Mr. Ballot's questions, one can accept that the people described could correspond to mermaid-like beings, but they could also be something else entirely that we do not know. This objection is admissible, but it must be accepted that exactly the same applies to the reading of the same image as a representation of "rain shamans!"

In the shamanic theory, elongated figures in rock paintings, like the filiform person at the bottom of the Ezeljagdspoort painting, illustrate, as we have seen, the sensation of elongation that is experienced during trance. This is quite possible, but Anne Solomon, who has taken an interest in the differences conventionally established between the sexes by the San, has stressed that they denote femininity through the notions of curviness, broadness, and smallness, whereas masculinity is marked by narrowness, length, and large size.[170] So there is as much chance that these paintings denote masculinity as trance (which, moreover, is not contradictory).

The drawings of eland are doubtless infused with similar notions, insofar as among the Zu/'hõasi this animal, associated with water, is considered female and fat, characteristics that are also ascribed to rain-carrying clouds, while clouds that do not bring precipitation are male and skinny. The red lines decorated with white trinkets, which sometimes join people and animals together, can perhaps be linked to a note by W. Bleek's informant, /Hanπkass'o, who specified that such lines were the rain's umbilical cord. The representation of such lines would be completely at home in images with mythological content, since, for the San, blood (a female element) and water (a male element) symbolize life and death respectively.[171] As for

Fig. 69 - Enigmatic assemblage at Klipplaat Dam (Queenstown District, South Africa) comprising an antelope, a mythical snake (with horns and ears?), and a zigzag motif (another snake?), among people in different postures. The antelope's unrealistic internal decoration, shows that this is a mythical being, probably a "rain bovid;" so it is no longer a surprise to see it next to a giant "water snake" in a spotted decoration (see figs. 4, 20, 30, 44 and 45).

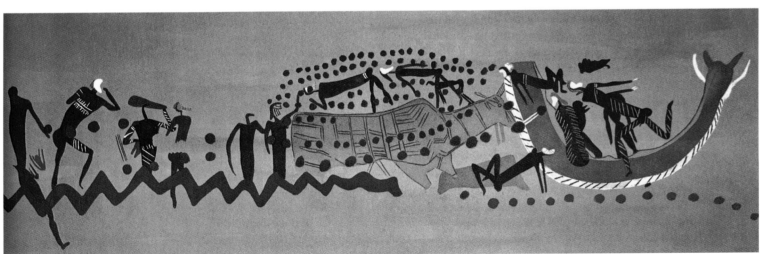

Fig. 69

[169] Hoff 1997, p. 28–29. [170] Solomon 1992, pp. 302, 308. [171] *Ibid.*, p. 298.

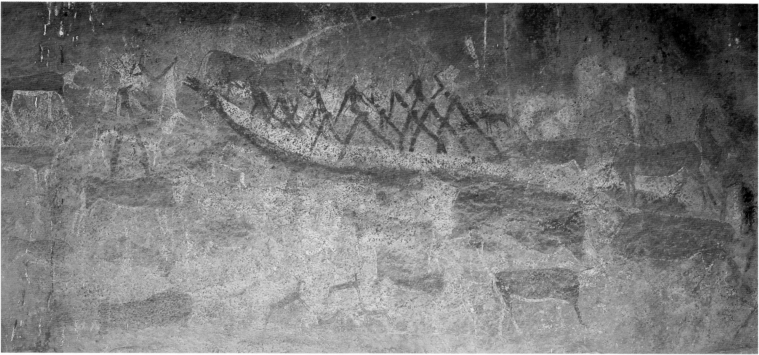

Fig. 70

the white dots on the bodies of certain people seen by some as a depiction of sweating during trance—sweat which the San use in healing rituals—they could just as well depict a particular body decoration. Nevertheless, it is more probable that these dots denote rain drops as much as the mythical nature of the beings that have them, since they are found both on mythical snakes (*fig. 29*) and on "rain animals" (*fig. 8*), particularly on the hide of "aquatic cattle," where they cannot describe a natural kind of coat (*figs. 46, 65, and 66*).

Fig. 70 - Painting at Tepelkop, district of Fouriesburg (Orange Free State, South Africa), associating a group of people with a double shooting star (?) and a "rain snake" with a red belly and light-colored back (photom modified by computer to improve the visibility of the star's trajectory in its upper part).

The power of the eland

Since the eland is the animal most often depicted in South African rock art in general, it is obvious that it was a central symbol in the artists' conception of the world. Research by Grant S. McCall among the Zu/'hõasi has confirmed the hypotheses linking this symbolism to an opposition between masculinity and femininity.[172] The eland, which is the world's biggest antelope, is also the southern African animal richest in fat, and above all it has a remarkable sexual dimorphism peculiar to this species. Contrary to what distinguishes males and females in numerous other antelope, in the eland they all have similar horns, but the male also has a large "dewlap" hanging beneath its neck. In the Cederberg Mountains (Western Cape), some well preserved paintings have shown that males were represented in red ocher with legs, head, and neck white, while females were painted in yellow ocher. When the white—an extremely fragile color—disappears, the contrast between males and females is attenuated in the paintings, but nevertheless the sexual dimorphism was important enough, from the cultural point of view, for the painters to reinforce it with a chromatic contrast (red = male/yellow = female) that does not really exist in nature (and, as we have already seen, these colors are precisely those of the rainbow and the "rain snake"). Another opposition that is only found in the eland, namely that the male is richer in fat than the female, could not fail to have been noticed by a society based on the division between sexes as much as that of the ancient San, who made great use of antelope fat. So it is hardly surprising that, among extremely realistic eland images, one can find a figure like the one in the Transvaal, for example,

Fig. 72

Fig. 71

172 McCall 2000

Fig. 71 - Scene painted at Orange Spring (South Africa) showing how men dance with sticks to the rhythm of women clapping, perhaps accompanied by a bullroarer player.

Fig. 72 - Painted panel at George (South Africa), in which a frieze of antelopes seems to be descending vertically—or falling—from the top of a cliff (after Thackeray 1994).

Fig. 73 - Photograph of the scene reproduced by Helen Tongue in 1909. Ninety-five years later, it bears witness to the site's excellent state of conservation, and the quality of Helen Tongue's tracing.

which shows one of these animals with a highly exaggerated "dewlap," making it a sort of "super-male."

The symbolic importance of antelope, and particularly the eland, can also be found in the rare oral testimonies collected from the San about painting techniques. In 1884, a magistrate by the name of W.E. Stanford learned from a certain Silayi, who had lived for almost three years among the Drakensberg San, that colors were applied with a brush made of hairs taken from a gnu's tail,[173] and Mapote, a Sotho from Basutoland (present-day Lesotho), explained to Marion How (1962) that his San half-brothers put blood from a freshly killed eland into their colors—a prerequisite for the mixture to be of good quality. The daughter of a San from the Transkei, born among the Mpondomise and aged about seventy-five in 1986, reported to Pieter Jolly that in her youth (that is, before 1918) she had seen paintings made. For instance an eland, having been sacrificed near a rock shelter, its blood was mixed with fat to form a powerful compound to smear on the throat and back of those who wished to acquire the animal's power, after which the rest of the product, with pigments added to it, was used for drawing on the wall with their fingers; the drawings were intended to protect the group from various dangers, notably from lightning.[174] All of this shows that the act of painting and the ingredients used to this effect integrated "magical" components, and that this act must have been at least as important in itself as its result—namely the finished painting that researchers study. It is therefore all the more regrettable that there

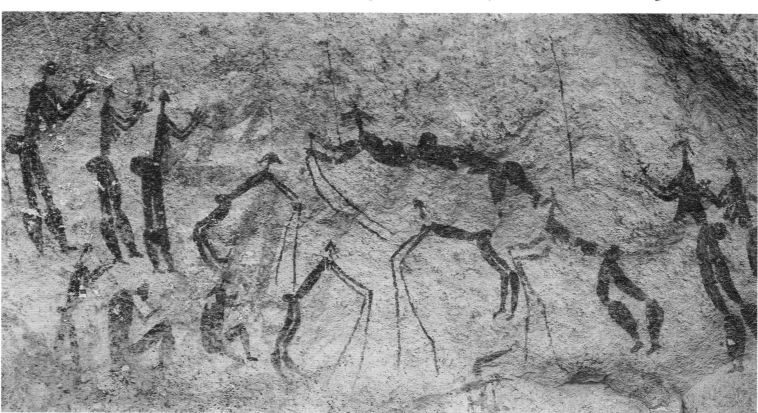

Fig. 73

[173] Stanford 1910, p. 439. [174] Jolly 1986, p. 6.

is a quasi-absence of information about a pictorial tradition, memories of which still survived in the nineteenth century and the beginning of the twentieth, as shown by this passage from a myth told to W. Bleek by /Hanπkass'o: "Little girls,' one of them said, 'It is //hára [specularite, black], therefore I think I shall draw a gemsbok with it.' Another said, 'It is tò [haematite, red], therefore I think I will draw a springbok with it.'"[175] The fact that the paintings were endowed with a certain power was confirmed by the female descendant of the Transkei San (who have since disappeared), mentioned above. In the 1980s, she explained that insofar as the works contained eland blood, a power emanated from them that one could absorb by placing one's hand on them. This same person also specified that among the ingredients used to make the paintings there were also elements taken from aquatic snakes.[176] This expresses an association of eland and reptiles that confirms the creation myth passed on by !King, according to which when one of the sons of the creator god /Kaggen killed the eland to which the latter's wife had given birth, /Kaggen scattered its blood, which when it fell first changed into snakes, then into a bubal antelope. Having then mixed this blood with fat from the first dead eland, he churned the mixture, which then gave birth to the multitude of actual eland, and /Kaggen said: "You see how you have spoilt the eland." Hence the term "spoilt" in no way referred to trance (as the supporters of the shamanic theory would have it), but evoked a second creation that took place after the break caused by the first murder: "Before that baboons were men, but since then they have tails," and since then "the snakes turned from being snakes and they became his people."[177] All this was understood perfectly in 1887 by Andrew Lang who, in *Myth, Ritual and Religion*, commented as follows on the myth told by !King to Orpen:

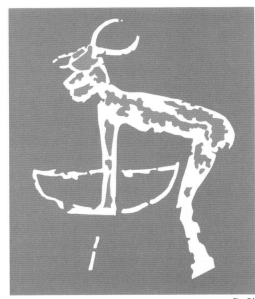

Fig. 74

> A few Bushmen in a curious mood seem to have been at a loss to explain the wildness of the eland. It would be so much more convenient if this animal was more friendly and let itself be taken easily. They explain this wild nature by telling that the eland was *spoiled* before Cagn,[178] the praying mantis, the creator or rather maker of all things, had completely finished it. Cagn's parents arrived and were the first to hunt the eland too early, and the consequence of this haste is that all the other eland have been wild.[179]

The primordial role played by the eland in San mythology makes it a symbol that allows a parallel to be drawn between hunting and sexuality within a system of relationships (called N!ao) associating big game, the mastery of rain, the hunting activities of men, and female fertility. Among this people, who have been called "the people of the eland," the passage to adulthood is accompanied by a dance that they themselves call the "dance of the eland." Female initiation occurs at the first menstrual bleeding, and male initiation authorizes boys to spill the blood of game for the first time. The arrow that injects into the animal the poison that will cause its death is paralleled by the phallus introducing into the woman the sperm that will cause the birth of a new man. From this viewpoint, menstruation is metaphorically a failed hunt—hence the taboo that imposes the separation of menstrual blood from everything to do with hunting. The same metaphor allows them to see women as eland and men as

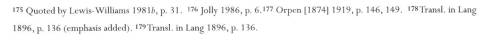

175 Quoted by Lewis-Williams 1981*b*, p. 31. 176 Jolly 1986, p. 6. 177 Orpen [1874] 1919, p. 146, 149. 178 Transl. in Lang 1896, p. 136 (emphasis added). 179 Transl. in Lang 1896, p. 136.

Fig. 74 - Archer painted in white at Naig Gorge (Brandberg, Namibia) and wearing a mask of the gazelle *Antidorcas marsupialis*. On the wall, he is shown approaching an animal of this species, painted in the same white. So this is definitely a hunting scene.

Fig. 76

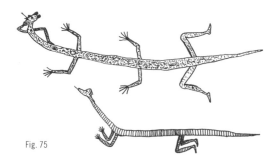

Fig. 75

Fig. 75 - Therianthropic snakes drawn in 1979 by Qam Xishe, a Zu/'hõasi San who specified that these were mythical ancestors.

Fig. 76 - Other drawings by Qam Xishe, made in 1980, and representing, from left to right, a "cattle-person," an "eland-person," and a "gemsbuck-person" belonging to primordial humankind yet, having kept some animal characteristics. The white lines at the knees are the places where the *!xo* (the creator) disarticulated these beings to "complete" them at the time of the second creation.

their hunters, while initiation enables one to live a counterpart of the "second creation" that put an end to the primordial time of the therianthropes and permitted the creation of humankind and the present-day animals.[180] This complex system, which can only be summarized very roughly here, is extensively echoed in the paintings, where one regularly sees separated groups of men and woman, where stress is placed on the eland's sexual dimorphism, and where the karosses worn by people are of the same color and shape as this antelope's body (see for example *fig. 37*), as if wearing this garment enabled the men to "become" eland.[181]

In Zimbabwe, it is not the eland that is most often depicted, but the Great Kudu,[182] which is also characterized by a pronounced sexual dimorphism: The male, far bigger than the female, has massive twisted horns; it is grey with white stripes, whereas the female's hide is a uniform brown-red. The importance that the artists accorded sexual dimorphism can be seen in the depictions of people: The men are thin and elongated, while the women are fat, with the emphasis placed on their buttocks and breasts. This leads one to suppose that ancient San societies, marked by an extreme division of labor between the sexes,[183] thought of themselves by means of an animal metaphor using the species that, in the region, are the most appropriate to this effect. Here, the kudu and there, the eland, the latter species being particularly remarkable through the reversal of the role of fat as a sexual marker in relation to humans.

Shamans or mythical beings?

So, for the most part, the rock art of southern Africa is less an evocation of dances and trances than an illustration of certain San myths about death and the Other World, or cosmogonic tales involving half-human and half-animal beings. In this case, the people represented in the form of therianthropes or beings with supernatural elongations are not shamans but dead people; and the collective scenes do not show trance ceremonies but illustrate life in the Other World, or episodes of cosmogony. Hence, if one returns to !King's commentary on the painting at Medikane (*fig. 42*), one has to consider that when he mentioned the fact of "spoiling" men and animals, he was alluding to the second creation in San mythology, the moment after which, in place of the initial indistinct therianthropes, there appeared men and animals in pure and

180 Parkington 1996. 181 Parkington *et al.* 1996. 182 *Tragelaphus strepsiceros.* 183 Lee 1979.

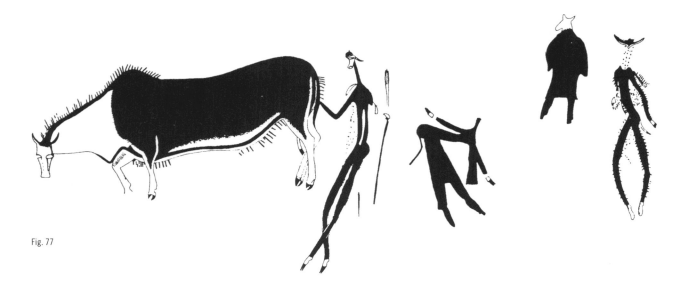

Fig. 77

complete form.[184] It was only after this second creation, which occurred after a founding break—caused by the accidental death of /Kaggen's son, who was an eland; or, among the /Xam, because of an unnatural union between a carnivore (lion) and a herbivore (springbok)—that both humans and beasts, like the mantis, the rock dassie, the mongoose, the suricate, the frog, the crane, the snakes, and the various antelope, acquired their present appearance.[185] Thus, in the rock art assemblages, every human or animal that is a bit "bizarre" can represent some primordial being or other—that is, something very different from what it seems to be today. This is also the interpretation proposed by Peter Garlake for the hybrid creatures painted in the Matopo Hills, because they are neither totally human nor totally animal.[186]

David Lewis-Williams has specified that it would be excessive to consider all of southern African rock art as the result of the hallucinations of those he calls shamans, but that one can nevertheless consider it as the reflection of a view of the world that implies the possibility of a passage between different levels of the Universe—for example through "doors" in the form of water holes—and that this view of the world can be termed "shamanic."[187] Nevertheless, this term is particularly unfortunate here, insofar as it encourages people to pursue analogies with true shamanism, whereas Africa is the continent of trance, and there is no reason to systematically associate trance with shamanism[188]—particularly given that Richard Katz, the foremost specialist in the healing rituals of the !Kung (or Zu/'hõasi), has concluded that the latter are totally ignorant of any shamanic tradition.[189] Even if one is trying to avoid the negative connotation of terms like "sorcerer" in modern Indo-European languages, to translate !gi:xa by "shaman" is incorrect,[190] particularly as, depending on the context, the original term sometimes designates masters of the rain or the officiants of a curative ritual, and sometimes denotes spirits of the dead who are capable of doing good and evil, and are especially feared for the power they have of sending illnesses.

In 1975, a Zu/'hõasi San by the name of Qam Xishe, who lived at /Ai/ai in northwest Botswana (and who had never had the opportunity to visit either the rock

[184] Hence the name adopted by the Zu/'hõasi (made up of Zu, "person," /'hõa "finished," "completed," with the plural suffix –si). So they are "complete men," in contrast to the "incomplete men" of the first creation. [185] Bleek & Lloyd 1924. [186] Garlake 2001, p. 653. [187] Lewis-Williams 1999. [188] Hamayon 1995. [189] Katz 1982, p. 231. [190] Lucy Lloyd had translated the /Xam word !gi:xa (from a root !gi meaning "magic," "magical power") by "sorcerer," before Dorothea Bleek preferred to translate it as "medicine man," before then returning to "sorcerer" (1935, 1956). Lewis-Williams (1981b) at first only used the expression "medicine man," and it was only after the end of the 1980s that he improperly generalized the use of "shaman" to translate the same notion.

Fig. 77 - Partial tracing of the wall of Game Pass Shelter at Kamberg (Drakensberg, South Africa), which, when shown to a group of Zu/'hõasi San, elicited a strictly mythological commentary from them. Indeed, their reading referred both to the creation myth of the elands and horses, and to San anthropogony, explaining how the primordial men were stripped of their animal characteristics to finally achieve their present humanity, and how there was a time when, as in this image, elands and horses shared certain common characteristics, such as mane and hairs at the base of the tail.

art sites of Tsodilo, 100 miles [160 km] from /ai/ai, or those of the Brandberg, 375 miles [600 km] from there), on observing the daughter of ethnologist Edwin N. Wilmsen making watercolors, began to draw on paper, and made such progress that, in September 1979, he was awarded one of the five prizes at Botswana's national artistic exhibition. In October 1979, he drew two therianthropic snakes (*fig. 75*) that looked highly enigmatic to Wilmsen. Having later learned of the existence of the horned and eared snakes in the Brandberg (*cf. figs. 23, 25, 69*), Wilmsen returned to see Qam in April 1980 and asked him for explanations of his work. Qam then began to speak of the mythical past of the San, specifying that the so-called snakes were mythical beings. Wilmsen asked him to illustrate his remarks, to facilitate his comprehension of the Zu/'hõasi creation story. This time Qam drew a series of horned therianthropes (*fig. 76*), which he described as being, from left to right, a "cattle-person," an "eland-person" and a "gemsbok-person," adding that the white lines at the knees were the places where !Xo [the creator] dislocated these beings to "complete" them at the time of the second creation (so they were not bracelets!). At Lewis-Williams's suggestion, Wilmsen showed his Zu/'hõasi friends some photocopies of rock art tracings from the Drakensberg, asking them simply to describe what they saw, and long discussions ensued. One of these is particularly interesting, because it concerns an image that Lewis-Williams has considered to be the "Rosetta stone" of all of South Africa's rock art (*fig. 78*). Indeed, according to him, the fact that certain features are shared by the

Fig. 78

Fig. 78 - View of the wall of Game Pass Shelter corresponding to the previous tracing. For David Lewis-Williams—who considers this panel as a "Rosetta stone" enabling him to decipher the art of southern Africa—the eland here is a metaphor of the trance undergone by the San shaman who is touching its tail, but this interpretation was not confirmed by the Zu/'hõasi San, whose reading is completely different.

eland and the depictions of therianthropes proves that the latter are shamans in the course of transformation, and that the eland itself is a metaphor of this. The details on which this opinion is based are as follows: The eland seems to be stumbling, and its hairs are sticking up, which could indicate that it is dying (and trance is a "little death"); its hind legs are crossed like those of the therianthrope that is touching its tail, and which has hooves instead of feet; the therianthrope on the right also has hair sticking up on its body (which is supposedly a reference to the kinesthetic sensations experienced during trance). However, when presented with the highly selective and partial tracing made by Lewis-Williams to support his demonstration (*fig. 77*), the Zu/'hõasi San who were questioned did not point out these details, but did indicate others: The antelope has one foot different from the others; it has the ears and mane of a horse, whereas its tail is that of an eland at its extremity but that of a horse in the hairs at its root, which are absent in true eland. They explained these details by a creation myth, according to which, in the past, eland and horses were identical, when they decided to exchange parts of their bodies. But while the horse played the game properly, this was not the case with the eland; so the latter has henceforth been "complete," contrary to the horse, which, afterwards, got its revenge by helping hunters pursue the eland. As for the therianthropes, recognized as "eland-men," the comments were as follows: "In the beginning . . . eland and horse were once the same, that is, they had their parts mixed up. Here man is holding eland to be completed." The therianthrope on the right of the scene provoked the narration of another myth: "!Xo originally made man and as he made animals with hair, hooves, horns, tail. Then he said, what have I done? I should make man different, so he started putting parts together. He took away the hair and horns and tail and gave man the head and wings of /wisa[191] [the eagle owls *Bubo africanus* and *B. lacteus*] but forgot to replace the hooves [as one can see, said the narrator, on the second man from the right]. He worked and worked and finally got everything right."[192] The San who were questioned even pointed out that on certain images of therianthropes the penis curves upwards, like that of the eland. This other detail proves that these are incomplete beings from the first creation, neither fully human nor fully animal. In this reading, there is absolutely no reference to trance, nor to any kind of "medicine men" or "shamans," as some wish to call them. And this reading is confirmed by a widespread San tradition: The !Kung say that the members of an ancient race, the !Xosi, had gemsbok heads on a human body, and that it was they who introduced the art of making ostrich eggshell beads. Similarly, the !Xõ of Botswana maintain that those who, in the past, taught men the technique of making these beads resembled the San, but had gemsbok heads.[193] Hence, even if this interpretation of the images of therianthropes in Zu/'hõasi terms should not be taken literally, its very existence confirms our earlier deductions, and considerably weakens—to say the least—the shamanic hypothesis. One can well understand why, in the most recent syntheses of his work,[194] Lewis-Williams never cites this study for which he was partly responsible!

The matter now seems well and truly settled. Even if one accepts that certain rock

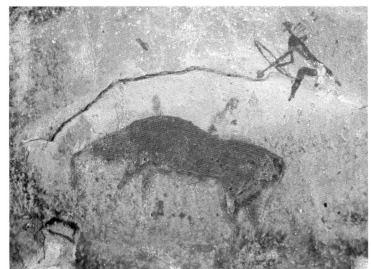

Fig. 79

Fig. 79 - Detail of the wall of Game Pass Shelter at Kamberg (Drakensberg, South Africa). Contrary to a widespread notion, in southern Africa there are very few paintings depicting hunting scenes, like this scene showing an archer aiming his weapon at an antelope.

images may depict healing rituals, it is obvious that conceptions of the Other World (and hence myths) were the inspiration behind a great deal of the art—and not trance rituals, contrary to the "shamanic" hypothesis. To once again pose the problem—so often debated by the first anthropologists!—of the relative primacy of myth or ritual in this case does not involve wondering whether the chicken or the egg came first, because it was certainly the mythical concepts that gave form to the visions caused by trance, and not trance that gave rise to the mythical images. For if these images were predetermined by neurological processes common to the whole of humanity—accompanying or causing trance—then the myths associated with trance should be more or less the same throughout the whole world, which is not the case. If the myths associated with Siberian shamanism are so different from San myths, it is because, on the one hand, San society as a whole is ignorant of "true" shamanism, and, on the other, because the link with trance is not obligatory. As for the appeal to psychological data needed to establish the universality of three supposed "stages of trance," a recent study by an American neuropsychologist has rebutted this. This is an old theory which has long been obsolete and is now irreparably refuted; it is now only of historical interest, and cannot be called upon to "prove" the existence of shamanic practices associated with even the least of the prehistoric African rock figures.[195]

Nevertheless, there is no question of replacing one monolithic explanation with another, and concluding that all the rock art of southern Africa was inspired by mythology! One only needs to recognize that certain mythemes have inspired numerous rock images, and that, in addition, these images are not all attributable to the San, for vast perspectives of research to open up before us.

The story of the frog-girl

The comments of the San questioned by Miss Lloyd and Wilhelm Bleek concerning these images allude to a myth that seemed to be well known at that time: that of the girl who was changed into a frog, along with all her family, following the breaking of a food taboo. Here is the version taken down by W. Bleek in 1874 or 1875, from dictation by !Kweiten ta//ken, the sister of Diä!kwain, and published in 1911:

> A girl formerly lay ill; she was lying down. She did not eat the food that her mothers gave her.[196] She lay ill. She killed the children of the Water;[197] they were what she ate. Her mothers did not know that she did thus, (that) she killed the Water's children; (that) they were what she ate; she would not eat what her mothers were giving to her.
>
> Her mother was there. They [all the women] went out to seek bushman rice. They spoke, they ordered a child to remain at home. The girl did not know (about) the child . . . And the old woman said that she must look at the things which her elder sister ate. And they left the child at home; and they went out to seek food (bushman rice).[198] They intended that the child should look at

[195] Helvenston & Bahn 2002. [196] Her mother and the other women. [197] !Kweiten ta//ken hadn't personally seen these but she had heard that they were very beautiful and striped like a /habba "zebra;" the Water was as big as a bull, and the children were the size of calves. [198] The name given to termites.

the things which her elder sister ate. The elder sister went out from the house of illness, (and) descended to the spring, as she intended again to kill a Water-child. The (bushman) child was in the hut, while she (the girl) did not know (about) the child. And she went (and) killed a Water-child, she carried the Water-child home. The (bushman) child was looking; and she (the girl) boiled the Water-child's flesh; and she ate it; and she lay down; and she again went to lie down, while she (the child) beheld her. And she went to lie down, when she felt that she had finished eating. The child looked at her; and she lay down.

And her mother returned. The child told her mother about it; for her elder sister had gone to kill a handsome thing at the water. And her mother said: "It is a Water-child!" And her mother did not speak about it; she again went out to seek for bushman rice.

And when she was seeking about for food, the clouds came up. And she spoke, she said: "Something is not right at home; for a whirlwind is bringing (things) to the spring. For something is not going on well at home. Therefore, the whirl-wind is taking (things) away to the spring."

Because her daughter killed the Water's children, therefore the whirlwind took them [the girl, her family and their goods] away to the spring. Something had not gone well at home, for her daughter had been killing the Water's chil-dren. That was why the whirlwind took them away to the spring. Because her daughter killed the Water's children, therefore the whirlwind took them away to the spring; because she had killed the Water's children.

The girl was the one who first went into the spring, and then she became a frog. Her mothers afterwards went into the spring; the whirlwind brought them to it, when she was already in the spring. She was a frog. Her mothers also became frogs; while the whirlwind was that which brought them, when they were on the hunting ground; the whirlwind brought them to the spring, when her daughter was already in the spring. She was a frog. And her moth-ers afterwards came; the whirlwind was that which brought them to it, when they were on the hunting ground. Meanwhile their daughter was in the spring; she was a frog.

Her father also came to become a frog; for the whirlwind brought her father—when he was yonder on the hunting ground—to the spring, (to) the place where his daughter was. Her father's arrows altogether grew out by the spring; for the great whirlwind had brought them to the spring. He also alto-gether became a frog; likewise his wife, she also became a frog; while she felt that the whirlwind had brought them to the spring. Their things entered that spring (in which) they were. The things entered that spring, because they (the people) were frogs. Therefore it was that their things went into the spring, because they were frogs. The mats (grew) out by the spring, like the arrows; their things grew out by the spring.[199]

Fig. 80 - Rock painting in the Beersheba region, traced by George Stow before it was deposited, in two pieces, at Bloemfontein Museum (South Africa). Miss Lloyd and W. Bleek showed this reproduction to one of the San friends, who commented on it as follows: "Frog. Thought to be a girl who ate what she should not and was changed into a frog. Her people go to her. The rain is below, a black rain. It has killed people. The girl ate touken, she displeased it. The arrows become reeds and stay at the spring, the sticks become bushes and are at the spring."

Fig. 81 - Painting traced by George Stow on the farm of Mooifontein, on the slopes of the Aasvogelberg (South Africa). Around 1874, a San commented on this image as follows: "The water is destroying these people, changing them into frogs, because a girl had been eating a touken, a ground food." And another added: "They become frogs. The girl whose fault it is in the brown dress (the sixth figure from the right), the Rain being angry with her. The third said to be her father, fourth her mother. The figure to the extreme left was hunting and is blown by the wind into the water."

[199] After Bleek and Lloyd 1911.

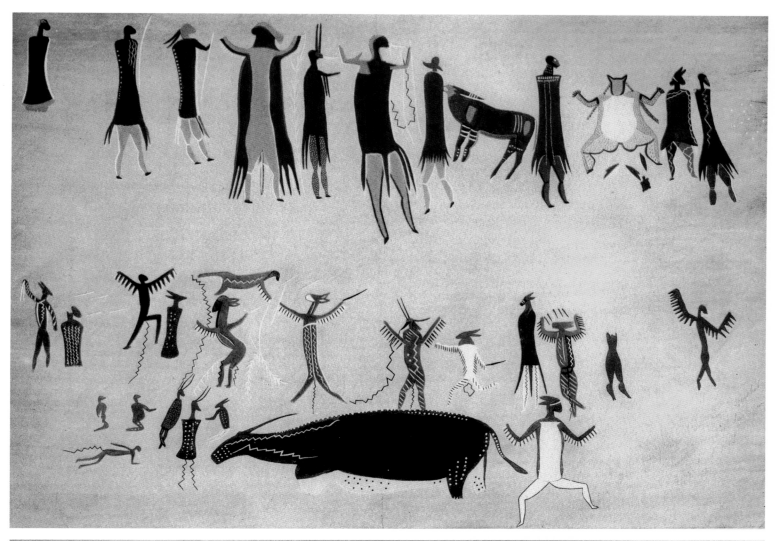

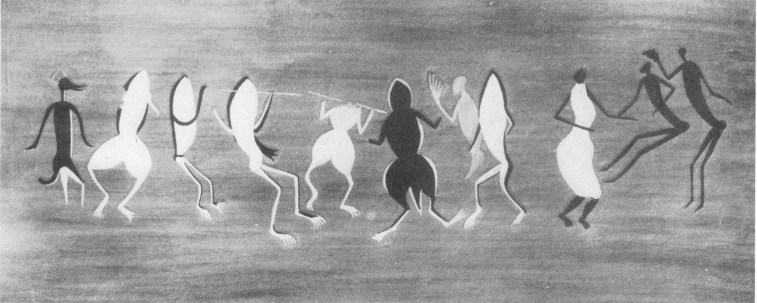

Fig. 80 and Fig. 81

Abbreviations

AS: African Studies.
BS: Bantu Studies.
EPA: Encyclopedia of Precolonial Africa: Archaeology, History, Languages, Cultures and Environments. Joseph O. Vogel (ed.), Walnut Creek / London / New Delhi: Altamira Press, 1997. 605 pp.
ICB: Institut colonial belge (Brussels).
INORA: International Newsletter on Rock Art (Foix, France).
JSA: Journal de la Société des Africanistes (Paris, France).
MSISN-MCSNM: Memorie della Società Italiana di Scienze Naturali e del Museo Civico di Storia Naturale di Milano (Milan, Italy).
NA: Notes Africaines (Dakar, Senegal).
RAR: Rock Art Research (Caulfield South, Australia).
SAAB: South African Archaeological Bulletin (Cape Town, South Africa).
SAASGS: South African Archaeological Society, Goodwin Series.
SAJS: South African Journal of Science.
TNR: Tanganyika Notes and Records.
TzNR: Tanzania Notes and Records.
ZfE: Zeitschrift für Ethnologie.

AAWBEB BOGALE (Abäbaw Bogalä), "The Culture of Pastoralist Guji of Borana Province." Addis-Ababa University Senior Essay, 1986, pp. vi-42.
ADAMSON, Joy. "Rock Engravings near Lake Rudolf." *Journal of East Africa and Uganda National History Society,* 19(1) (1946), pp. 70–72.
AGHALI ZAKARA, Mohammed; Drouin, Jeannine. *Traditions touarègues nigériennes.* Paris: L'Harmattan, 1979. 112 pp.
ALEXANDRE, Sir James Edward. *Narrative of a Voyage of Observation among the Colonies of Western Africa and of a Campaign in Kaffir-land.* London: Henry Colburn, 1837, 2 vols.
ALMÁSY, Ladislaus E. de. *Récentes explorations dans le désert libyque* (1932–1936). Cairo: Schindler, 1936 (adapted from *Az ismeretlen Szahara* ["Sahara inconnu"]. Budapest: 1934; German translation, *Schwimmer in der Wüste* ["Swimmers in the desert"]). Vienna: 1990.
ANATI, Emmanuel. *L'Art rupestre dans le monde: L'imaginaire de la préhistoire.* Paris: Larousse, 1997. 422 pp., 325 fig.
ANDERSON, Andrew A. *Twenty-five Years in a Wagon in the Gold Regions of Africa.* London: 1887. 2 vols.
ANFRAY, Francis. "Les sculptures rupestres de Chabbè dans le Sidamo." *Annales d'Éthiopie* 7 (1967), pp. 19–32.
———. "Les sculptures rupestres de Galma dans le Sidamo." *Annales d'Éthiopie* 10 (1976), pp. 53–5.
APPS, Peter. *Wild Ways, Field Guide to the Behaviour of Southern African Mammals.* Halfway House, Southern Book Publishers, 1992, pp. ix–197.
ARUNDELL, R.D.H. "Rockpaintings in Bukoba District." *Journal of the Royal Anthropological Institute* 66 (1936), pp. 113–16.
ATHROPE, R. "A note on Nsenga girls' puberty designs." *SAAB* 17 (1962), pp. 12–13.
AUMASSIP, Ginette. "Entre Adrar des Ifoghas, Tassili et Aïr: les contacts du bassin avec le Nord-Est." In: Jean Devisse (ed.), *Vallées du Niger.* Paris: Réunion des Musées nationaux, 1993, pp. 92–102. 573 pp.
BÂ, Amadou Hampâté. *Contes initiatiques peuls.* Njeddo Dewal, mère de la calamité. Kaïdara, Paris: Pocket, 1993. 397 pp.
BÂ, Amadou Hampâté; Dieterlen, Germaine. *Koumen Texte initiatique des pasteurs peuls.* Paris-La Haye: Mouton (collection "Cahiers de l'Homme"), 1961. 96 pp.
———. "Les fresques d'époque bovidienne du Tassili n'Ajjer et les traditions des Peuls: hypothèses d'interprétation." *JSA* 36, 1966, pp. 141–57.

BAGSHAWE, F. J. "Rock paintings of the Kangeju Bushmen, Tanganyika Territory." *Man* 23 (1923), pp. 146–7.
BAHN, Paul G. *The Cambridge Illustrated History of Prehistoric Art.* Cambridge: Cambridge University Press, 1998. 302 pp.
Barnard, Alan J. *Hunters and Herders of Southern Africa: A Comparative Ethnography of the Khoisan Peoples.* Cambridge: Cambridge University Press, Studies in social and cultural anthropology, 85, 1992, pp. xxv–349
BARROW, John. *An Account of Travels into the Interior of Southern Africa in the Years 1797 and 1798.* 2 vols.
BARTH, Heinrich. *Reisen und Entdeckungen in Nord- und Central-Afrika in den Jahren* 1849 bis 1855, Gotha: J. Perthes, 1857–58, 5 vol. (English translation, *Travels and Discoveries in North and Central Africa.* London: Longman, Brown, Green, Longmans and Roberts, 1857, 5 vols.)
BATAILLE, Georges. *A Tale of Satisfied Desire (The Story of the Eye).* Translated by Austryn Wainhouse from *Histoire de l'œil.* Paris: Olympia Press, 1953.
BAYLE DES HERMENS, R. de. *Recherches préhistoriques en République centrafricaine.* Nanterre: Labethno, 1975. 343 pp., 124 fig., LVII pl.
BELLIN, Paul. "Pierres à cupules et rituel africain." *Bulletin des études préhistoriques alpines* 2, 1969–70, pp. 178–81.
BIESELE, Megan. "A contemporary Bushman's comments on the Brandberg paintings." *Mitteilungen South West Afrika Wissentschaftliche Gesellschaft,* 15 (1974) pp. 3–7.
———. *Folklore and Ritual of !Kung Hunter-Gatherers.* Cambridge (Mass.): Harvard University, Ph.D. thesis, 1975, 2 vol.
BLANGUERNON, Claude. *Le Hoggar.* Paris: Arthaud, 1955. 228 pp., 55 héliogravures.
BLEEK, Dorothea F. *The Mantis and his Friends.* Bushman Folklore, Cape Town-London-Oxford, T. Maskew Miller-Basil Blackwell, 1923, 68 pp.
———. *Rock Paintings in South Africa from Parts of the Eastern Province and Orange Free State.* London: Methuen, 1930.
———. "Beliefs and customs of the /Xam Bushmen. Part VII: Sorcerers." *BS* 9 (1935), pp. 1–47.
———. "Beliefs and customs of the /Xam Bushmen. Part VIII: More about sorcerers and charms." *BS* 10 (1936), pp. 131–62.
———. *Cave Artists of South Africa: 48 Unpublished Reproductions of Rock Paintings.* Collected by the late Dorothea Bleek; with a Biographical Introduction on Miss Bleek by Eric Rosenthal; and an Archeological Introduction by A.J.H. Goodwin. Cape Town: A.A. Balkema, 1953. 80 pp.
———. *A Bushman Dictionary.* New Haven: American Oriental Society, 1956.
BLEEK, Wilhelm H.I. *Second Report concerning Bushman Researches with a short Account of Bushman Folklore.* Cape Town: Saul Soloman and Co., 1875.
———. "Remarks." *Folklore* 30 (1919), pp. 139–57 (commentaire à Orpen 1919).
BLEEK, Wilhelm H.I.; Lloyd, Lucy. *Specimens of Bushman Folklore.* Collected by the late W.H.I. Bleek and L.C. Lloyd; edited by the latter; with an Introduction by George McCall Theal. London: George Allen, 1911. pp. xl–468
———. (Dorothea Bleek, ed.). *The Mantis and his Friends.* Cape Town, 1924.
———. *Stories that Float from Afar: Ancestral Folklore of the San of Southern Africa.* Edited by J.D. Lewis-Williams. College Station: Texas University Press, 2000. 285 pp.
BLUNDELL, Geoffrey. *The Unseen Landscape: A Journey to Game Pass Shelter.* Johannesburg: University of Witwatersrand (Rock Art Research Institute), 2002.
BLUST, Robert. "The Fox's Wedding." *Anthropos* 94 (1999), pp. 487–99.
BOTHA, L. J.; Thackeray, J. Francis. "A note on Southern

African rock art, medicine-men and Nguni diviners." *SAAB* 42 (1987), pp. 71–3.
BOUAKAZE-KHAN, Didier. *L'Art rupestre de la Corne de l'Afrique: Étude globale dans son contexte archéologique et anthropologique. Modèle d'interprétation.* Paris: Université de Paris I-Panthéon-Sorbonne, 2002. 2 vols.
BRADLOW, E.; BRADLOW, F. (eds.), *William Somerville's Narrative of his Journeys to the Eastern Cape Frontier and to Lattakoe, 1799–1802.* Cape Town: Van Riebeeck Society Second Series, 10, 1979.
BRENTJES, Burchard. *African Rock Art.* Translated by Anthony Dent from *Fels- und Höhlenbilder Afrikas.* Leipzig, Koehler and Amelang, 1965; New York, Clarkson and N. Potter, 1970, 104 pp., 56 drawings by Hans-Ülrich Herold, 1 map, 23 illustrations (color and monochrome).
BREUIL, Henri. "Peintures rupestres préhistoriques du Harar (Abyssinie)." L'Anthropologie 44 (1934), pp. 473–83.
———. "The White Lady of the Brandberg (S.W. Africa), her companions and her guards." *SAAB* 3, 1948, 13 pp., 3 pl.
———. "Les figures incisées et ponctuées de la grotte de Kiantapo (Katanga)." Tervuren, Annales du Musée royal du Congo belge, Préhistoire, 1, 1952, pp. 3–31, pl. I–XIV.
———. *The White Lady of the Brandberg.* With the Collaboration of Mary Boyle and Dr. E.R. Scherz, London, Trianon Press-Abbé Breuil Trust, 1955. pp. x-31, 22 pl., 17 photos.
———. "Les roches peintes d'Afrique australe." Paris: Imprimerie nationale, Mémoires de l'Académie des inscriptions et belles-lettres, XLIV, 1965, pp. 121–45, VI pl.
———. *Les Roches peintes de la Rhodésie du Sud. Les environs de Fort Victoria et d'autres sites.* With the collaboration of Mary E. Boyle, preface by Roger Heim. Paris: Éditions Trianon-Fondation Singer-Polignac, 1966. 124 pp., 18 fig., 60 pl.
Calame-Griaule, Geneviève. *Ethnologie et langage: La parole chez les Dogon.* Paris: Gallimard, 1965. 589 pp.
Calegari, Giulio. *L'Arte rupestre dell'Eritrea: Repertorio ragionato ed esegesi iconografica.* Milan: Museo Civico di Storia Naturale (Memorie XXIX-1), 1999. 174 pp., 268 fig.
CALONNE-BEAUFAICT, A. de. "Les graffitis du mont Ngundu." *Revue d'ethnographie et de sociologie* 3-4, 1914, pp. 109–17.
CAMPBELL, Joseph. *Historical Atlas of World Mythology.* Vol. 1: The Way of the Animal Powers, Part. 1: "Mythologies of the Primitive Hunters and Gatherers." New York: Harper and Row, 1987. 125 + CXL pp.
CAMPBELL, A.; DENBOW, J.; WILMSEN, E. "Paintings like engravings. Rock art at Tsodilo." In: Thomas A. Dowson and J. David Lewis-Williams (eds.), *Contested Images: Diversity in South African Rock Art Research.* 1994. pp. 131–58.
CAMPS, Gabriel. "Chacal." *Encyclopédie berbère, XII:* 1858–1859. Aix-en-Provence: Edisud, 1993.
CARNOCHAN, Frederic Grosvenor; Adamson, Hans Christian. *Out of Africa.* London: Cassell, 1937. pp. XIII–301.
CARTER, P.L. and P.J. "Rock Paintings from Northern Ghana." Transactions of the Historical Society of Ghana VII, 1964, pp. 1–3, pl. 1–3.
CARVALHA, P. da. "The rock paintings at mount Chinhamapere, Serra Vumba, Macequece." In: Louis S.B. Leakey and Sonia Cole (eds.), Proceedings of the Pan-African Congress on Prehistory. Nairobi 1947: Oxford, Blackwell, 1952. pp. 229–32.
CERVICEK, Pavel. "Rock paintings of Laga Oda (Ethiopia)." *Paideuma* 17 (1971), pp. 122–36.
CERVICEK, Pavel; Ulrich Braukämper. "Rock Paintings of Laga Gafra (Ethiopia)." *Paideuma* 21 (1975), pp. 47–60.
CHAKER, Salem. "Anzar: pluie." *Encyclopédie berbère, VI:* 798. Aix-en-Provence: Edisud, 1989.

CHAPLIN, J.H. "Further unpublished examples of rock art from Northern Rhodesia." *SAAB* 17 (1962), pp. 5–13.

———. "The Prehistoric Rock Art of the Lake Victoria Region." *Azania* 9, 1974, pp. 1–50.

CHIPPINDALE, Christopher; Taçon, Paul S.C. *The Archaeology of Rock-Art*. Cambridge: University Press, 1998. 373 pp.

CHOPPY, Jacques and Brigitte. "Le *djenoun*, définition et aire de répartition." *Sahara* 8 (1996), pp. 86–90.

CHOPPY, Jacques and Brigitte; Le Quellec, Jean-Loïc; Scarpa Falce, Sergio and Adriana. *Images rupestres en Libye: Aouis*. Paris: J. and B. Choppy, 2002. 330 pp.

CLAMENS, Gabriel. "Gravures rupestres en Côte d'Ivoire." *NA* 49 (1951), p. 1.

CLARK, John Desmond. "Schematic art." *SAAB* 13 (1958), pp. 72–4.

CLIST, Bernard. "L'âge du fer ancien en Centrafrique." In: Raymond Lanfranchi and Bernard Clist, *Aux origines de l'Afrique centrale*. Paris: Sépia-Centres culturels français d'Afrique centrale-Centre international des civilisations bantu, 1991, pp. 197–201.

COLE, Sonia. *The Prehistory of East Africa*. London: Penguin Books, 1954. 301 pp., 43 fig., 16 pl.

COLETTE, J.-R.-F. "Les rites de l'eau dans le néolithique congolais." Brussels: XVIe Congrès international d'anthropologie et d'archéologie préhistorique, 1936, pp. 1044–56.

COLLINSON, J.D.H. "The Makolo rockpaintings of Nyamwezi." *Azania* 5 (1970), pp. 55–64.

COOKE, Cranmer Kenrick. "Ships, snakes, eels, or good red herring." *SAAB* 18 (72) (1963), pp. 181–2.

CORY, Hans. *Wall Paintings by Snake Charmers in Tanganyika*. New York: The Grove Press, 1953. 99 pp.

COULSON, David; Campbell, Alec. *African Rock Art: Paintings and Engravings on Stone*. New York: Harry N. Abrams, 2001. 255 pp., 309 fig.

CULWICK, Arthur Theodore. "Ritual use of rockpaintings at Bahi, Tanganyika Territory." *Man* 31, 1931*a*, pp. 33–6.

———. "Some Rock-Paintings in Central Tanganyika." *Journal of the Royal Anthropological Institute of Great Britain and Ireland* 59 (1931*b*), pp. 443–53.

DARS, R. "Découverte de grottes et de ruines au Soudan occidental." *NA* 68 (1955), pp. 99–100.

DART, Raymond A. "Paintings that link South with North Africa." *SAAB* 18 (69) (1963), pp. 29–30.

DeCORSE, Christopher R. "Rock paintings in Northern Sierra Leone." *Bolletino del Centro Camuno di Studi Preistorici* 24 (1988), pp. 121–4.

DESPLAGNES, Augustin Marie Louis. *Le Plateau central nigérien: Une mission archéologique et ethnographique au Soudan français*. Paris: 1907. 504 pp., 236 fig., CXIX pl., 1 map.

DOWSON, Thomas Arthur. "Rock art research's umbilical cord: a review of Africa Praehistorica, vol. 1: The rock paintings of the upper Brandberg, Amis Gorge." *Cimbebasia* 12 (1990), pp. 172–6.

———. *Rock Engravings of Southern Africa*. Johannesburg: Witwatersrand University Press, 1992. 124 pp.

———. "The making of the 'blue ostriches': further light on a scientific fraud." *SAJS* 89 (1993), pp. 360–1.

DOWSON, Thomas Arthur; Tobias, Phillip Valentine; Lewis-Williams, J. David. "The Mystery of the Blue Ostriches: Clues to the Origin and Authorship of a Supposed Rock Painting." *AS* 53 (1994), pp. 3–38.

DUBA GOLOLCA. *Warfare and Hunting Practices among the Guji-Oromo*. Addis-Ababa University: Senior Paper in Sociology and Social Administration, 1987, pp. iv–49.

EASTWOOD, E.B. "Red lines and arrows: attributes of supernatural potency in the San rock art of the Northern Province, South Africa and south-western Zimbabwe." *SAAB* 54 (169) (1999), pp. 16–27.

EGO, Renaud. *San Art rupestre d'Afrique australe*. Paris: Adam Biro, 2000. 206 pp., 127 ill.

ERRICO, Francesco d'; Henshilwood, Christopher; Nilssen, Peter. "An engraved bone fragment from c. 70,000-year-old Middle Stone Age levels at Blombos Cave, South Africa: implications for the origin of symbolism and language." *Antiquity* 75 (2001), pp. 309–18.

ERVEDOSA, Carlos. *Arqueologia angolana*. Lisbon: Edições 70, 1980. 444 pp., 143 fig., CXXXIII pl.

ÉVRARD, Franck. *De la fellation dans la literature: De quelques variations autour de la fellation dans la littérature française* (preface by Anna Alter). Bordeaux: Le Castor Astral, 2001. p. 233.

FAGG, B.E.B. "The cave paintings and rock gongs in Birnin Kudu." *Actes du IIIe Congrès panafricain de préhistoire et d'étude du quaternaire* (Livingstone, 1955), London, 1957, pp. 306–12.

FOCK, Gerhard Jürgen. "Non-representational rock-art in the Northern Cape." *Annals of the Cape Provincial Museums* 6 (1969), pp. 103–36.

———. *Felsbilder in Südafrika. Teil I: Die Gravierungen auf Klipfontein, Kapprovinz*. Cologne: Böhlau Verlag, 1979.

FOCK, Gerhard Jürgen; Fock, Dora M. L. *Felsbilder in Südafrika. Teil II: Kinderdam und Kalahari*. Cologne: Böhlau Verlag, 1984.

———. *Felsbilder in Südafrika. Teil III: Die Felsbilder im Vaal-Orange-Becken*. Cologne: Böhlau Verlag, 1989.

FORBERG, Friedrich-Karl. *Manuel d'érotologie classique*. Monaco: Éditions du Rocher, 1979. 208 pp.

FOSBROOKE, Henry A. (ed.). "Tanganyika Rock Paintings." *TNR* 29 (1950), pp. 1–64.

———. "Further light on rock engravings in northern Tanganyika." *Man* 54 (1954), pp. 101–2.

FOSBROOKE, H. A. and J.; Ginner, P.; Leakey, L.S.B. "Tanganyika rock paintings: a guide and record." *TNR* 29 (1950), pp. 1–61.

FOZZARD, P.M.H. "Some rock paintings in south and south-west Kondoa-irangi district, Central Province." *TNR* 52 (1959), pp. 94–110.

FROBENIUS, Leo. *Hadschra Maktuba: Urzeitliche Felsbilder Kleinafrikas*. Munich: Kurt Wolff Verlag, 1925. 61 pp., 160 pl.

———. *Madsimu Dsangara Südafrikanische Felsbilderchronik*. Berlin-Zürich: Atlantis Verlag, 1931. 2 vol., 34–6 pp., 144 pl.

FRY, Roger. "The Art of the Bushmen." *Burlington Magazine* 16 (1910), pp. 334–8.

GALLAY, Alain. "Peintures rupestres récentes du bassin du Niger (propos de recherche)." *JSA* 34(1) (1964), pp. 123–39.

GANAY, Solange de. "Rôle protecteur de certaines peintures rupestres du Soudan français." *JSA* 10 (1940), pp. 87–98.

GARLAKE, Peter S. "The First Eighty Years of Rock Art Studies, 1890–1970." *Heritage of Zimbabwe* (Harare) 12 (1993), pp. 1–15.

———. *The Hunter's Vision: The Prehistoric Art of Zimbabwe*. Seattle: University of Washington Press, 1995.

———. "Sub-Saharan Africa." In: David S. Whitley (ed.), *Handbook of Rock Art Research*. Walnut Creek (California)-Lanham-New York-Oxford: Altamira Press, 2001. pp. 637–64.

GAUTHIER, Jean-Gabriel. "Gravures rupestres et peintures du pays Fali (Nord-Cameroun)." *MSISN-MCSNM* 26(2) (1993), pp. 257–60.

GENEVOIS, H. "Un rite d'obtention de la pluie. La 'fiancée d'Anzar.'" *Proceedings of the Second International Congress of Studies on Cultures of the Western Mediterranean*, Malta, 1976, pp. 393–400.

GIGAR TESFAY. "Rock Art around the Zalanbesa Area in the Eastern Zone of Tigrai (Ethiopia)." *Annales d'Éthiopie* 16 (2000), pp. 89–92 and pl. I–III.

GRAZIOSI, Paolo. "New discoveries of rock paintings in Ethiopia." *Antiquity* 38 (1964*a*), pp. 91–8 and 187–90.

———. "Figure rupestre schematiche nell'Acchelè Guzai (Etiopia)." *Rivista di Scienze Preistoriche* 6 (1–4) (1964*b*), pp. 265–76.

GRIAULE, Marcel. *Masques dogons*. Paris: Institut d'ethnologie (Travaux et Mémoires XXXIII), 1938. 896 pp., 261 fig., XXXII pl.

GUIART, Jean. *Les Religions de l'Océanie*. Paris: PUF, 1962. 155 pp.

GUILBAUD, Armand. "Azrou, Demeure d'Élias, dans l'Aïr." *Emenir* 11 (1993), pp. 13–14.

GUTIERREZ, Manuel. *L'Art pariétal de l'Angola*. Paris: L'Harmattan, 1996. 318 pp., 87 fig.

———. "L'art rupestre, l'ethnographie et la religion." In: Ya A. Sher (ed.), *International Prehistoric Art Conference*, 3–8 August 1998, Kemerovo (Russia), UNESCO/Siberian Association of Prehistoric Art Researchers, I, 1999, pp. 216–23.

HABERLAND, Eike. *Altvölker Süd-Äthiopiens*. Stuttgart: W. Kohlhammer Verlag, 1959. 455 pp., 48 pl.

HACHID, Malika. *Le Tassili des Ajjer. Aux sources de l'Afrique: 50 siècles avant les pyramides*. Algiers-Paris: EDIF 2000, Paris Méditerranée: 2000. 310 pp., 458 ill.

HAMAYON, Roberte. "Pour en finir avec la 'transe' et l'extase' dans l'étude du chamanisme." *Études mongoles et sibériennes* 26 (1995), pp. 155–90.

HARDING, J.R. "Interpreting the 'White Lady' rock-painting of South West Africa: some considerations." *SAAB* 23 (1967), pp. 31–4.

HARLOW, M.A.B. "The rock art of the Lake Victoria region in its African Context." *Azania* 9 (1974), pp. 43–7.

HARRIS, William Cornwallis. *The Wild Sports of Southern Africa; Being the Narrative of an Expedition from the Cape of Good Hope, through the Territories of the Chief Moselekatse, to the Tropic of Capricorn*. London: John Murray, 1839. pp. xxiv–387.

HASELBERGER, H. "Pétroglyphes à Toussiana." *NA* 119 (1968), pp. 94–5.

HELVENSTON, Patricia; Bahn, Paul G. *Desperately Seeking Trance Plants: Testing the "Three Stages of Trance" Model*. New York: RJ Communications, 2002. 52 pp.

HENNINGER, Jean. "Abris sous roche de la région de Bobodioulasso." *NA* 64 (1954), pp. 97–9.

———. "Signification des gravures rupestres d'une grotte de Borodougou. *NA* (Haute-Volta) 88 (1960), pp. 106–10.

HENSHILWOOD, C.S. "A revised chronology for the arrival of pastoralism in southernmost Africa: new evidence of sheep at ca. 2000 b.p. from Blombos Cave, South Africa." *Antiquity* 70 (1996), pp. 945–949.

HERDT, Gilbert H. *Rituals of Manhood*. Berkeley-Los Angeles: University of California Press, 1982.

HIGGINS, Rodney. "The plant-lore of courtship and marriage." In: Roy Vickery (ed.), *Plant-Lore Studies*, The Folklore Society Mistletoe Series 18, 1984, pp. 94–110.

HOFF, Ansie. "The Water Snake of the Khoekhoen and /Xam." *SAAB* 52 (1997), pp. 21–37.

HOLUB, Emil I. *Sieben Jahre in Süd-Afrika (1872–1879)*. Vienna-London: 1881, 2 vols., 235 ill., 2 maps.

———. *Von der Kapstadt ins Land der Maschukulumbe: Reisen im südlichen Afrika in den Jahren 1883-1887*. Vienna: Hölder, 1890. 2 vols.

HOW, Marion Walsham. *The Mountain Bushmen of Basutoland* (illustrated by James Walton). Pretoria: Van Schail, 1962. 63 pp. (2nd ed. 1970).

HUE, Edmond. *L'Âge de la pierre au Fouta Djalon*. Le Mans: Monnoyer, 1913. 71 pp.

HUFFMAN, T. N. "The trance hypothesis and the rock art of Zimbabwe." *SAASGS* 4 (1983), pp. 49–53.

HUGOT, Henri-Jean; Bruggmann, Maximilien. *Sahara, art rupestre*. s.l., Les Éditions de l'Amateur, 1999. 590 pp., 660 photos.

HUMPHREYS, A.J.B. "Ezeljagdspoort and Mermaids." *SAAB* 33 (127) (1978), pp. 2.

HUYSECOM, Éric. Fanfannyégèné I. *Un abri-sous-roche à occupation néolithique au Mali — La fouille, le matériel archéologique, l'art rupestre. Avec les contributions de Louis Chaix et Erhard Schulz.* Wiesbaden: Franz Steiner Verlag, 1990. 79 pp., 84 fig., 11 tables.

HUYSECOM, Éric; Marchi, Séverine. "Western African Rock Art." *EPA* (1997), pp. 352–7.

HUYSECOM, Éric; Mayor, A. "Étude stylistique *de l'art rupestre de la boucle du Baoulé, Mali.*"*Bulletin du Centre genevois d'anthropologie* 3 (1991–92), pp. 160–62.

HUYSECOM, Éric; Mayor, Anne; Marchi, Séverine; Conscience, Anne-Catherine. "Styles et chronologie dans l'art rupestre de la boucle du Baoulé (Mali): l'abri de Fanfannyégèné II." *Sahara* 8 (1996), pp. 53–60.

JACKSON, George; Gartlan, J. Stephen; Posnansky, Merrick. "Rock gongs and associated rock paintings on Lolui Island, Lake Victoria, Uganda." *Man* 65 (1965), pp. 38–40.

JACOBSON, L. "The White Lady of the Brandberg: a reinterpretation." *Namibiana* 2 (1) (1980), pp. 21–9.

JACQUOT, F. "Expédition du général Cavaignac dans le Sahara algérien." *L'Illustration, Journal universel*, t. IX, n° 227 (Saturday, 3 July), 1847, pp. 283–5, 7 fig.

JAEGER, P. "Précisions au sujet des sites rupestres de la région de Kita." *NA* 60 (1953), pp. 97–9.

JOLEAUD, Léonce. "Gravures rupestres et rites de l'eau en Afrique du Nord. Rôle des Bovins, des Ovins et des Caprins dans la magie berbère préhistorique et actuelle." *Journal de la Société des africanistes* 2 (1933), pp. 197–282.

JOLLY, Pieter. "A first generation descendant of the Transkei San." *SAAB* 41 (1986), pp. 6–9.

————. "Melikane and Upper Mangolong revisited: the possible effects on San art of Symbiotic contact between southeastern San and southern Sotho and Nguni communities." *SAAB* 50 (1995), pp. 68–80.

————. "Modelling change in the contact of the south-eastern San, southern Africa." In: Chippindale and Taçon 1998, pp. 247–67.

JOUSSAUME, Roger; Barbier, Sylvie; Gutherz, Xavier. "L'art rupestre du Sidamo (Éthiopie)." *International Newsletter on Rock Art* 9 (1994), pp. 7–11.

KATZ, Richard. *Boiling Energy: Community Healing among the Kalahari !Kung*. Cambridge (Mass.)-London: Harvard University Press, 1982. pp. xv–329.

KEENAN, Jeremy H. "The lesser gods of the Sahara." *Public Archaeology* 2, (2002), pp. 131-150.

KENNY, Michael. "The symbolism of East African Rock Art." *ZfE* 101 (1976), pp. 147–60.

KESTELOOT, Lilyan; Dieng, Bassirou. *Les Épopées d'Afrique noire.* Preface by François Suard. Paris: Karthala-Unesco, 1997. 626 pp.

KINAHAN, John. *Pastoral Nomads of the Central Namib Desert: the People History Forgot.* Windhoek: Nambia Archaeological Trust-New Namibia Books, 1991.

————. "Theory, practice and criticism in the history of Namibian archaeology." In: P. J. Ucko (ed.), *Theory in Archaeology: A World Perspective*. London: Routledge, 1995. pp. 76–95.

KÖHLER, Oswin. "Die rituelle Jagd bei den Kxoé-Bushmännern von Mutsiku." In: K. Tauchmann (ed.), *Festschrift zum 65. Geburtstag von Helmut Petri*. Cologne: Böhlau Verlag, 1973.

KOHL-LARSEN, L. and M. *Felsmalereien in Innerafrika*. Stuttgart, 1938.

————. *Die Bilderstrasse Ostafrikas: Felsbilder in Tanganyika*. Stuttgart, 1958.

KUBIK, Gerhard. *Tusona — Luchazi Ideographs: A Graphic Tradition Practised by a People of West-Central Africa*. Vienna: Föhrenau (Acta ethnologica et linguistica 61, Series Africana 18.) 1987. 312 pp.

————. "Ideogramas tusona no leste de Angola e zonas limitrofes." *Leba* 7 (1992), pp. 389–410.

KUPER, Rudolph. *Weiße Dame — Roter Riese: Felsbilder aus Namibia*. Cologne: Heinrich Barth Institut, 1996. pp. XIV–39.

LAFITTE, J.-P. "Les grottes peintes du Soudan." *La Nature*, July 9, 1910, pp. 85–6.

LAJOUX, Jean-Dominique. *Tassili n'Ajjer. Art rupestre du Sahara préhistorique*. Paris: Chêne, 1977. 182 pp.

LANG, Andrew. *Myth, Ritual and Religion*. 1st ed. London: Longman Green, 1887. 2 vols.

LEAKEY, Mary. *Africa's Vanishing Art: The Rock Paintings of Tanzania*. New York: Doubleday, 1983. 128 pp.

LEE, D. Neil. "Domestic dogs in South African rock art." *Pictogram* 10 (2) (1999), pp. 1–9.

LEE, Richard B. *The !Kung San: Men, Women, and Work in a Foraging Society*. Cambridge: Cambridge University Press, 1979.

LEEUWENBURG, J. "A Bushman legend from the George district." *SAAB* 25 (1969), pp. 145–46.

LEGUAY, Thierry. *Histoire raisonnée de la fellation*. Paris: Le Cercle, 1999. 256 pp.

LEIRIS, Michel. *Miroir de l'Afrique*. Paris: Gallimard (coll. "Quarto") 1996. 1,476 pp.

LENSSEN-ERZ, Tilman. "Perceptions du cadre écologique et ses expressions métaphoriques dans l'art ruprestre du Brandberg, Namibie." *L'Anthropologie* 100 (2/3) (1996), pp. 457–72.

————. Brandberg. *Der Bilderberg Namibias: Kunst und Geschichte einer Urlandschaft*. Stuttgart: Jan Thorbecke Verlag, 2000. 127 pp., 150 fig.

LE QUELLEC, Jean-Loïc. *Symbolisme et art rupestre au Sahara.* Paris: L'Harmattan, 1993. 638 pp.

————. *Art rupestre et préhistoire du Sahara: Le Messak.* Paris: Payot (coll. "Grande bibliothèque scientifique"), 1998. 616 pp., 189 fig.

————. "Images of shamans or imaginary shamanism?" *Pictogram* 11 (1) (1999), pp. 20–44.

————. "Shamans and Martians: the same struggle!" In: Henri-Paul Francfort, Roberte N. Hamayon and Paul Bahn (eds.), *The Concept of Shamanism: Uses and Abuses*. Budapest: Akadémiai Kiadó, 2001. 408 pp. pp. 135–59.

———— (ed.). "Henri Lhote et le lootoori." In: *Ithyphalliques, traditions orales, monuments lithiques et art rupestre au Sahara. Hommages à Henri Lhote*. Paris: AARS/AFU, 2002. 248 pp. pp. 141–56.

LE QUELLEC, Jean-Loïc; Abegaz, Gezachew. "New sites of South Ethiopian rock engravings: Godana Kinjo, Ejersa Gara Hallo, Laga Harro; and remarks on the Sappe-Galma school." *Annales d'Éthiopie* 17, 2001, pp. 205–24.

LE QUELLEC, Jean-Loïc; Sergent, Bernard. *Dictionnaire critique de mythologie*. Paris: PUF, (soon to be published).

LEROI-GOURHAN, André. *Gesture and Speech* (transl. from *Le Geste et la parole*, by Anna Bostock Berger. Cambridge: MIT Press, 2003.

LEROY, Pierre. *Matériaux pour servir à l'étude de la préhistoire de l'Uele. Le dallage d'Api — Le mégalithe d'Obeledi.* Brussels: Académie royale des sciences d'outre-mer, 1961, 48 pp.

LÉVI-STRAUSS, Claude. The Way of the Masks (transl. from *La Voie des masques*, by Sylvia Modelski), London, Jonathan Cape, 1983.

LEWIS-WILLIAMS, James David. "Ezeljagdspoort Revisited: New Light on an Enigmatic Rock Painting." *SAAB* 32 (126) (1977), pp. 165–69.

————. "The thin red line: Southern San notions and rock paintings of supernatural potency." *SAAB* 36 (1981a), pp. 5–13.

————. *Believing and Seeing: Symbolic Meanings in Southern San Rock Paintings*. London-New York-Toronto-Sydney-San Francisco: Academic Press, 1981b, 151 pp. 40 fig.

————. *The Rock Art of Southern Africa*. Cambridge-London-New York-New Rochelle-Melbourne-Sydney: Cambridge University Press, 1983, 68 pp. 25 + 109 fig.

————. "The empiricist impasse in southern African rock art studies." *SAAB* 39 (1984), pp. 58–66.

————. "The San artistic achievement." *African Arts* 18 (3) (1985), pp. 54–9.

————. "Beyond Style and Portrait: A Comparison of Tanzanian and Southern African Rock Art." In: *Contemporary Studies on Khoisan*, Part 2, ed. by Vossen and K. Keuthmann, 1987, pp. 93–139. Quellen zur Khoisan-Forschung 5.2, Helmut Nuske, Hamburg.

————. *Discovering Southern African Rock Art, Cape Town-Johannesburg*. David Philip, 1990a, 102 pp.

————. "Documentation, analysis and interprétation: dilemmas in rock art research." *SAAB* 45 (1990b), pp. 126–36.

————. "Quanto? The issue of many meanings in southern African San rock art research." *SAAB* 53 (1998a), pp. 86-96.

————. "The Mantis, the Eland and the Meerkats. Conflict and Mediation in a Nineteenth-Century San Myth." *African Studies* (1998b), pp. 195-216.

————. Meaning' in southern African San rock art: another impasse?" *SAAB* 170 (1999), pp. 141–45.

————. *A Cosmos in Stone: Interpreting Religion and Society through Rock Art*. Walnut Creek-Lanham-New York-Oxford: Altamira Press, 2002a, 309 pp.

————. *The Mind in the Cave*. London: Thames and Hudson, 2002b, 320 pp.

————. *L'Art rupestre en Afrique du Sud: Mystérieuses images du Drakensberg*. Paris: Seuil, 2003, 126 pp. 75 fig.

LEWIS-WILLIAMS, James David; Dowson, Thomas A.; Deacon, Janette. "Rock art and changing perceptions of southern Africa's past: Ezeljagdspoort reviewed." *Antiquity* 67 (1993), pp. 273–91.

LEWIS-WILLIAMS, James David, Loubser, Jannie H.N. "Deceptive appearances: a critique of southern African rock art studies." *Advances in World Archaeology* 5 (1986), pp. 253–89.

LHOTE, Henri. "Le vêtement dans les gravures et les peintures rupestres au Sahara." *Tropiques* 51 (357) (1953), pp. 15–23.

————. "Gravure rupestre de Tihoubar-n-Attaram (Tassili-n-Ajjer)." Ile Congrès panafricain de préhistoire, Algiers, 1952. Paris: A.M.G., 1954. pp. 737–38.

————. *Peintures préhistoriques du Sahara. Mission H. Lhote au Tassili* (preface by the Abbé Breuil). Paris: Musée des Arts décoratifs, 1957, 63 pp.

————. "Les peintures pariétales d'époque bovidienne du Tassili. Éléments sur la magie et la religion." *JSA* 36 (1) (1966), pp. 7–27, 12 photos.

————. *Les Gravures du nord-ouest de l'Aïr*. Paris: Arts et Métiers Graphiques, 1972. 206 pp.

————. *À la découverte des fresques du Tassili*. Paris: Arthaud, 1973. 261 pp., 73 héliogravures, 4 pl. in colour, 4 maps, 1 drawing. (1st ed. 1958)

————. *Vers d'autres Tassilis: Nouvelles découvertes au Sahara*. Paris: Arthaud, 1976a. 257 pp., 75 ill.

————. *Les Gravures rupestres de l'Oued Djerat (Tassili-n-Ajjer)*. Algiers: Mém. du CRAPE XXV, 1976b, 2 vol., 2 606 fig., 98 photos.

————. *Les Gravures de l'Oued Mammanet (nord-ouest du massif de l'Aïr)*. Dakar: Les Nouvelles Éditions africaines, 1979. 431 pp.

————. *Les Touaregs du Hoggar*. Paris: Armand Colin, 1984, 253 pp.

LHOTE, Henri; Colombel, Pierre. *Gravures, peintures rupestres et vestiges archéologiques des environs de Djanet (Tassili-n-Ajjer)*. Algiers: OPNT, 1979, 64 pp., 66 + 9 fig, 14 photos, map.

LHOTE, Henri; Colombel, Pierre; Bouchart, H. *Les Gravures du pourtour occidental et du centre de l'Aïr*. Paris: ADPF (RGC, Mem. n° 70), 1987. 281 pp., 78 pl., 2 664 fig., 17 photos.

LINDGREN, N.E.; Schoffeleers, J. Matthews. *Rock Art and Nyau Symbolism in Malawi*. Zomba (Malawi): Department of Antiquities. Publication no 18, 1985, 52 pp.

LOUBSER, Jeannie H. N.; Dowson, Thomas. "Tombo-la-Ndo: the Venda perception of San rock art." *SAAB* 42 (1987), pp. 51–4.

LYDALL, Jean; Strecker, Ivo. *The Hamar of Southern Ethiopia, II: Baldambe Explains*. Göttingen: Klaus Renner Verlag ("Arbeiten aus dem Institut für Völkerkunde"), 1979.

LYNCH, B. Mark; Donahue, R. "A Statistical Analysis of Two Rock-Art Sites in Northwest Kenya." *Journal of Field Archaeology* 7 (1) (1980), pp. 75–85.

LYNCH, B. Mark; Robbins, L. "Animal brands and interpretation of rock art in East Africa." *Current Anthropology* 18 (3) (1977), pp. 538–9.

MAACK, Reinert. "Die 'Weiße Dame' vom Brandberg. Bemerkungen zu den Felsmalereien des paläolithischen Kulturkreises in Südwest-Afrika." *Ethnologica* NF 3 (1966), pp. 1–84.

MACFARLANE, D. R. "An early copyist of Bushman drawings." *SAAB* 9 (1954), pp. 49–50.

MAGGS, Tim M. O'C. "A quantitative analysis of the rock art from a sample area in the western Cape." *SAJS* 63 (1967), pp. 100–104.

————. "Neglected Rock Art: The Rock Engravings of Agriculturist Communities in South Africa." *SAAB* 50 (162) (1995), pp. 132–42.

MANHIRE, Tony; Parkington, John. "A distributional approach to the interpretation of rock art in the South-Western Cape." *SAASGS* 4 (1983), pp. 9–33.

MARCHI, Séverine. "The Cave Paintings of Modjodje-Do (Republic of Mali)." In: *News 95 – International Rock Art Conference Proceedings*, ed. on CD-rom. Centro Studi e Museo d'Arte Prehistorica: Pinerolo (Italy), 1999a.

————. "The Rock Art of Aire Soroba (Republic of Mali)." 1999b, ibid.

MARLIAC, Alain. *Recherches sur les pétroglyphes de Bidzar au Cameroun septentrional*. Paris: ORSTOM, Mémoire 92, 1981. 213 pp., LI pl.

MARSHALL, Lorna. *Nyae Nyae !Kung beliefs and rites*. Cambridge (Mass.): Peabody Museum of Archaeology and Ethnology Harvard University (Peabody Museum Monographs no 8), 1999, pp. XXXVII–361.

MASAO, Fidelis Taliwawa. *The Later Stone Age and the Rock Paintings of Central Tanzania*. Wiesbaden: Franz Steiner Verlag, 1979, 311 pp., 97 fig.

————. "Speculation on the motivation and meaning of Central Tanzania rock paintings." In: Shirley Ann Pager (ed.), *Rock Art. The Way Ahead*. Occasional Sarara Publications (Southern African Rock Art Association) 1, 1991a, pp. 127–37.

————. "The rock art of Lukuba Island in the wider context of the rock art of the Lake Victoria Basin." In: Shirley Ann Pager (ed.), *Rock Art. The Way Ahead*. Occasional Sarara Publications (Southern African Rock Art Association) 1, 1991b, pp. 175–82.

MAUNY, Raymond. "Note à Jaeger 1953." *NA* 60, 1953, pp. 99.

————. "Évocation de l'Empire du Mali." *NA* 82 (numéro spécial: L'Empire du Mali), 1959.

MCCALL, Grant S. "Why the Eland? An Analysis of the Role of Sexual Dimorphism in San Rock Art." *Trace*, February 2000.

MOFFAT, Robert. *Missionary Labours and Scenes in Southern Africa*. London: John Stow, 1842. XVI + 624 pp.

MOHAUPT, Nicole. *The Dances of the Youth, as Reflection of Gender Relations and a Gerontocratic Society in a village of Bashada*. Hausarbeit zur Erlangung des Akademischen Grades eines Magister Artium vorgelegt, dem Fachbereich Sozialwissenschaften der Johannes Gutenberg Unitversität Mainz, 1995.

MOCKERS, P.; Clamens, Gabriel. "Hauts lieux et gravures rupestres en pays Djimini (Côte d'Ivoire)." *NA* 46 (1950, pp. 35–6.

MORRIS, David. "Engraved in place and time: a review of variability in the rock art of the Northern Cape and karoo." *SAAB* 43 (1988), pp. 109–21.

————. "Rock art observations and research in the Northern Cape and the Development of the McGregor Museum's collection." In: Shirley-Ann Pager (ed.), *Rock Art – The way Ahead*. Occasional SARARA Publication n° 1 (1991), pp. 151–65.

MORRIS, David; Beaumont, P. "Portable Rock Engravings at Springbokoog and the Archaeological Contexts of Rock Art of the Upper Karoo.". In: Thomas A. Dowson and David Lewis-Williams (eds.), *Contested Images. Diversity in South African Rock Art Research*. Johannesburg: Witwatersrand University Press, 1994. pp. 11–28.

MORTELMANS, Georges. "Les dessins rupestres gravés, ponctués et peints du Katanga. Essai de synthèse." Tervuren: Annales du Musée royal du Congo belge, Préhistoire, 1, 1952, pp. 35–54, pl. XV-XIII.

MORTELMANS, Georges; Monteyne, R. "La grotte peinte de Mbafu, témoignage iconographique de la première évangélisation du Bas-Congo." IVe Congrès panafricain de préhistoire et de l'étude du quaternaire, Léopoldville 1959, Tervuren, 1961, pp. 457–85.

MOSSOP, E. E. (ed.). *The Journal of Hendrik Jacob Wikar (1799) and the Journals of Jacobus Coetzé Jansz (1766) and Willem Van Reenen (1791)*. With Translations by A. Van der Horst and E. E. Mossop. Publications from the Van Riebeeck Society, no 15. Cape Town: Van Riebeeck Society, 1935. xii–327 pp.

MUZZOLINI, Alfred. "Masques et théromorphes dans l'art rupestre du Sahara central." *ArchéoNil* 1, 1991, pp. 16–42.

————. "Le profane et le sacré dans l'art rupestre saharien." *Bulletin de la société française d'égyptologie* 124 (1992), pp. 24–70, 9 pl.

————. *Les Images rupestres du Sahara*. Toulouse: the author, 1995. 447 pp., 510 ill.

NENQUIN, Jacques. "Sur deux gravures rupestres du Bas-Congo." *Bulletin de la Société royale belge d'anthropologie et de préhistoire* 70 (1961), pp. 153–8.

NJIDDA, Hajara. "Ta Ghencidu. Study of Marghi Rock Paintings." In: Wilhelm Seidensticker, Michael Broß and Amed Tela Baba (eds.), *Guddiri Studies. Languages and Rock Paintings in Northeastern Nigeria*. Cologne: Rüdiger Köppe Verlag (Westafrikanische Studien, Frankfurter Beiträge zur Sprach-und Kulturgeschichte herausgegeben von Hermann Jungraithmayr und Norbert Cyffer, Band 16) (1997), pp. 85–122.

NOUGIER, Louis-René; Robert, Romain. "De l'accouplement dans l'art préhistorique." *Préhistoire ariégeoise* 29 (1974), pp. 15–63.

ODAK, Osaga. "Kakapeli and other rockpaintings in western Kenya." *Azania* 12 (1977), pp. 187–92.

————. "Interpretations of West Kenya Schematic Rock Art." In: *Cultural Attitudes to Animals, Including Birds, Fish and Invertebrates*. World Archaeological Congress, 1986, vol. 2.

————. "Kenya Rock Art Studies and the Need for a Discipline." In: Michel Lorblanchet (ed.), *Rock Art in the Old World*, Papers presented in Symposium A of the AURA Congress, Darwin (Australia) 1988. New Delhi: Indira Gandhi National Center for the Arts, 1992a. pp. 33–47.

————. "Cup-Mark Patterns as an Interpretation Strategy in some Southern Kenyan Petroglyphs." In: Ibid., 1992b, pp. 49–60.

————. "Ethnographic Context of Rock Art Sites in East Africa." In: M.J. Morwood and D.R. Hobbs (eds.), *Rock Art and Ethnology AURA Occasional Papers* (5), 1992c, pp. 67–70.

ODNER, Knut. "An Archaeological Survey of Iramba, Tanzania." *Azania* 7 (1971), pp. 151–98.

OLIVEIRA, O.R. de. "The Rock Art of Moçambique." In: Murray Schoonraad (ed.), *Rock Paintings of Southern Africa*. South African Association for the Advancement of Science, Special Publication (Johannesburg) 2, 1971, pp. 4–6.

ORPEN, Joseph Millerd. "A glimpse into the mythology of the Maluti Bushmen." *Folklore* 30 (1919), pp. 139–57 (reprint of the almost unobtainable *Cape Monthly Magazine* 9 [1874], pp. 1–13).

OSLISLY, Richard; Peyrot, Bernard. *Les Gravures rupestres de la vallée de l'Ogooué (Gabon)*. Saint-Mau: Sépia, 1993. 93 pp.

OUZMAN, Sven. "Ritual and political uses of a rock engraving site and its imagery by San and Tswana-speakers." *SAAB* 50 (1995), pp. 55–67.

PAGER, Harald. "The magico-religious importance of bees and honey for the rock painters and Bushmen of Southern Africa." *South African Bee Journal* 46 (6) (1974).

————. *Stone Age Myth and Magic as Documented in the Rock Paintings of South Africa*. Graz: Akademische Druck-u. Verlagsanstalt, 1975. 118 pp.

————. "The ritual hunt: parallels between ethnological and archaeological data." *SAAB* 38 (1982), pp. 80–87.

————. *The Rock Paintings of the Upper Brandberg. Part II: Amis Gorges*. Cologne: Heinrich Barth Institut, 1989.

————. *The Rock Paintings of the Upper Brandberg. Part II: Hungorob Gorges*. Cologne: Heinrich Barth Institut, 1993.

————. *The Rock Paintings of the Upper Brandberg. Part III: Southern Gorges*. Cologne: Heinrich Barth Institut, 1995.

————. *The Rock Paintings of the Upper Brandberg. Part IV: Umuab and Karoab Gorges*. Cologne: Heinrich Barth Institut, 1998.

————. *The Rock Paintings of the Upper Brandberg. Part V: Naib Gorge (A) and the Northwest*. Cologne: Heinrich Barth Institut, 2000, 2 vol.

PANKHURST, Rita. "The Coffee Ceremony and the History of Coffee consumption in Ethiopia." In: Katsuyoshi Fukui, Eisei Kurimoto and Masayoshi Shigeta (eds.), *Ethiopia in Broader Perspective: International Conference of Ethiopian Studies*. Kyoto: Shokado, 1997, vol. 2. pp. 516–39.

PARKINGTON, John. "What is an Eland? N!ao and the Politics of Age and Sex in the Paintings of the Western Cape." In: *Skotnes* 1996, pp. 281–9.

PARKINGTON, John; Manhire, Tony; Yates, Royden. "Reading San images." In: Janette Deacon and Thomas A. Dowson (eds.), *Voices from the past: /Xam Bushmen and the Bleek and Lloyd Collection*. Johannesburg: Witwatersrand University Press (Khoisan heritage series), 1996. p 212–33.

PARRY, Elspeth. "Mysticism, myth or misconception. An important, previously unrecorded site in the Matopo, Zimbabwe." *Pictogram* 11 (1), 1999, pp. 45–53.

————. *Legacy on the Rocks: The Prehistoric Hunter-gatherers of the Matopo Hills, Zimbabwe*. London: Oxbow Books, 2000. 134 pp.

PELLEGRINI, Béatrice. "Hypothèses et théories sur le peuplement de l'Afrique: Introduction à la génétique des populations subsahariennes." Geneva: Laboratoire de génétique et de biométrie, département d'anthropologie, travail de diplôme, multigraphié, 1987, 107 pp.

PEROIS, L. "Les dessins rupestres du point G à Bamako (grotte de Medina Koura)." *NA* 27 (1945), t. I, fig. pp. 12.

Phillipson, David W. *Prehistoric Rock Paintings and Engravings of Zambia*. Livingstone: Livingstone Museum (Exhibition catalogue), 1972a, 70 pp., 39 fig.

————. "Zambian rock paintings." *World Archaeology* 3, 1972b, pp. 313–27.

PITTARD, Eugène. "Gravures rupestres (qu'on pourrait peut-être considérer comme capsiennes?) découvertes dans le haut-Katanga (Congo belge)." *Archives suisses d'anthropologie générale* 8 (2), 1935, pp. 163-72.

PIVETEA, Vianney. *Dictionnaire du Poitevin saintongeais*. La Crèche: Geste Éditions, 1996. 489 pp.

POTGIETER, E. F. *The Disappearing Bushmen of Lake Chrissie: A Preliminary Survey*. With notes on the language by D. Ziervogel. Pretoria: Van Schaik, 1955. 64 pp. (Hiddingh-Currie publications of the University of South Africa, no 1).

PRINS, Frans. "African perceptions of rock paintings in Kwazulu-Natal and the Eastern Cape Province." *The Digging Stick* 13 (1) (1996a), pp. 1–2.

————. "Praise to the Bushman Ancestors of the Water. The integration of San-related concepts in the beliefs and ritual of a diviner's training school in Tsolo, Eastern Cape." In: Skotnes 1996(b), pp. 211–23.

PROBST-BIRABEN, J. A. "Les rites d'obtention de la pluie dans la province de Constantine." *JSA* 2 (1932), pp. 95–132.

RACHEWILTZ, Boris de. *Éros noir, Mœurs sexuelles de l'Afrique, de la préhistoire à nos jours*. Paris: La Jeune Parque, 1963. 334 pp., 251 ill.

RAHTZ, Philip A.; Flight, Colin. "A quern factory near Kintampo (Ghana)." *West African Journal of Archaeology* 4 (1974), pp. 1–31.

RANGELEY, W. H. J. "Two Nyasaland rain shrines. Makewana – The mother of all people." *The Nyasaland Journal* 5 (1952), pp. 31–50.

RAYMAEKERS, Paul; Van Moorsel, R. F. Hendrik. *Lovo, contribution à l'étude de la préhistoire de l'Ouest centrafricain*. Université de Léopoldville, 1964. 22 pp., 51 pl.

READ, K. E. "Nama cult of the Central Highlands, New Guinea." *Oceania*, vol. 23, n° 1, Sydney, 1952, pp. 1–25.

REDINHA, José. "As gravuras rupestres do Alto-Zambeze e primeira tentativa da sua interpretaçao." Lisbon, Diamang. Publicaçôes Culturais (Subsidios para a Historia, Arqueologia e Etnografia dos Povos da Lunda) 2, 1948, pp. 65–92.

————. *Paredes Pintadas da Lunda*. Lisbon: Diamang. Publicaçôes Culturais (Subsidios para a Historia, Arqueologia e Etnografia dos Povos da Lunda) 18, 1953, 16 + 17 pp., 64 fig., 55 pl., maps.

RITCHIE, Carson I. *Rock Art of Africa*. New York-London-Philadelphia: A.S. Barnes and Company-Thomas Yoseloff Ltd-The Art Alliance Press, 1979. 157 pp.

ROSET, Jean-Pierre. "Azrou." *Encyclopédie berbère*, Aix-en-Provence, Edisud, t. VII, 1990, pp. 1224–31.

ROUCH, Jean. "Gravures rupestres de Kourki, Niger." *BIFAN* 9 (3–4), 1949, pp. 340–53.

————. "Restes anciens et gravures rupestres d'Aribinda (Haute-Volta)." *Études voltaïques* 2, 1961, pp. 61–70.

ROUMEGUÈRE-EBERHARDT, Jacqueline. *Pensée et société africaines:*

Essais sur une dialectique de complémentarité antagoniste chez les Bantu du Sud-Est. Aix-en-Provence: Publisud, 1986. 86 pp.

RUDNER, Jalmar; RUDNER, Ione. *The Hunter and his Art: A Survey of Rock Art in Southern Africa*. Cape Town, C. Struij, 1970. 278 pp., 87 fig., 60 pl.

RUELLAN, Suzanne; CAPRILE, Jean-Pierre. *Contes et récits du Tchad: La femme dans la littérature africaine*. Paris: CILF. 1993, 121 pp.

SANDERSON, G. M. "Inyango: The Picture Models of the Yao Initiation Ceremonies." *The Nyasaland Journal* 8 (2), 1955, pp. 36–58.

SANOGO, Klena. "Réflexions sur les problèmes et perspectives d'interprétation des gravures et peintures rupestres du Mali." *MSISN-MCSNM* 26 (2), 1993, pp. 447–51.

SANTOS JÚNIOR, Joaquim Rodrigues dos. "Les peintures rupestres du Mozambique." In: Lionel Balout (ed.), Actes du Congrès panafricain de préhistoire, 2nd Session, Algiers. Paris: Arts et Métiers Graphiques, 1952, pp. 747–58.

SANTOS JÚNIOR, Joaquim Rodrigues dos; Erdevosa, Carlos M. N. *As pinturas rupestres do Caninguiri*. Luanda: Publicaçao de Ciencias Biologicas da Fac. de Ciencias, 1971.

————. "As pinturas rupestre da Galanga, Angola." *Leba* 1, 1978, pp. 11–57 and pl. I–XXV.

SASSOON, H. "Cave paintings recently discovered near Bauchi, Northern Nigeria." *Man* 70 (1960), May–June.

SCARPA FALCE, Adriana and Sergio. "Uadi Sakallem, Tadrart Acacus: il 'sito del dragone'" *Sahara* 13 (2001–02), pp. 91–102 and pl. G–K.

SCHAEFFNER, André. "Peintures rupestres de Songo." *Le Minotaure* 1 (2), 1933, pp. 2–55.

SCHERZ, Ernst Rudolf. *Felsbilder in Südwest Afrika. Vol. 3: Die Malereien*. Cologne: Böhlau, 1986.

SCHMIDT, Sigrid. "Der trickster der Khoisan-Volkserzählungen als Regenkämpfer." *Journal of the SWA Scientific Society* 29 (1977–78), pp. 67–77.

————. "The rain bull of the South African Bushmen." *AS* 38 (2), 1979, pp. 201–24.

SCHNEIDER, Harold K. "Turu Esthetic Concepts." *American Anthropologist* 65 (1966), pp. 156–60.

SCHÖNLAND, S. "On some supposed Bushman inscriptions and rock-carvings found in Bechuanaland." Transactions of the South African Philosophical Society 9, 1895–97, pp. XIX–XX.

SEIDENSTICKER, Wilhelm. "The Rock Paintings and Rock Gongs of Shira." In: Wilhelm Seidensticker, Michael Broß and Amed Tela Baba (eds.), *Guddiri Studies: Languages and Rock Paintings in Northeastern Nigeria*. Cologne: Rüdiger Köppe Verlag (Westafrikanische Studien, Frankfurter Beiträge zur Sprach- und Kulturgeschichte herausgegeben von Hermann Jungraithmayr und Norbert Cyffer, Band 16), 1997, pp. 65–93.

SHAPERA, Isaac. *The Khoisan Peoples of South Africa*. London: Routledge and Kegan Paul, 1963. pp. xi–450.

SHORTER, A. E. M. "Rock paintings in Ukimbu." *TzNR* 67 (1967), pp. 49–55.

SILBERBAUER, George. *Hunter and Habitat in the Central Kalahari Desert*. Cambridge University Press, 1981.

SKOTNES, Pippa (ed.). *Miscast: Negotiating the Presence of the Bushmen*. Cape Town: University of Cape Town Press, 1996. 383 pp.

SMITH, Benjamin W. *Zambia's Ancient Rock Art: The Paintings of Kasama*. Livingstone (Zambia): National Heritage Conservation Commission, 1997. 60 pp.

————. "Forbidden Images: Rock Paintings and the Nyau Secret Society of Central Malawi and Eastern Zambia." *African Archaeological Review* 18 (4) (2001), pp. 187–211.

SOLOMON, Anne. "Gender, representation, and power in San

ethnography and rock art." *Journal of Anthropological Archaeology* 11 (1992), pp. 291–329.

————. "The myth of ritual origins? Ethnography, mythology and interpretation of San rock art." *SAAB* 52, 1997, pp. 3–13.

————. "Meaning, models and minds: a reply to Lewis-Williams." *SAAB* 169 (1999a), pp. 51–60.

————. "Thoughts on therianthropes, myth and method." *Pictogram* 10 (2) (1999b), pp. 10–16.

————. "Pigment and paint analyses and their potential in San rock art research." *Pictogram* 11 (2), 2000, pp. 12–16.

————. "Magic, diversity and interpretation of San rock paintings in Southern Africa." *Pictogram* 12 (1), (2001), pp. 52–8.

SOMMIER, J.R. "Restes anciens dans le cercle de Sikasso (Soudan)." *NA* 47 (1950), pp. 68.

SOPER, Robert C. "Cup-marks and grinding grooves." *Azania* 1 (1966), pp. 155.

————. "Petroglyphs of Northern Kenya." *Azania* 3 (1968), pp. 189–91.

SOPER, Robert C; Golden, B. "An Archaeological Survey of Mwanza Region, Tanzania." *Azania* 4 (1969), pp. 15–79.

STANFORD, W.E. "Statement of Silayi with reference to his life among Bushmen." Transactions of the Royal Society of Southern Africa 1 (1910), pp. 435–40.

STANLEY, Henry Mortimer. *Through the Dark Continent, or the Sources of the Nile, around the Great Lakes of Equatorial Africa and Down the Livingstone river to the Atlantic Ocean*. London: Sampson Low, Marston, Searle and Rivington, 1878, 2 vols.

STANNUS, H.S. "The Wa Yao of Nyasaland." *Harvard African Studies* 3 (1922), pp. 229–372.

STANNUS, H.S.; Davey, J.B. "The initiation ceremony for boys among the Yao of Nyasaland." *Journal of the Royal Anthropological Institute* 43 (1913), pp. 119–23.

STAUDINGER, P. "Funde und Abbildungen von Felzeichnungen aus den alten Goldgebieten von Portugiesisch-Südostafrika." *ZfE* (Berlin) 43 (1911), pp. 140–46.

STOW, George William; Bleek, Dorothea. *Rock Paintings in South Africa, from Parts of the Eastern Province and Orange Free State*. Copied by George William Stow, with an Introduction and Descriptive Notes by Dorothea F. Bleek. London: Methuen and Co. Ltd, 1930. XXVIII p ., 72 pl.

SUMMERS, Roger (ed.). *Prehistoric Rock Art of the Federation of Rhodesia and Nyasaland*. Paintings and Descriptions by Elizabeth Goodall, C.K. Coole, J. Desmond Clark. Salisbury: National Publications Trust, 1959. 267 pp., 116 pl., 61 fig.

SZUMOWSKI, G. "Notes sur la grotte préhistorique de Bamako." *NA* 58 (1953), pp. 35–40.

————. "Sur une gravure rupestre du Niger à Bamako." *BSPF* 69 (1955), pp. 19–23.

————. "Vestiges préhistoriques dans la région de Bandiagara." *NA* 69 (1956), pp. 19–23.

TADESSE BERISSO. *Traditional Warfare among the Guji of Southern Ethiopia*. Michigan State University, Dept of Anthropoloy, P.A., 1988. 66 pp.

TAMSIR NIANE, Djibril. "Recherches sur l'empire du Mali au Moyen Âge." *Recherches africaines* 1 (1959), pp. 6–56.

TANAKA, Jiro O. *The San, Hunter-Gatherers of the Kalahari: a Study in Ecological Anthropology*. University of Tokyo Press, 1980. pp. XVI–200

TANNER, R.E.S. "A series of rock paintings near Mwanza." *TNR* 34 (1953), pp. 62–7.

TEN RAA, Eric. "Geographical names in South-eastern Sandawe." *Journal of African Languages* 5 (3) (1966), pp. 175–207.

————. "Sandawe pre-history and the vernacular tradition." *Azania* 4 (1969), pp. 91–103.

————. "Dead Art and Living Society: A Study of Rock-paintings in a Social Context." *Mankind* 8 (1971), pp. 42–58.

————. "A record of some pre-historic and some recent Sandawe rock paintings." *TzNR* 75 (1974), pp. 9–27.

THACKERAY, J. Francis. "Disguises, animal behaviour and concepts of control in relation to rock art of southern Africa." *SAASGS* (1983), pp. 38–43.

————. "Masquerade and therianthropes in art." *The Digging Stick* (Newsletter of the South African Archaeological Society) 1 (1984), pp. 2.

————. "Animals, conceptual associations and Southern African Rock Art. A Multidisciplinary, Exploratory Approach." In: Thomas A. Dowson and David Lewis-Williams (eds.), *Contested Images. Diversity in South African Rock Art Research*. Johannesburg: Witwatersrand University Press, 1994, pp. 223–35.

————. "The Melikane rock painting in Lesotho, compared to a photograph of a 'buckjumper' recorded in the Southern Kalahari in 1934." *Pictogram* 10 (2) (1999), pp. 25–7.

THACKERAY, Anne I; Thackeray, J. Francis; Beaumont, Peter B.; Vogel, J. C. "Dated Rock Engravings from Wonderwerk cave, South Africa." *Science* 214 (1981), pp. 64–7.

THOMPSON, Stith. *Motif-Index of Folk-Literature: A Classification of Narrative Elements in Folktales, Ballads, Myths, Fables, Mediaeval Romances, Exempla, Fabliaux, Jest-Books and Local Legends*. Bloomington: Indiana UP, 1966. 6 vols. (1st ed.: 1955 ; enriched and revised edition on CD-ROM, 1993).

TONGUE, M. Helen. *Bushman Paintings, with a Preface by Henry Balfour*. Oxford: Clarendon Press, 1909. 47 pp., 105 pl.

TORNAY, Serge (ed.). *Voir et nommer les couleurs*. Nanterre: Laboratoire d'ethnologie et de sociologie comparative, 1978. 680 pp.

TROST, Franz. "Gravures et peintures rupestres de Tonja (Mali)." *Sahara* 9 (1997), pp. 51–62.

————. "Petroglyphen in Südwest-Burkina Faso." *Stonewatch* 5, 2000, pp. 5–11.

TSCHUDI, Yolande; Gardi, René. *Les Peintures rupestres du Tassili-n-Ajjer*. Neuchâtel: À la Baconnière, 1956. 104 pp., 16 fig. in-t., 27 + XX pl.

TUCKEY, James Kingston. *Narrative of an Expedition to Explore the River Zaire, Usually Called the Congo, in South Africa, in 1816, under the Direction of J.K. Tuckey*. London: Murray, 1818. 498 pp.

URVOY, Yves. "Peintures rupestres de Takoutala (Soudan français)." *JSA* 7 (2), 1938, pp. 97–101 + pl. III.

————. "Gravures rupestres dans l'Aribinda (boucle du Niger)." *JSA* 11 (1), 1941, pp. 1–5.

VAN ALBADA, Axel and Anne-Michelle. *La Montagne des hommes-chiens: Art rupestre du Messak libyen*. Paris: Seuil, 2001. 138 pp., 126 ill.

VAN BREUGEL, J. W. M. *Chewa Traditional Religion, Blantyre (Malawi)*. Kachere Monograph no 13, 2001, 288 pp.

VAN DER KERKEN, G. *Le Mésolithique et le néolithique dans le bassin de l'Uele. Le pavement d'Api ; les graffitis ; les cupules ; les pédiformes ; les mégalithes ; les outils et les autres objets en pierre ; le problème des populations mésolithiques et néolithiques du bassin de l'Uele*. Brussels: ICB, Mém. X, fasc. 4, 1942, 118 pp.

VAN VREEDEN, B.F. *Die Wedersydse Beïnvloeding van die Blanke-, Bantoe- en Kleurling-kulture in Noord-Kaapland*. University of Witwatersrand: unpublished M.A. Thesis, 1957 (cited in Humphreys 1978).

VAUGHAN, James H. "Rock paintings and rock gongs among the Marghi of Nigeria." *Man* 83 (1962), pp. 49–52.

VERNET, Robert (ed.). *L'Archéologie en Afrique de l'Ouest. Sahara et Sahel*, Nouakchott-St-Maur, CRIAA/Sépia, 2000, 323 pp.

VINNICOMBE, Patricia. "The recording of rock paintings: an interim report." *SAJS* 63 (1967), pp. 282–4.

————. *People of the Eland: Rock Paintings of the Drakensberg Bushmen as a Reflection of their Life and Thought*. Pietermaritzburg: University of Natal Press, 1976.

WALKER, Nicholas J. "The dating of Zimbabwean rock art." *RAR* 4 (2) (1987), pp. 137–49.

————. "Painting and ceremonial activity in the Later Stone Age of the Matopos, Zimbabwe." In: Thomas A. Dowson and J. David Lewis-Williams (eds.), *Contested Images: Diversity in South African Rock Art Research*. Johannesburg: Witwatersrand University Press, 1994. pp. 118–30.

WALTER, N. "L'art rupestre du Botswana." *INORA* 5 (1993), pp. 23–9.

WEBER, Edgar. *Petit Dictionnaire de mythologie arabe et des croyances musulmanes*. Paris: Ententes, 1996. 386 pp.

WENDT, Wolfgang Erich. "Art mobilier aus der Apollo 11-grotte in Südwest-Afrika. Die ältesten datierten Kunstwerke Afrikas." *Acta Praehistorica et Archaeologica* 5 (1974), pp. 1–42 (reprinted in 'Art mobilier' from Apollo 11 cave, South-West Africa: Africa's oldest dated works of art." *SAAB* 31 (1976, pp. 5–11).

WENTZEL, Volkmar. "Angola, unknown Africa." *National Geographic* 120 (3) (1961), pp. 346–83.

WHITLEY, David S.; Annegarn, Harold J. "Cation-ratio Dating of Rock Engravings." In: Thomas A. Dowson and J. David Lewis-Williams (eds.), *Contested Images: Diversity in South African Rock Art Research*. Johannesburg: Witwatersrand University Press, 1994. pp. 189–97.

WIKAR, Hendrick Jacob. *The Journal of Hendrick Jacob Wikar (1779)*. Translated by A. W. Van der Horst. Cape Town: Van Riebeeck Society, 1935.

WILMAN, Maria. *The Rock-Engravings of Griqualand and Bechuanaland. South Africa*, Cape Town: A. A. Balkema, 1968. XII + 77 pp., 70 pl., 1 map.

WILLCOX, Alexander Robert. *Rock Paintings of the Drakensberg: Natal and Griqualand East*. London: Max Parrish, 1956. 96 pp.

————. *The Rock Art of South Africa*. London-Johannesburg: Nelson, 1963. 96 pp., xxiv + 42 fig.

WILMSEN, Edwin. "Of paintings and Painters, in Terms of Zu/'hõasi Interpretations." *Contemporary Studies on Khoisan* 2 (1986), pp. 347–72.

WINBERG, Marlene Sullivan. *My Eland's Heart: A Collection of Stories and Art*. !Xun and Khwe San Art and Culture Project, Claremont: David Philip Publishers, 2001, 136 pp.

WOLHUTER, Harry. *Memories of a Game Ranger*. The Wild Life Protection Society of South Africa, 1950.

WOODHOUSE, H.C. Bert. "The Medikane rock-paintings: sorcerers or hunters?" *SAAB* 23 (1967), pp. 37–9.

————. "Themes in the rock art of Southern Africa." Lecture delivered on September 17, 1969, Johannesburg, ISMA (Institute for the Study of Man in Africa), ISPA Paper 8, 1969, pp. 1–10.

————. "Bushman paintings of comets?" *Mnassa* 45 (3–4) (1986a), pp. 33–34.

————. "Comets in the rock art of Southern Africa." In: V. Poore (ed.), *Collected Papers in Honor of James G. Bain*. Papers of the Archaeological Society of New Mexico 12, 1986b, pp. 55–60.

————. "Bees and honey in the Prehistoric rock art of Southern Africa." *The Digging Stick* 6 (2) (1989), pp. 5–7.

————. *The Rain and its Creatures as the Bushmen Painted Them*. Cape Town: William Waterman Publications, 1992. 100 pp.

WOODHOUSE, H.C. Bert; Lee, D. Neil. *Art on the Rocks of Southern Africa*. Johannesburg: Purnell, 1970.

————. *Bushman Art of Southern Africa: 40 Significant Bushman Rock-Art Sites*. Cape Town-Johannesburg-Durban: Art Publishers, 2002. 48 pp.

WRIGHT, Richard. "A painted Rock Shelter on Mount Elgon." Proceedings of the Prehistoric Society 27, 1961, pp. 28–34.

YATES, Royden; Manhire, Anthony. "Shamanism and rock paintings: Aspects of the use of rock art in south-western Cape, South-Africa." *SAAB* 46 (1991), pp. 3–11.

YOSHIDA, Kenji. "Masks and Secrecy among the Chewa." *African Arts* 26 (2) (1993), pp. 34–45, 92.

YUSUF MTAKU, Chr. "The rock painting of Birnin Kudu, Geji and Bauchi." In: W. Seidensticker, Michael Bross, Ahmad Tela Baga (eds.), *Guddiri Studies: Languages and Rock Painting in Northeastern Nigeria*. Cologne: Rüdiger Köppe Verlag, 1997, pp. 123–169.

ZELÍZKO, Jan Vratislav I. *Felsgravierungen der südafrikanischen Buschmänner, auf Grund der von Dr. Emil Holub mitgebrachten Originale und Kopien*. Leipzig: 1925, 28 pp., 27 pl.

ZELTNER, Fr. de. "Les grottes à peinture du Soudan français." *L'Anthropologie* 22 (1911), pp. 1–12.

Photographic credits

Page 2. Hoa-Qui / G. Guittard.
Pages 4, 8 and 11. Author's own.

THE SAHARA

Figs. 1, 10–14, 18–24, 29, 35, 37–60.
Author's own.
Fig. 2. Almásy, 1936.
Fig. 3. Barth Institut.
Fig. 4. Barth, 1857–1858.
Fig. 5. Lhote, 1979, pl. 40, no. 614.
Fig. 6. Ibid., pl. 161.
Fig. 7. Lhote, 1973, p. 240.
Fig. 8. Ibid., modified.
Fig. 9. Lhote, 1966, photo 12.
Fig. 15. Lhote, 1976b, no. 1265.
Fig. 16. Ibid., no. 1313.
Fig. 17. Ibid., no. 1386.
Fig. 25. Lhote, 1996b.
Fig. 26. Lhote and Colombel, 1979, p. 6, no. 1.
Fig. 27. Lhote, 1996b, no. 1544.
Fig. 28. Author's own.
Fig. 30. Lhote, 1996b, no. 1652.
Fig. 31. Ibid., nos. 842–843.
Fig. 32. Ibid., no. 1566.
Fig. 33. Author's own.
Fig. 34. Lhote, 1976b, nos. 1328–1330.
Fig. 36. André-Paul Hesse.

THE INTERTROPICAL ZONE

Figs. 1 and 6. Hoa-Qui / M. Renaudeau.
Fig. 2. Carvalha, 1952, fig. 2.
Fig. 3. Author's own. Adapted from Rouch,
1949, fig. 8-III.
Fig. 4. Author's own. Adapted from
DeCorse, 1988, fig. 84.
Fig. 5. Author's own. Adapted from Carter
and Carter, 1964.
Fig. 7. Top: Frobenius, 1925, pl. 158.
Bottom, left: Leiris, 1996, pp. 274–275.
Bottom, right: Schaeffner, 1933, p. 53.
Fig. 8. Schaeffner, 1933.
Fig. 9. Griaule, 1938, fig. 214.
Fig. 10. Ibid., fig. 183g.
Fig. 11. Ibid., fig. 175.
Fig. 12. Ibid., fig. 176c.
Fig. 13. Ibid., fig. 211, modified.
Fig. 14. Ibid., fig. 206.
Fig. 15. Ibid., fig. 218a.
Fig. 16. Ibid., fig. 224d.
Fig. 17. Ibid., fig. 222c.
Fig. 18. Ibid., fig. 190.
Fig. 19. Schaeffner, 1933.
Fig. 20. Ganay, 1940, fig. 17.
Fig. 21. Jaeger, 1953.
Figs. 22 and 23. Alain Gallay,
Éric Huysecom, and Séverine Marchi.
Fig. 24. Author's own. Adapted from
Huysecom, 1990, fig. 82.
Fig. 25. Ibid., figs. 75–80.
Fig. 26. Trost, 2000, fig. 6.
Fig. 27. Ibid., fig. 7.
Fig. 28. Author's own. Adapted from
Rouch,1961, fig. 2-V.

Fig. 29. Author's own. Adapted from
Clamens, 1951.
Fig. 30. 1, 2, 4, 7 and 8: Njidda 1997, fig. 3,
7 and 8, 22 and 23. 5 and 6: Seidensticker
1997, figs. 11–12.
Figs. 31, 32 and 33. Jean-Gabriel Gauthier.
Fig. 34. Raymaekers and Van Moorsel, 1964,
pl. 27, no. 330.
Fig. 35. Ibid., pl. 27, no. 325.
Fig. 36. Author's own. Adapted from Bayle
des Hermens, 1975, fig. 123.
Fig. 37 and 39. Royal Museum for Central
Africa, Tervuren.
Fig. 38. Author's own. Adapted from Colette,
1936, fig. 1.
Fig. 40. Author's own. Adapted from Oslisly
and Peyrot, 1993, photo 31.
Fig. 41. Ibid., fig. 5.
Fig. 42. Ibid., fig. 8.
Fig. 43. Ibid., photo 27.
Fig. 44. Breuil, 1952, pl. XII.
Fig. 45. Tuckey, 1818, pl. H.T.
Figs. 46 and 47. Ibid., pp. 380 and 382.
Fig. 48. Redinha, 1948, p. 71.
Fig. 49. Ibid., p. 72.
Fig. 50. Author's own. Adapted from ibid.,
p. 74.
Fig. 51. Author's own. Adapted from Rudner
and Rudner, 1970, pp. 4–5.
Fig. 52. Author's own.
Fig. 53. Redinha, 1948, p. 73, photo 4.
Fig. 54. Kubik, 1992, fig. 6.
Fig. 55. Redinha, 1953, pl. 1.
Fig. 56. Author's own. Adapated from
Carvalha, 1952., fig. 1.
Fig. 57. Author's own. Adapted from Santos
Júnior and Erdevosa, 1978, fig. 25.
Figs. 58 and 59. Claude Boucher.
Fig. 60. Summers, 1959, pl. 110.
Figs. 61 and 62. Claude Boucher.
Fig. 63. Author's own. Adapted from
Lindgren and Schoffeleers, 1985, p. 31.
Fig. 64. Ibid., p. 28, detail.
Fig. 65. Claude Boucher.
Figs. 66 and 67. Author's own.
Fig. 68. Claude Boucher.
Fig. 69. Lindgren and Schoffeleers, 1985,
p. 49.
Fig. 70. Ibid., p. 50.
Fig. 71. Ibid., p. 52.
Figs. 72 and 73. Claude Boucher.
Fig. 74. Summers, 1959, pl. 49.
Fig. 75. Phillipson, 1972b, fig. 25.
Fig. 76. Ibid., fig. 2, and Summers, 1959,
pl. 95.
Fig. 77. Author's own. Adapted from
Phillipson, 1972b, fig. 7.
Fig. 78. Author's own. Adapted from ibid.,
fig. 10.
Fig. 79. Author's own. Adapted from ibid.,
fig. 36.

AZANIA

Figs. 1, 3, 5–6, 15–29, 45–46, 49–50.
Author's own.
Fig. 2. Leakey, 1983, fig. 26.
Fig. 4. Breuil, 1934.
Fig. 7. Leakey, 1983, p. 40.
Fig. 8. Fozzard, 1959.
Fig. 9. Leakey, 1983, fig. 13.
Fig. 10. Jean-Marc Large.
Fig. 11. Leakey, 1983, p. 78.
Fig. 12. Jean-Marc Large.
Fig. 13. Leakey, 1983, fig. 47.
Fig. 14. Kohl-Larsen, 1958, fig. 49.
Fig. 30. Haberland, 1959, pl. 45, fig. 2.
Fig. 31. Gigar Tesfay, 2000, pl. II.
Fig. 32. Ibid., pl. I.
Fig. 33. Leakey, 1983, fig. 42.
Fig. 34. Ibid., fig. 15.
Fig. 35. Arundell, 1936.
Fig. 36. Fosbroocke, 1950, fig. 7.
Fig. 37. Ten Raa, 1974, fig. 18.
Fig. 38. Author's own. Adapted from ibid.,
fig. 17.
Fig. 39. Author's own. Adapted from
Culwick, 1931, fig. 8.
Figs. 40 and 41. Ibid., fig. 7.
Fig. 42. Author's own. Adapted from Odak,
1977, fig.1.
Fig. 43. Author's own. Adapted from Lynch
and Donahue, 1980.
Fig. 44. Lynch and Donahue, 1980.
Fig. 47. Bouakaze-Khan, 2002, vol. 2, fig. 117.
Fig. 48. Giulio Calegari.

SOUTHERN AFRICA

Figs. 3–4, 7, 10, 27–28, 34–35, 37, 47, 50,
52, 64, 73, 78–79. Author's own.
Fig. 1. Hoa Qui / J. Brun.
Fig. 2. Pager.
Fig. 5. Bahn, 1998.
Fig. 6. Ibid.
Fig. 8. Stow and Bleek, 1930, pl. 34.
Fig. 9. Fock, 1989, pl. 32–1.
Fig. 11. Holub, 1890.
Fig. 12. Willcox, 1963, fig. II.
Fig. 13. Tongue, 1909, pl. VIII-23.
Fig. 14. Frobenius, 1931, pl. 138.
Fig. 15. Ibid., pl. 6.
Fig. 16. Breuil, 1955, fig. d.
Fig. 17. Breuil, 1966, frontispiece, and pl. 46.
Fig. 18. Breuil.
Fig. 19. Willcox, 1963, fig. XI.
Fig. 20. Breuil, 1955.
Fig. 21. Rudner, 1970.
Fig. 22. Brentjes, 1965.
Fig. 23. Adapted from Pager, 1998, p. 391.
Fig. 24. Pager.
Fig. 25. Adapted from Pager, 1975, p. 44.
Fig. 26. Rudner, 1970, fig. 57.
Fig. 29. Garlake, 2001, fig. 9.
Fig. 30. Hoa-Qui / M. Huet.
Fig. 31. Janet Duff, in Parry, 2000, p. 7.
Fig. 32. Ibid.
Fig. 33. Pager, 1998, p. 17.

Fig. 36. Bernadéte Bidaude.
Fig. 38. Kuper, 1996, modified.
Fig. 39. Source:
http://naples.cc.sunysb.edu/CAS/cape.nsf/.
Fig. 40. Wendt, 1974.
Fig. 41. Thackeray, 1981.
Fig. 42. Author's own. Adapted from various
drawings and photos.
Fig. 43. Stow and Bleek, 1930, pl. 50.
Fig. 44. Author's own. Adapted from various
drawings and photos.
Fig. 45. Author's own. Adapted from photo
by L. Marshall in Campbell, 1987, p. 93,
no. 170.
Fig. 46. Stow and Bleek, 1930, pl. 67A.
Fig. 48. Lewis-Williams, 1981b, p. 98 C.
Fig. 49. H. Pager, in Pager, 1983, fig. 2.
Fig. 51. Pager, 1975, p. 49.
Fig. 53. Ibid., p. 75.
Fig. 54. Woodhouse, 1989, fig. 1.
Fig. 55. H. Pager, 1971, figs. 387–8b.
Fig. 56. Hoa-Qui/P. de Wilde.
Fig. 57. Hoa-Qui/P. de Wilde.
Figs. 58–59. Stow and Bleek, 1930, pl. 13–14.
Fig. 60. M. Pearse.
Fig. 61. Lewis-Williams, 1981b, p. 98 F.
Fig. 62. Author's own. Adapted from
Frobenius, 1931, p. 22.
Fig. 63. Pager, 1975, p. 46.
Fig. 65. Tongue, 1909, pl. XVIII-29.
Fig. 66. Ibid., pl. VI-8.
Fig. 67. Stow and Bleek, 1930, pl. 21.
Fig. 68. Pager, 2000, p. 78, no. 126.
Fig. 69. Rudner and Rudner, 1970, pl. 48.
Fig. 71. Tongue, 1909, pl. XXXVI-60.
Fig. 72. Thackeray, 1994.
Fig. 74. Author's own. Adapted from Pager,
2000, p. 264, no. 77.
Fig. 75. Wilmsen, 1986.
Fig. 76. Ibid.
Fig. 77. Provided by D. Lewis-Williams, and
reproduced by Wilmsen, 1986.
Fig. 80. Stow and Bleek, 1930, pl. 58.
Fig. 81. Ibid., pl. 45.